T0187123

The Art of **PIXAR**

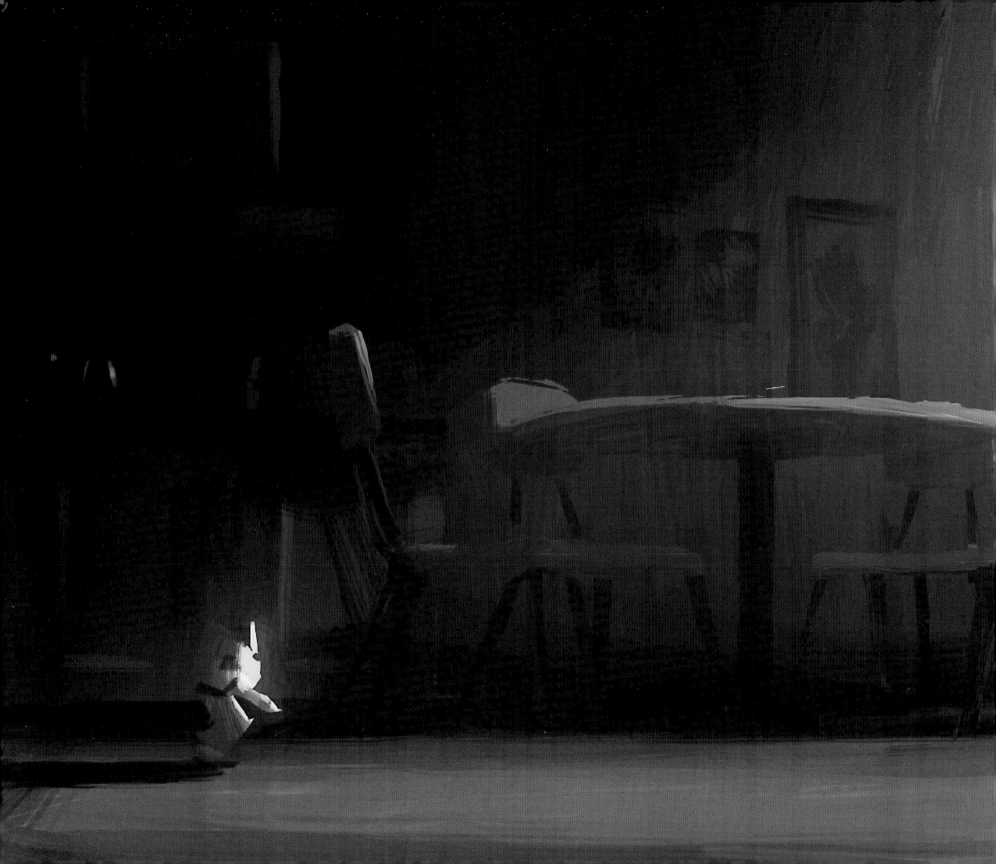

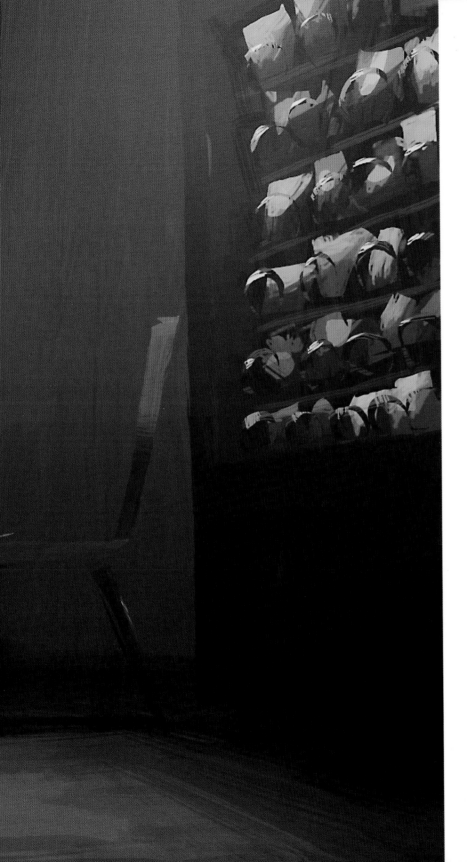

The Art of **PIXAR**

The Complete Colorscripts and Select Art from 25 Years of Animation

Amid Amidi
Foreword by John Lasseter

CHRONICLE BOOKS

SAN FRANCISCO

Copyright © 2011 by Disney Enterprises, Inc./Pixar

All rights reserved. No part of this book may be reproduced in any form without written permission from the publisher.

Library of Congress Cataloging-in-Publication Data

Amidi, Amid.
 The art of Pixar : the complete colorscripts and select art from 25 years of animation / by Amid Amidi ; foreword by John Lasseter.
 p. cm.
 ISBN 978-0-8118-7963-7 (hardcover)
 1. Pixar (Firm) 2. Animated films—United States. 3. Motion picture plays, American. I. Title.
 NC1766.U52P5832 2011
 791.430973—dc22

 2011005946

Manufactured in China.

Designed by Jacob T. Gardner
Colorscripts layout by Janis Reed

20 19 18 17 16 15 14 13 12

Chronicle Books LLC
680 Second Street
San Francisco, California 94107
www.chroniclebooks.com

pages 2–3: Colorscript, *Toy Story 3*, Dice Tsutsumi, Digital, 2009
page 320: Colorscript, *Toy Story 3*, Dice Tsutsumi, Digital, 2009

Etch A Sketch™ © The Ohio Art Company. Slinky® Dog is a registered trademark of Poof-Slinky, Inc. © Poof-Slinky, Inc. Mr. and Mrs. Potato Head® and Playskool Portable Baby Monitor® are registered trademarks of Hasbro, Inc. Used with permission. © Hasbro, Inc. All rights reserved. Mattel and Fisher-Price toys used with permission. ©Mattel, Inc. All rights reserved.

Materials and characters from the movies *Cars* and *Cars 2*. Copyright © 2011 Disney/Pixar. Disney/Pixar elements © Disney/Pixar, not including underlying vehicles owned by third parties; and, if applicable: Dodge, Hudson Hornet, Plymouth Superbird, Pacer, and Gremlin are trademarks of Chrysler LLC; Jeep® and the Jeep® grille design are registered trademarks of Chrysler LLC; Petty marks used by permission of Petty Marketing LLC; Mack is a registered trademark of Mack Trucks, Inc.; Maserati logos and model designations are trademarks of Maserati S.p.A. and are used under license; Fairlane, Mercury, and Model T are registered trademarks of Ford Motor Company; Darrell Waltrip marks used by permission of Darrell Waltrip Motor Sports; Porsche is a trademark of Porsche; Sarge's rank insignia design used with the approval of the U.S. Army; Volkswagen trademarks, design patents and copyrights are used with the approval of the owner, Volkswagen AG; Audi is a trademark of Audi AG; Bentley is a trademark of Bentley Motors Limited; BMW is a trademark of BMW AG; Mustang is a trademark of Ford Motor Company; Citroën is a trademark of Automobiles Citroën; Datsun is a trademark of Nissan Motor Co., Ltd.; FIAT, Alfa Romeo, and Topolino are trademarks of FIAT S.p.A.; Honda is a trademark of Honda Motor Co., Ltd.; Cadillac Coupe DeVille, H-1 Hummer, Pontiac GTO, Monte Carlo, Corvette, El Dorado, and Chevrolet Impala are trademarks of General Motors; Mini Cooper is a trademark of BMW AG; Nissan is a trademark of Nissan Motor Co., Ltd.; The trademarks OPEL, VAUXHALL, ASTRA, CORSA, MERIVA, and ZAFIRA are registered trademarks of Opel Eisenach GmbH/GM UK Ltd.; Peugeot is a trademark of Automobiles Peugeot; Piaggio is a trademark of Piaggio & C. S.p.A.; is a trademark of General Motors; Renault is a trademark of Renault. Ferrari Elements produced under license of Ferrari S.p.A. FERRARI, the PRANCING HORSE device, all associated logos and distinctive designs are property of Ferrari S.p.A. The body designs of the Ferrari cars are protected as Ferrari property under design, trademark and trade dress regulations. PETERBILT and PACCAR trademarks licensed by PACCAR INC, Bellevue, Washington, U.S.A.; KENWORTH and PACCAR trademarks licensed by PACCAR INC, Bellevue, Washington, U.S.A.; Mazda Miata is a registered trademark of Mazda Motor Corporation; Background inspired by the Cadillac Ranch by Ant Farm (Lord, Michels and Marquez) © 1974.

CONTENTS

FOREWORD

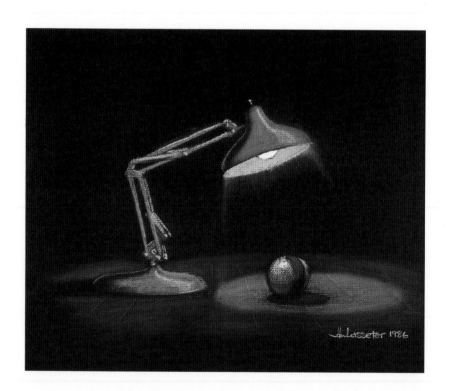

Pixar's first colorscript, **LUXO JR.**, John Lasseter, Pastel, 1986

It takes years to make one of our films, and thousands of pieces of art: character sketches, concept paintings, environment layouts, and color and texture studies, to name just a few. This work is hardly ever seen onscreen, but it's absolutely essential to finding our worlds and leading us to the characters and places, and even events, that you see in the finished film. Being able to work with beautiful art every day is a huge inspiration for me, so I'm always excited when we have the chance to share it outside the studio.

One of the most important pieces of art produced for any film at Pixar is the colorscript. Colorscripts are always featured in the "art of" book for each movie, but often there's only room to show a piece or two. So I'm very happy that this book has finally given us the chance to share all the colorscripts produced for the studio's films, in their entirety.

I first learned what a colorscript was early on in the development of *Toy Story*. Ralph Eggleston, the production designer, had told me he was going to put one together, but I didn't know exactly what to expect when I stopped by his office to review it for the first time.

On his desk was a series of very small, postage-stamp-sized images—each from a different scene in the story—all connected together, like a filmstrip of the movie. It was absolutely fascinating to see Woody's journey unfold in the colors of each image. They range from the warm, comforting light in the introduction to Andy's room, to the darkness that sneaks into the film as Woody's jealousy takes over, to the night scenes showing Woody and Buzz fighting as they try to get back to Andy's, and finally to the warmth of the Christmas lights we see when everyone is reunited at the end of the film.

Every single element in a film must support the emotional arc of the story, which is really the emotional journey of the main character, and I've always felt that the two things that communicate the underlying emotion of a movie better than anything else are music and color. Because color is so charged with feeling and provokes such a strong response in an audience, it is one of the most powerful tools at a filmmaker's disposal. The characters may be saying one thing, but if the color and lighting make the scene feel gloomy, or if the music is unsettling, the audience knows something else is going on—the character's dialogue can't be taken at face value. So the colorscript, which allows you to see the whole arc of a film's color mood at a single glance, is essential in planning and refining the visual and emotional rhythm of a film to support its story. As a film-making tool, it's indispensable.

What's so wonderful, though, is that, because of the amazing skill of the artists who create them, the colorscripts for Pixar's films are also works of art in their own right, just as inspiring as the more detailed visual development pieces that explore the look and feel of individual scenes and characters. Seeing the colorscripts collected alongside one another is a great way to get a sense of the remarkable range of styles among the studio's production designers and art directors, who work with their directors to establish the visual tone and direction for the films, and with their teams of artists to develop those ideas and ultimately bring them to life.

We've put together a selection of visual development art from our feature films to go with these colorscripts, featuring some of the most gorgeous as well as creatively influential pieces of art from each project. Taken all together, this compilation of colorscripts and specific explorations—arcs and moments—is a terrific collection, a sort of colorscript of some of the looks and talents that have helped shape Pixar's films over the years. I hope you'll enjoy it as much as I do.

—JOHN LASSETER

THE
COLOR

SCRIPTS

"COLOR IS MY DAY-LONG OBSESSION, JOY AND TORMENT."

—Claude Monet

Painter and teacher Josef Albers once said that if you asked a group of people to imagine the color red, every person in that group would have a different hue of red in mind.

Color is elusive. Take that same color, red. A heart is red, but so is a stop sign. It is a color equally capable of arousing pleasure as it is of warning of danger ahead. Across different cultures and religions, red symbolizes feelings and concepts as varied as happiness, bravery, luck, sin, and mourning. There are also psychological effects—seeing red can alternately make us irritable and elicit happiness—and physiological effects—studies have shown that the color red stimulates brain-wave activity, increases heart rate, and causes blood pressure to rise.

The mutability of a single color, with its infinite variations of tint, shade, and tone, and, further, the way it is viewed in relation to its neighboring colors, makes color an effective tool for expressing a variety of moods and emotions. Its nebulous nature also gives way to personal interpretation, as when Van Gogh wrote that he was trying "to express the terrible passions of humanity by means of red and green" in his famous painting *The Night Café*.

For the artists who create animated films, color is integral in setting the tone of a film and conveying the right atmosphere to support the characters and plot. Few studios have explored its possibilities as the artists at Pixar have, and it all begins with a colorscript.

• • •

Ralph Eggleston had spent weeks thinking about the story in *Toy Story*, Pixar's first feature film, and discussing its themes with director John Lasseter and other key members of the filmmaking team. In an inspired spurt of a week or so, he painted the colorscript, a roadmap for the way the color (and thus emotion) would be applied throughout the film. The colorscript, which also suggested lighting ideas for scenes, had been undertaken on Eggleston's own initiative, and he was apprehensive about how it would be received by the crew.

As Eggleston tells the story, Lasseter stood there in silence staring at the colorscript for a minute or two. Then he walked over, threw his arms around Eggleston, and gave him a hug. Eggleston, who was in his late twenties at the time, nearly a full decade younger than Lasseter, had impressed the first-time feature director by giving him a new way of seeing the film. "It was a highlight of my life," Eggleston said. "He was in another world. Honestly, it was thrilling, because he could begin to see the whole movie."

Lasseter spread the word around the studio, and soon everybody was popping into Eggleston's office for a look. One Saturday morning after having pulled an all-nighter at the studio, Eggleston returned to his office, freshly showered, to find a stranger looking at the colorscript. The scruffy, bearded man, dressed in a dowdy jacket, blue corduroy shorts, and socks pulled up to his knees, was studying the script intently. "I said, 'Umm, can I help you?' And he goes, 'Oh, I'm sorry, is this your office?' It was a little awkward because he thought I knew who he was and I didn't," Eggleston recalled. "And then he said, 'Oh, my name's Steve Jobs.'" The resoundingly successful reception of Eggleston's work, which had originally been just another piece of exploratory art, cemented the colorscript as a cornerstone of the production design process at Pixar.

• • •

Prior to Pixar, no animation studio consistently mapped out color and lighting in relation to story and character through a formal colorscripting phase. The process, however, is more than seventy years old, having begun with the early 1940s Disney animated features. The artistic choreography of certain musical sequences in *Fantasia*, like "Toccata and Fugue" and "Nutcracker Suite," required dozens of color conceptual sketches that effectively served as

colorscripts for those sequences. Later, the production design by Tyrus Wong for *Bambi* advanced the use of color further. Wong's evocative inspirational artwork added an emotional dimension to color and aimed to "create the atmosphere, the feeling of the forest," instead of the largely literal and utilitarian expression of color in the earlier full-length Disney features.

A similar colorscripting process was employed in Hollywood's live-action films beginning in the mid-'30s when Natalie Kalmus, the former wife of Technicolor founder Herbert Kalmus, supervised Technicolor's color-control department. As part of her duties, she and a group of consultants would create "color charts" for live-action features after analyzing the script to "ascertain what dominant mood or emotion is to be expressed." The comprehensive charts account for every scene, set, sequence, and character in a film. "This chart may be compared to a musical score, and amplifies the picture in a similar manner," Kalmus wrote in a film industry journal.

The idea of presenting an entire animated film's color structure in a single piece of artwork didn't fully materialize until the films made at United Productions of America, the modernist animation studio that revolutionized the design and content of Hollywood animation. Building upon the Disney process, and employing many artists who had worked there, UPA created "color continuity sketches" for their films beginning in the mid-'40s. The studio's color continuity sketches most closely resemble Pixar's colorscripts in their goal of conveying the sweeping, panoramic flow of color throughout a film's span. The biggest difference between the UPA and Pixar colorscripts is length; UPA's shorts were between six and eight minutes long, and Pixar's features are upward of ninety minutes.

The modern resurgence of the colorscript may be traced again to Disney, and one artist in particular, Richard Vander Wende. When Vander Wende painted a colorscript for *Aladdin*, he had never before seen one. His inspirations were a series of color keys that Eyvind Earle had drawn for a romantic nighttime scene in *Lady and the Tramp*, as well as color bars [an abstract cousin of the colorscript] that had been painted for *Beauty & the Beast*, which was in production at the same time as *Aladdin*. On a single piece of 8½-by-11-

inch paper, Vander Wende painted a couple of dozen thumbnail-sized gouache paintings capturing scenes from the entire film. "I painted it small so I could get it done quickly, as there were always more design decisions to be made than I had time for," he said.

There is enduring ambiguity about what constitutes a colorscript in animation or at what stage in the pre-production process it should be done, with as many versions of the process as there are artists who create them. Even the term *colorscript* has only recently become canonized, and that is largely due to Pixar's amplification of its role in their filmmaking process.

Directors, in particular, like colorscripts. For the first time in the production, they are able to see their entire film in color, in one place, on a single board. Seeing things in one place is a rare event in the fragmented computer-animated filmmaking process. The goal for both the director and colorscript artist, however, isn't to dress scenes in the prettiest or most harmonious color combinations, as Eggleston made clear while describing his relationship with Andrew Stanton, the director of *Finding Nemo* and *WALL·E*. "What I really like about working with Andrew is that he doesn't care about the specifics of the color too soon. It's 'What's the story and is this feeling right for the story?' And if he sees something odd, he goes, 'What's going on in the story there?' He doesn't ask, 'What's that color?' And that's heaven to me, because that's all I want to try and focus on. It's all about the story; it's all about the characters. If you stay focused on those things and you're in tune with the director, then you can actually make anything work and make anything happen."

Colorscripts evolve in an organic manner as directors and production designers refine their thinking about a film. While developing a sequence in *Up*, in which we see Carl as a young man, enjoying married life with his wife, Ellie, lighting art director Lou Romano and production designer Ricky Nierva envisioned draping the sequence in nostalgic sepia tones. After seeing the colorscript, John Lasseter, who executive produced the film, suggested a different approach; instead of desaturation, those scenes should be as vibrant "as when you first fall in love." This kernel helped establish the color framework for the rest of the film, while reinforcing the dramatic arc of the story. After

Ellie's death, Carl's world becomes dark and gloomy. Color is slowly reintro-
duced in the form of the balloons that lift him into the sky, Russell and his
rainbow sash of Wilderness Explorer merit badges, and Kevin, the colorful bird
of Paradise Falls. Magenta, which is Ellie's color, remains absent from the film
until Carl reaches Paradise Falls.

. . .

The idea for colorscripting an entire feature fermented in Eggleston's mind
long before he was hired as Pixar's first art director in 1992. An animator by
training, Eggleston had helped art direct an early-1990s animated feature, *Fern
Gully.* During a particularly tight production crunch, the filmmakers needed a
couple of hundred background color key paintings from Eggleston, and he had
exactly three days to paint them. Realizing the impracticality of the deadline,
he decided to make quick-and-dirty pastel drawings on thin horizontal strips
of paper that would convey the colors for multiple scenes in broad strokes.
Eggleston indicated general ranges of color in a linear progression, giving the
background painters who followed him a guide for arranging their palettes.

By the time Eggleston was ready to begin his colorscript for *Toy Story*, he
had also seen Vander Wende's colorscript for *Aladdin* in a "making of" book
about the film. That artwork validated his own approach on *Fern Gully*, open-
ing the door for expansion of a technique that he'd originally conceived in
desperation.

The colorscript, Eggleston feels, is akin to composing a symphony, which
is comparable to Kalmus's assertion that the color chart is like a musical score.
And like a composer who arouses aural interest through variations of tempo,
rhythm, and instrumentation, Eggleston heightens the emotions in a film by
varying his color palettes. In *Finding Nemo*, as Marlin and Dory descend into
the murky depths of the ocean, Eggleston shifts to an increasingly minimal-
ist and ominous palette—a graphic intensification of Marlin's neuroses. He will
often choose a piece of music to listen to while drawing the colorscript—a
composition unrelated to the film except that it captures the moods he's trying
to convey. For *Finding Nemo*, he listened to George Solti conducting the

Chicago Symphony Orchestra's performance of Liszt's "Faust Symphony."
Albert Roussel's ballet score *Bacchus and Ariadne* served as a source of inspir-
ation for another colorscript.

. . .

Bill Cone, the artist charged with creating the colorscript for *A Bug's Life*, the
studio's second feature, had a tough act to follow, and not only because Egg-
leston's *Toy Story* colorscript set such a high bar. Prior to joining Pixar, Cone
had spent the better part of a decade creating editorial illustrations on the
staff of the *San Francisco Chronicle*. Most of his work appeared in black and
white, and he had only occasionally done color illustrations.

During the production of *Toy Story*, Cone was hired by Eggleston to work
in the art department, where he drew sketches and made paintings of key
locations, like Andy and Sid's homes and Pizza Planet. The studio was operating
on such a shoestring budget in those days that Cone would be hired for a few
weeks, laid off, and then rehired.

The color work he had done up to that point had been almost exclusively
in gouache and acrylic, but for *A Bug's Life* he aspired to recreate the pastel
look of Eggleston's colorscript, which he felt was a masterful accomplishment.
"It literally lit this fire," Cone said. "I wanted to do one of those. If I ever wanted
to get better at color, what could be a more interesting, rewarding field of
study than to do a colorscript for a feature film?"

He struggled at first, especially when he tried to recreate the soft gradi-
ents that Eggleston achieved so gracefully, and found it difficult to mimic
Eggleston's idiosyncratic style of drawing with pastels on black paper. "I
never put down enough color, so my colors were dying against the black,"
Cone recalled. "Then, John [Lasseter] would say, 'I love color. Give me color.
Make it brighter.'"

Cone worked tirelessly to improve his command of the technique. Dur-
ing lunch breaks, he would take bike rides with other Pixar crew along the
shoreline of San Francisco Bay, and he'd whip the pastels out of his daypack to
paint quick studies of the ever-shifting sunlight and its impact on the natural

environment. "I became more aware of how dynamic and complex nature is. It began to affect how I felt about light, and how to describe it. How to get the sense of the way light from the sky illuminates the world even when you can't see sun, or to understand the nature of shadows. I think I became more sensitive about how to use these effects in film, which was of great value for my work. I went out to explore nature and get away from work, but what I learned came back to work with me."

Whereas a colorscript by Eggleston will usually have a theatrical quality of color, in the tradition of earlier animation production designers like Mary Blair and Maurice Noble, Cone found his authentic voice and style in the world of natural light. One of his earlier pieces of development artwork on *A Bug's Life*, which went a long way toward convincing Lasseter to make Cone the film's production designer, was a quick marker and colored pencil sketch on tracing paper that showed ants walking across a "leaf bridge," their bodies silhouetted behind the translucent leaves. The unique way that light interacts with nature, such as creating translucency in certain objects, informed Cone's approach to color and gave him "a lot of confidence about how to think on that movie."

Cone discovered that sometimes a scene's strength is derived not from how many colors are added but from how many are subtracted. During *A Bug's Life*, Cone and Sharon Calahan, lighting director of photography, were inspired by a menacing fog scene in Federico Fellini's *Amarcord* and wanted to emulate the stark atmosphere of those shots in a scene where the grasshoppers return to menace the ant colony. Sucking the color out of a sequence wasn't an easy idea to sell to Lasseter, though. "John has some things that he's very consistent about," Cone explained. "One is he tends to love or push saturation and just take pleasure in it. And so sometimes I'm trying to pull him away from that or create a better dynamic so it's not just up all the time." As Cone pondered how to present the fog sequence colorscripts, the crew watched a nature documentary about insects, and, as luck would have it, there was a fog scene in that film, too. Walking out of the screening, Lasseter remarked to Cone, "Did you see the fog?" Cone seized the moment and rushed Lasseter into his office to show him his own fog studies.

Bill Cone also did colorscripts for *Toy Story 2*, along with Jim Pearson, but his most triumphant turn came as the production designer of *Cars*. By the time Cone began working on *Cars*, he had become a dedicated plein air painter outside of the studio, and he relished the idea of exploring color and lighting possibilities for a film set in the majestic expanse of the Southwest. Even when the palette was limited, as in the film's numerous night scenes, he found opportunities for color. The pitch-black darkness when Lightning McQueen barrels through Radiator Springs chased by Sheriff is lit with the tense orangish-yellow glow of the streetlights and the turquoise fluorescence of Flo's V8 Cafe, whereas the cool blue moonlit sky of Lightning and Mater's tractor-tipping escapades conveys a relaxed and light-hearted mood. The jubilant atmosphere of Radiator Springs with all its neon lights flipped on brings out yet another facet of nighttime. "This was some of the funnest stuff I did," Cone said. "It's night, but it's the night I want it to be."

. . .

Although its function remains consistent, there is no single correct way for producing a colorscript. Harley Jessup conjured up his own "nutty version" for *Ratatouille*. Jessup is a born experimenter and learned about color by working with backlit papers and theatrical gels on earlier cut-out animated films. On *Ratatouille* he worked small, creating a series of cut-out style illustrations that graphically showed the color for the sets. For the rat character palette, he gathered bunches of dyed yarns, arranging them onto black card stock to create a range of stylized fur colors from violet-gray to cinnamon. Jessup resists following established color patterns—for example, the use of red to evoke danger or evil. Color schemes should "grow out of what the mood needs to be and the natural colors of that setting," Jessup explained. "Sometimes the climax could be black and white or it could be colored very cool, and still get across the sort of climactic emotions that you're supposed to be feeling."

"Harley has good taste," Cone said. "He manages to make it look good without going overboard in terms of effect or expression, just playful and lovely designs." Jessup, like Cone, never anticipated winding up in animation.

While earning a master's degree in graphic design from Stanford, he created a typographically oriented animated short that showed words arguing with one another. The piece caught the eye of Oscar-winning Bay Area filmmaker John Korty, who hired Jessup to work on a series of *Sesame Street* segments and made him the art director on a quirky cut-out animated feature called *Twice Upon a Time*. He later became a visual effects art director at Industrial Light and Magic, where he worked on films like *Innerspace*, *Ghostbusters II,* and *The Hunt for Red October*, before ending up as production designer of the stop-motion/live-action feature *James and the Giant Peach*. It was there that he met Joe Ranft, who brought him to Pixar.

When Jessup joined Pixar in 1996, he drew upon a wealth of production design experience and discovered similarities to his earlier work. "I think there are definite correlations between computer animation and live-action," Jessup said as he described the complex lighting and cinematographic decisions involved in both mediums. "Everything about CG animated features is still pretty new, but as in live-action films where color is concerned, there is a really close collaboration between the production designer and the director of photography."

For Jessup's two most recent films, *Ratatouille* and *Cars 2*, Sharon Calahan created the master lighting studies (a more detailed version of the colorscript that communicates specific lighting and color instructions for individual scenes). Typically, the master lighting studies are created by the art director or production designer, but Jessup works differently with Calahan: "Like a great live-action cinematographer, Sharon has a crystal clear vision for the lighting design on the films we've done together. We work hard at the beginning of the process to trade ideas and watch films together, and we feel completely on the same wavelength by the time the film is in production. Sharon is an excellent painter and has a wonderful sense of color besides her brilliant lighting talent. My goal is to design a world that is sculpturally interesting as well as being beautifully colored and textured. We try to give the lighting team something strong to work with, so I'll always be designing with the lighted scenes in mind."

Jessup's discerning taste as a designer is reflected in the way he sets up universal color relationships that exploit contrasts and heighten tensions inherent in the stories. On *Monsters, Inc.*, he teamed with art director Dominique Louis and lighting director Jean-Claude Kalache to explore the visual contradictions between a drably colored, workaday industrial town setting and its population of bright, candy-colored monsters straight out of a child's imagination. In *Ratatouille*, Jessup and Calahan fashioned a coolly colored underground rat world against the warm, rich tones of the human world. Jessup explained, "This color dynamic supported the idea that the rats are always on the outside looking in and made Remy's yearning to be part of the human world even more understandable."

• • •

More recently, Pixar has turned to a younger generation of artists to create colorscripts: Lou Romano (b. 1972) created the colorscripts for *The Incredibles* and *Up*, while Dice Tsutsumi (b. 1974) was responsible for scripting *Toy Story 3*. Romano was a natural choice to create the colorscripts for *The Incredibles*. His first job in visual development had been on *Ray Gunn*, an unmade film that *The Incredibles* director Brad Bird had developed in the mid-'90s. Later, Romano helped Bird create pitch artwork for *The Incredibles* while he was still working on *The Iron Giant*.

Romano created three very different versions of the colorscript for *The Incredibles*, each distinct in style and tone, before he considered the job to be finished. The evolution of his thought process is fascinating to see. His first script, from 2000, was painted in gouache and is a fairly static representation of individual settings and characters. The transitional colorscript was created with a combination of gouache and digital illustration. The sixty horizontal panels contain multiple scenes, reflecting how the story has been fleshed out in the intervening years. His saturated palette is joyous, its tone almost too happy for the story being told. The final colorscript, finished in 2004, was drawn digitally into the computer, a first at Pixar. Romano's assertively large fields of solid color unveil a superheroic Matisse. Juxtaposed against punchy colors are

stark areas of black and white. His riveting, high-contrast approach to color, which were faithfully recreated in the film to the extent that computer animation allows, reinforces the adventurous and dramatic elements of the story in pure color.

The colorscript for *Toy Story 3* painted by Tokyo-born artist Dice Tsutsumi follows in the painterly footsteps of Bill Cone, albeit painted digitally. Tsutsumi's first job out of the School of Visual Arts was at Lucas Learning, during which time he saw a lecture by Bill Cone about colorscripting. "I became interested in colorscripting after seeing Bill's work," Tsutsumi said. "His attention to light and color has influenced me more than anyone in the business."

Prior to arriving at Pixar, Tsutsumi worked at Blue Sky Studios on the East Coast. The colorscript he created for *Horton Hears a Who!* is among the more unconventional examples of the form. Tsutsumi infused certain colors with meaning specific only to the film. So, pink became the unlikely embodiment of devastation, and during *Horton's* climactic third act, the entire palette is driven by pink, magenta, and violet before shifting to yellow (a complementary color to the others) as the film reaches its happy resolution.

Tsutsumi continued this unique approach of associating emotions with specific colors when he began working at Pixar. In *Toy Story 3*, the color blue has special significance. The film's director Lee Unkrich explained, "We came up with the concept of blue connoting safety and home. At the beginning of the film, Andy . . . his bedroom is blue, the sky is blue, his T-shirt is blue. He is in blue jeans, he's got a blue car—these are not accidents. These are conscious choices. Everything in the movie is there for a reason. We are making a commitment to say that blue will connote safety and trying to avoid that in situations where we don't want the audience to feel safe."

The manner in which Tsutsumi combines rigorous studies of painterly light with an emotional application of color suggests a melding of the styles of Cone and Eggleston. He acknowledges the influence of Eggleston's colorscripts on his own process. "When I studied *Toy Story* to learn more about what was done on the original film, I could not believe how much thinking went into Ralph's colorscript. His scripts are about cinematic thinking, and made me consider more than just painting. I turned to his approach when I made my *Toy Story 3* colorscript."

. . .

Colorscripts can be painted in a multitude of formats and styles, but there is one tenet that every artist agrees on: "Colorscripting is not about how well you can paint," Tsutsumi said. "Your job is not to make beautiful pictures. It's about how you can support the story with these images and lighting concepts." Which is an alarming thought: if these colorscripts represent the caliber of work that these artists create when they're not trying to make beautiful pictures, imagine what they can do when they're actually trying.

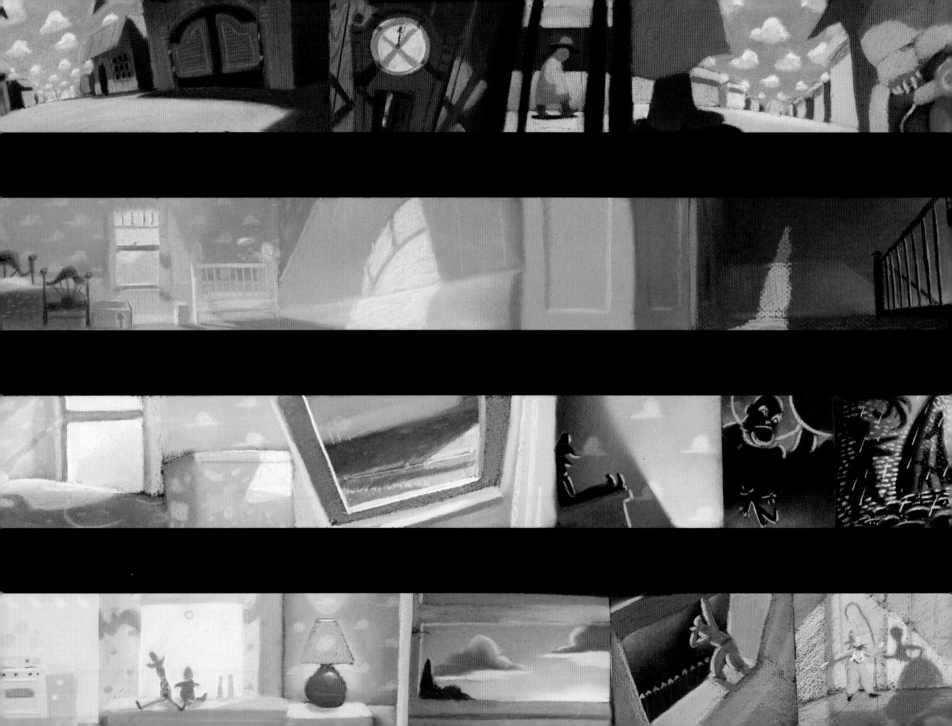

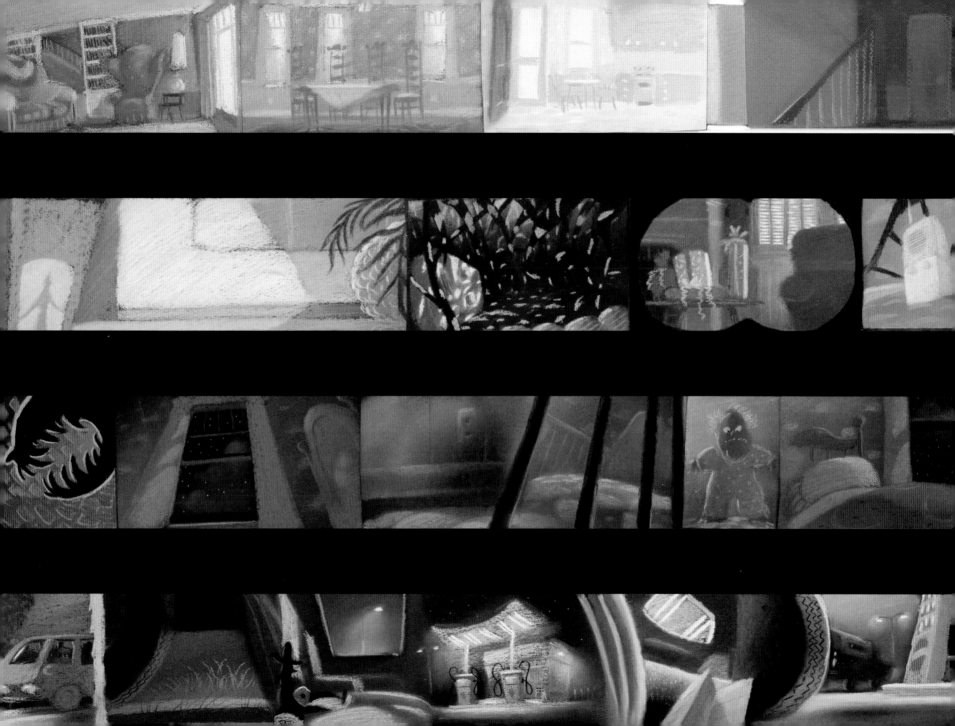

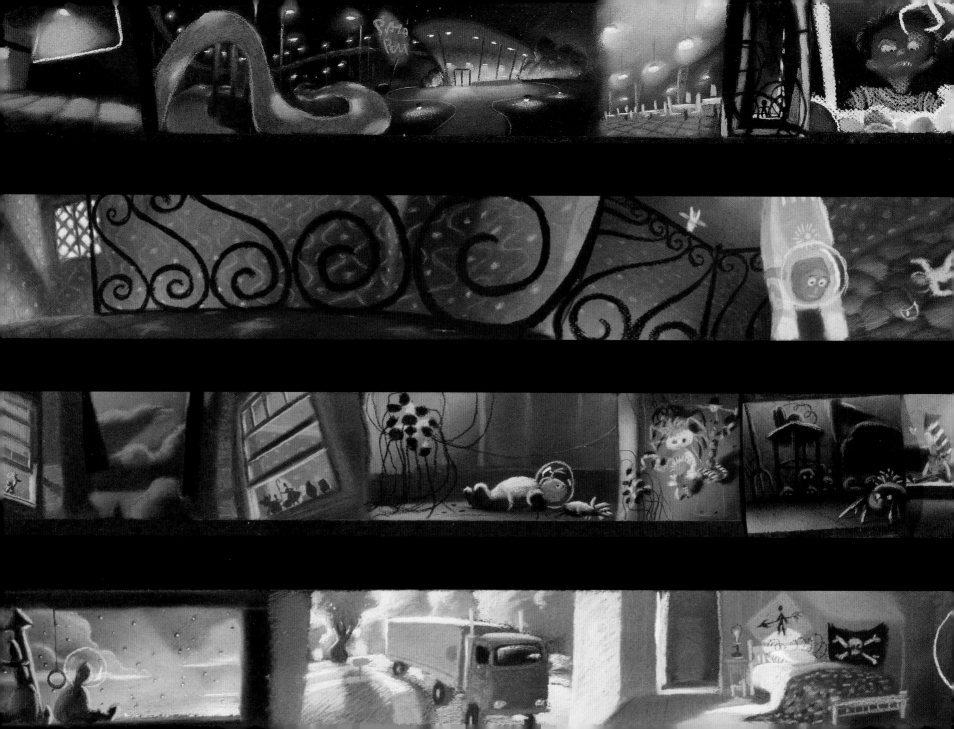

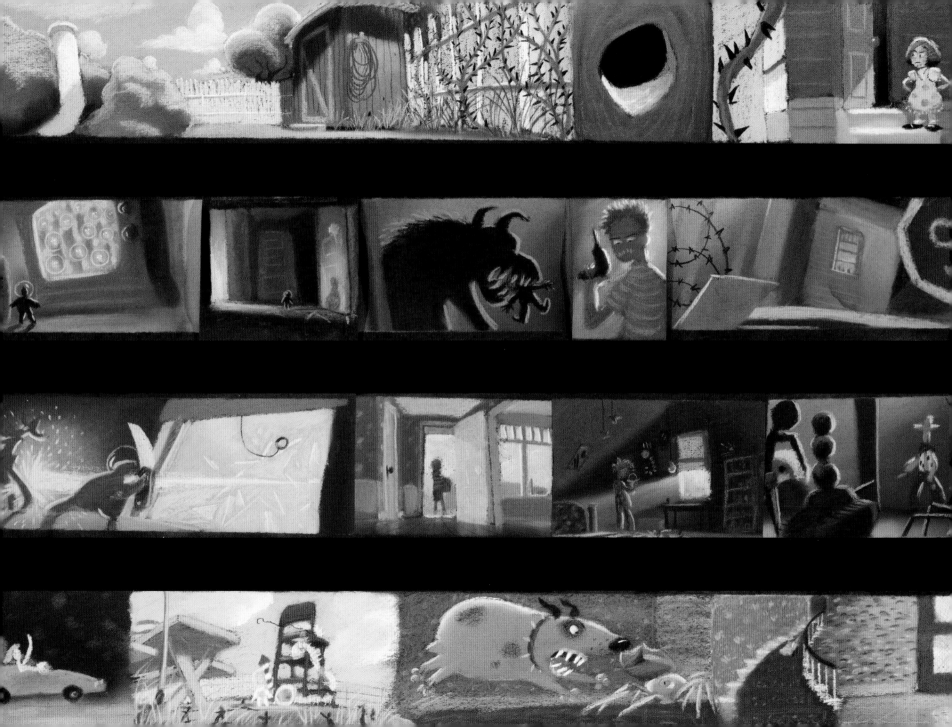

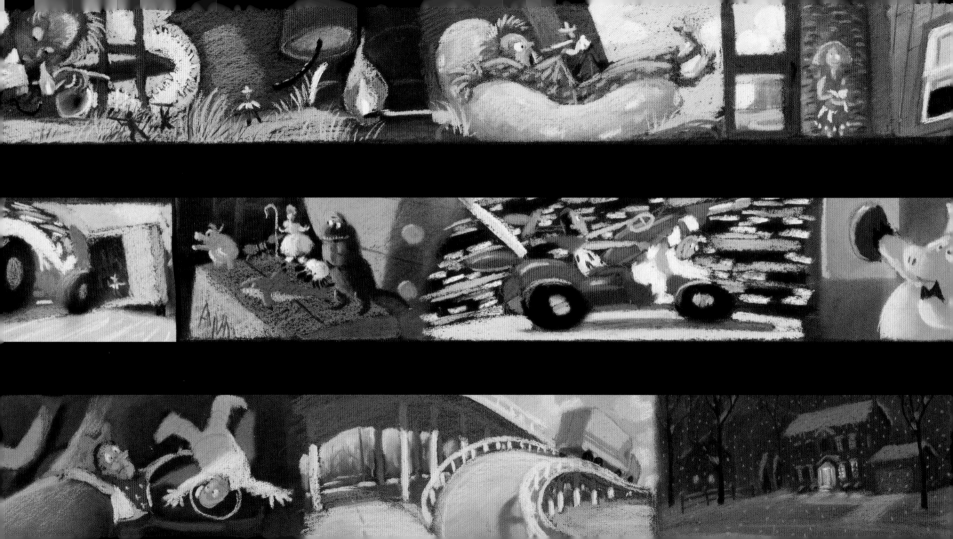

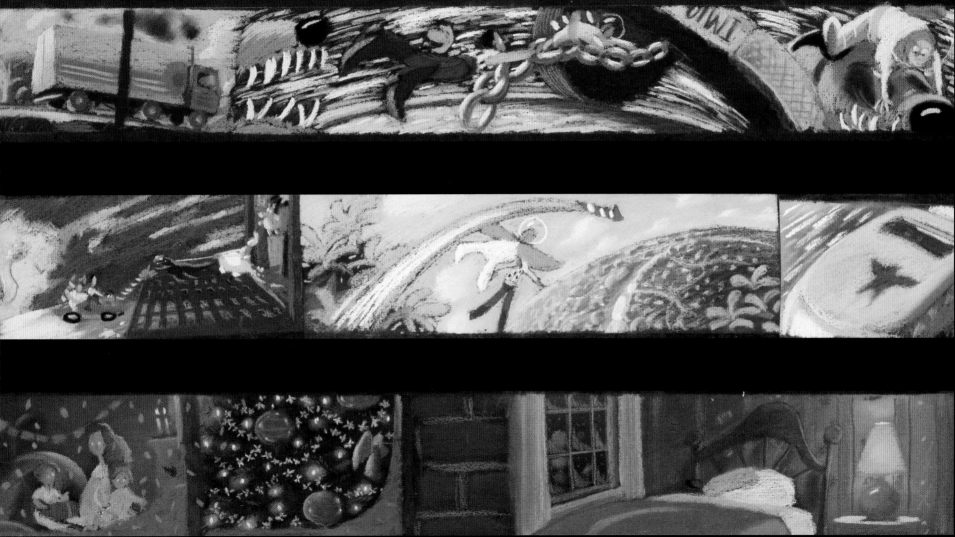

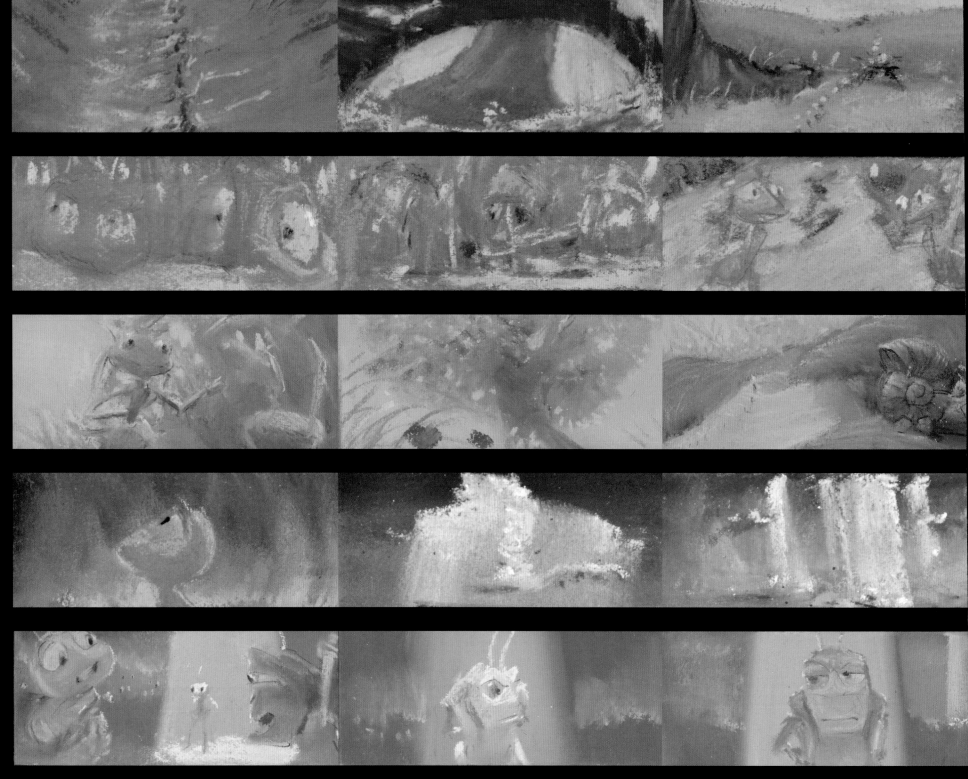

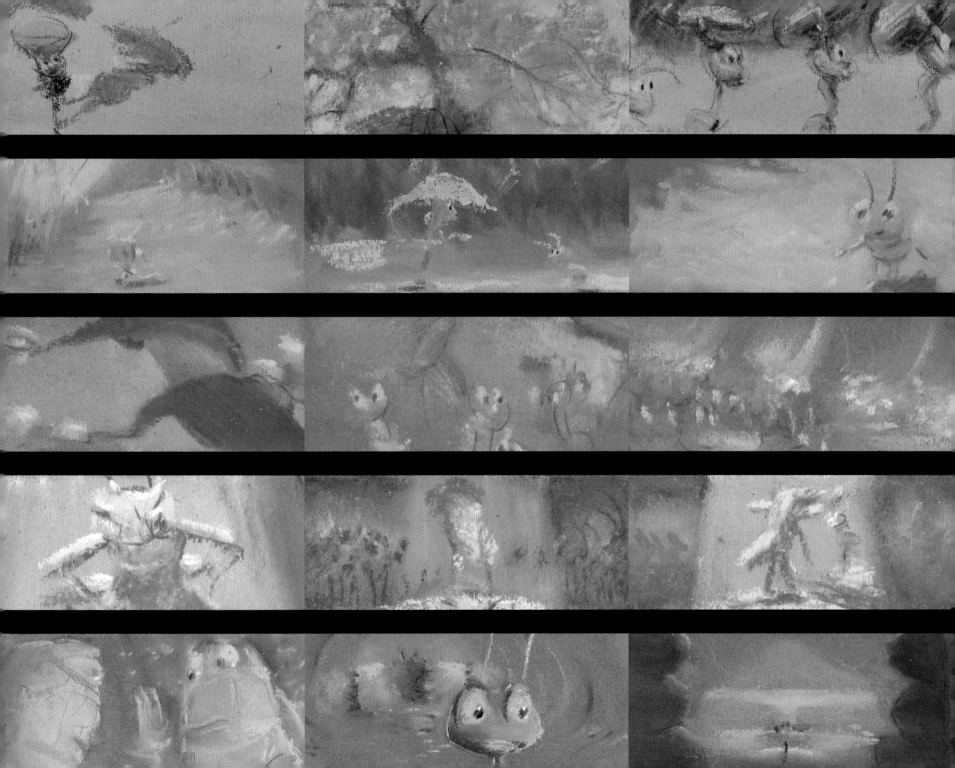

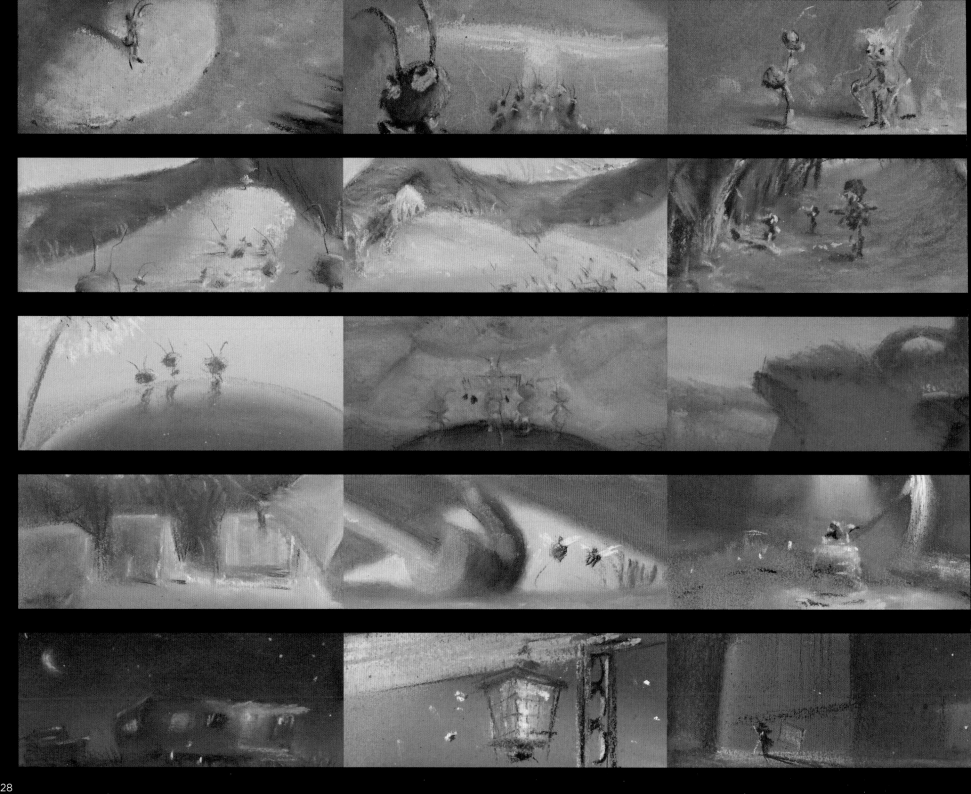

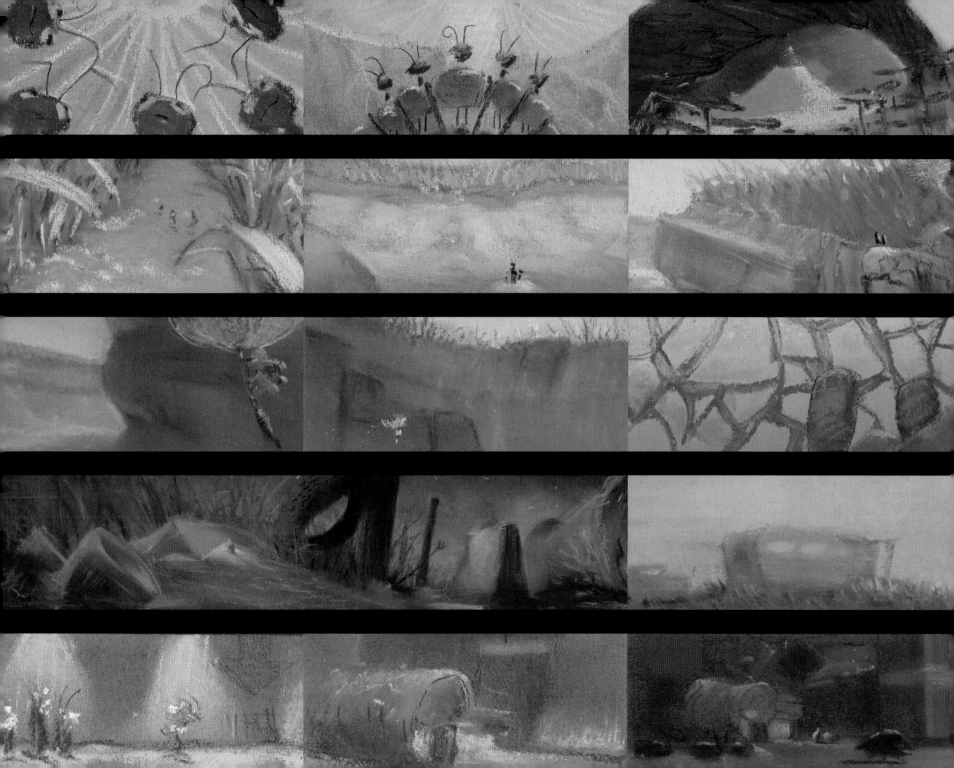

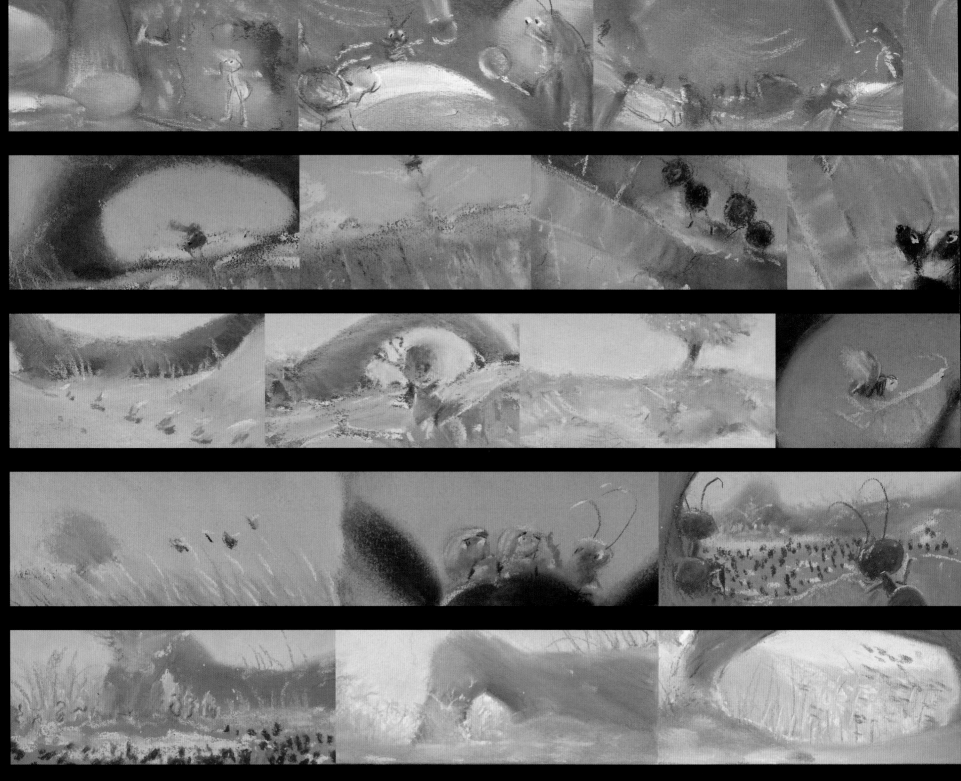

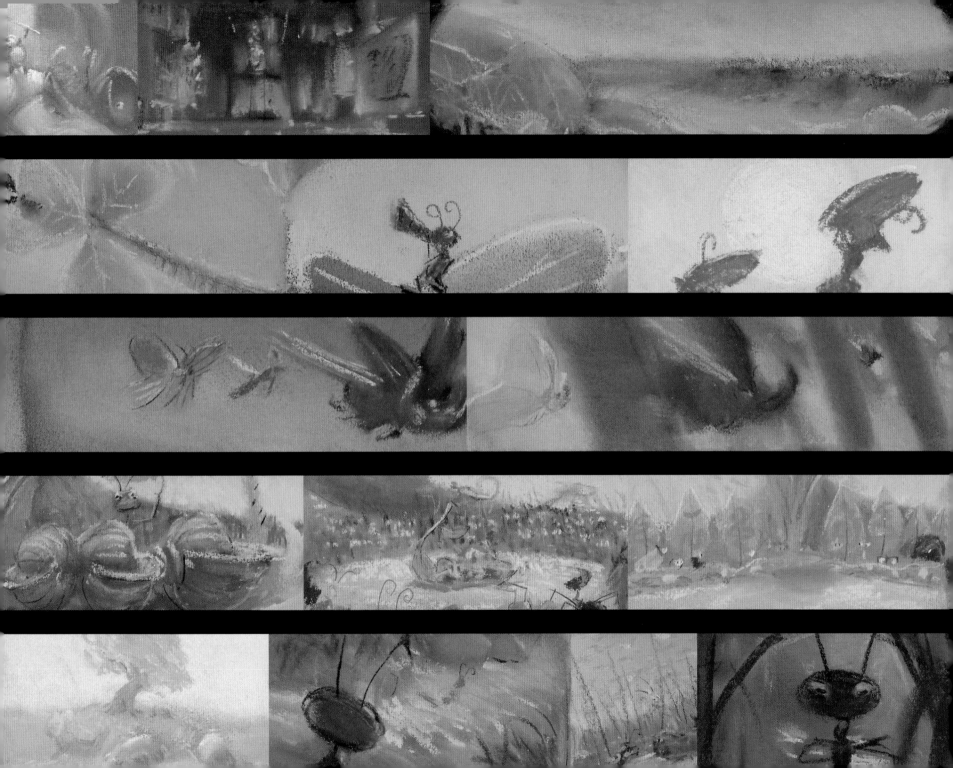

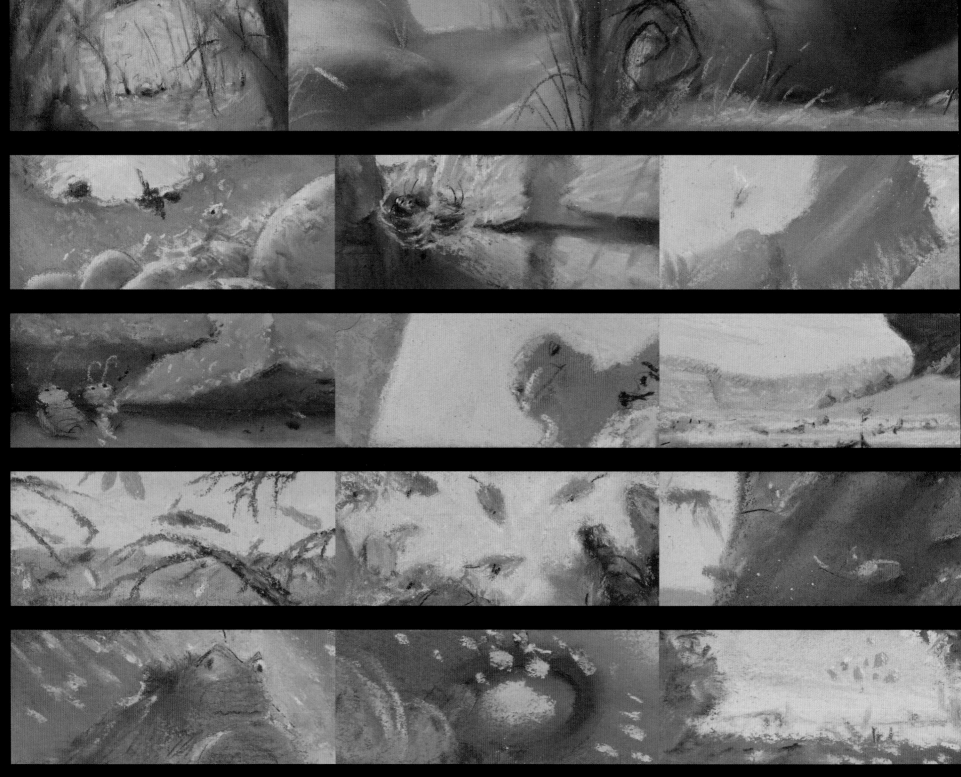

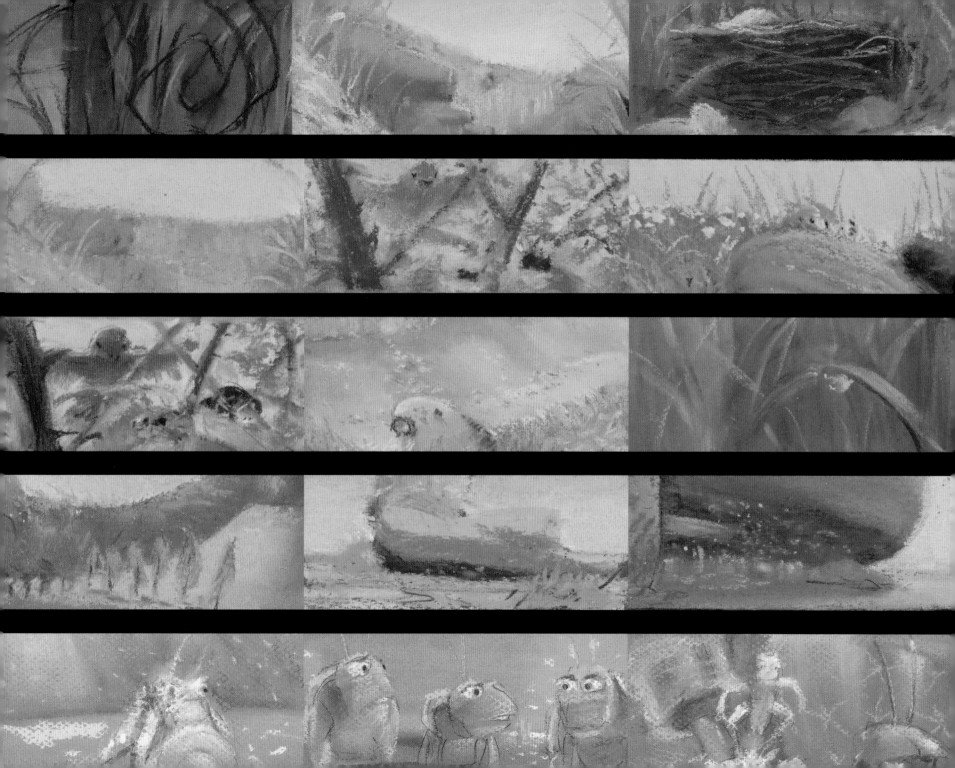

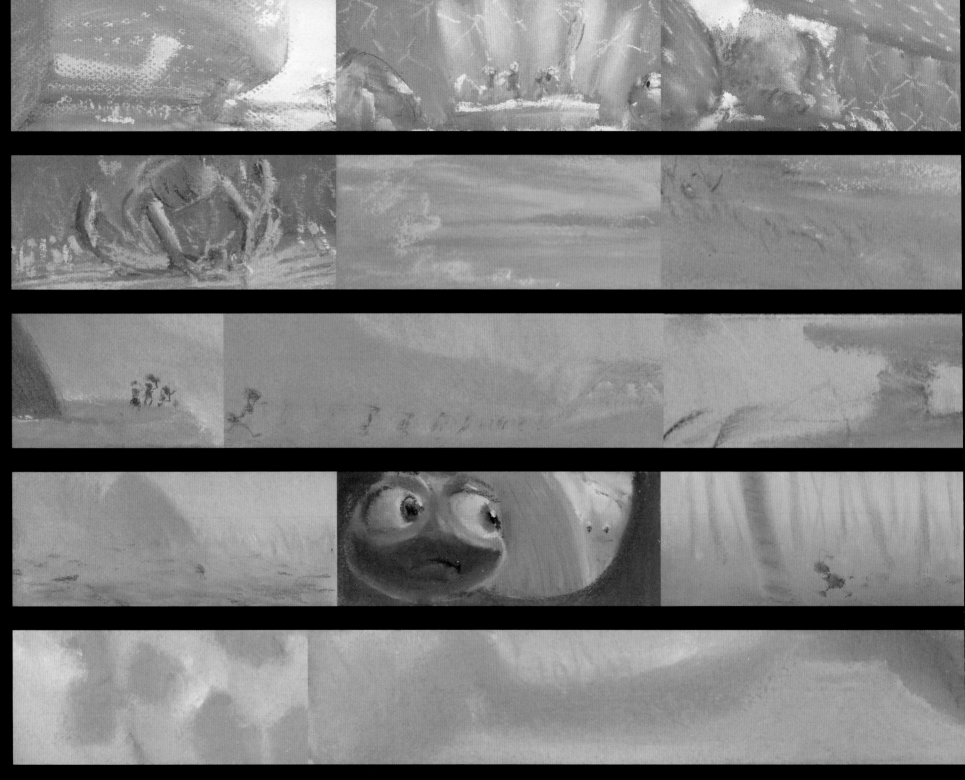

34

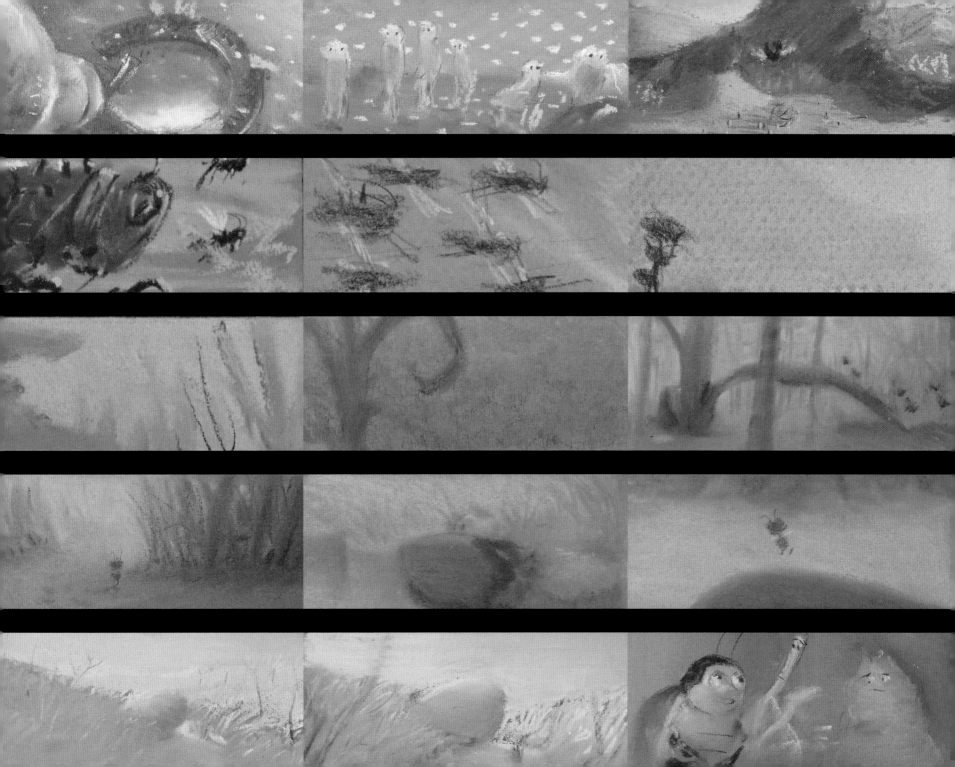

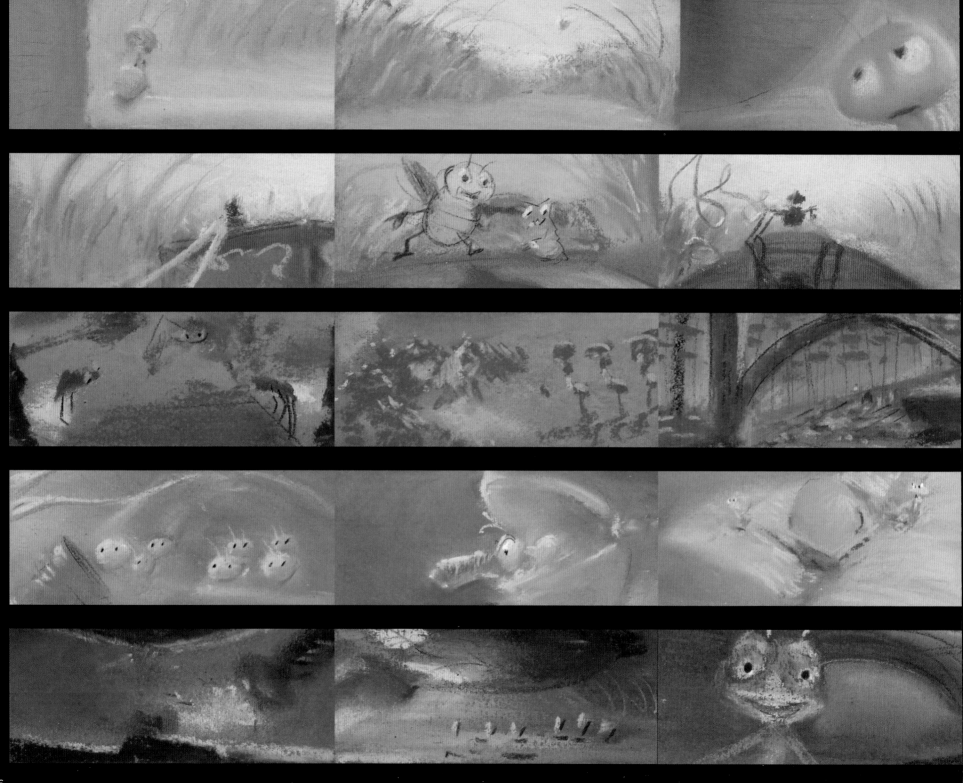

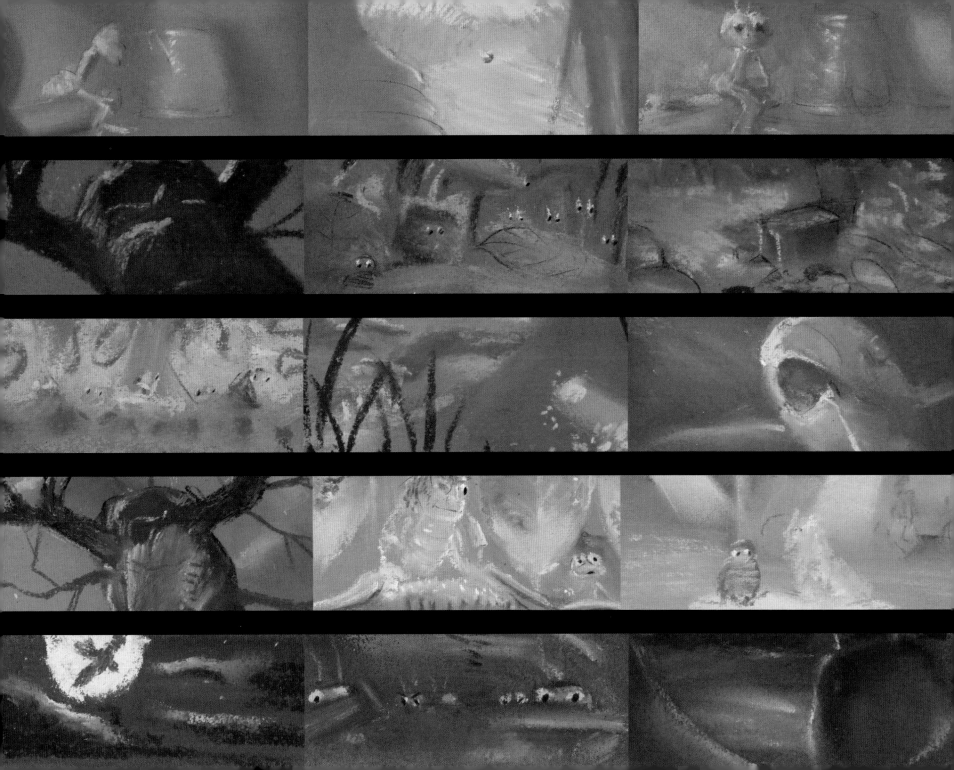

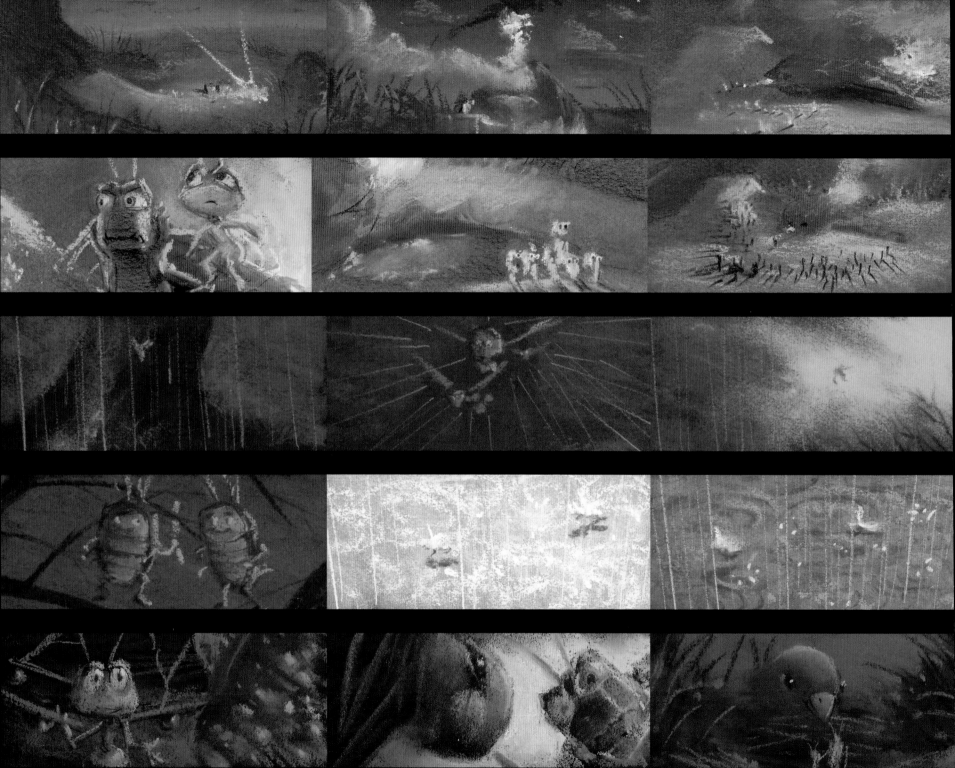

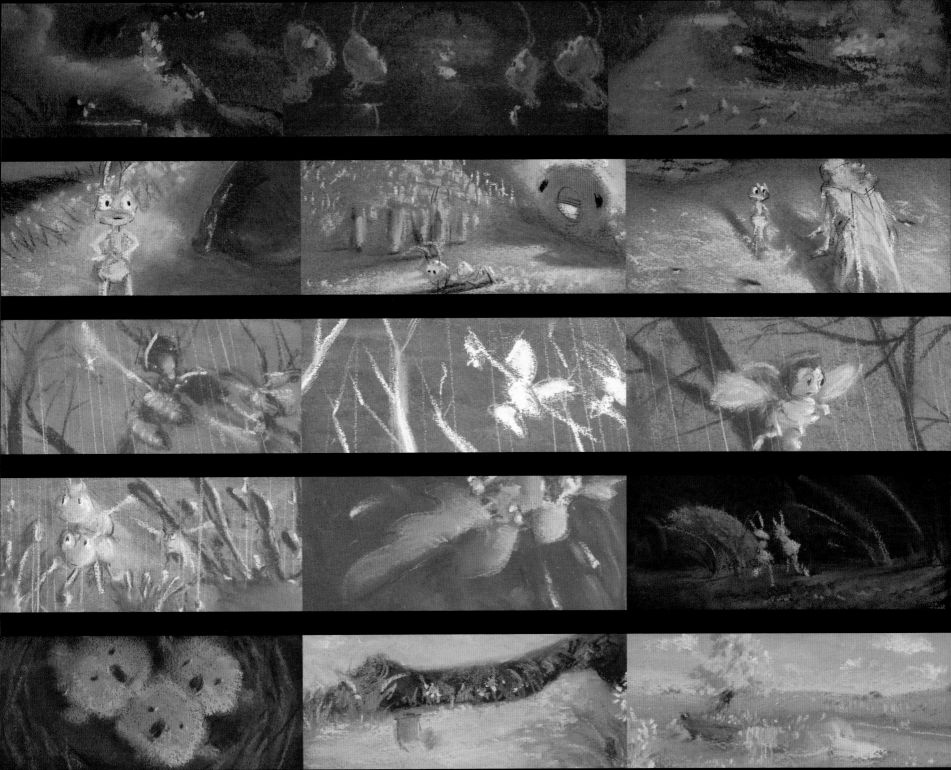

The original Jim Pearson colorscripts for *Toy Story 2* were created for the direct-to-DVD version of the film. Once the film shifted to a feature film, Bill Cone took over to further develop the script, this time more for lighting than story. Due to this scenario, neither script is complete.

Early direct-to-DVD release colorscript, Jim Pearson, Pastel, 1996

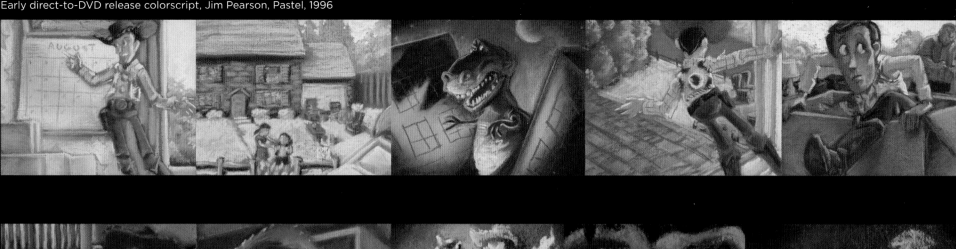

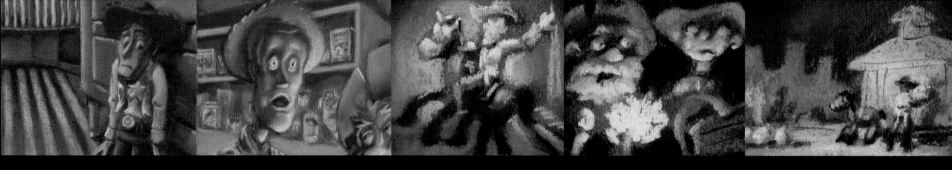

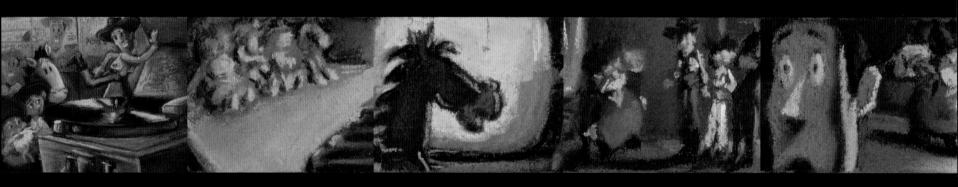

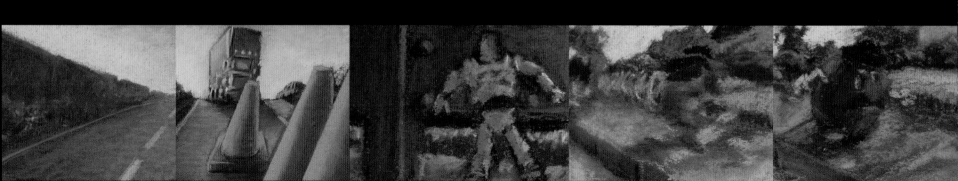

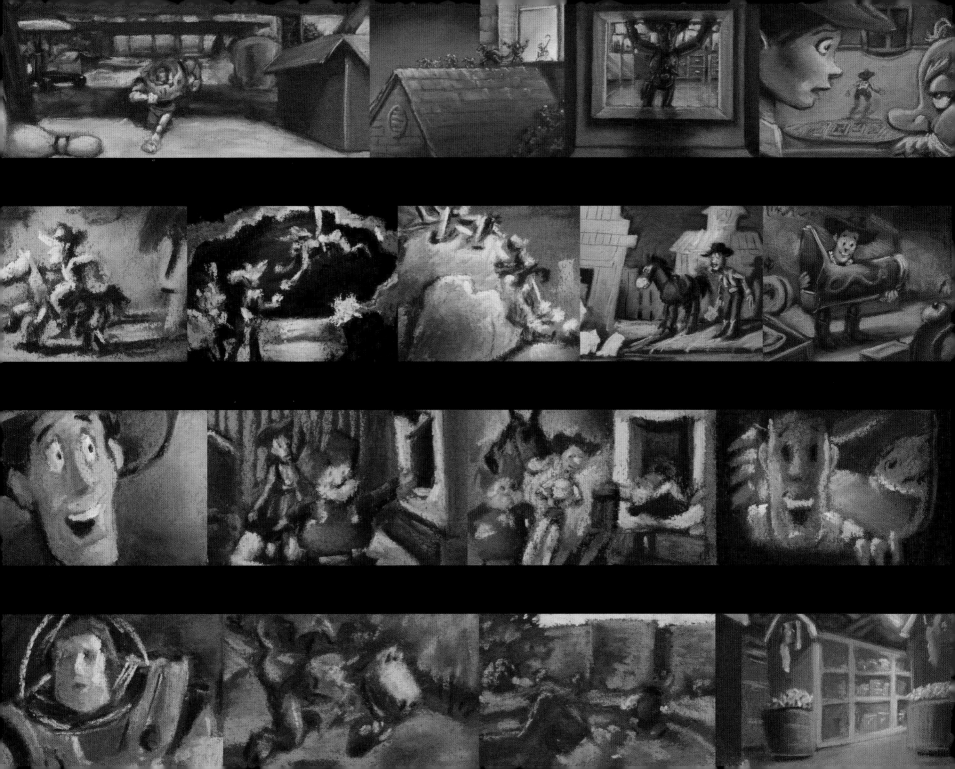

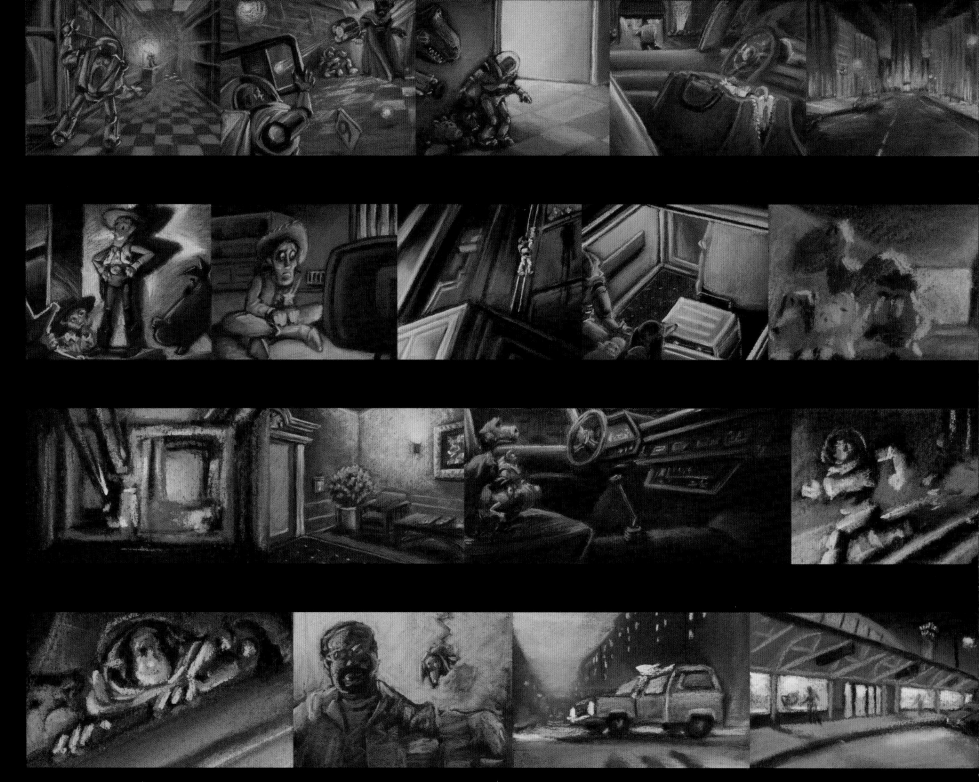

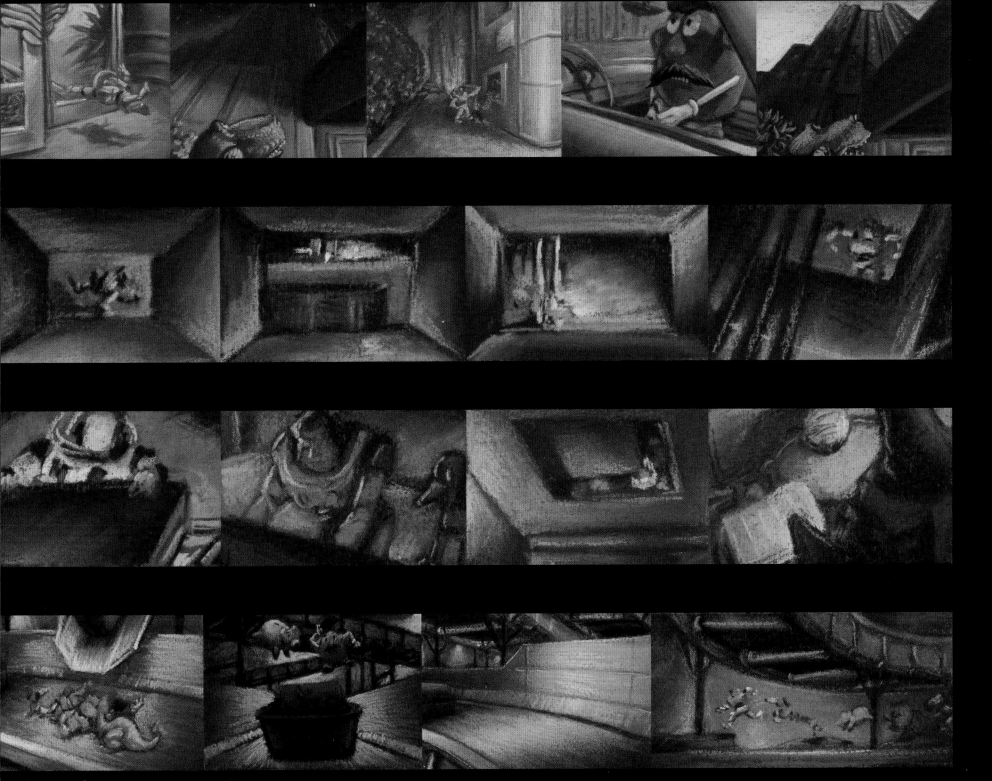

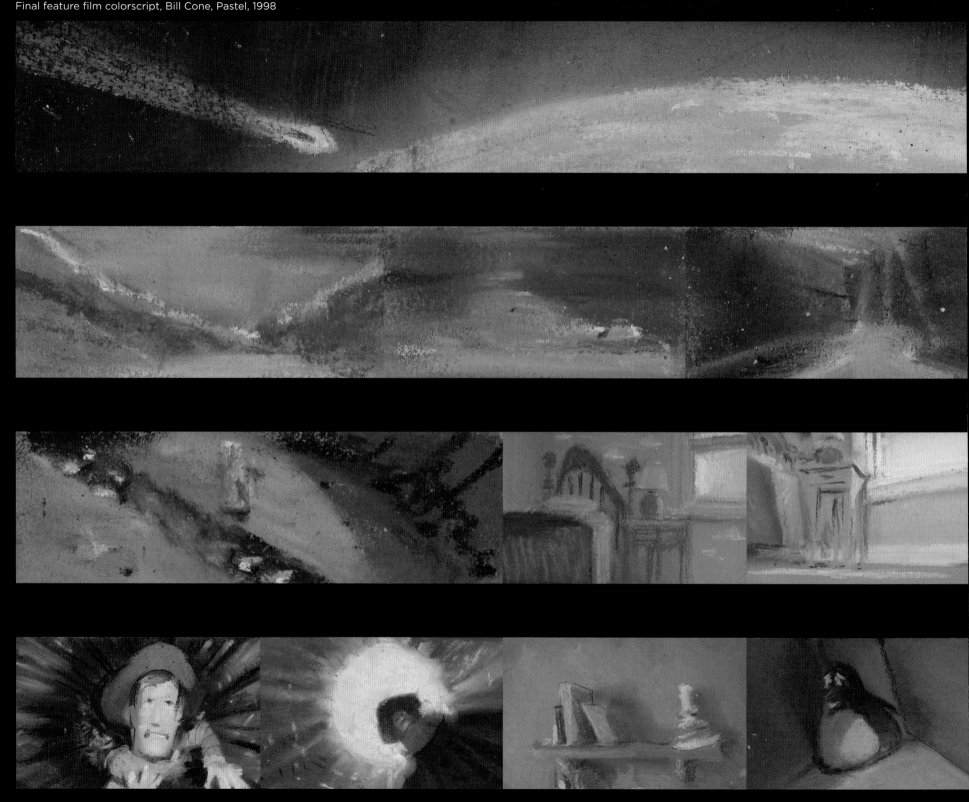

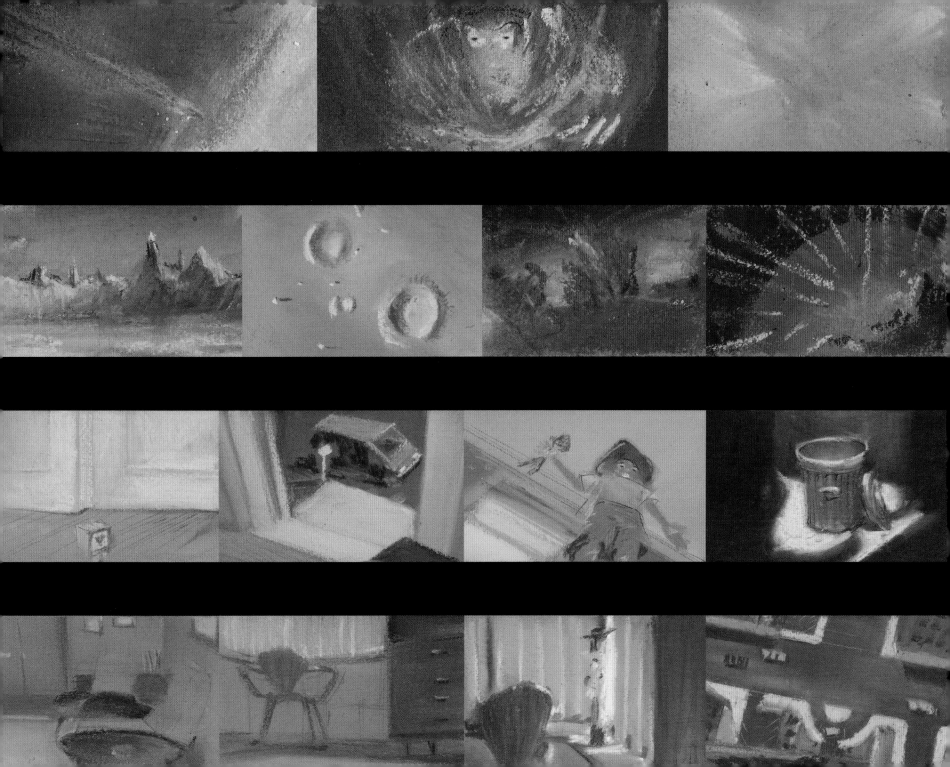

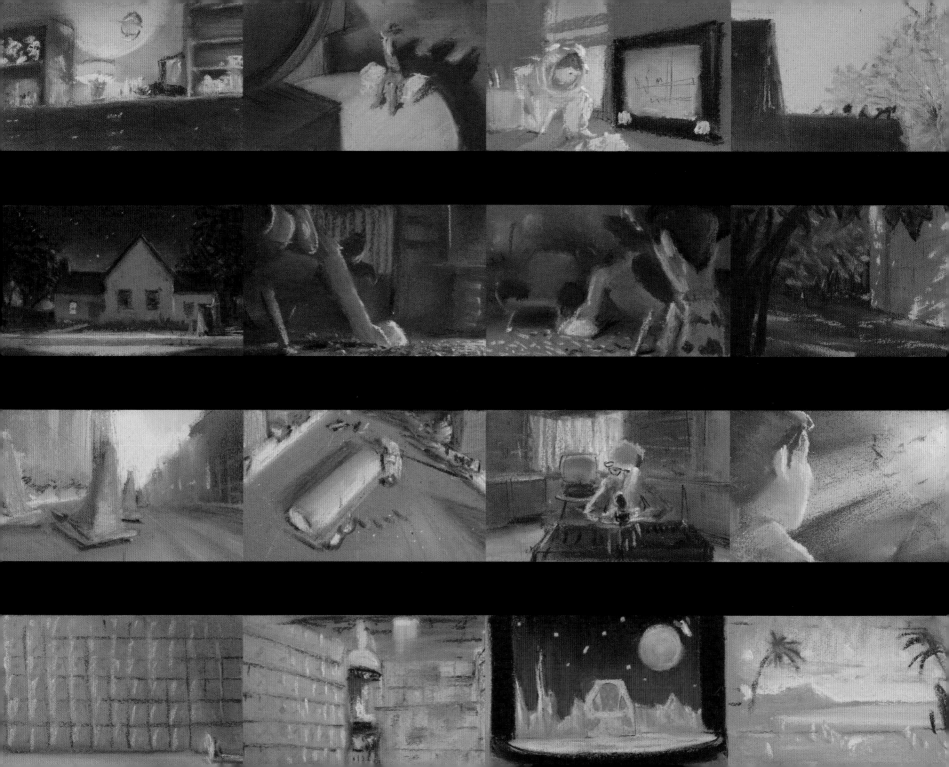

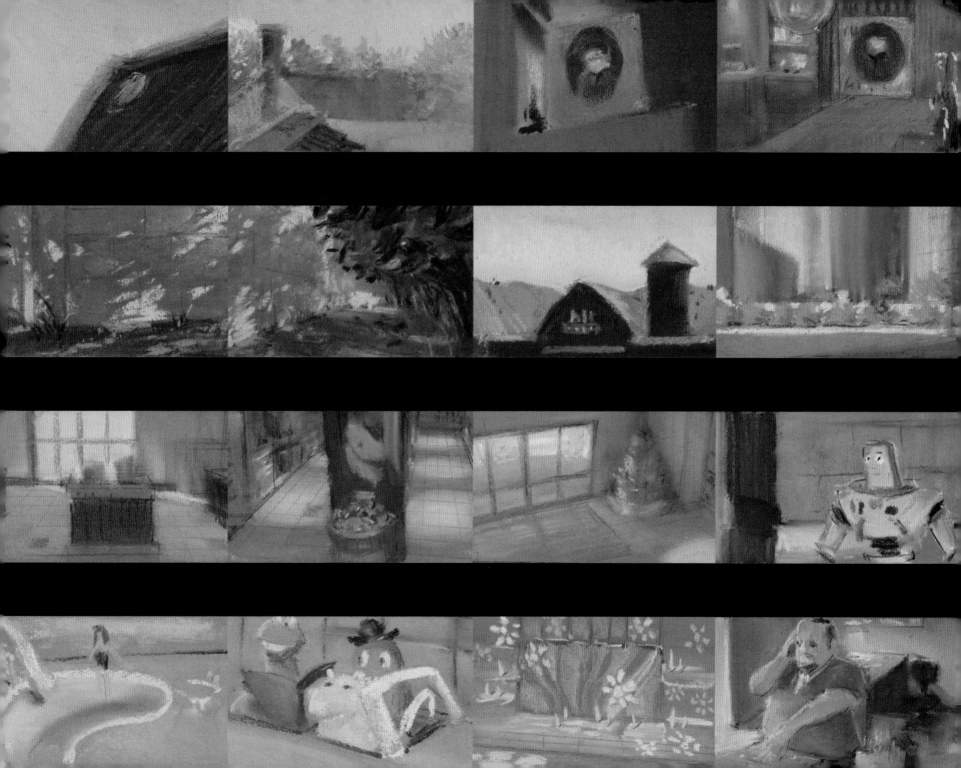

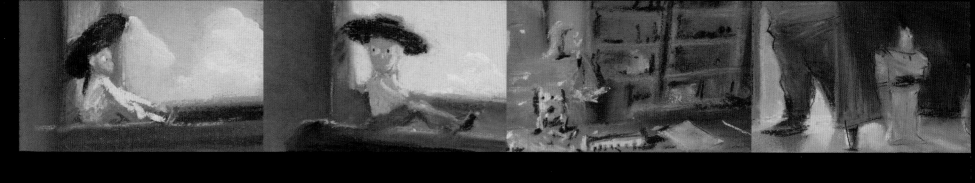

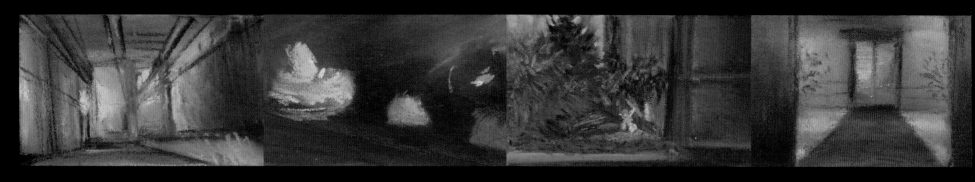

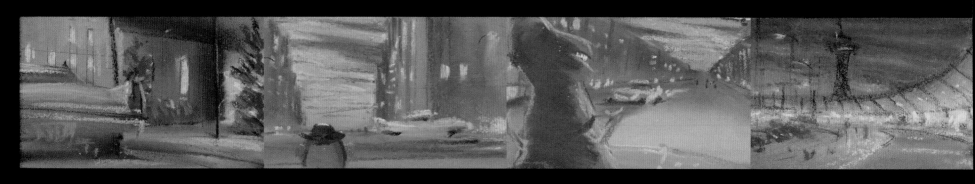

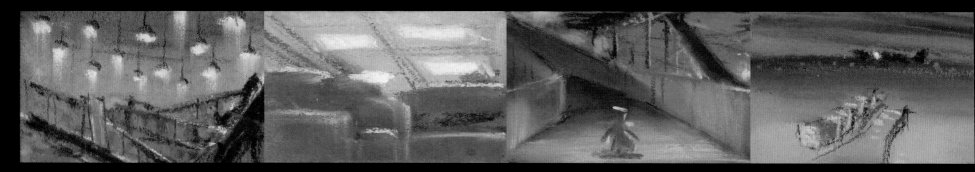

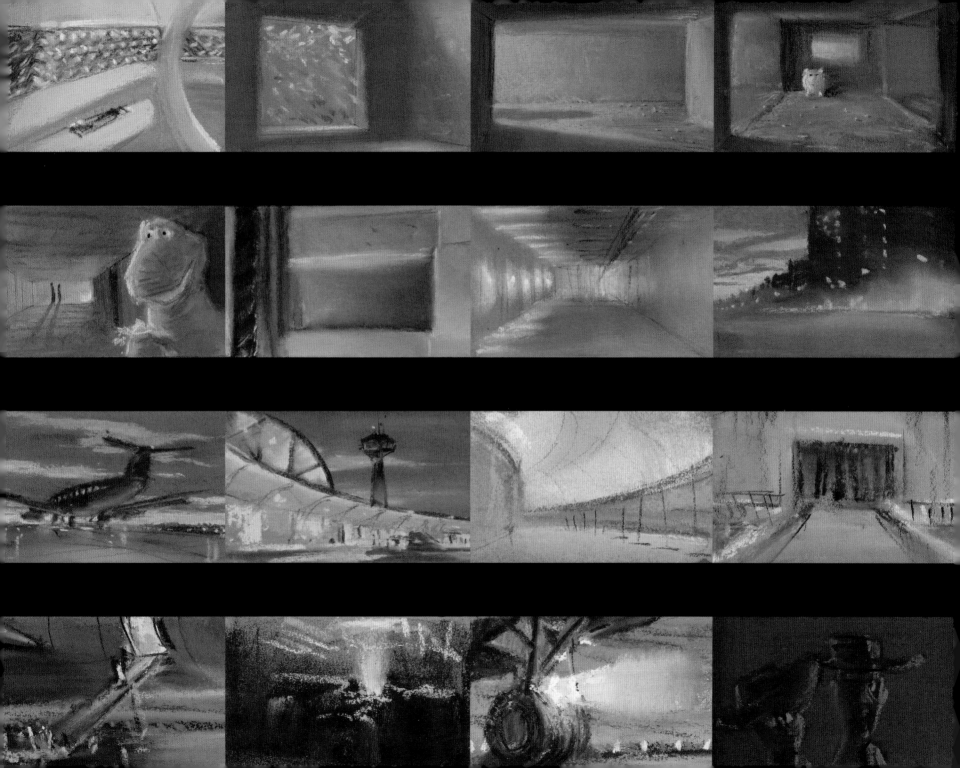

ERS, INC.

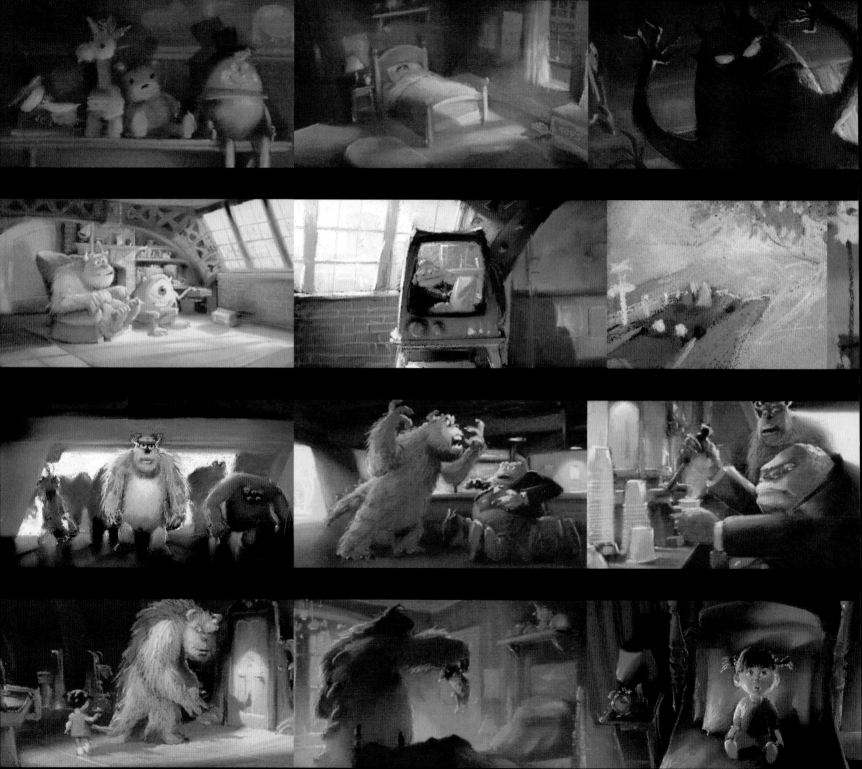

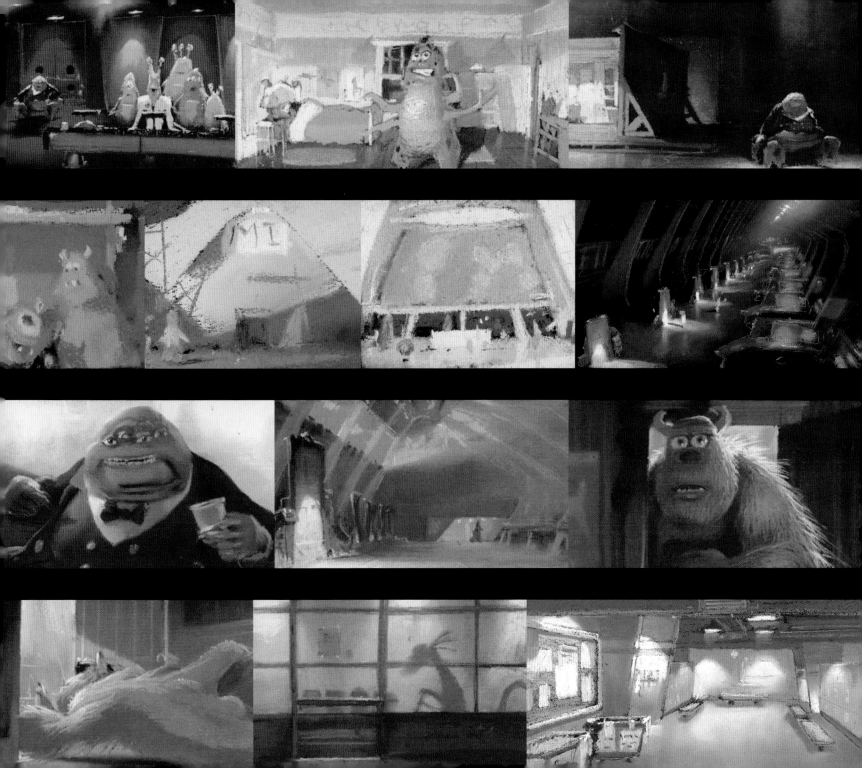

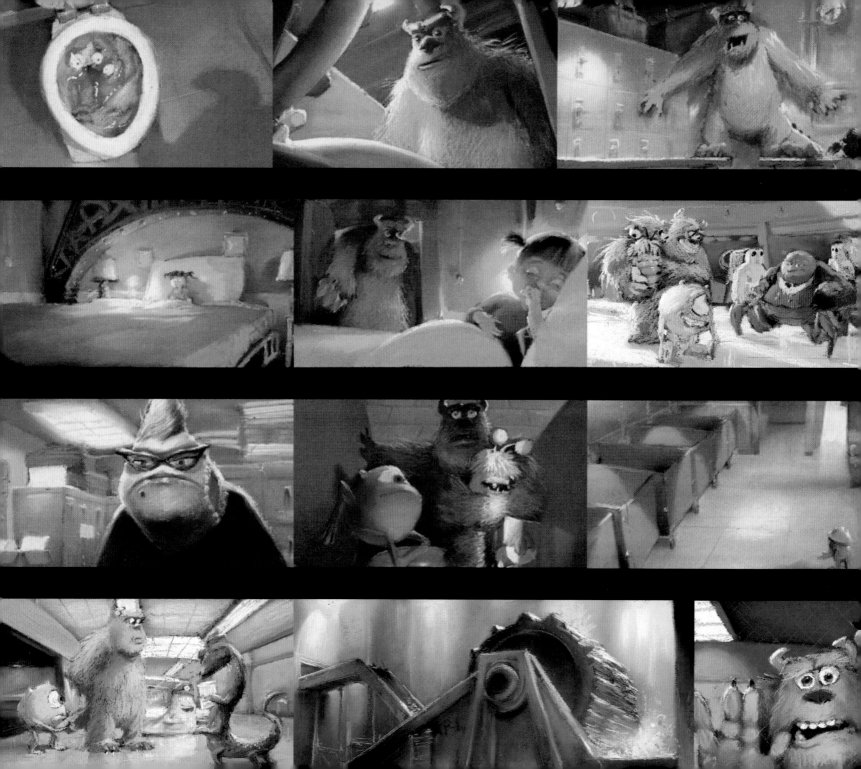

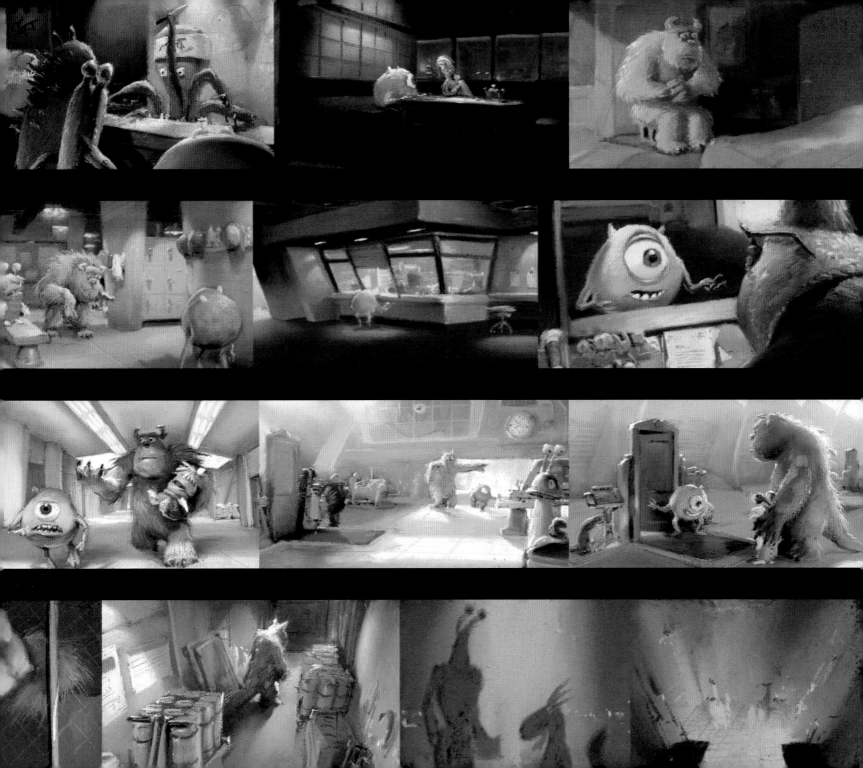

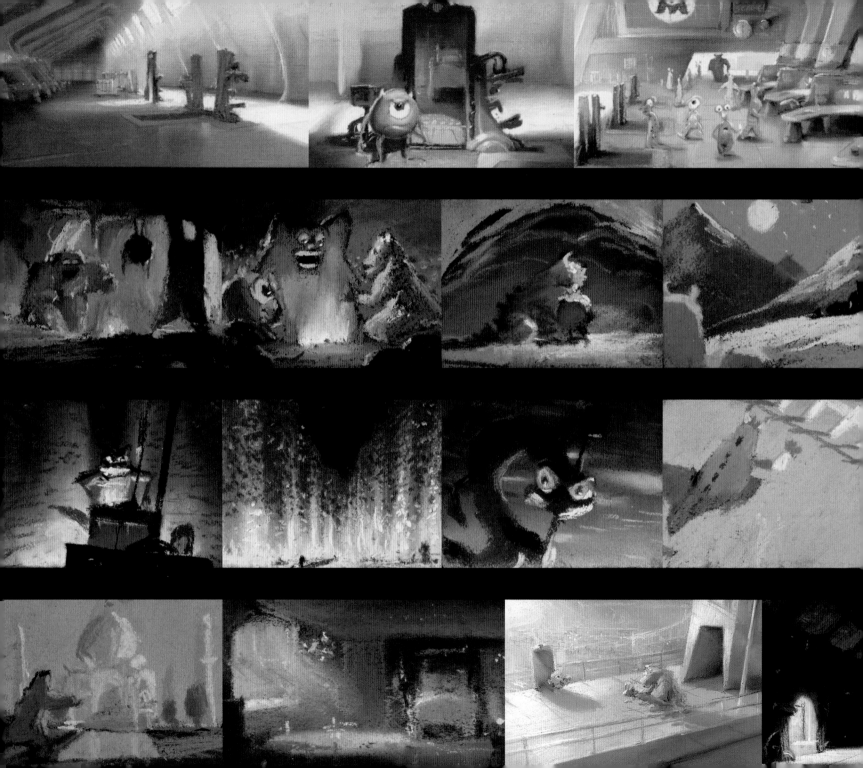

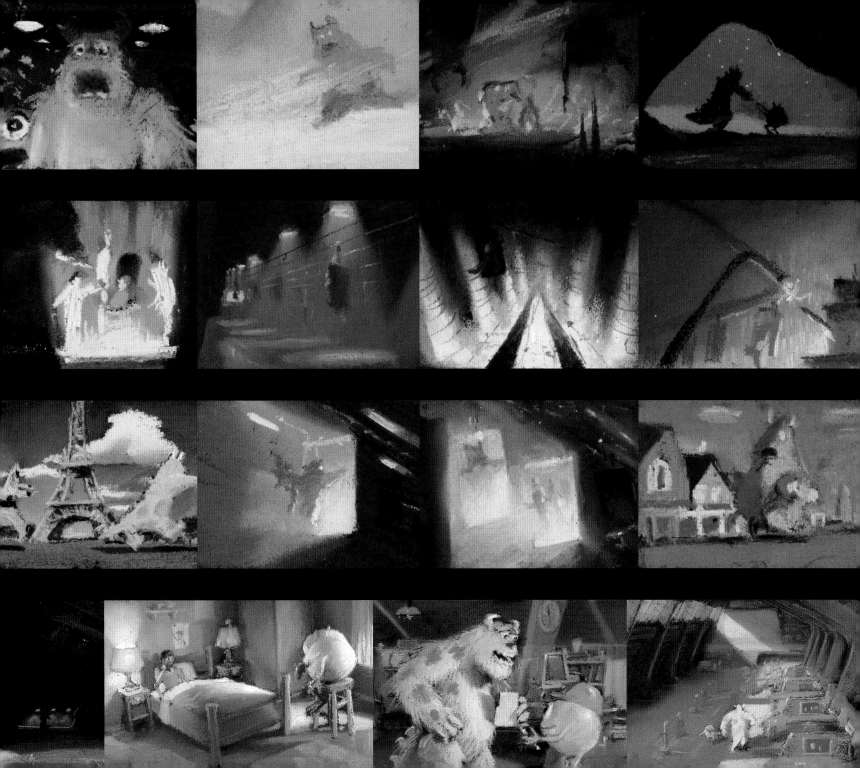

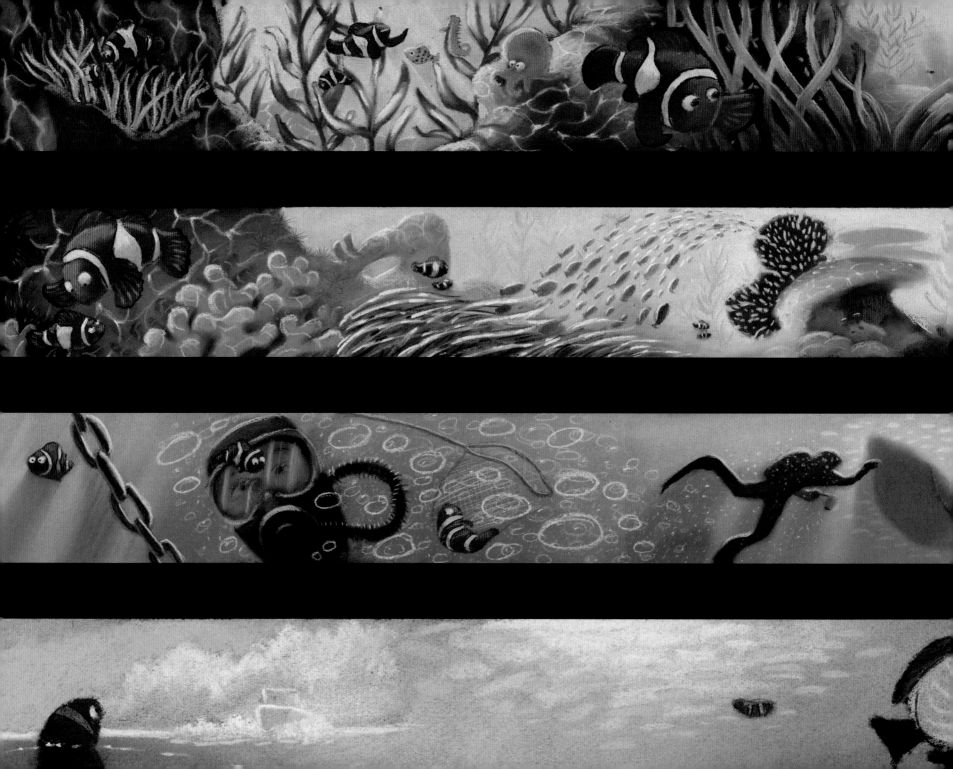

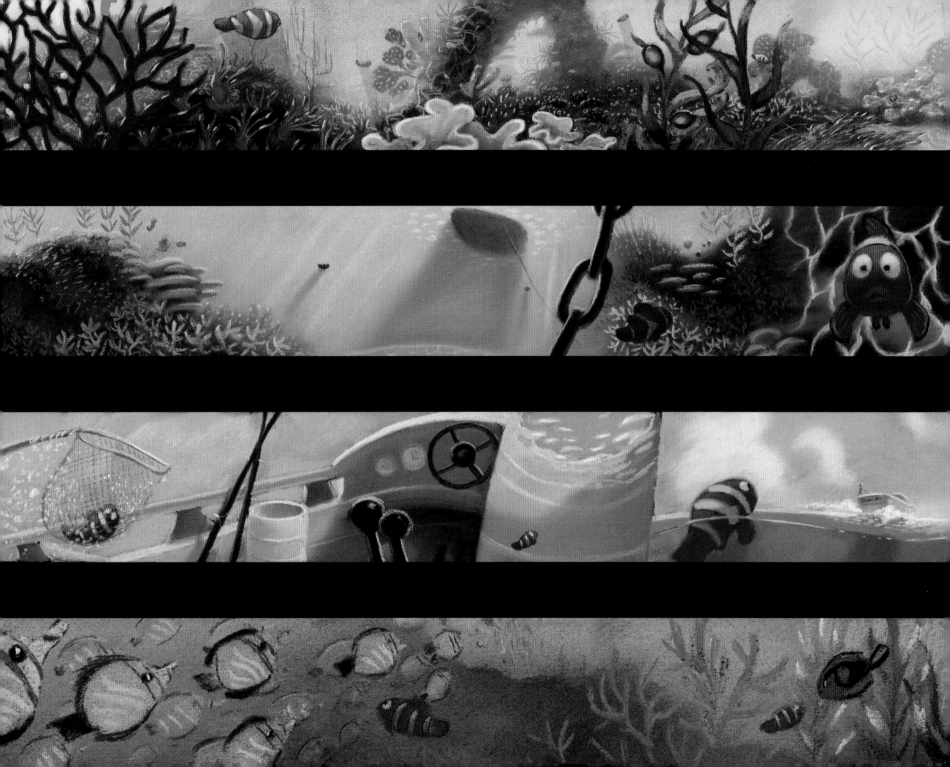

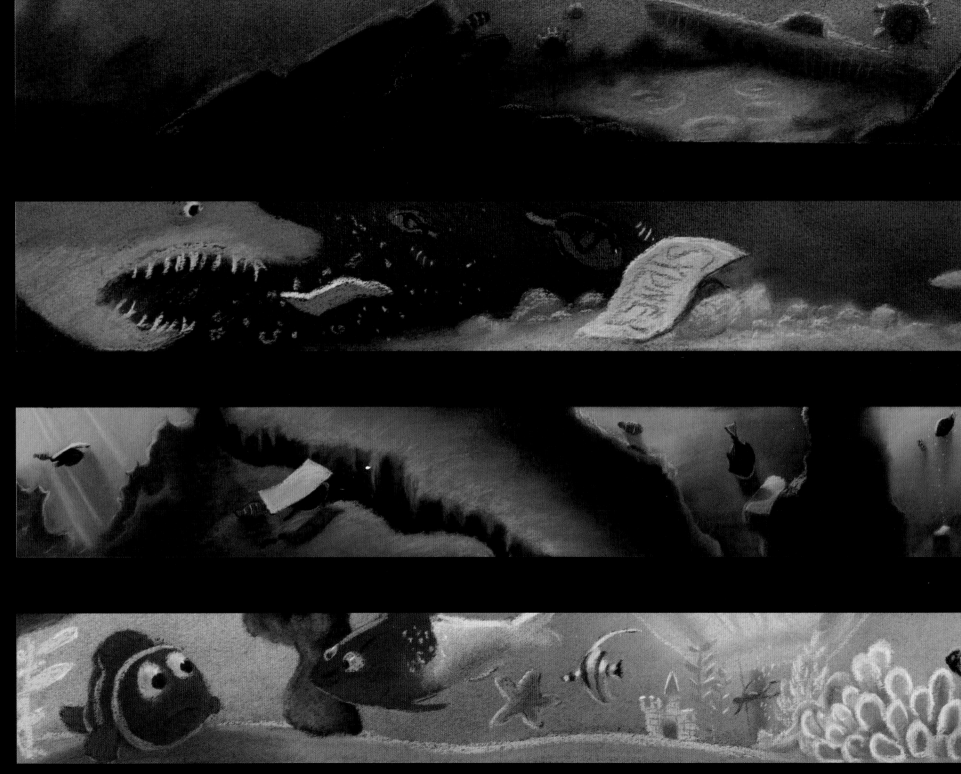

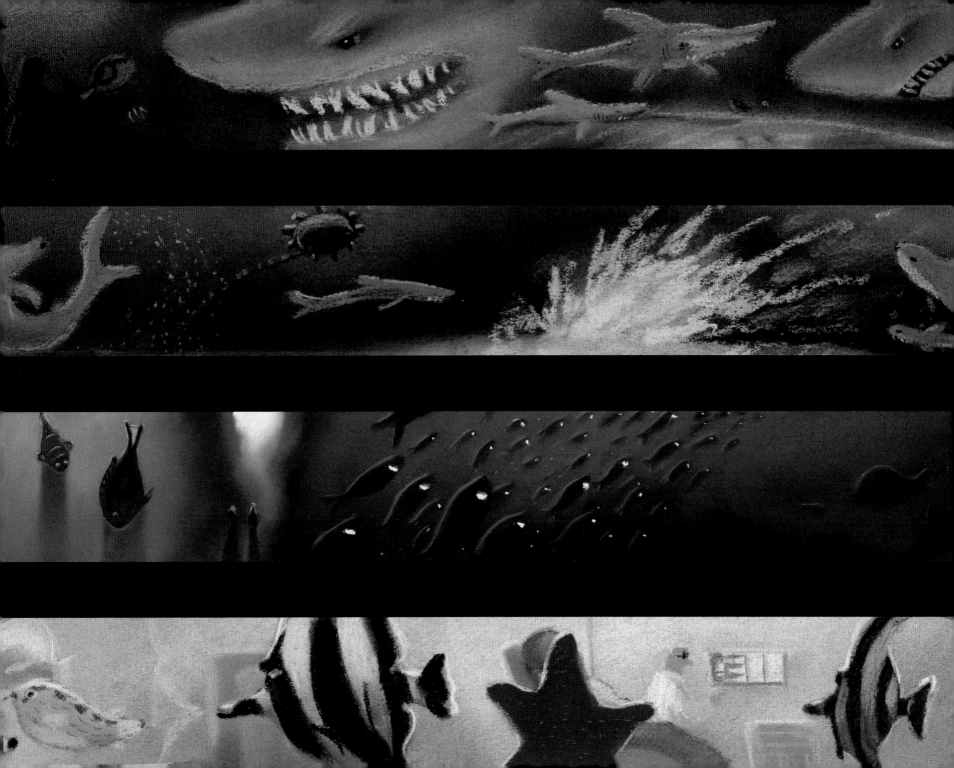

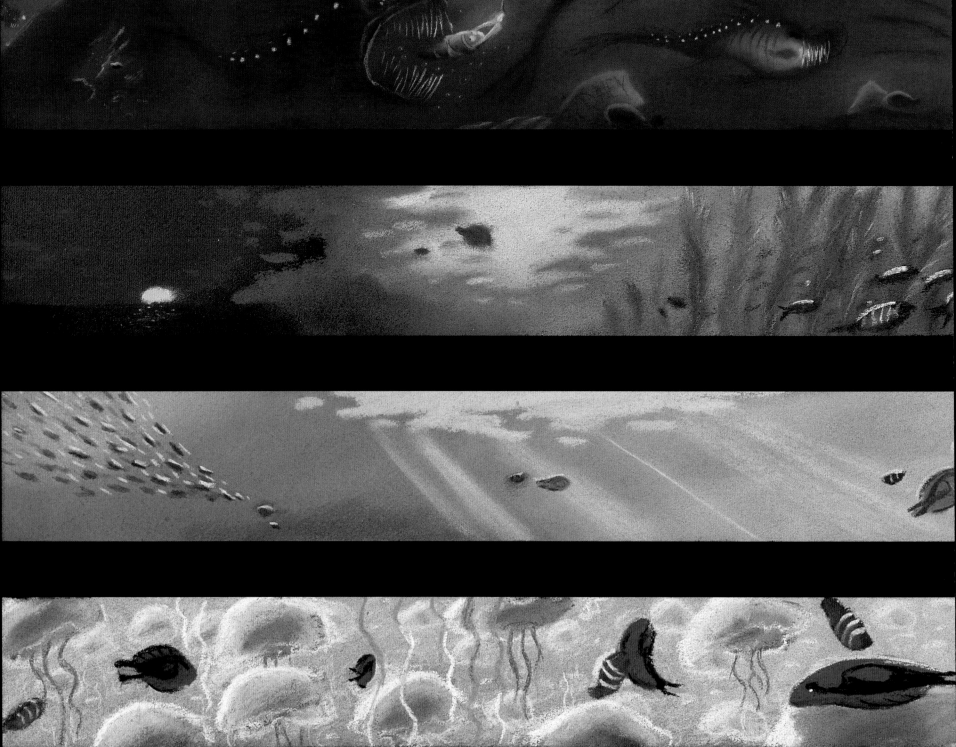

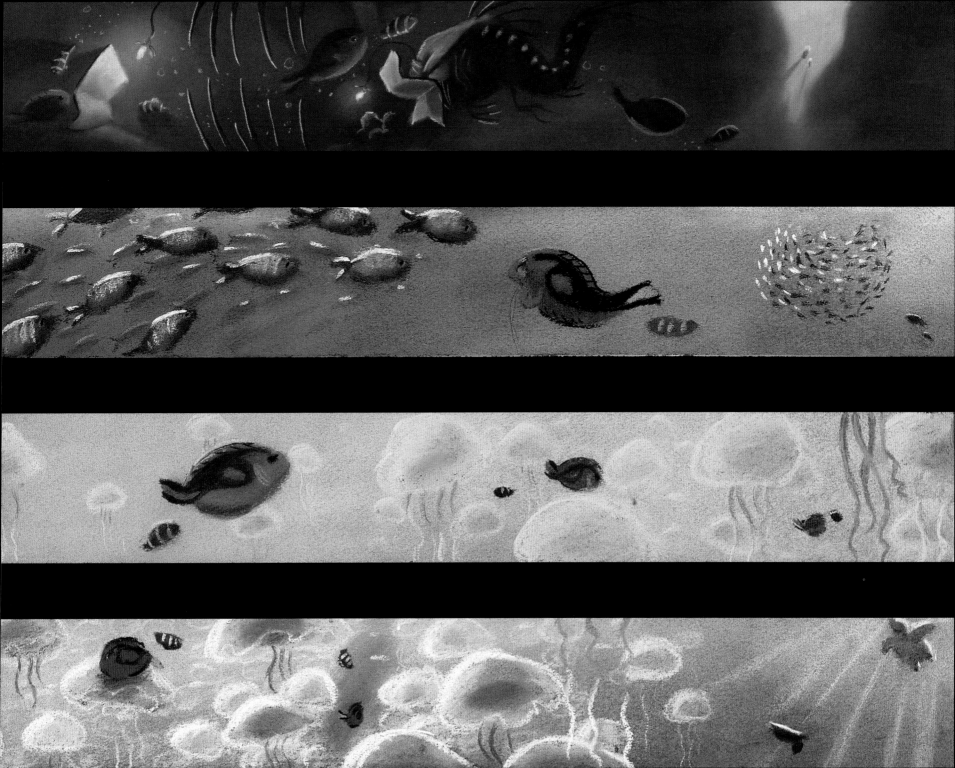

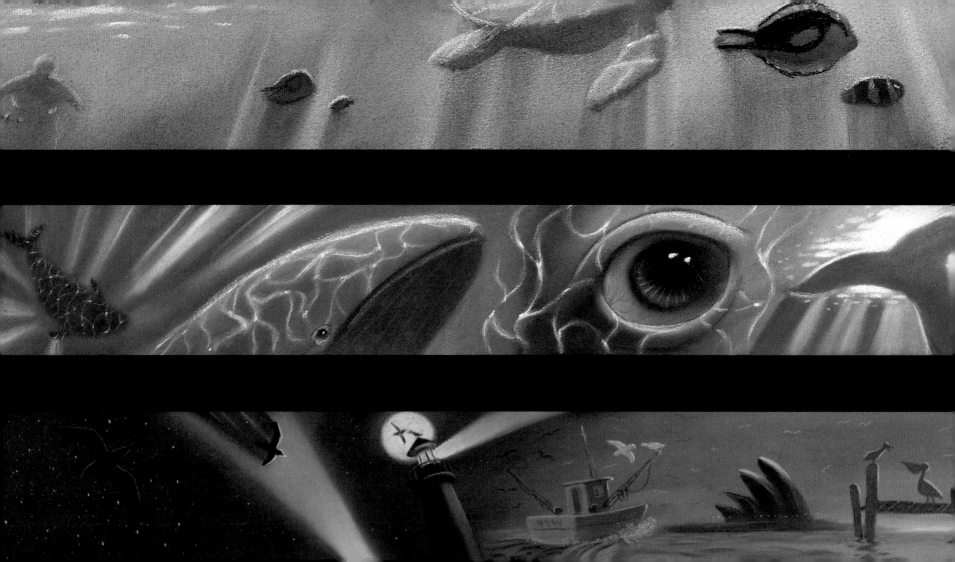

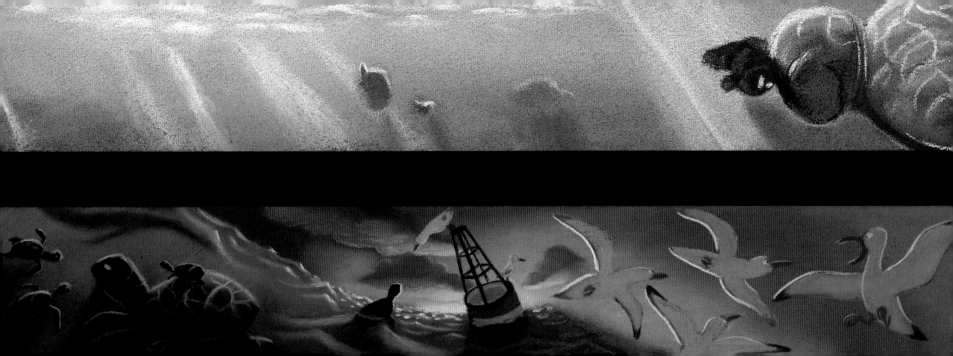

THE INCRE

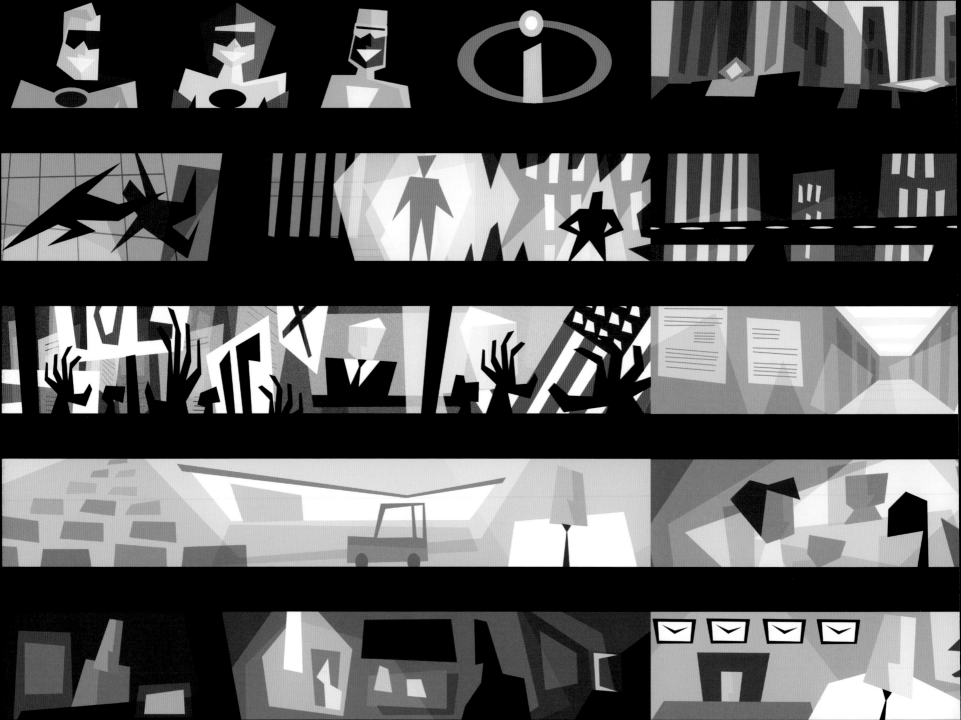

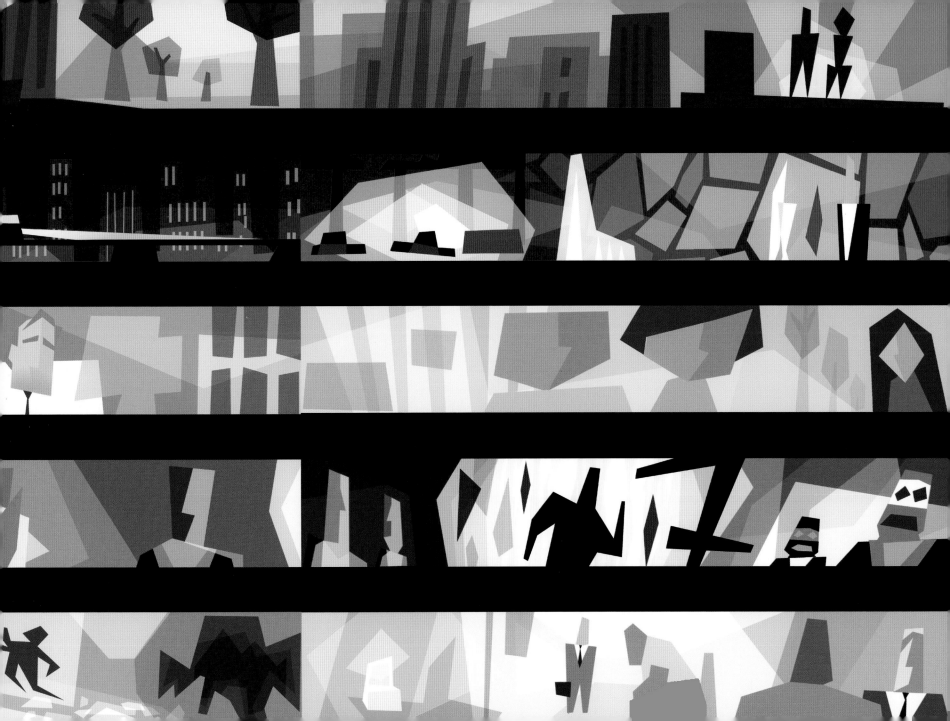

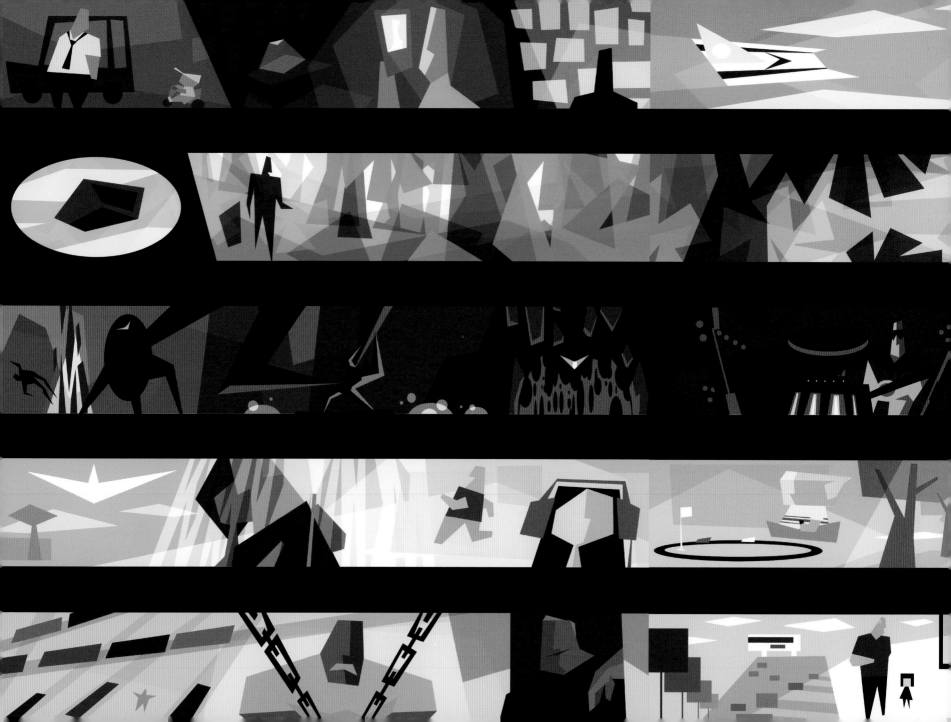

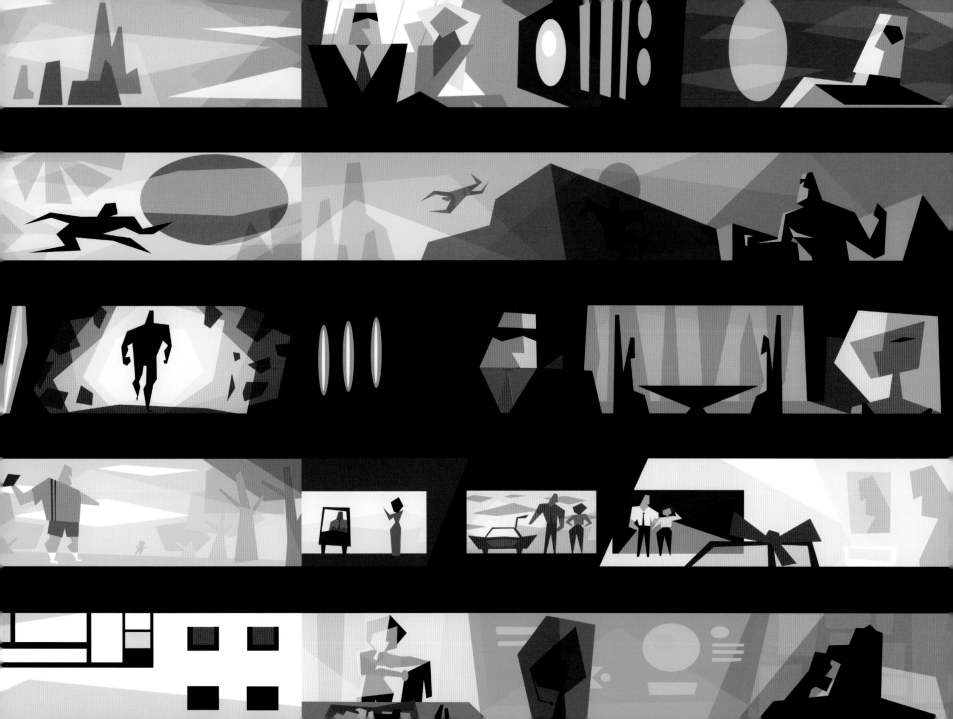

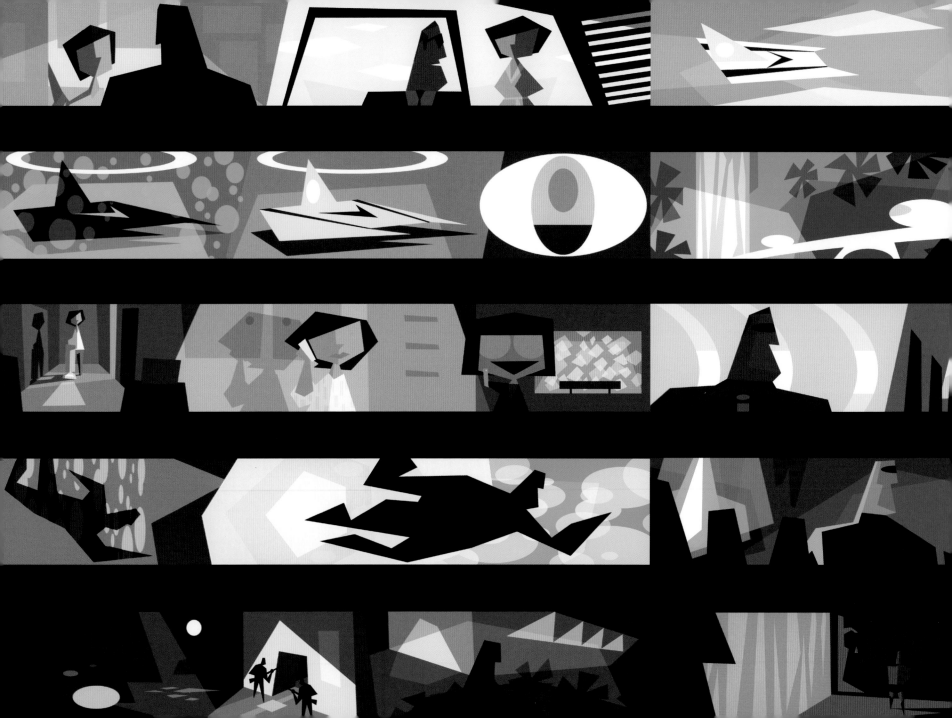

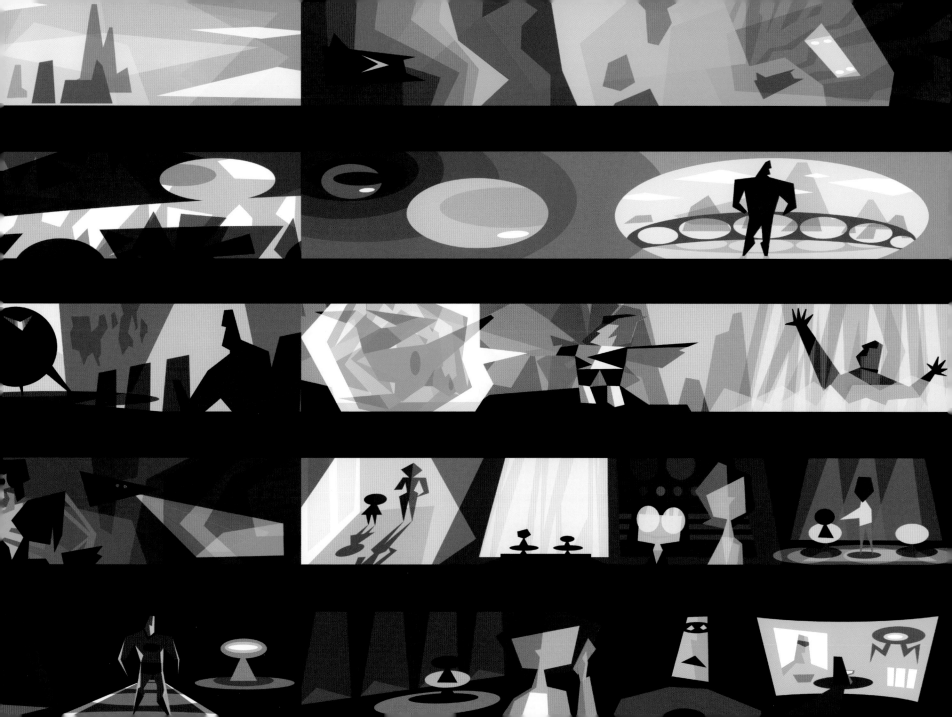

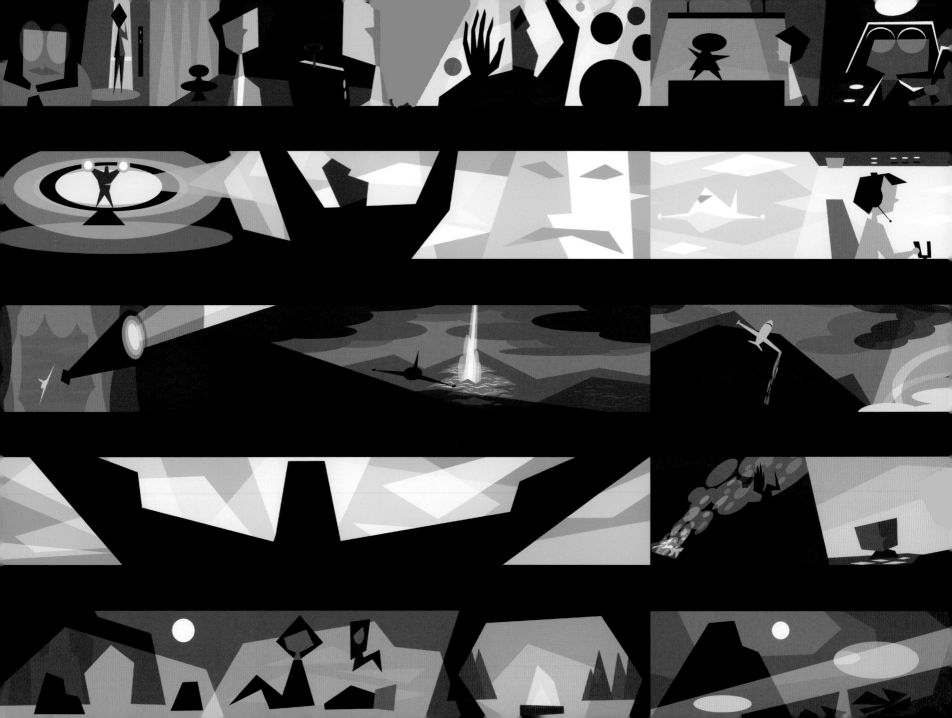

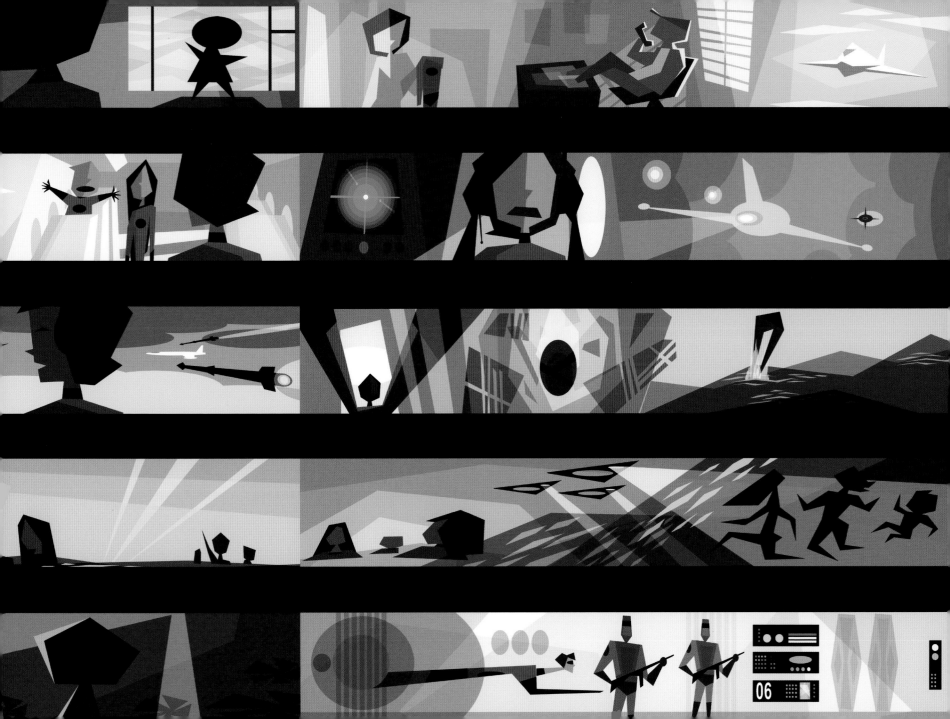

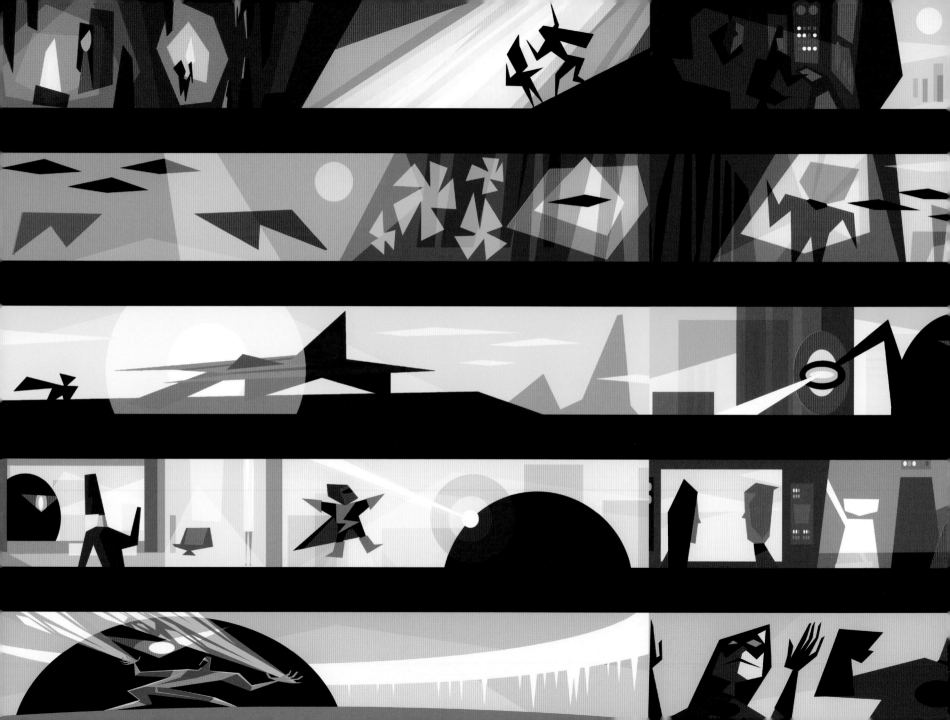

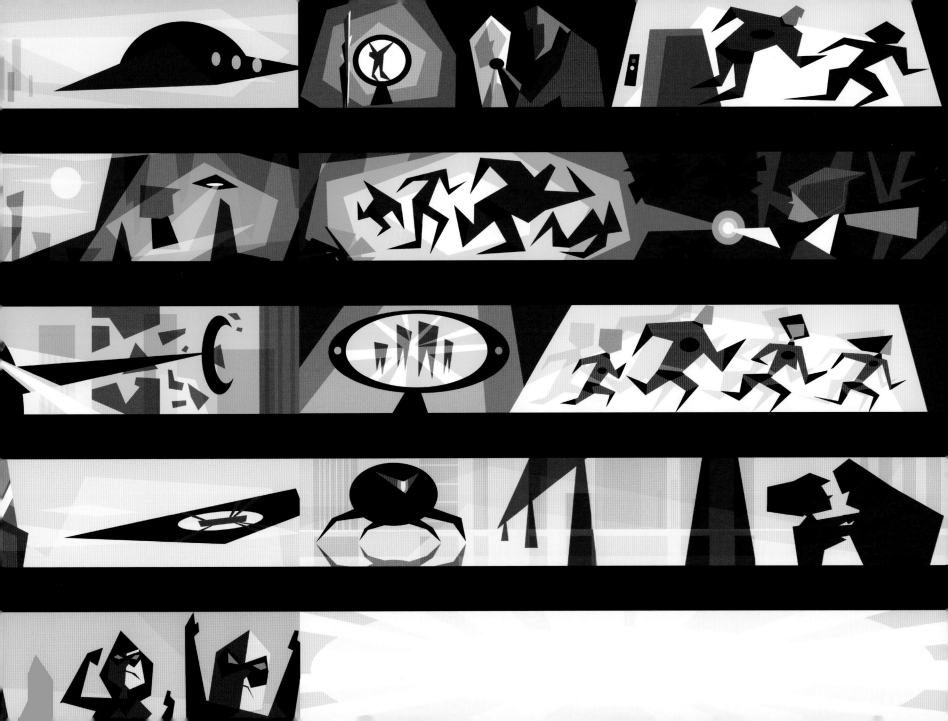

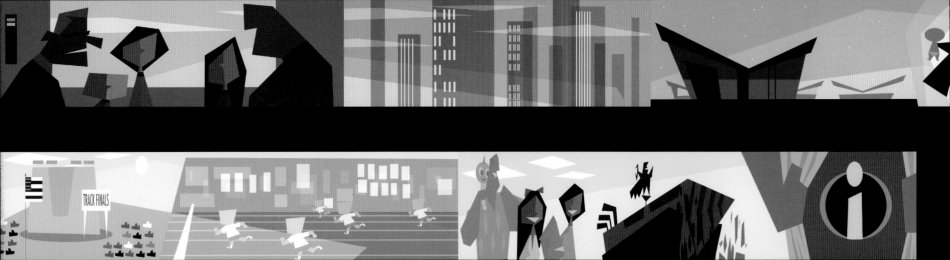

TRACK FINALS

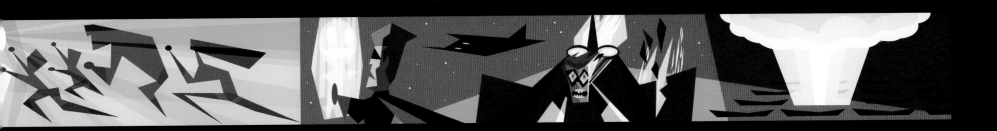

Bill Cone, Pastel, 2004–2005

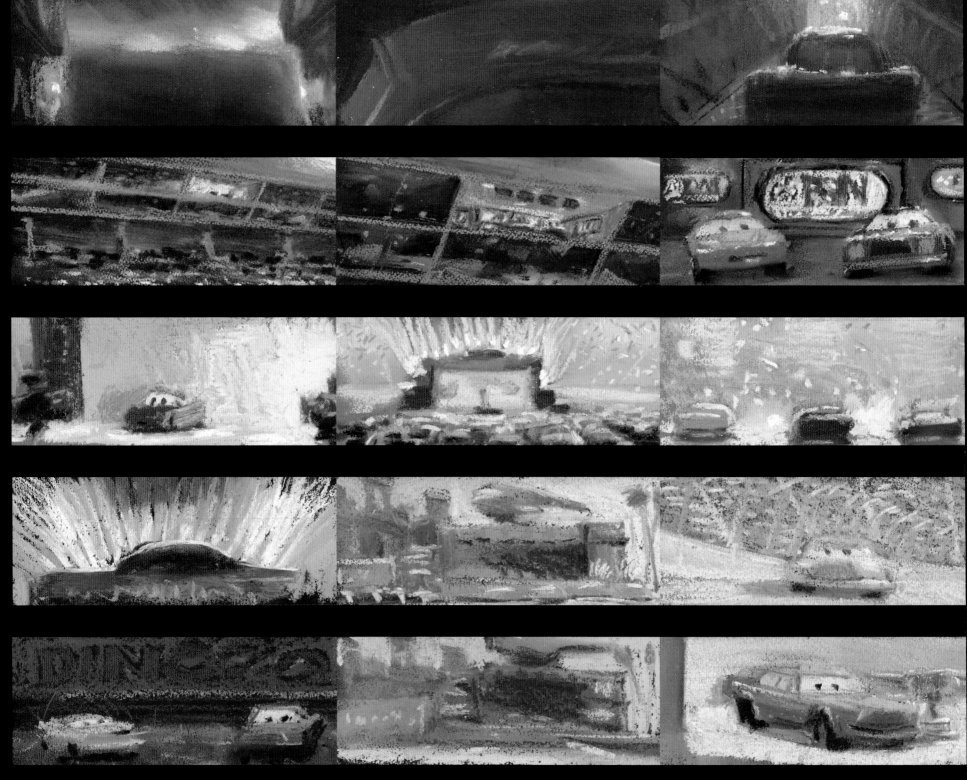

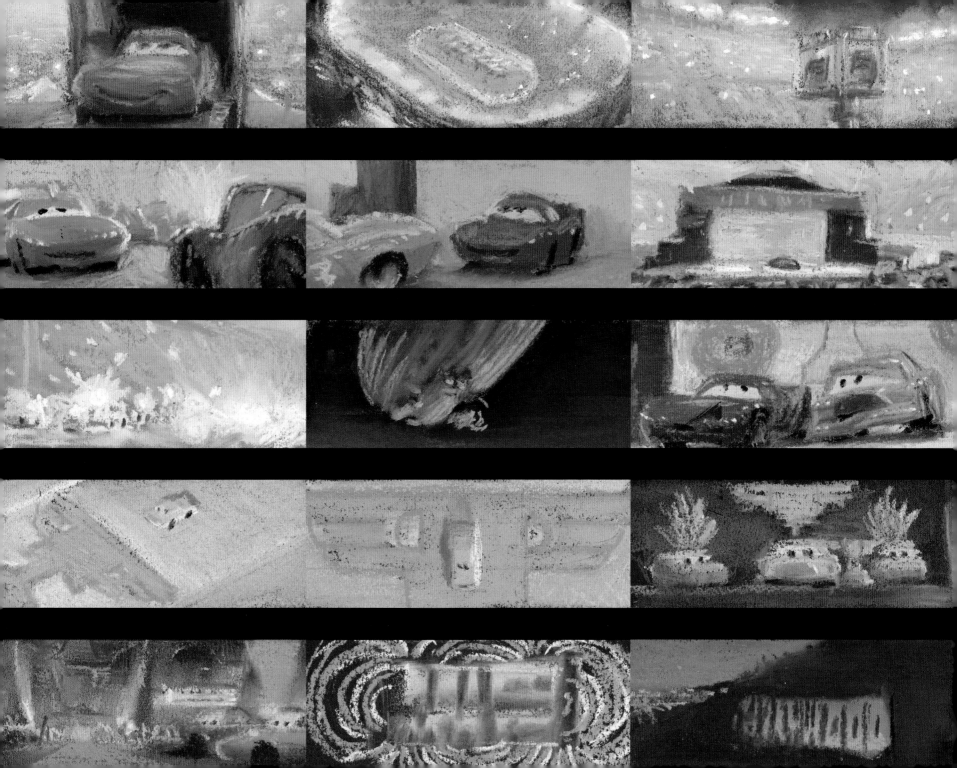

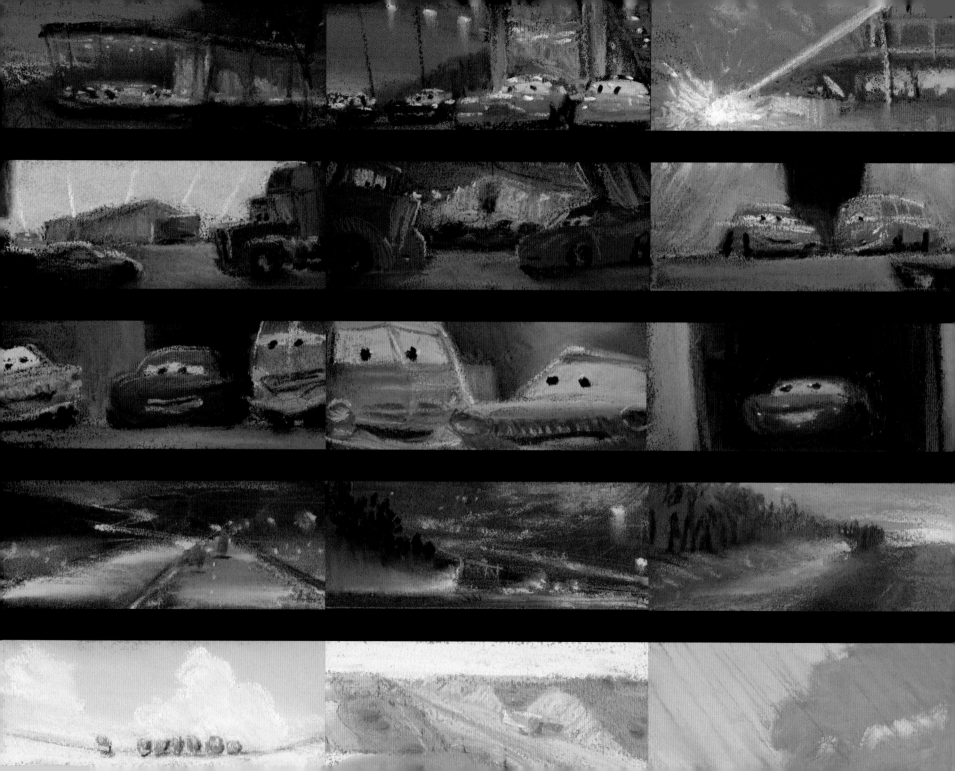

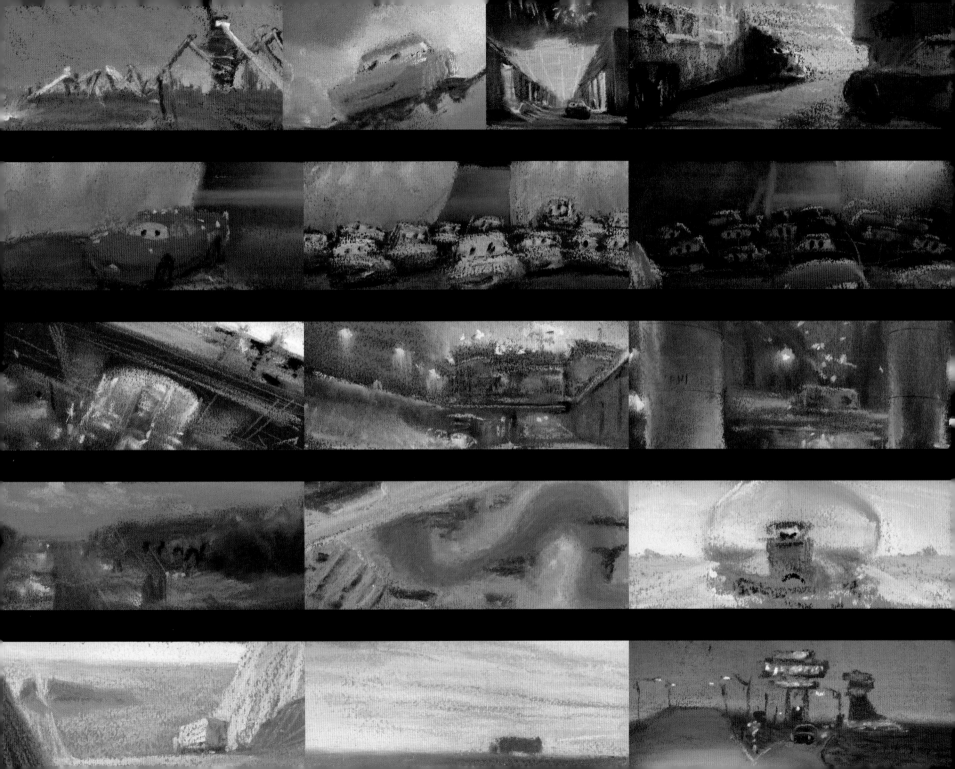

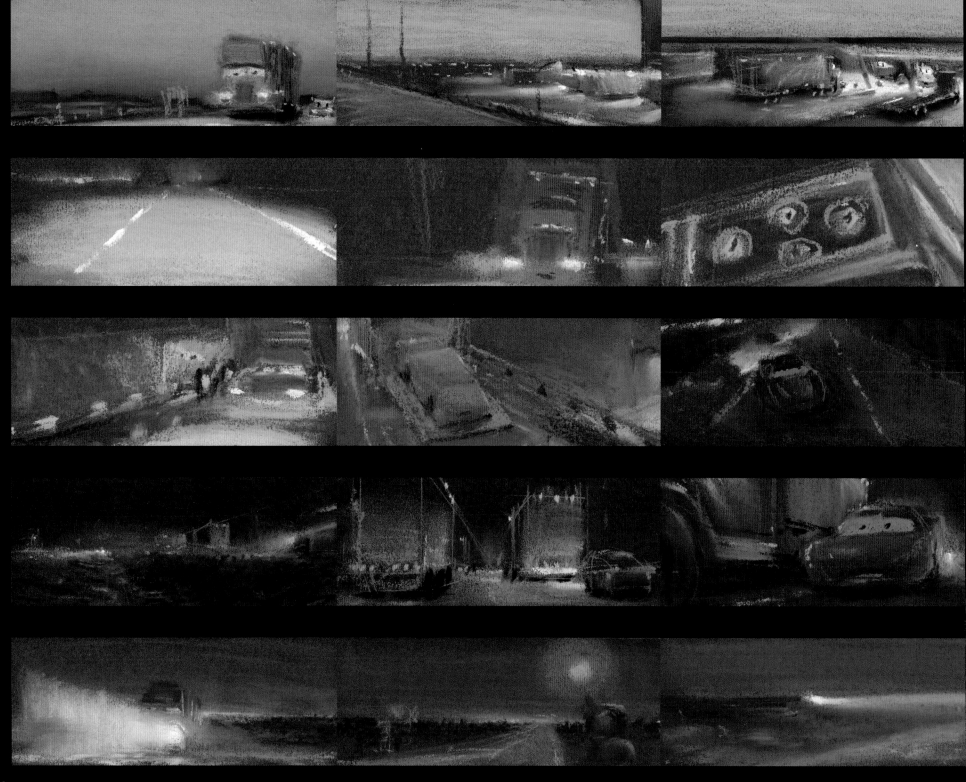

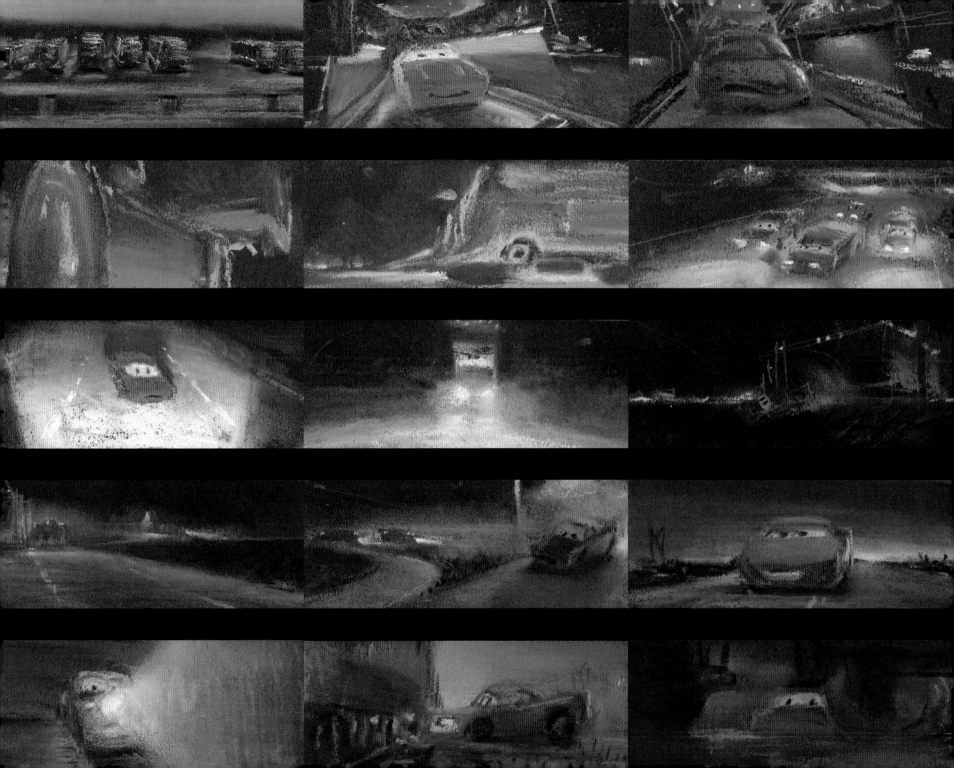

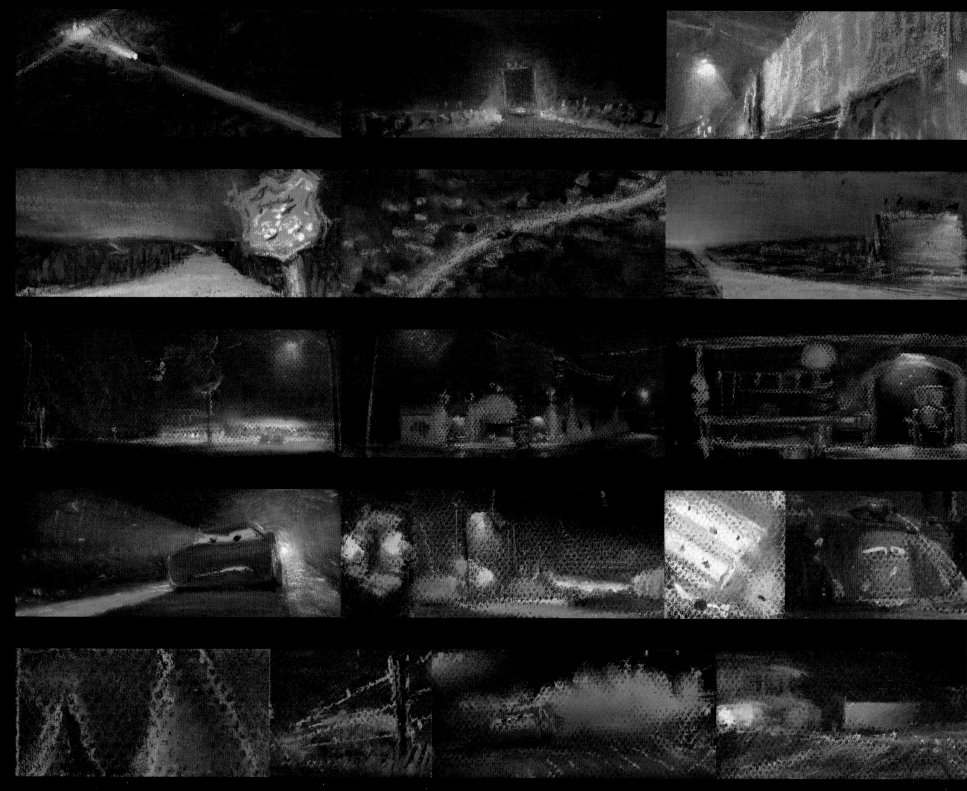

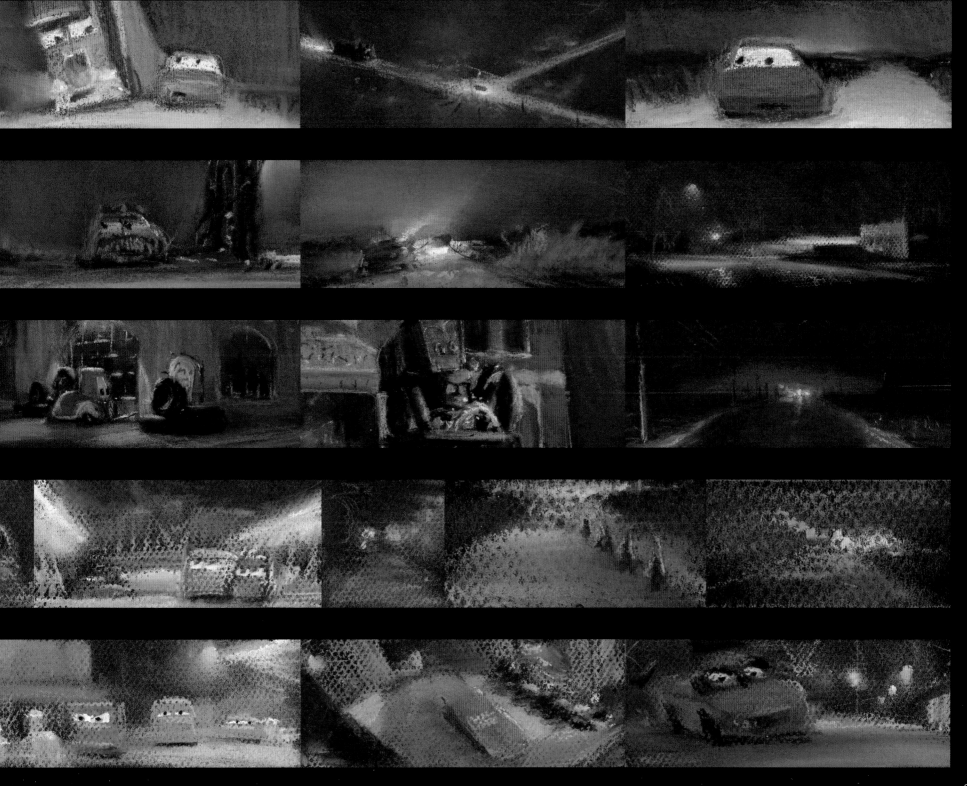

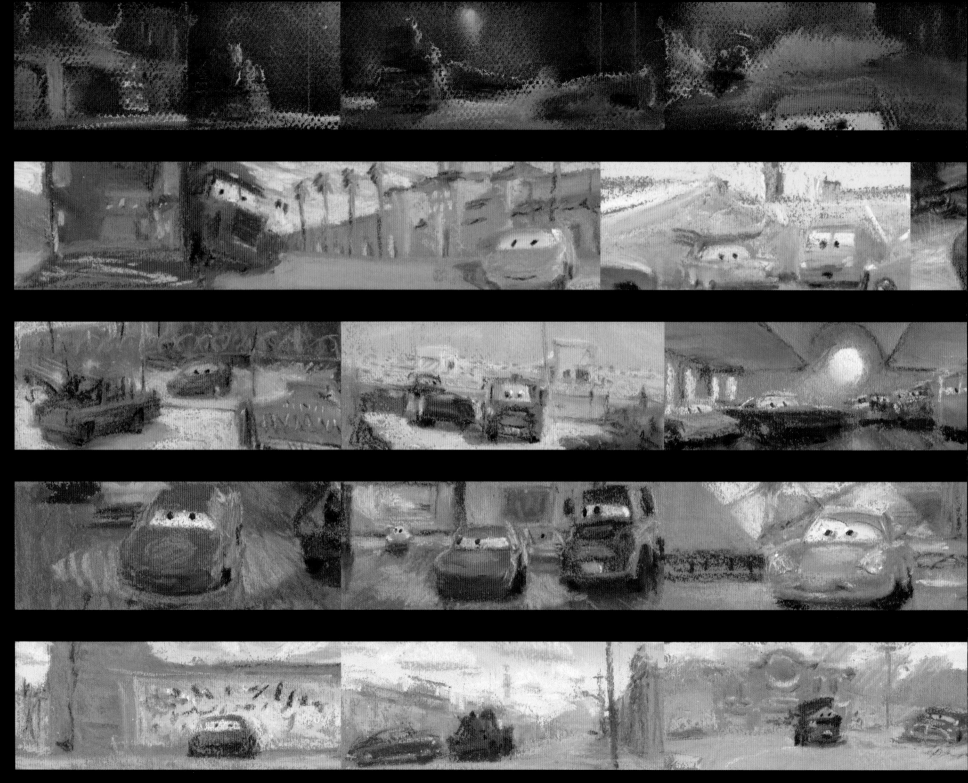

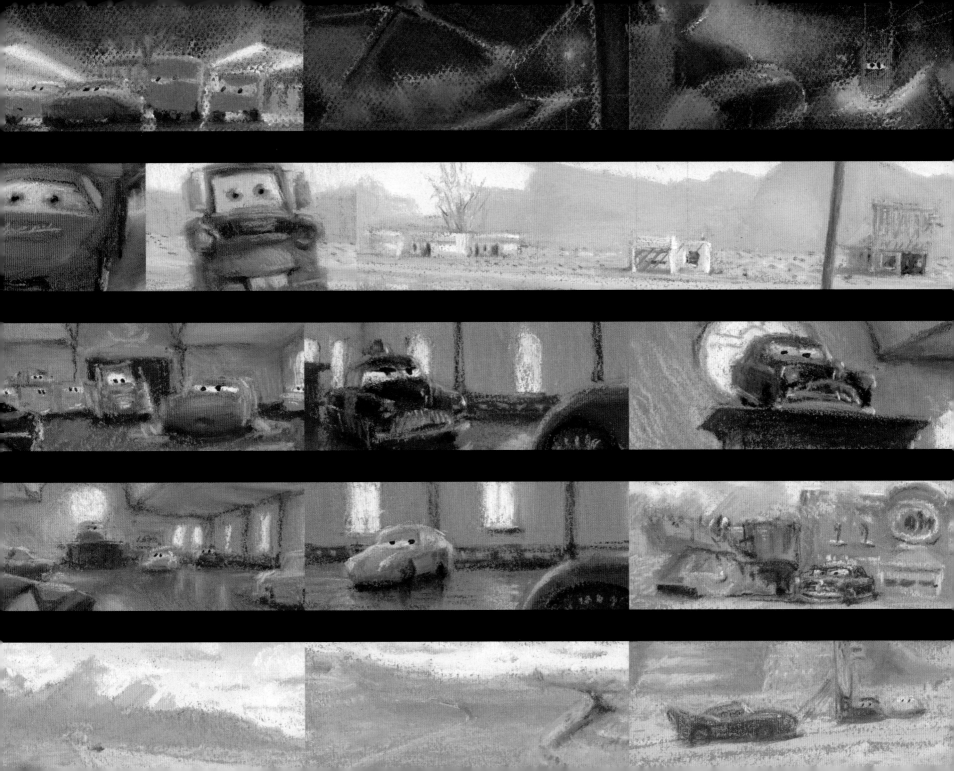

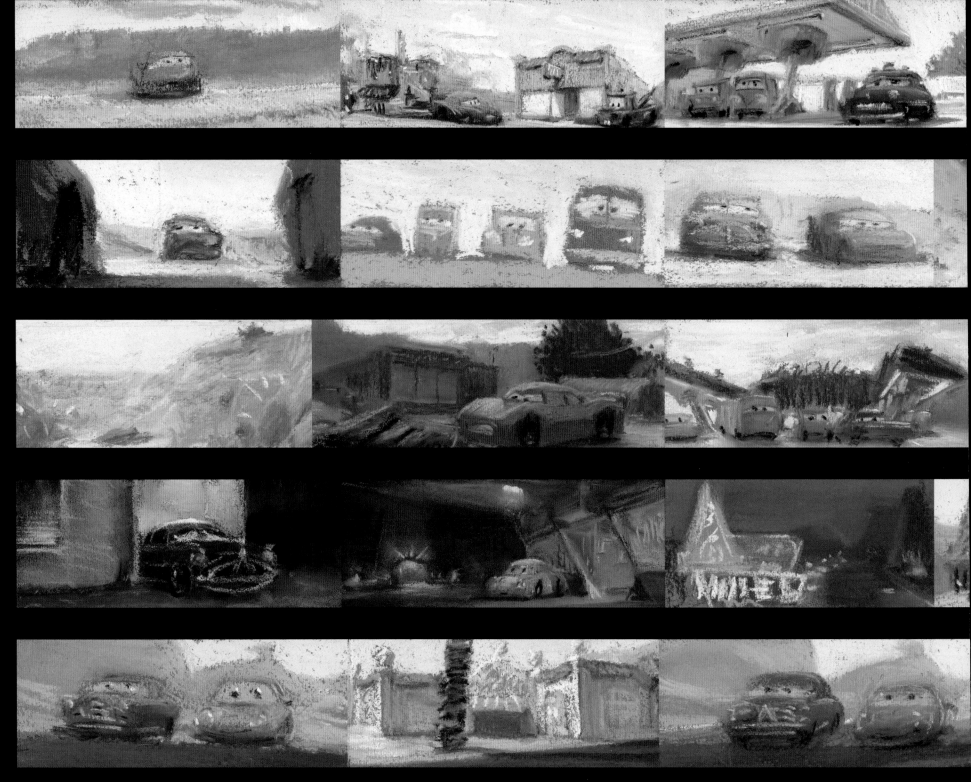

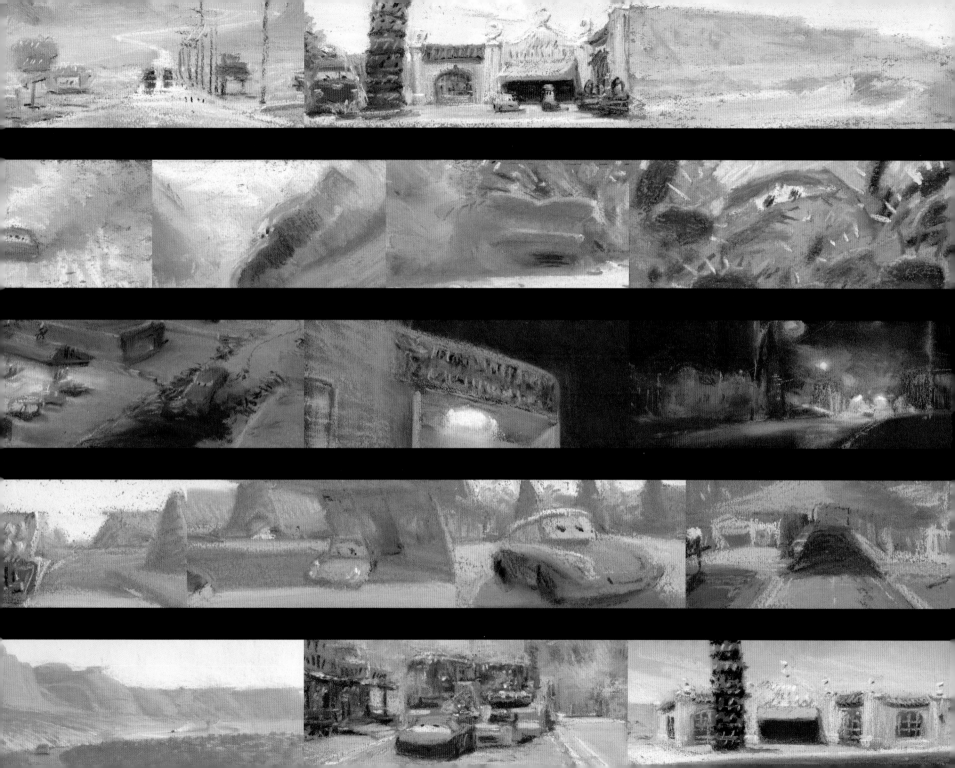

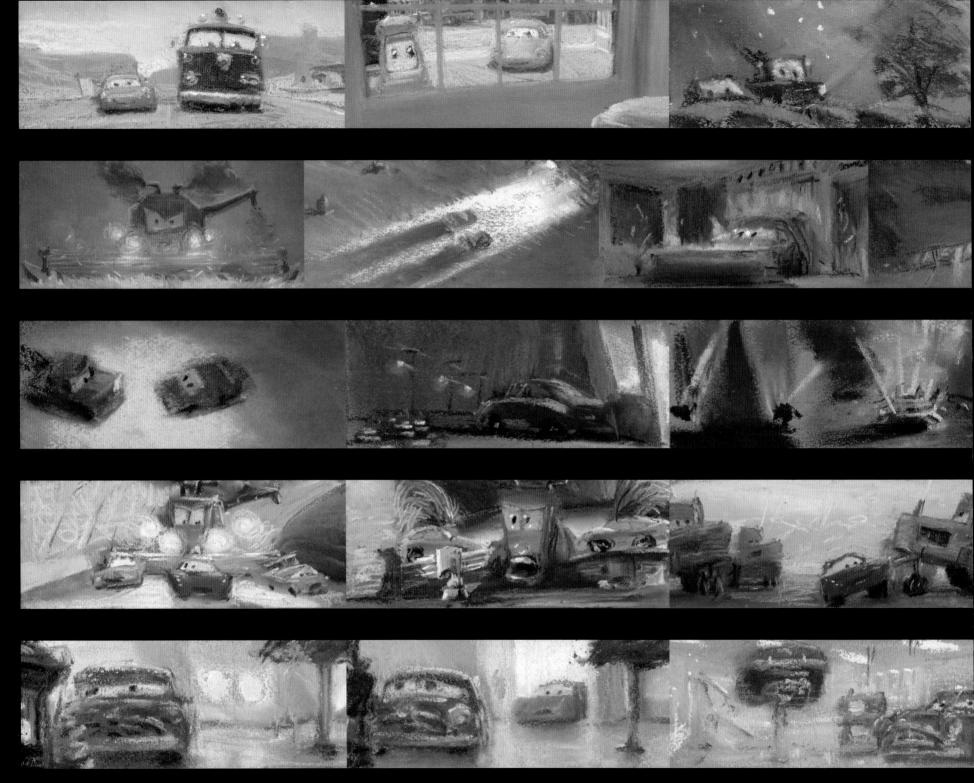

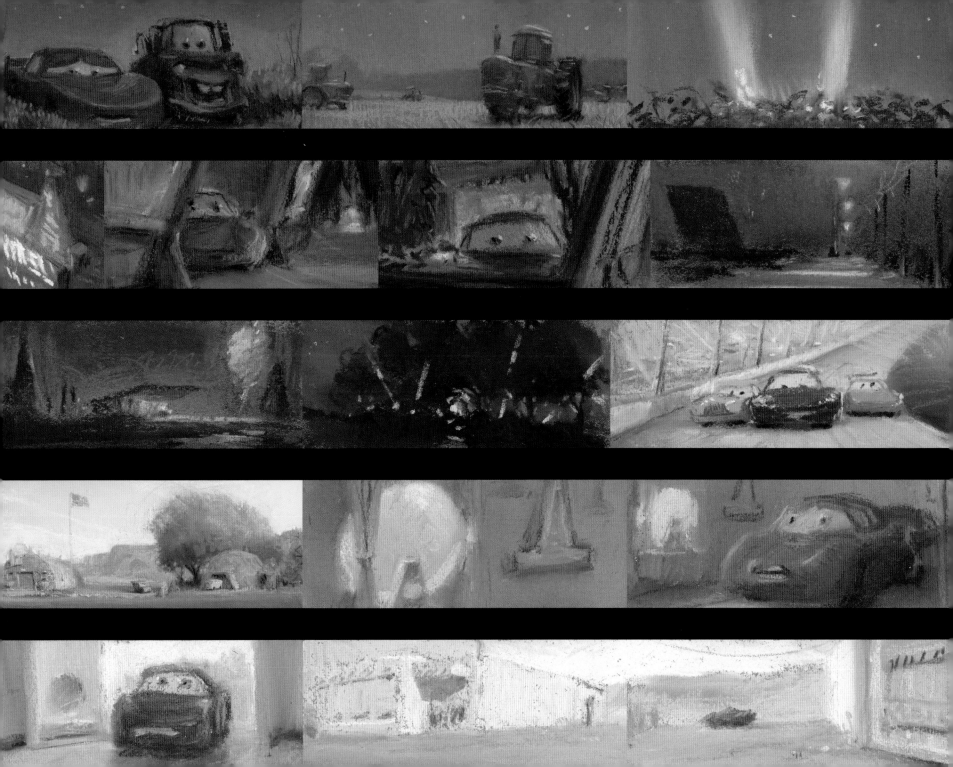

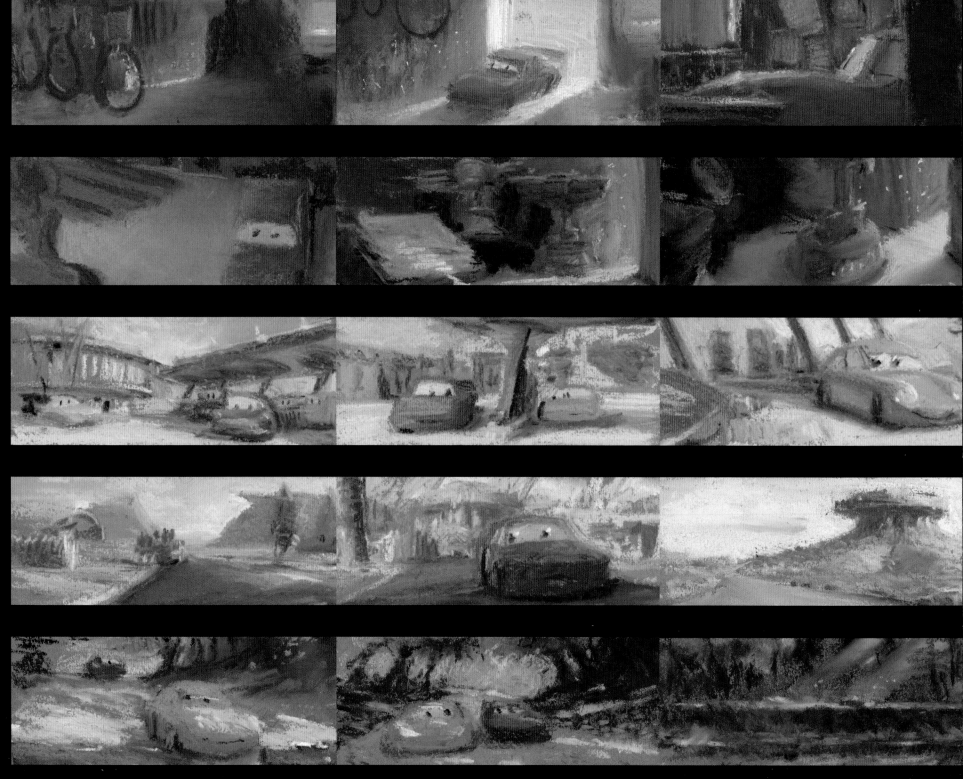

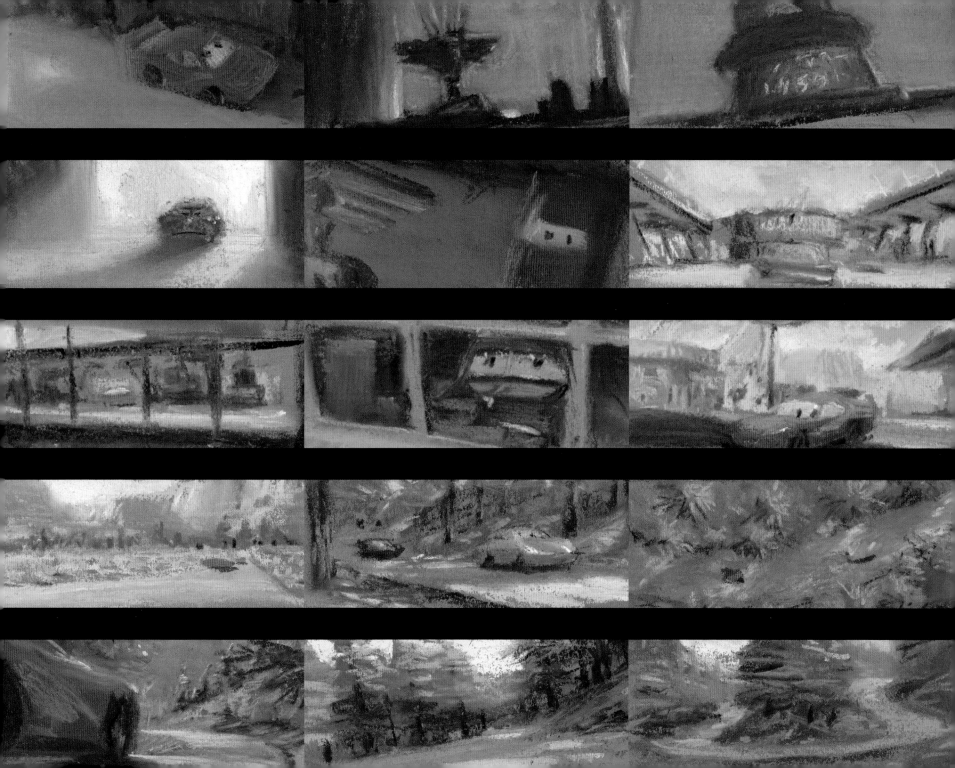

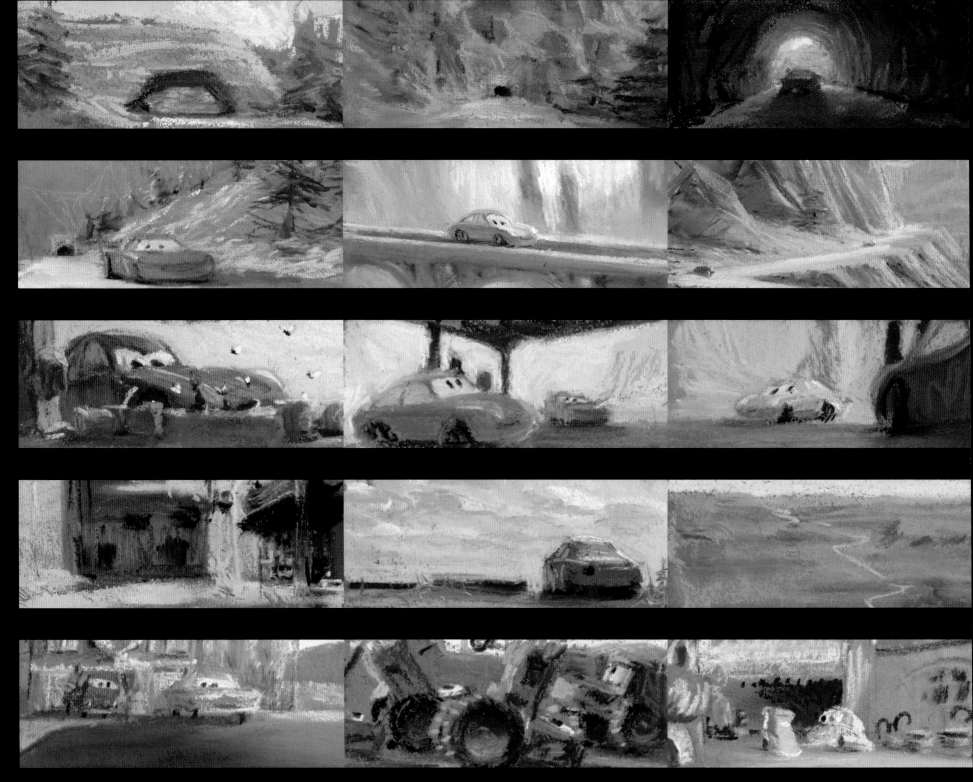

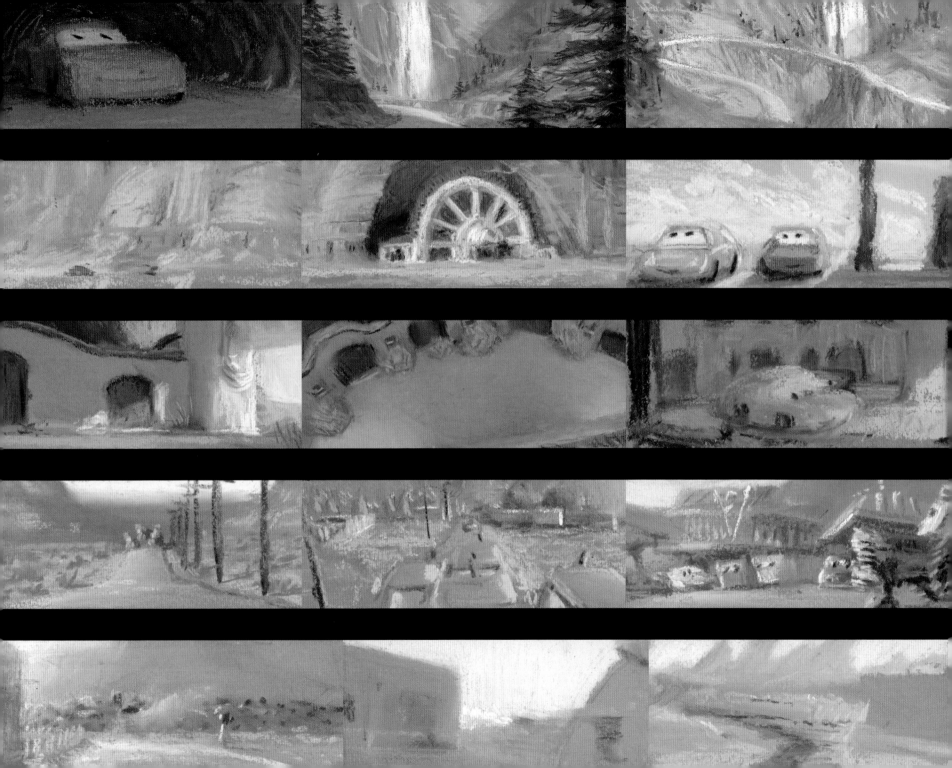

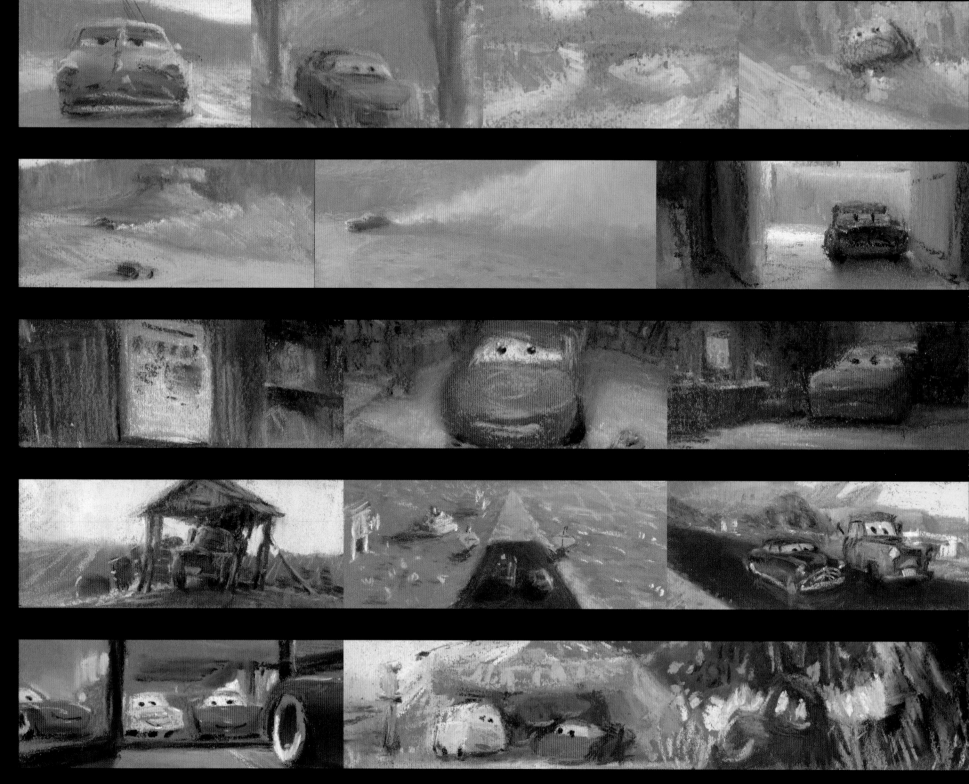

104

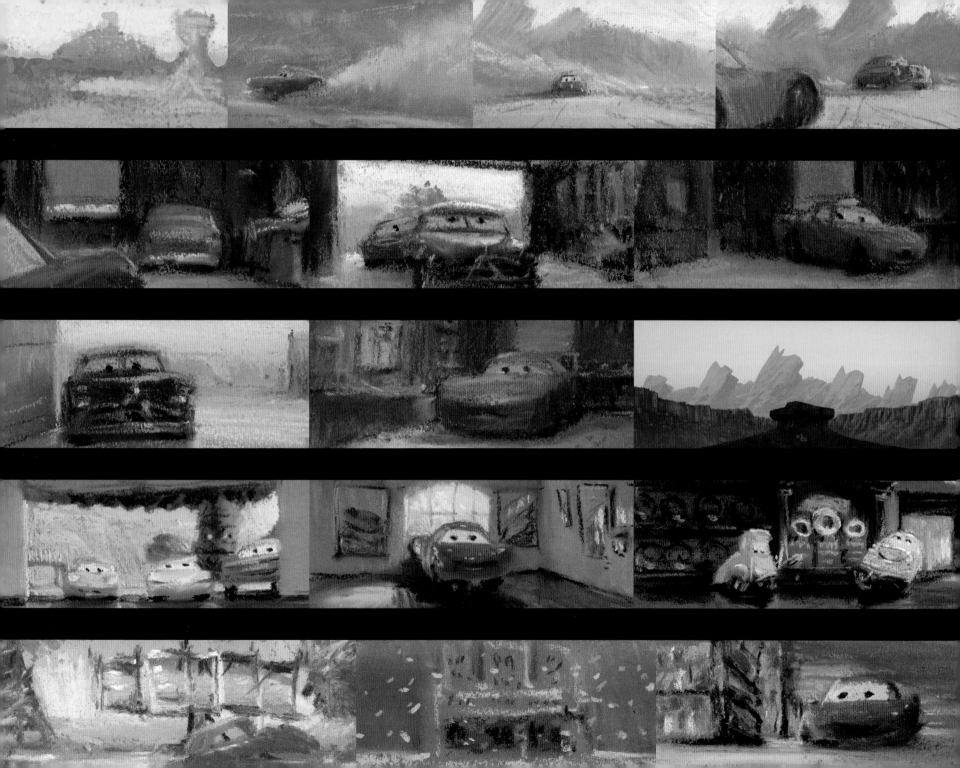

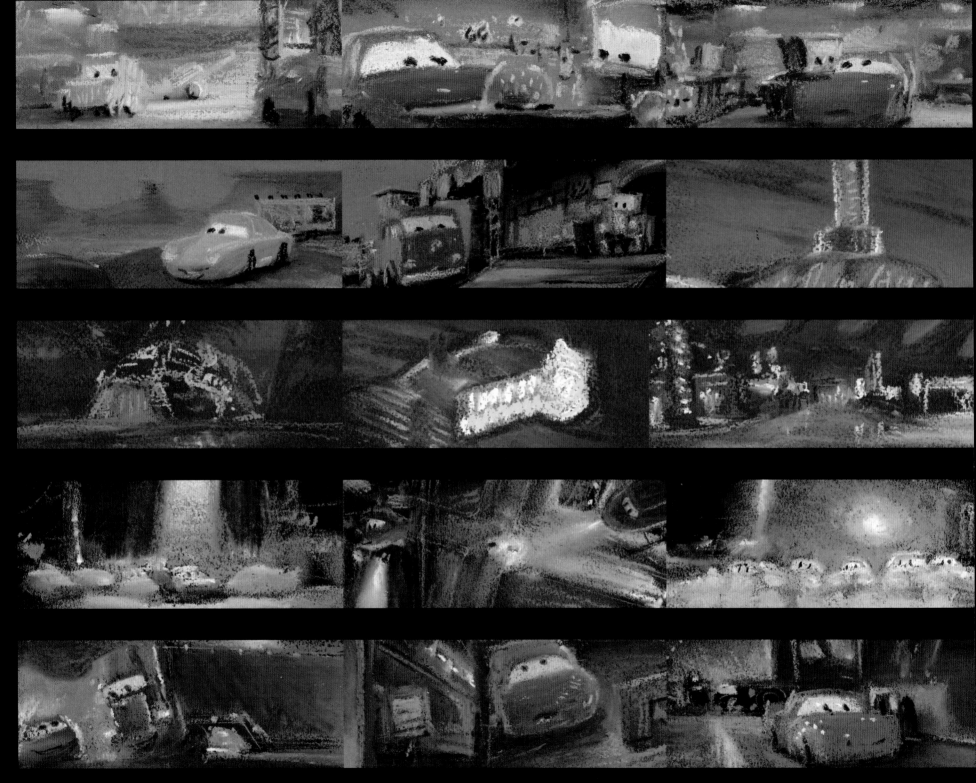

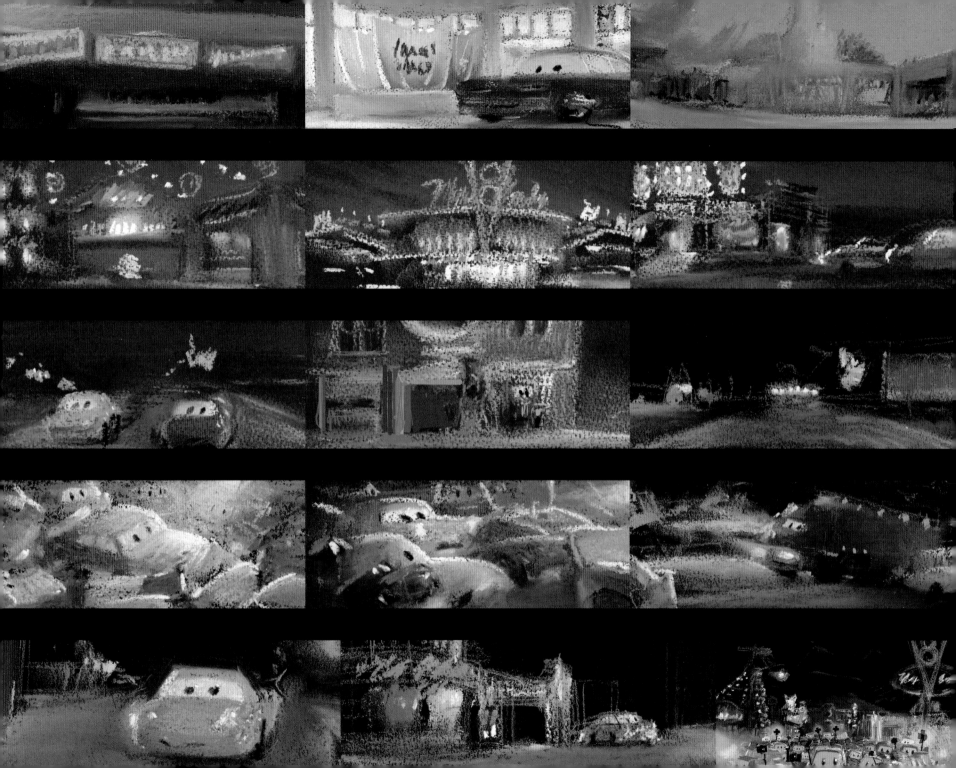

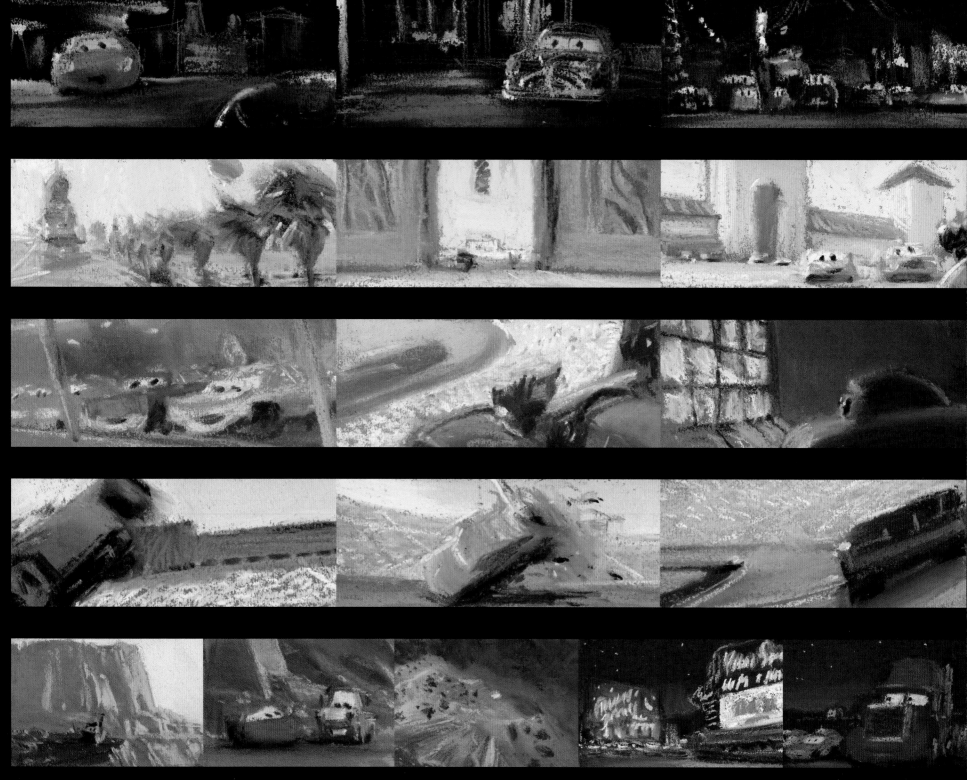

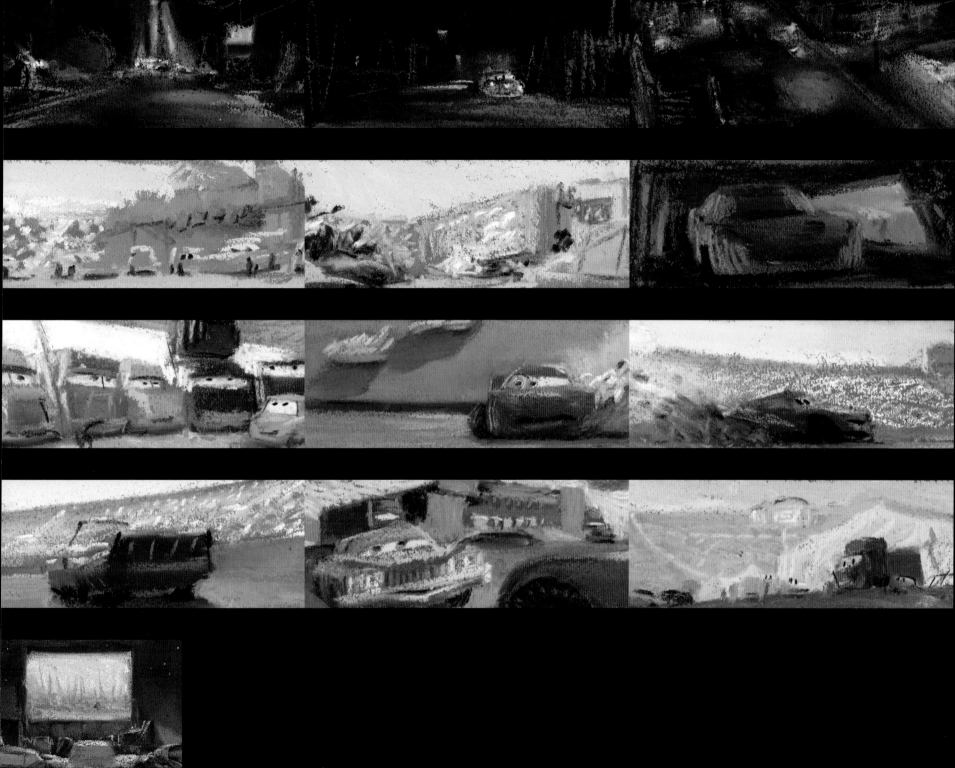

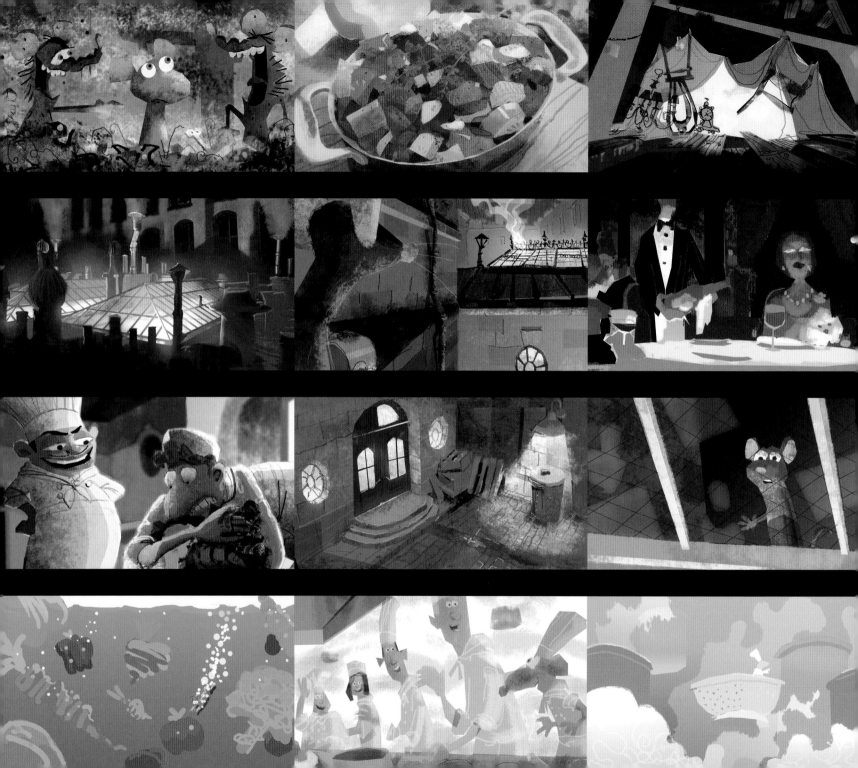

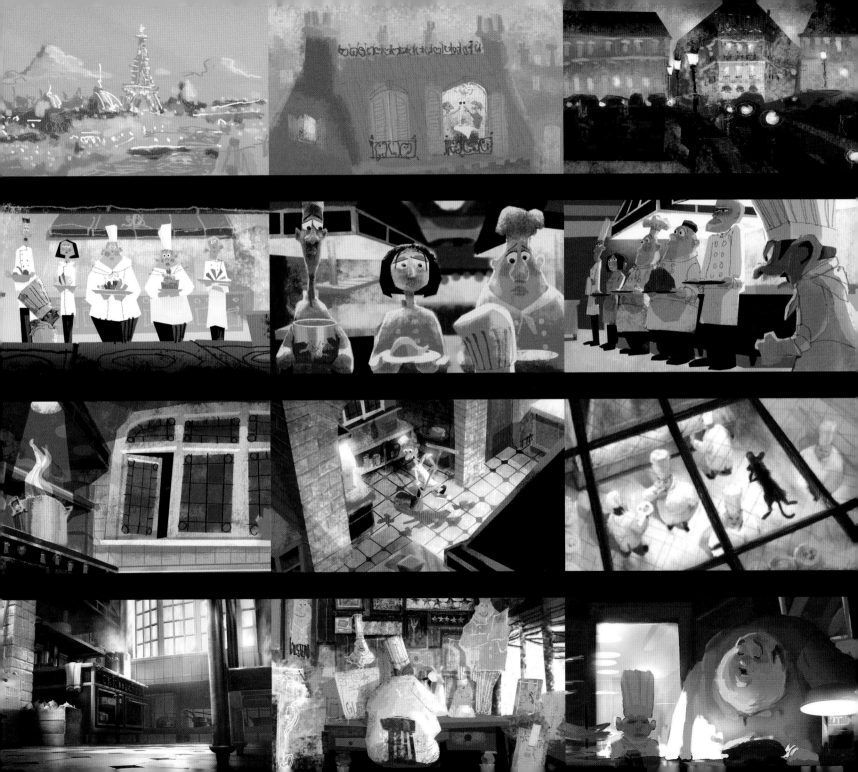

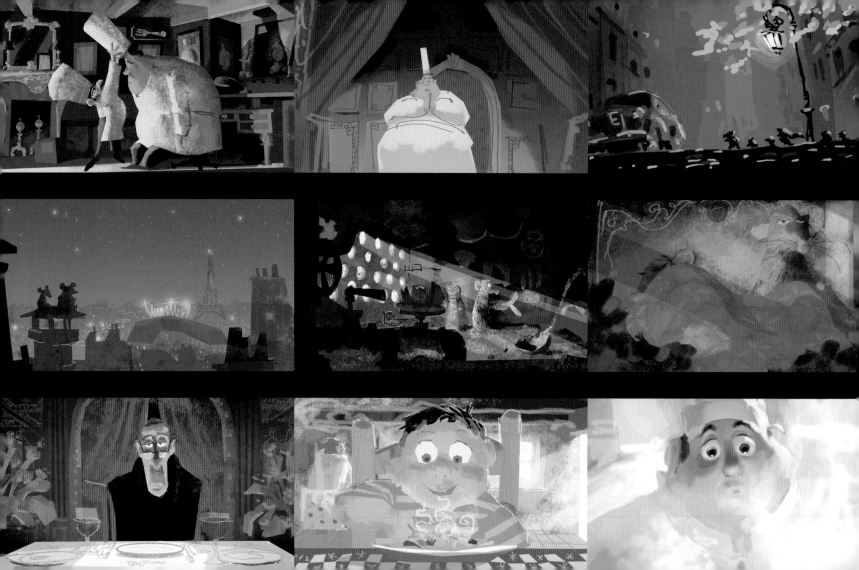

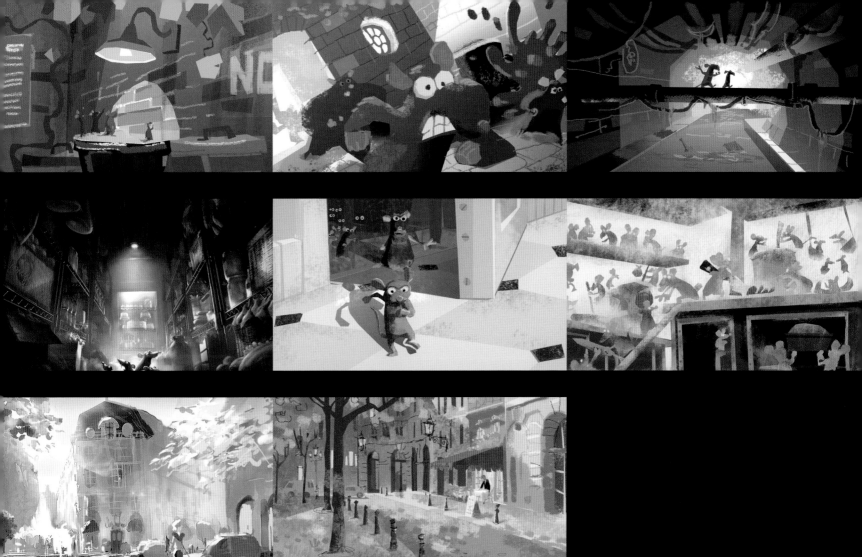

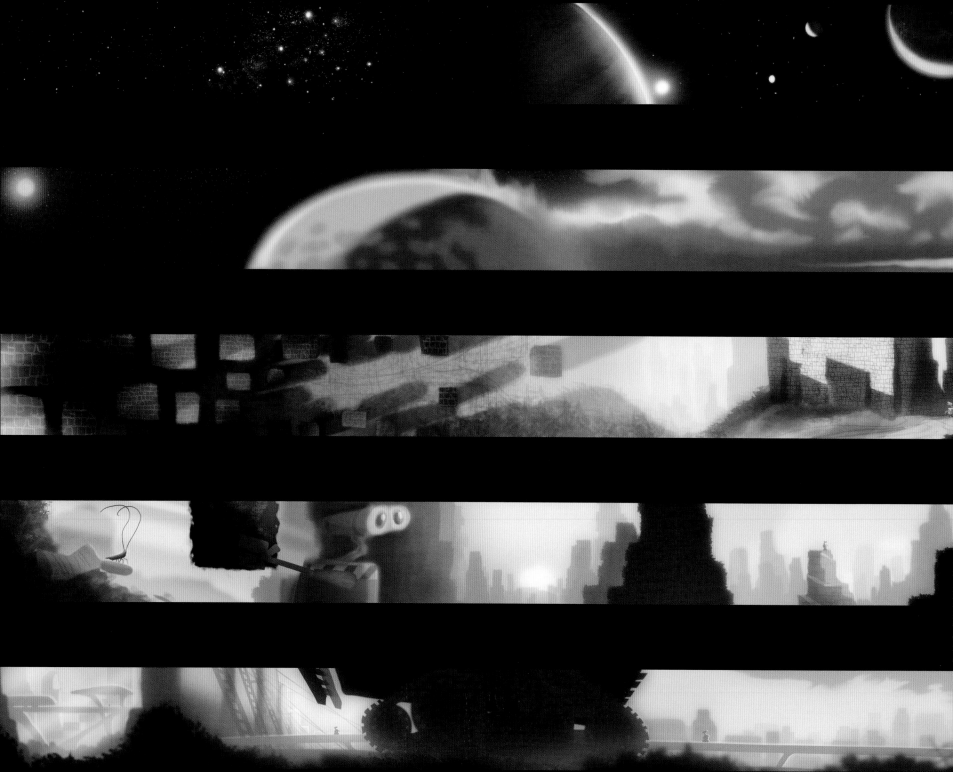

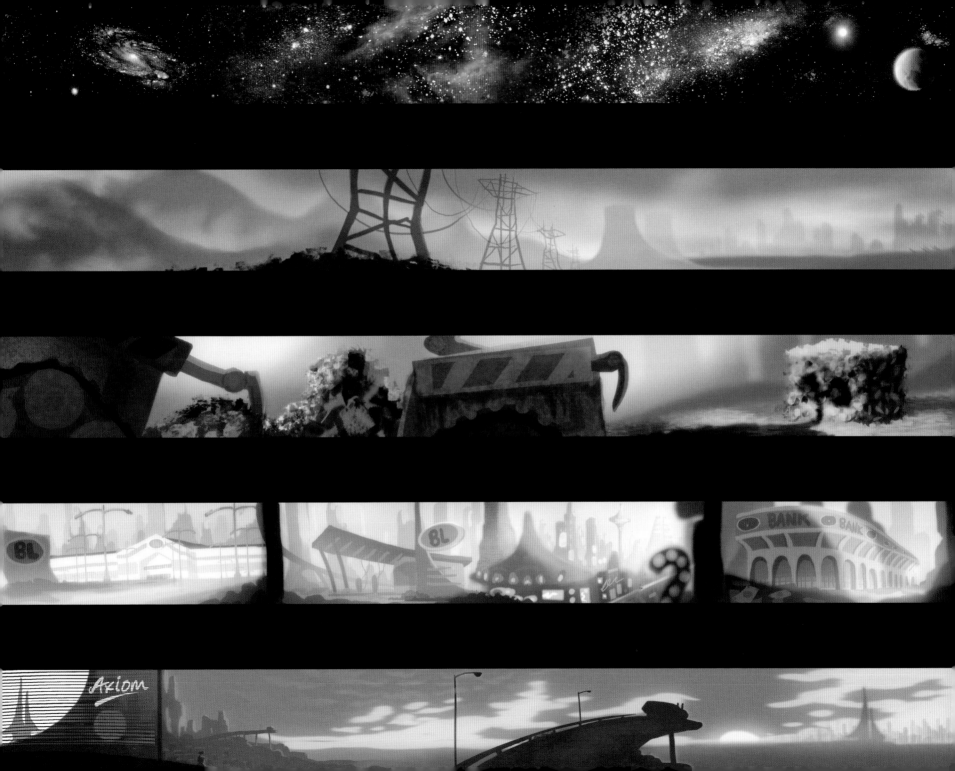

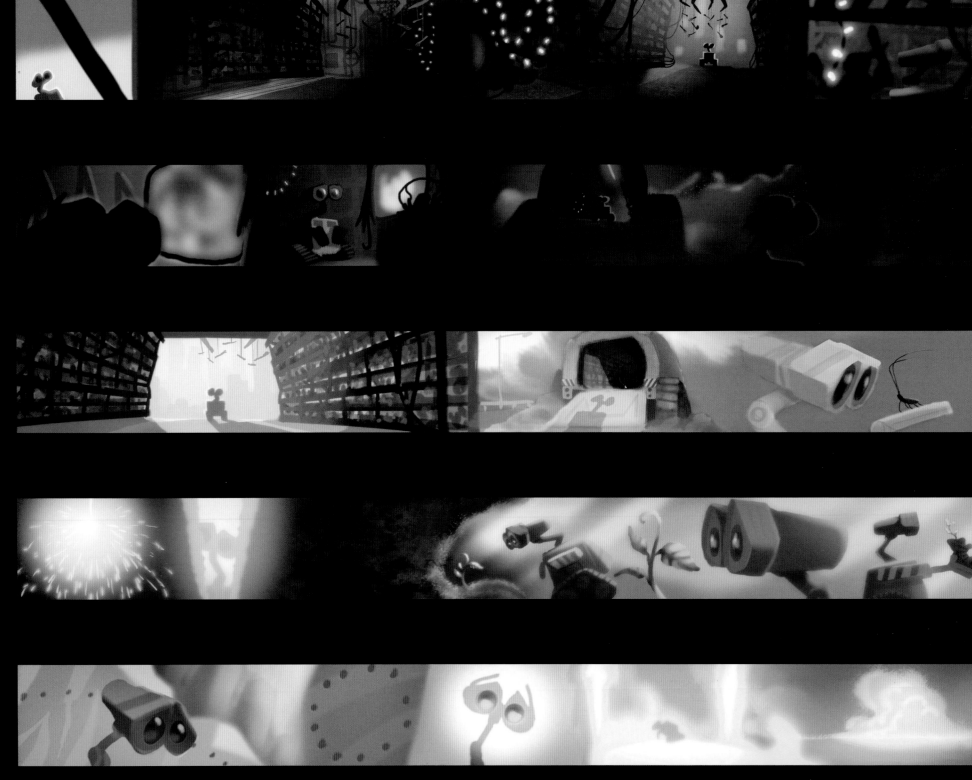

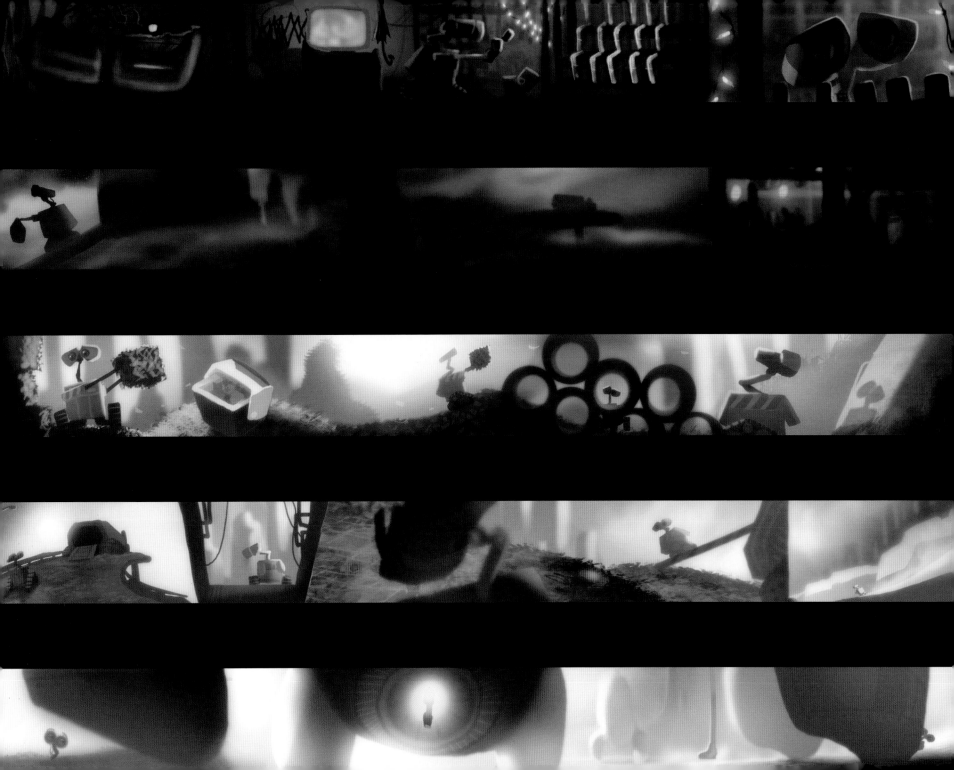

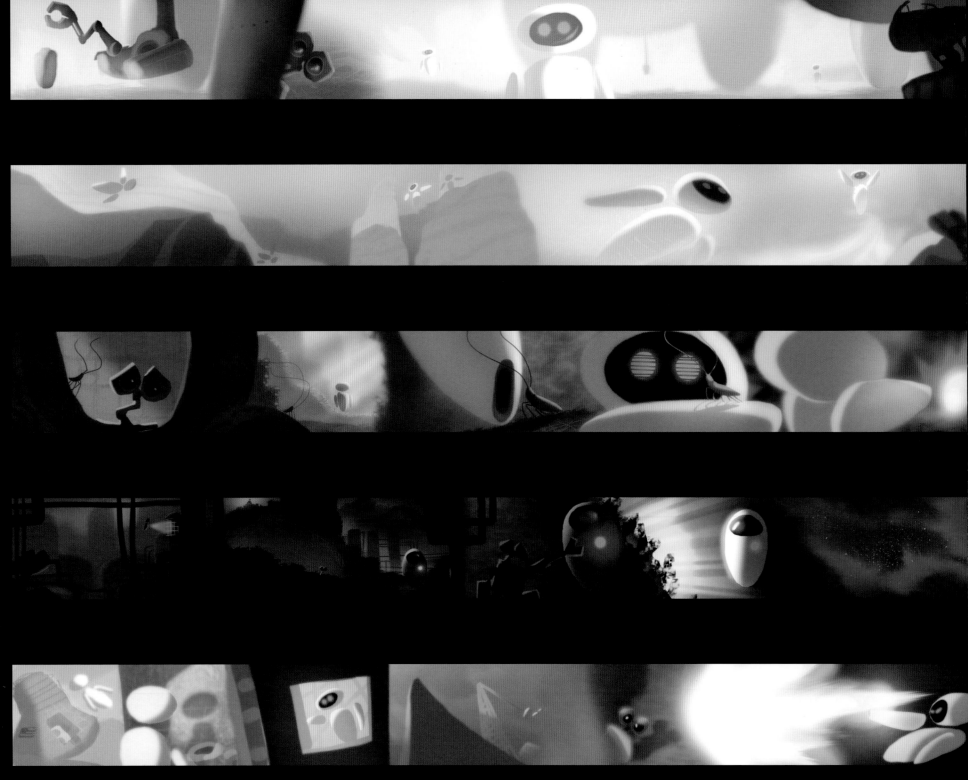

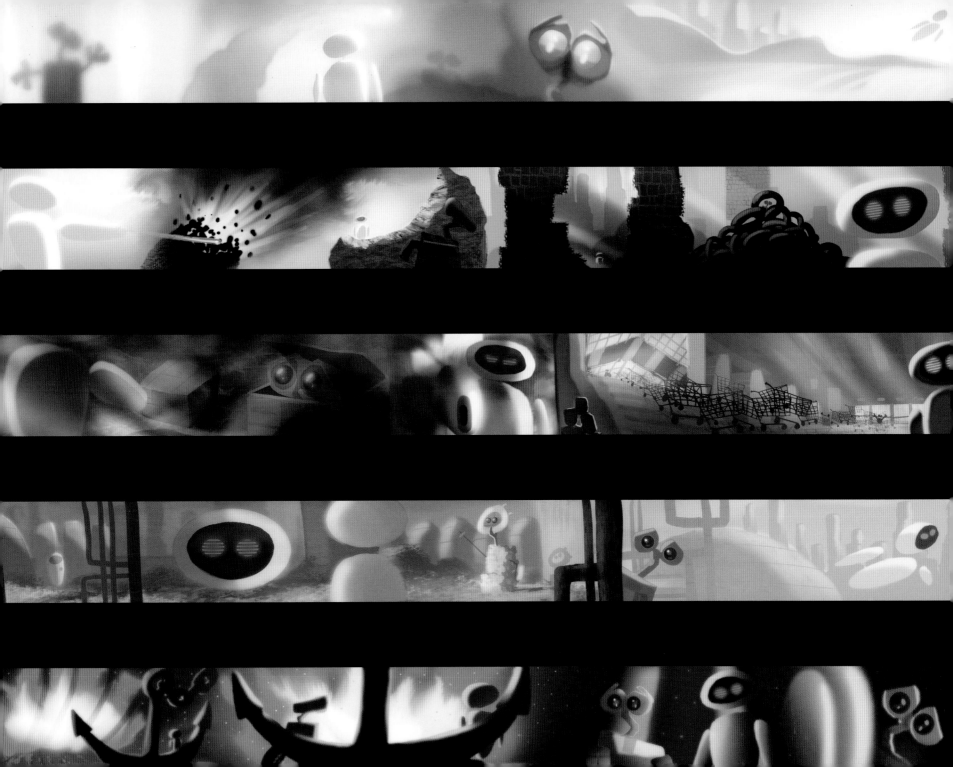

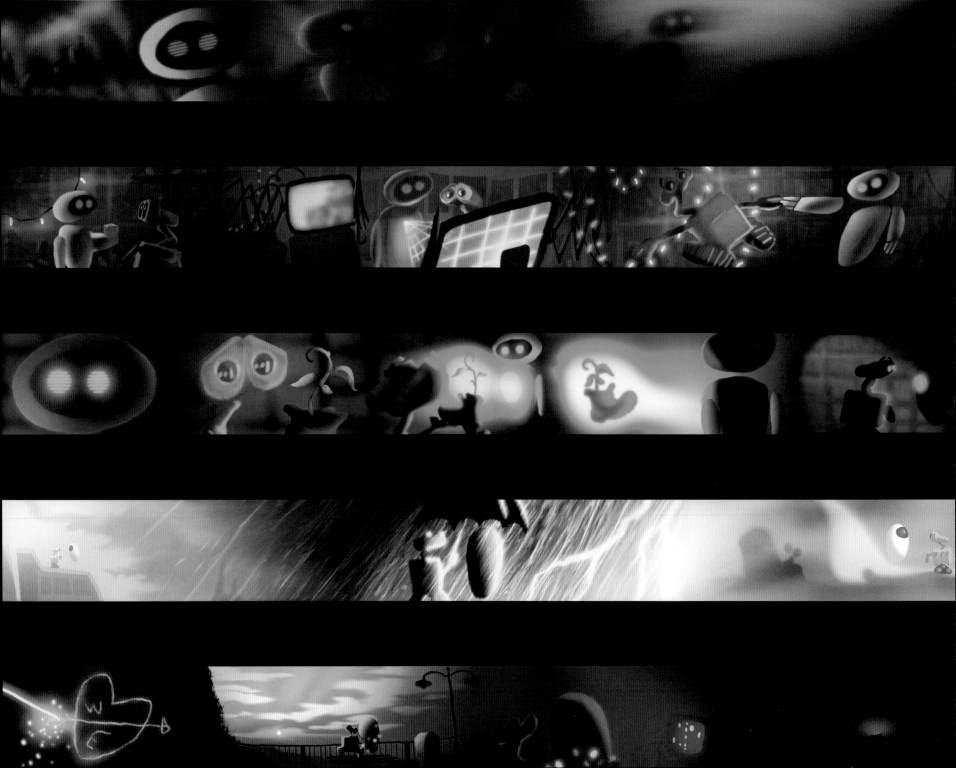

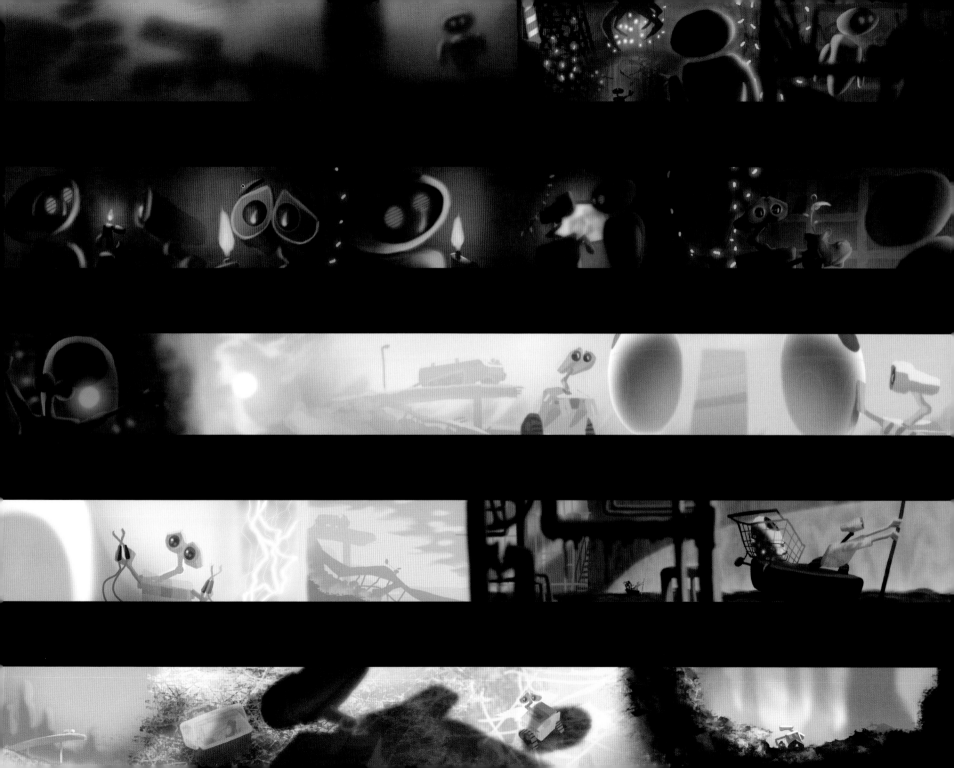

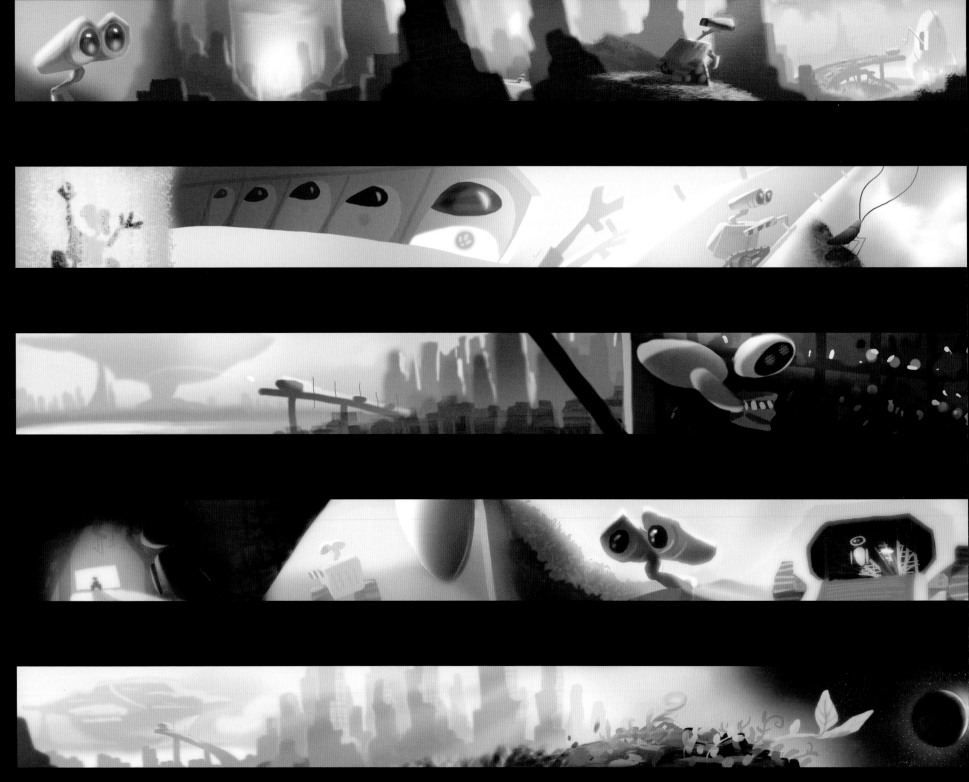

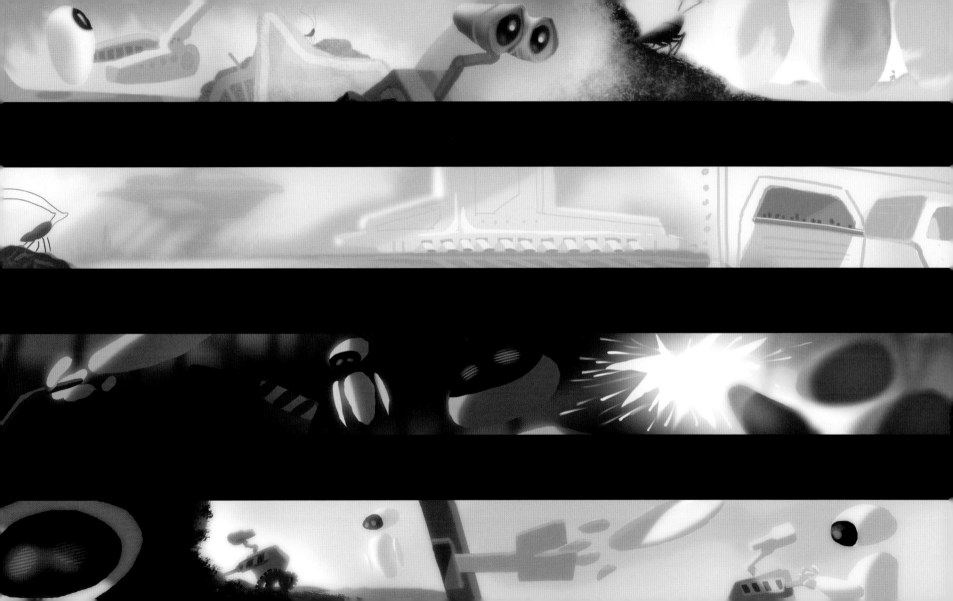

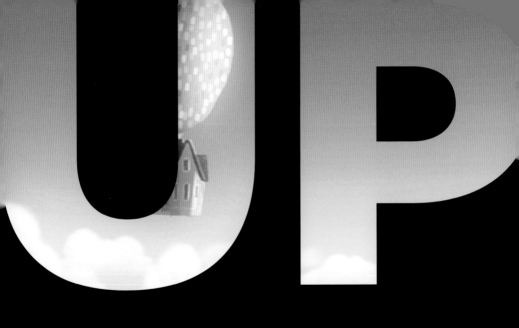

Lou Romano Digital 2008

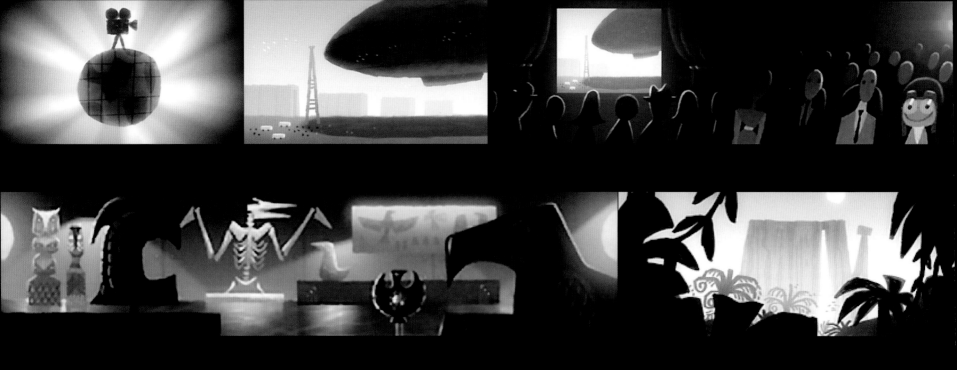

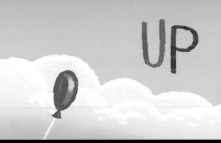
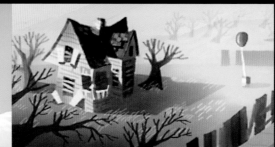
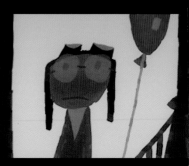

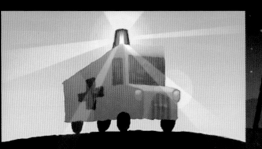
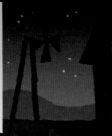
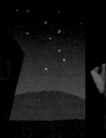

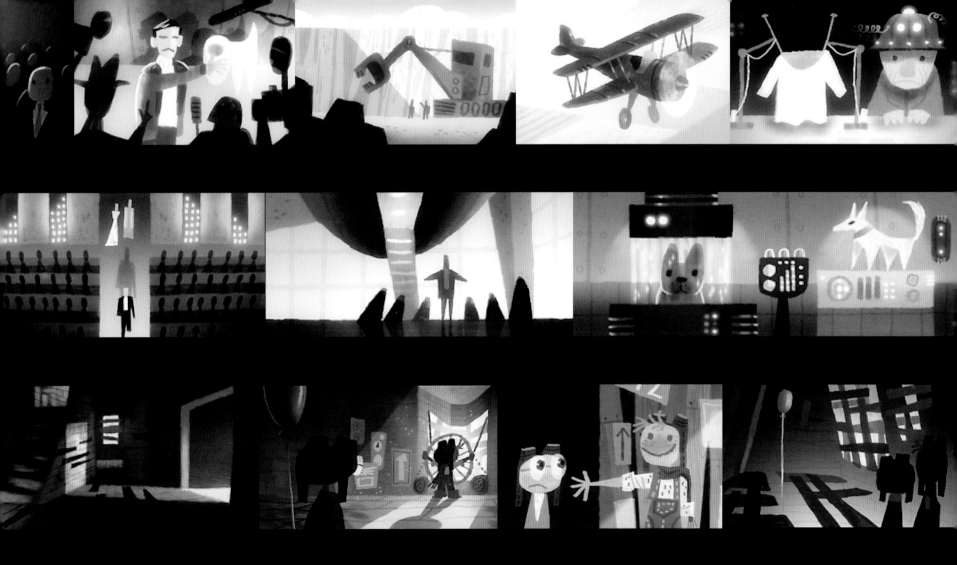

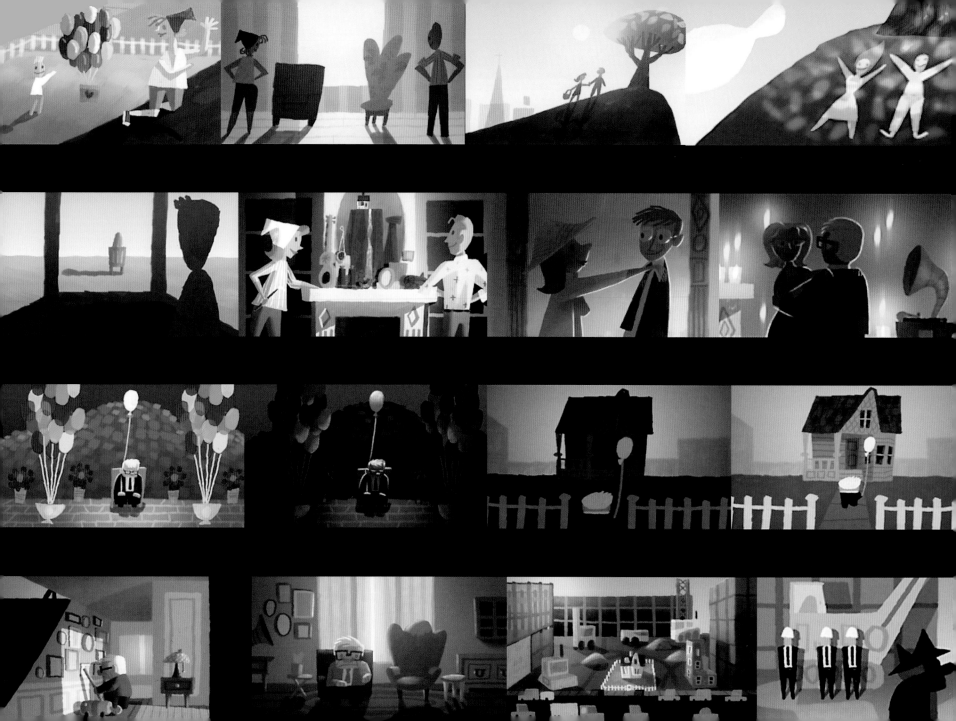

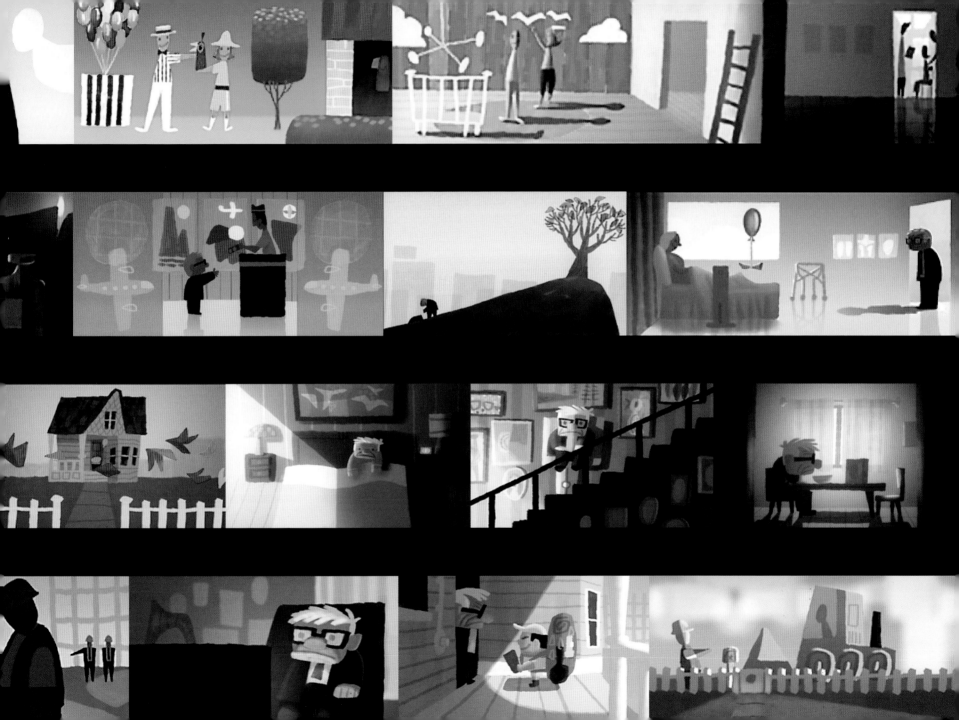

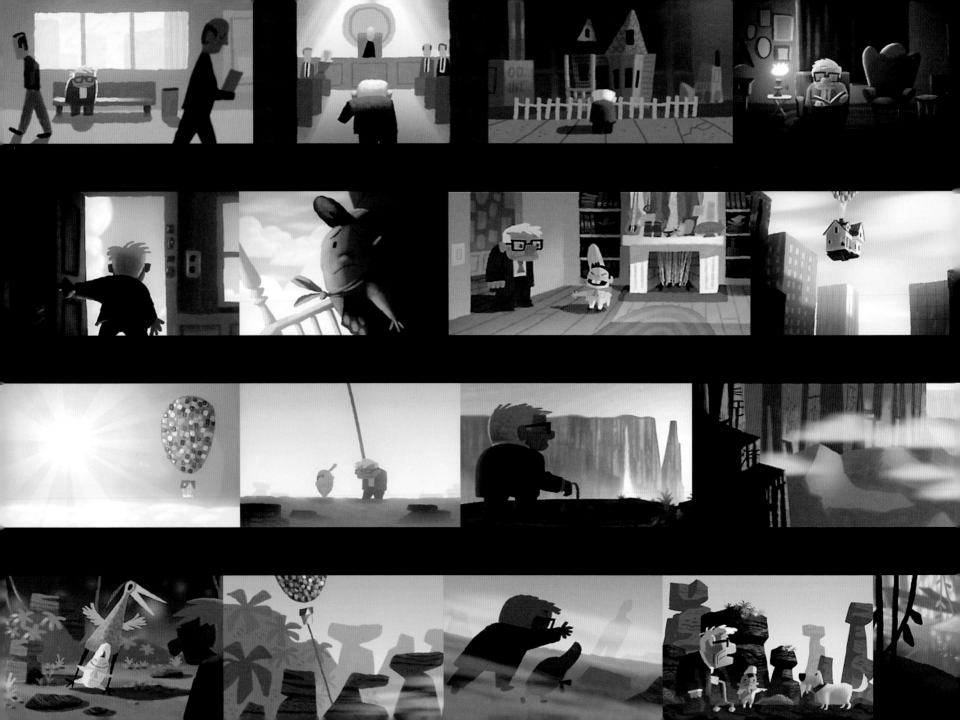

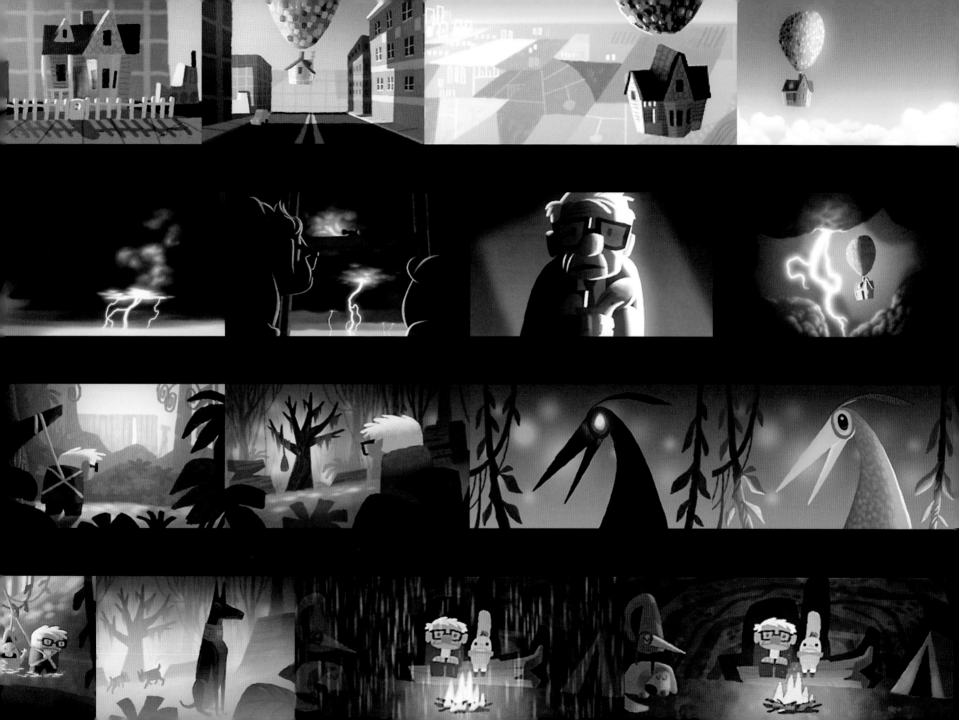

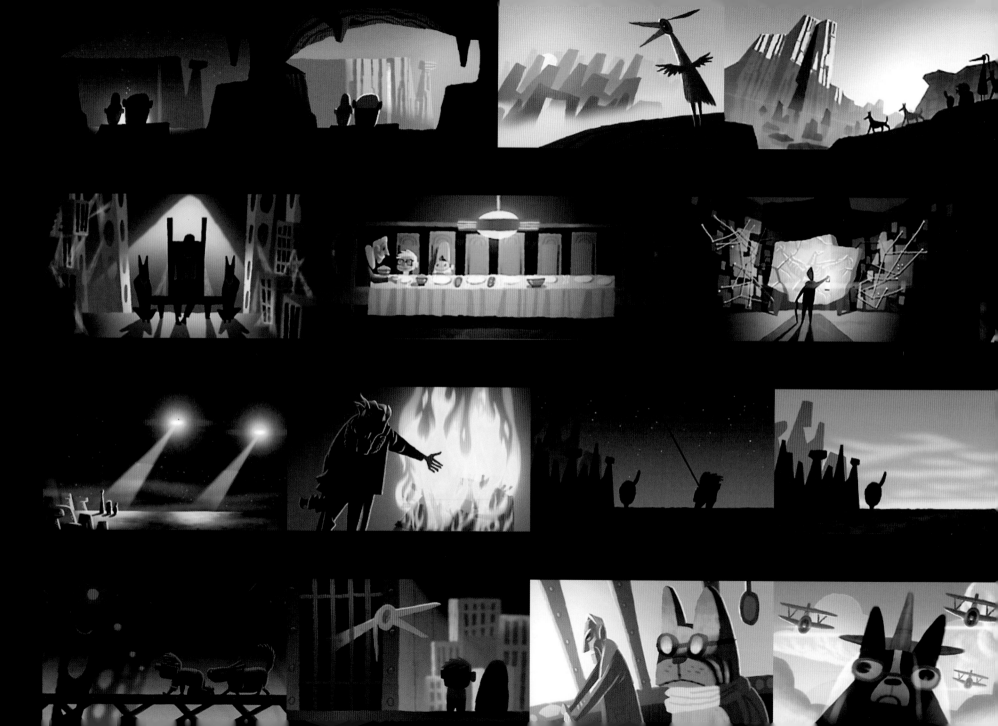

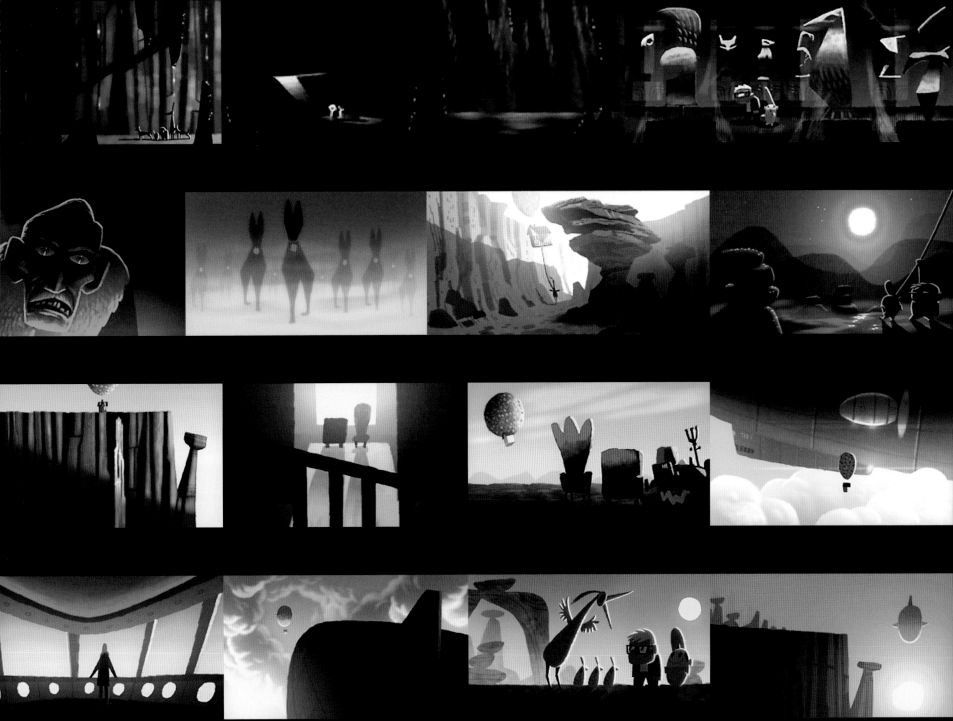

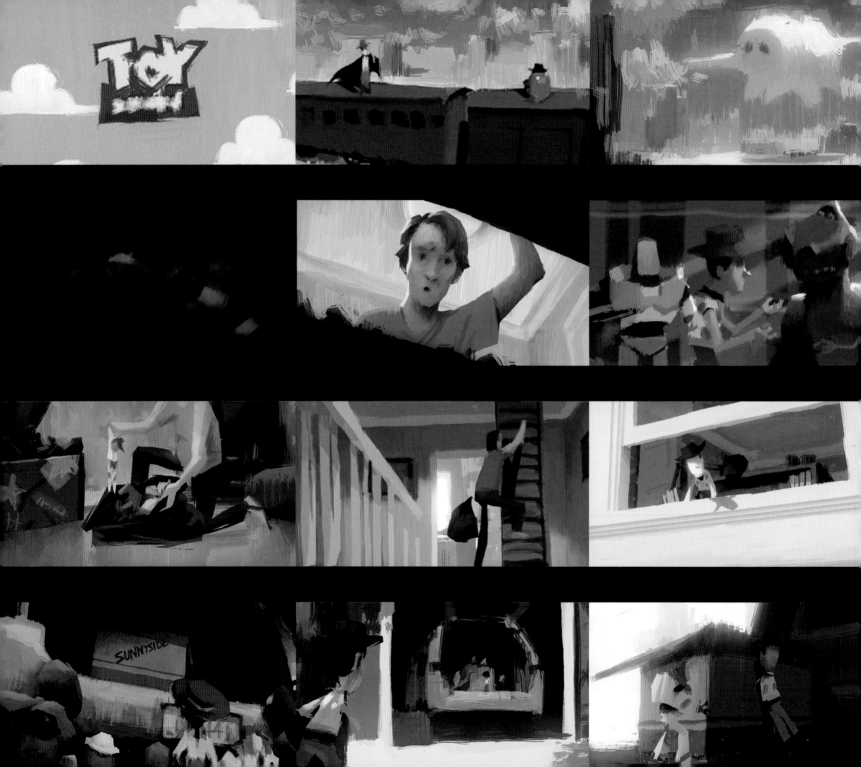

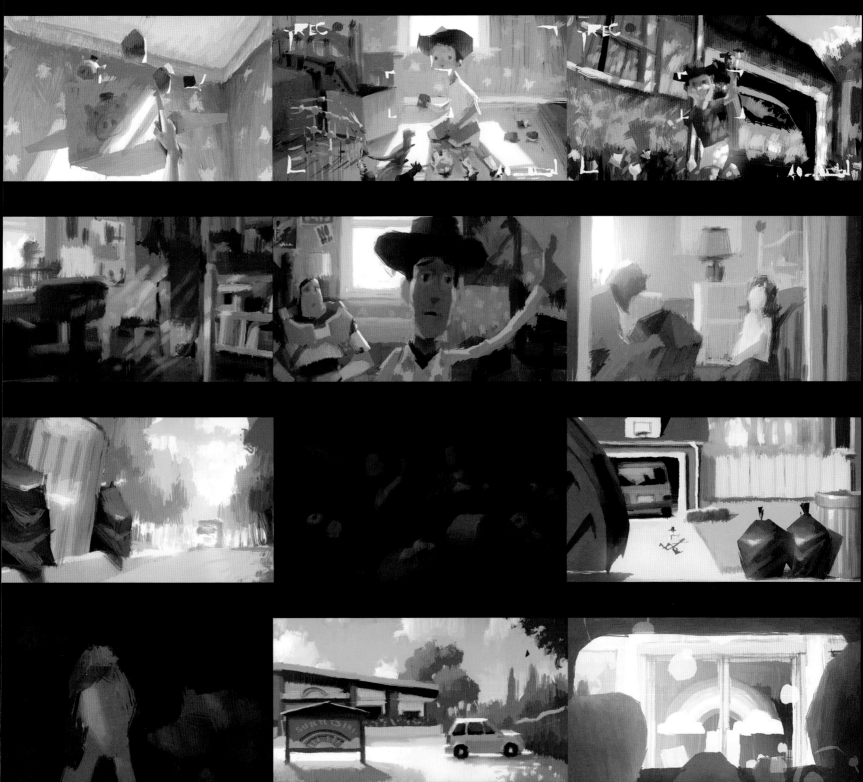

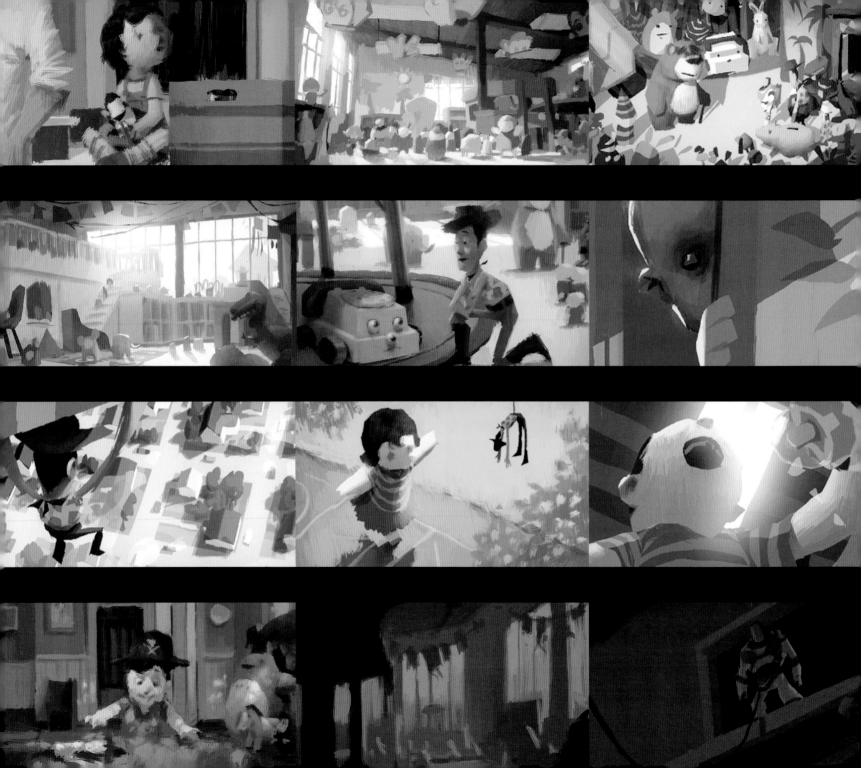

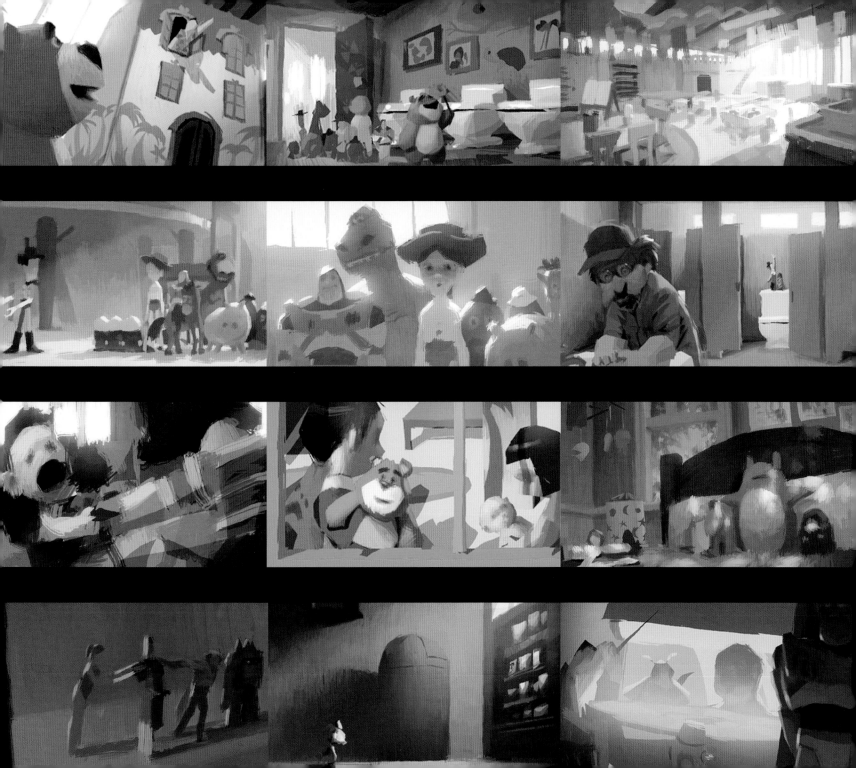

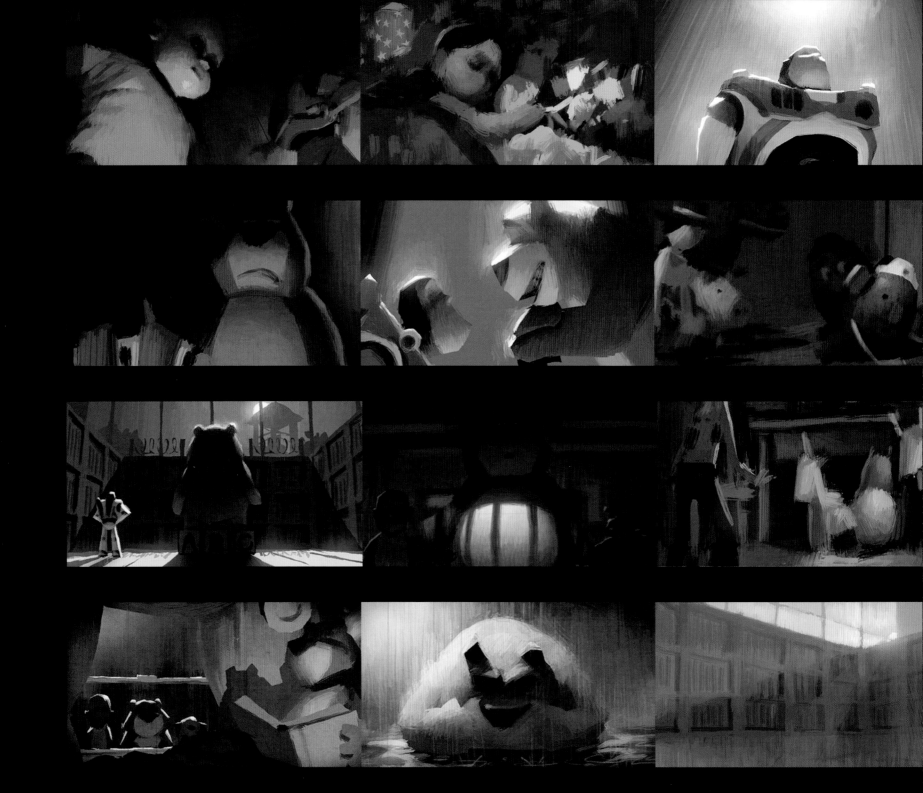

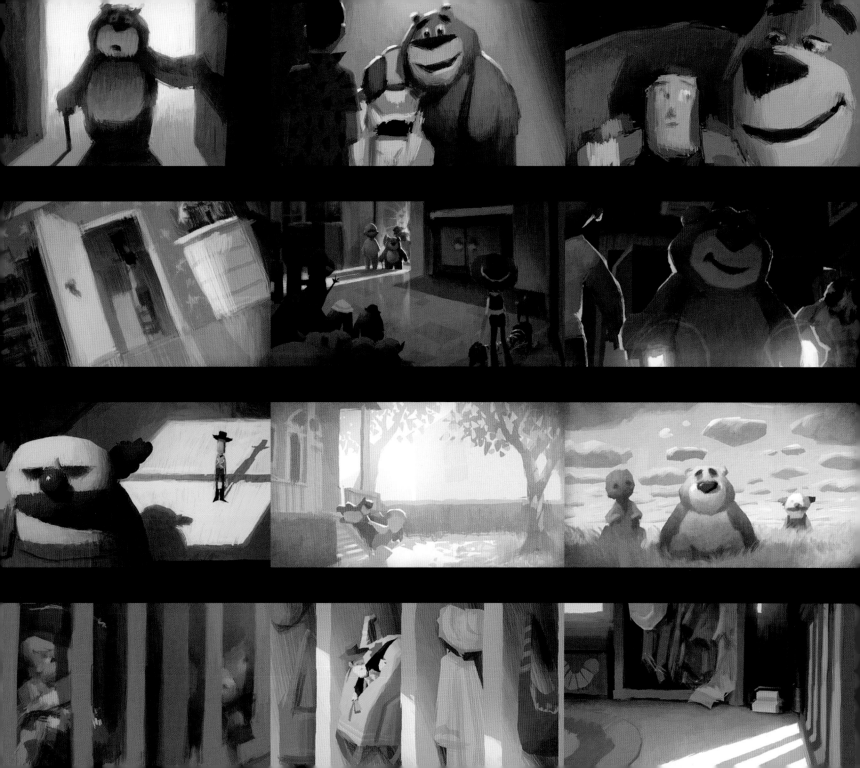

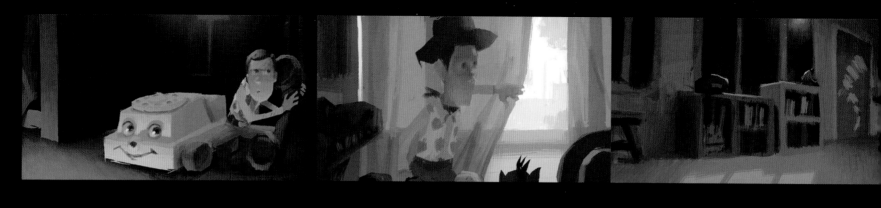
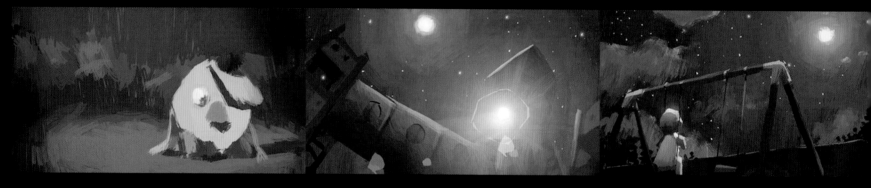
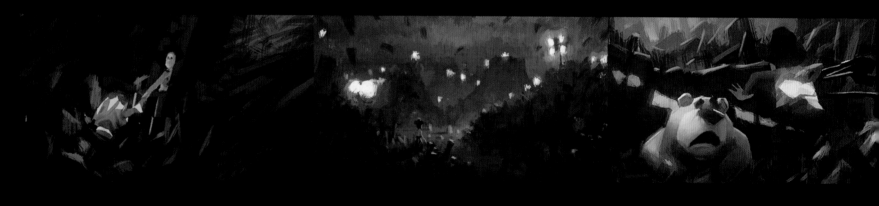

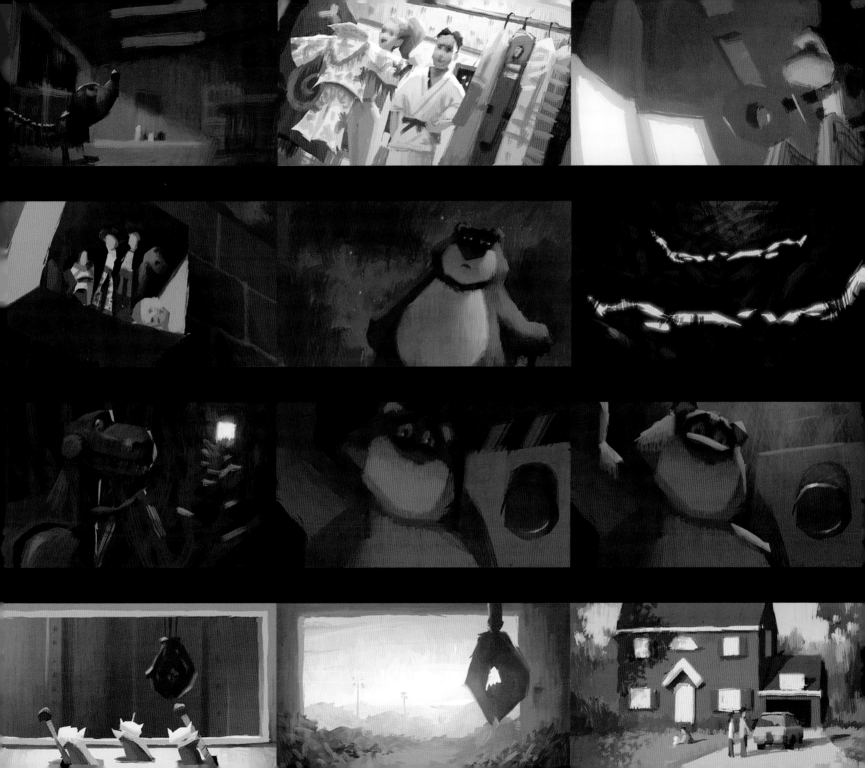

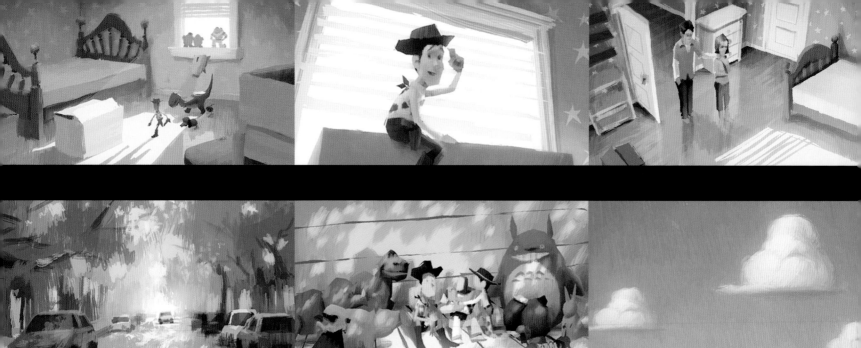

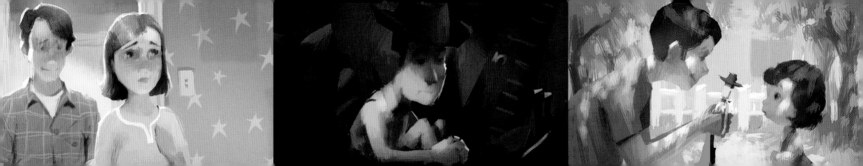

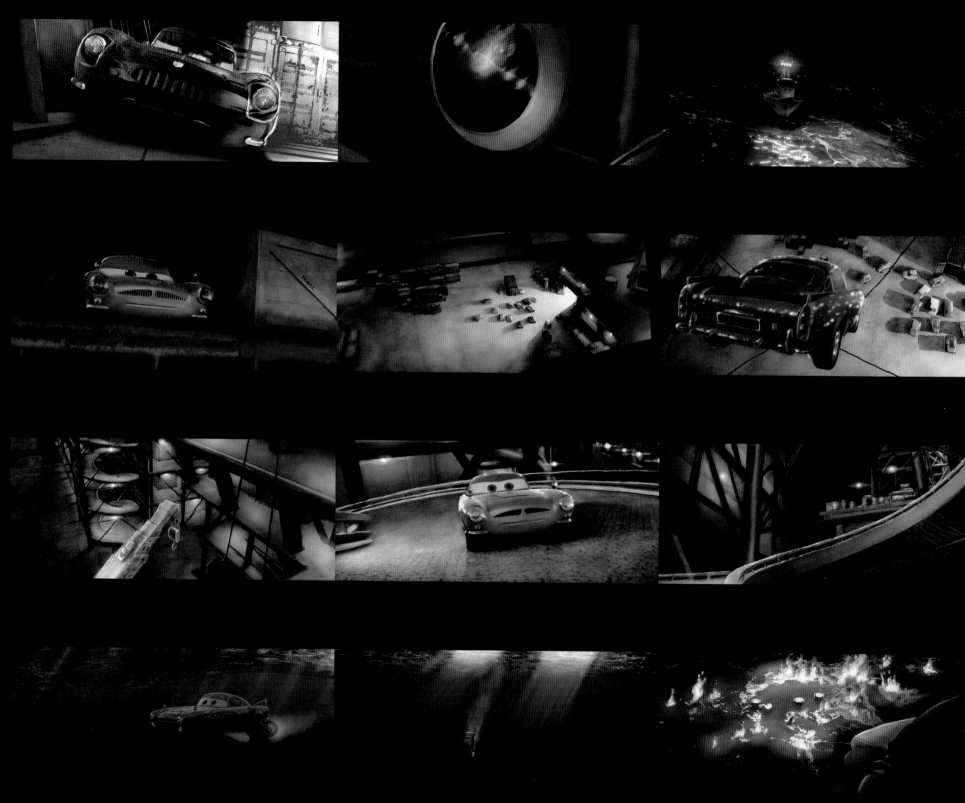

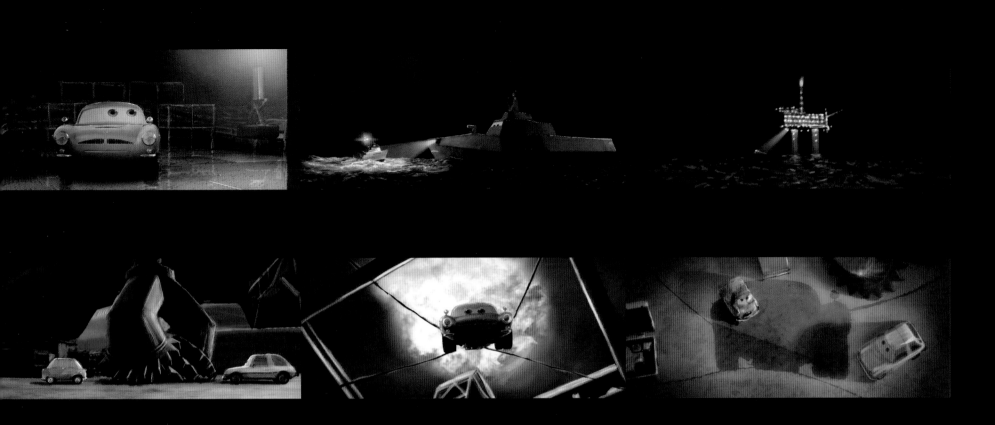

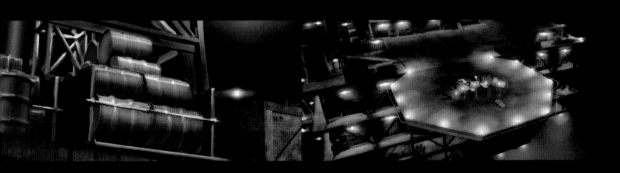

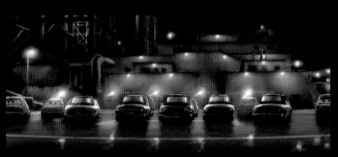

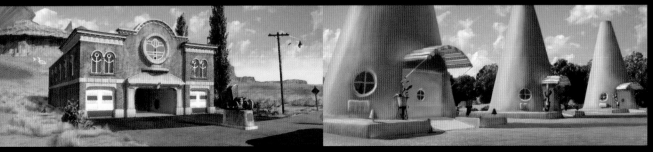

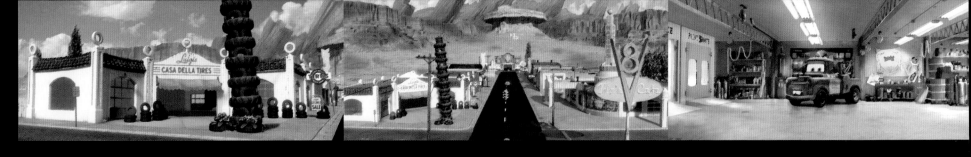

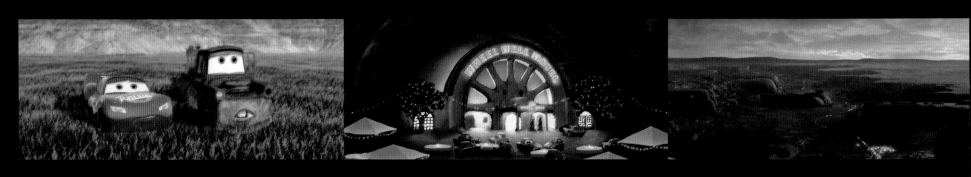

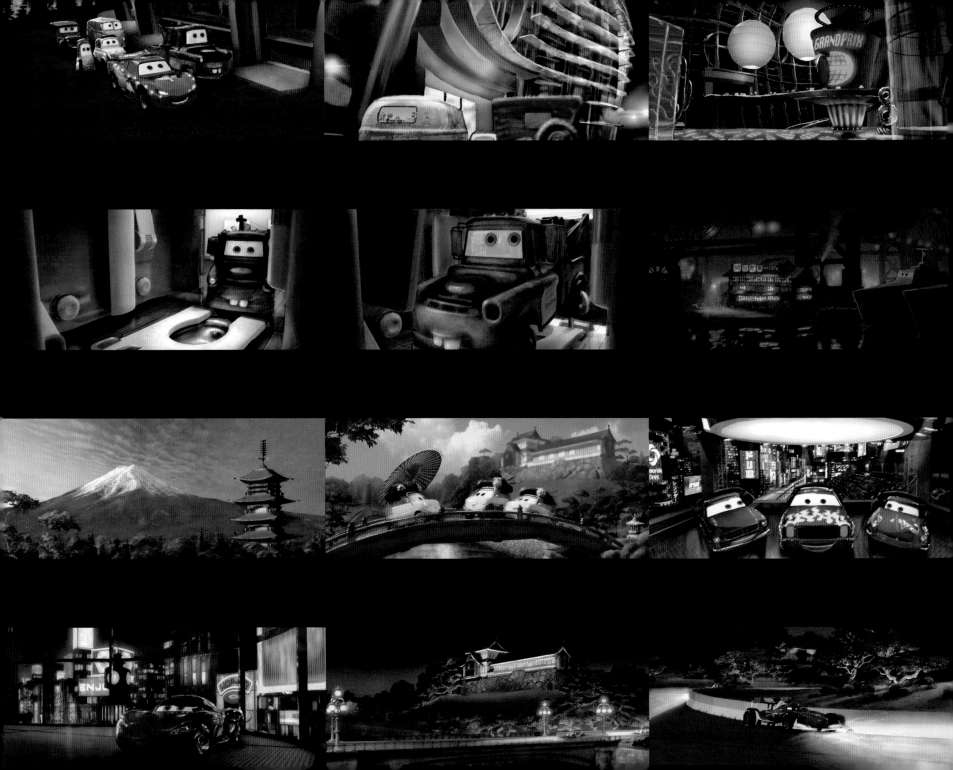

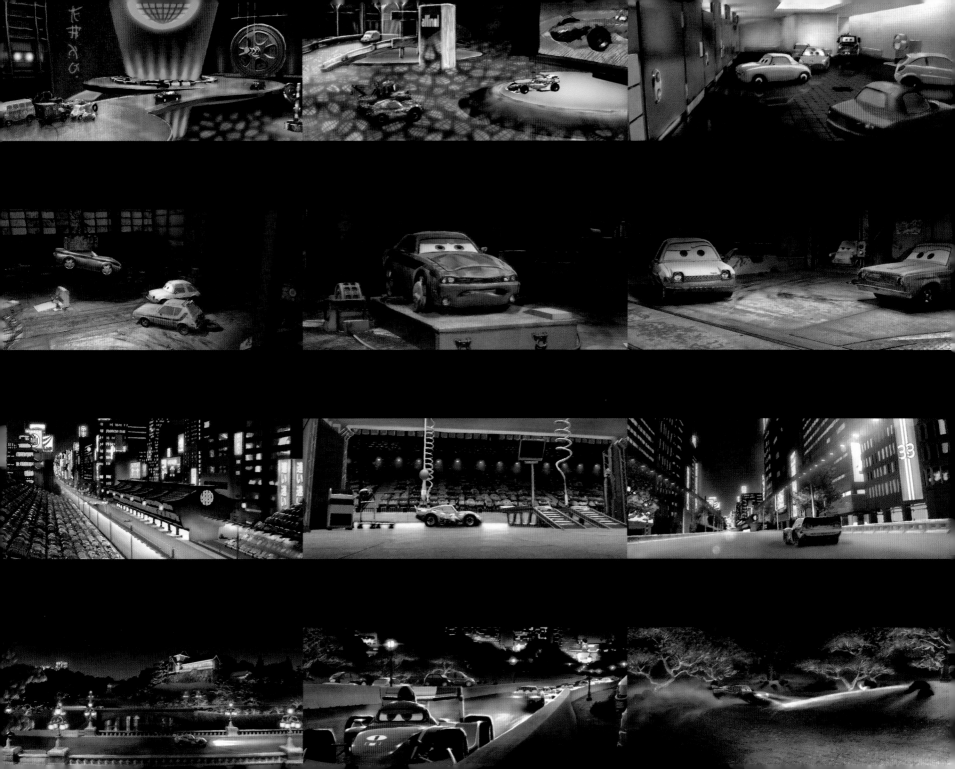

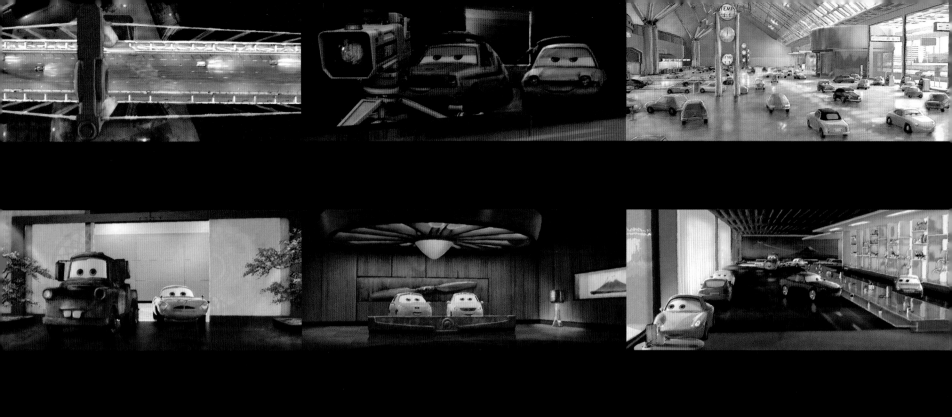

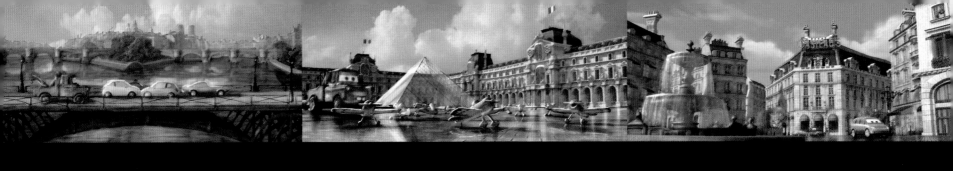

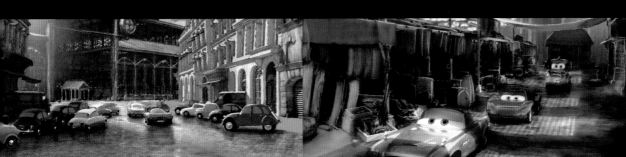

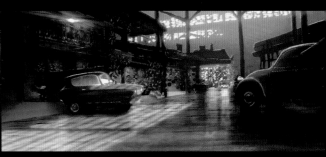

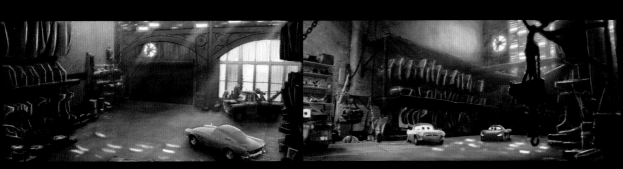

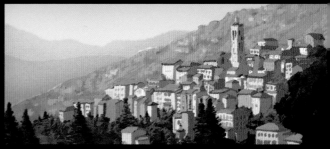

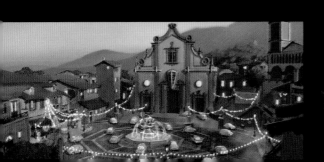

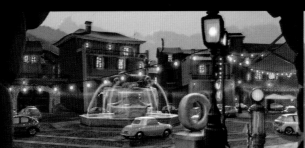

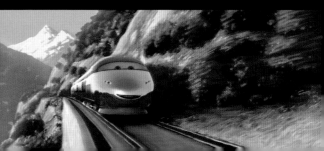

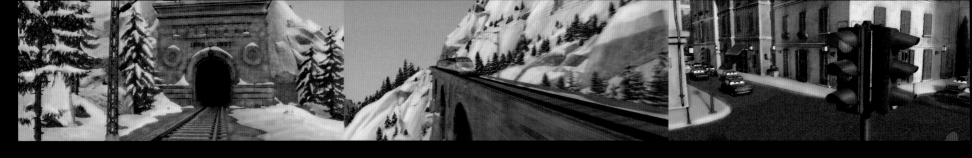

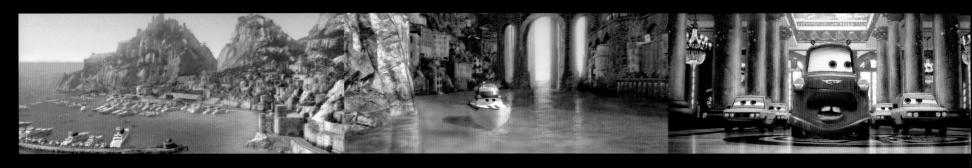

This chapter features available colorscripts from Pixar's original and feature-based short films. Due to production schedules, colorscripts are not created for all the feature short films, and some are incomplete due to time constraints.

BOUNDIN'

Dominique R. Louis, Digital, 2002

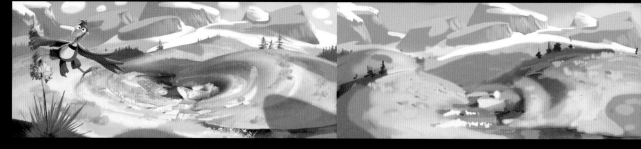

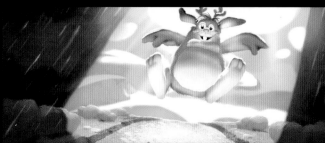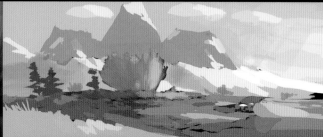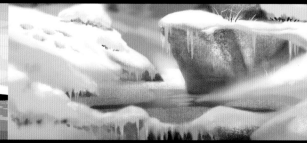

MATER AND THE GHOSTLIGHT

Bill Cone, Pastel, 2005

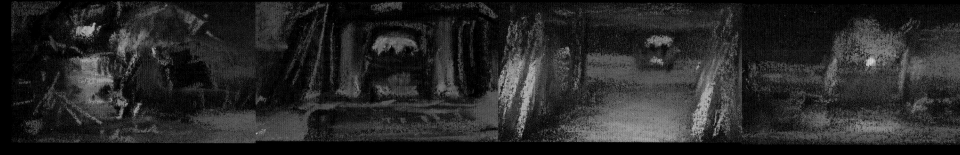

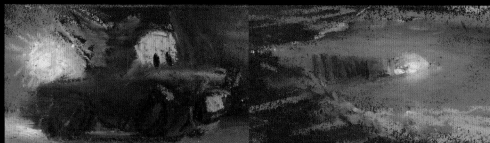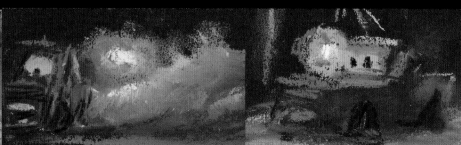

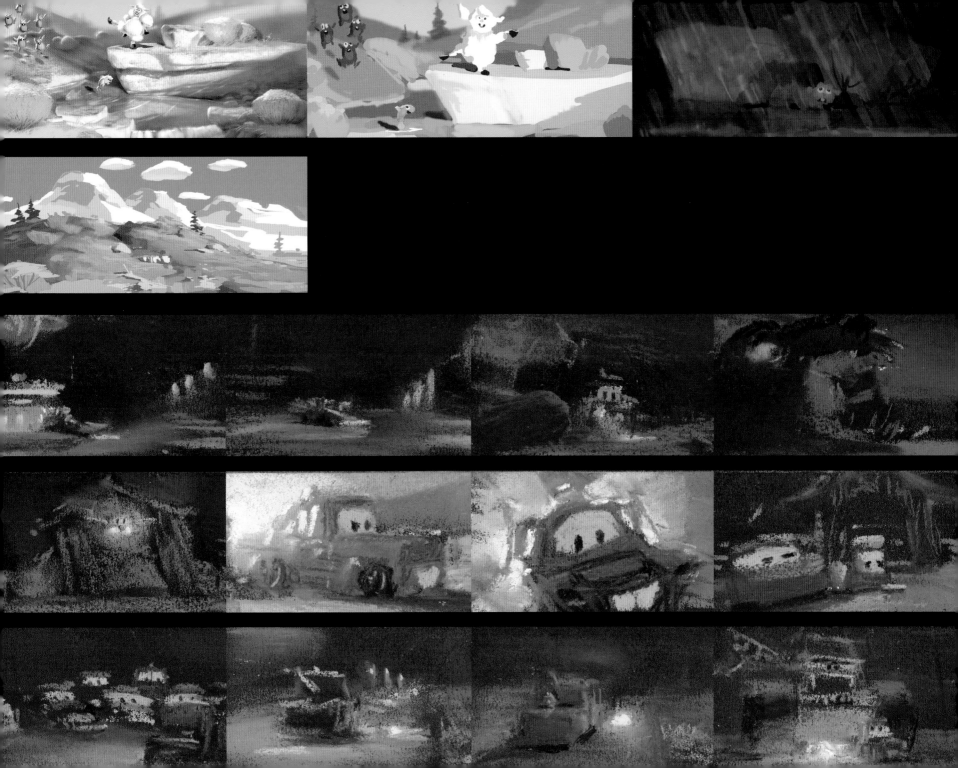

JACK-JACK
ATTACK

Lou Romano, Digital, 2004

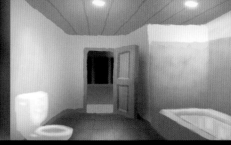

PRESTO

Harley Jessup, Digital, 2007

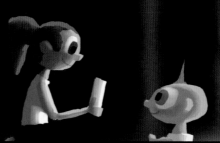

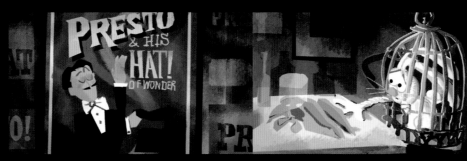
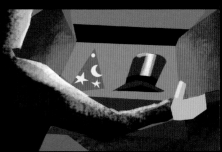

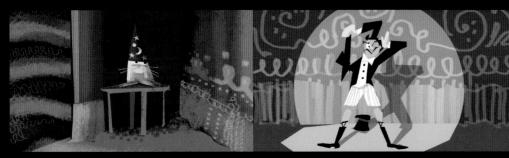
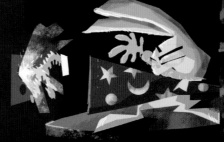

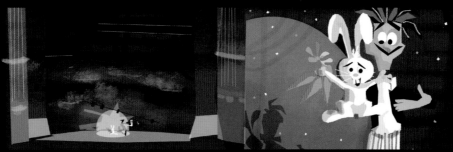

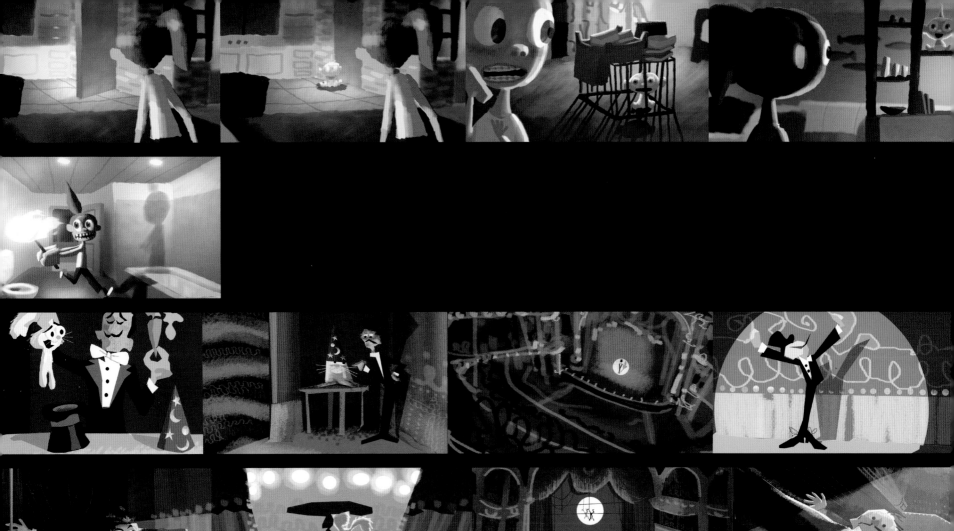

LIFTED

Mark Holmes, Digital, 2005

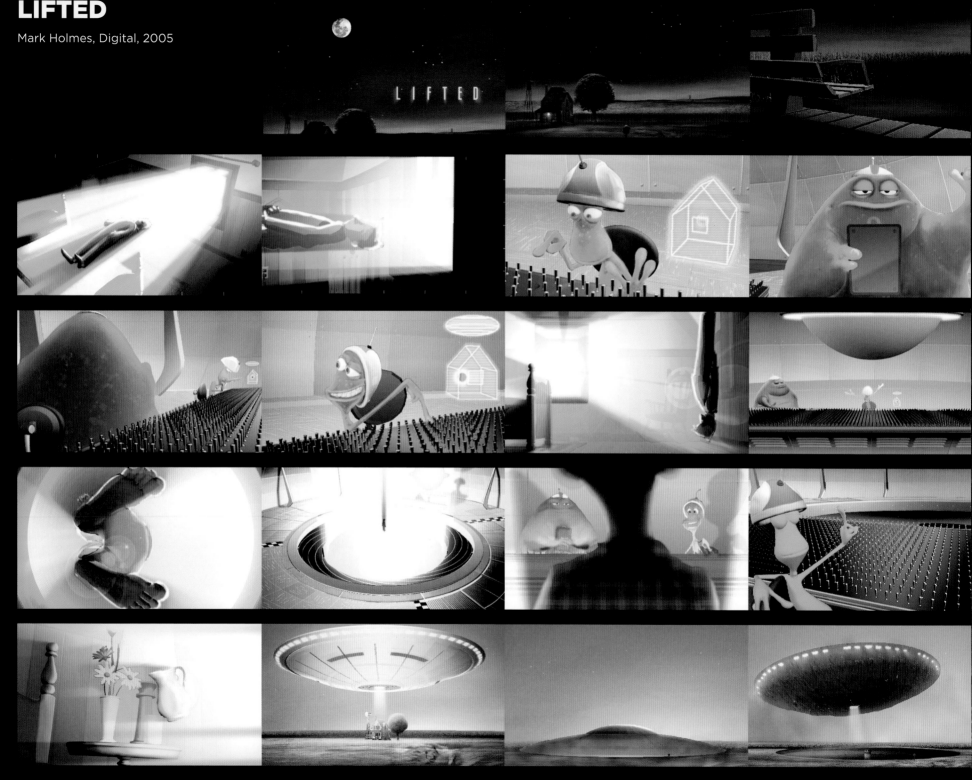

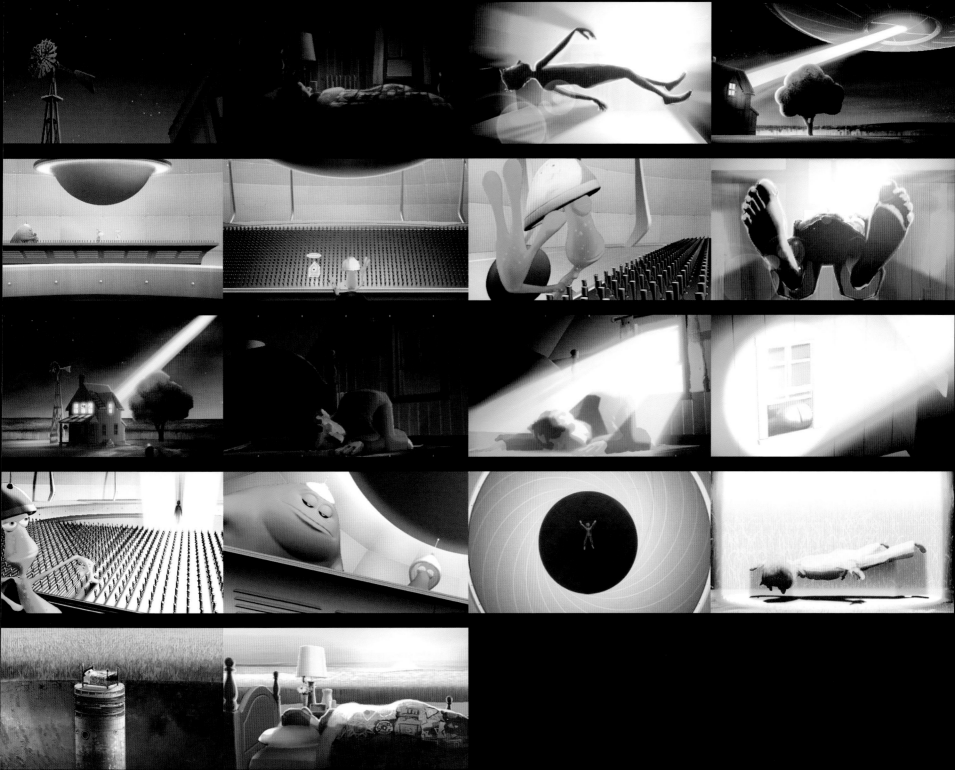

YOUR FRIEND THE RAT

Nate Wragg, Layout by Jim Capobianco and Jeff Pidgeon, Mixed media, 2006

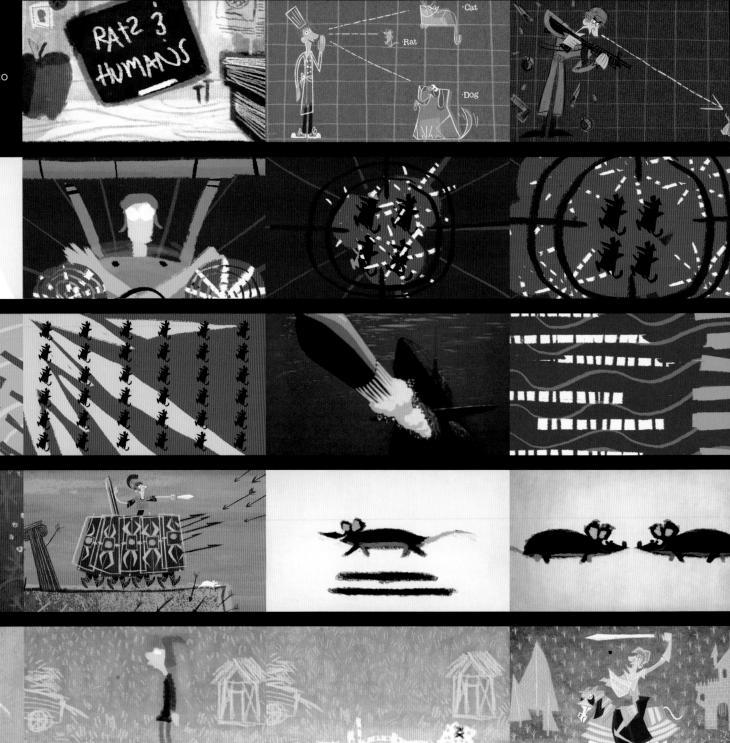

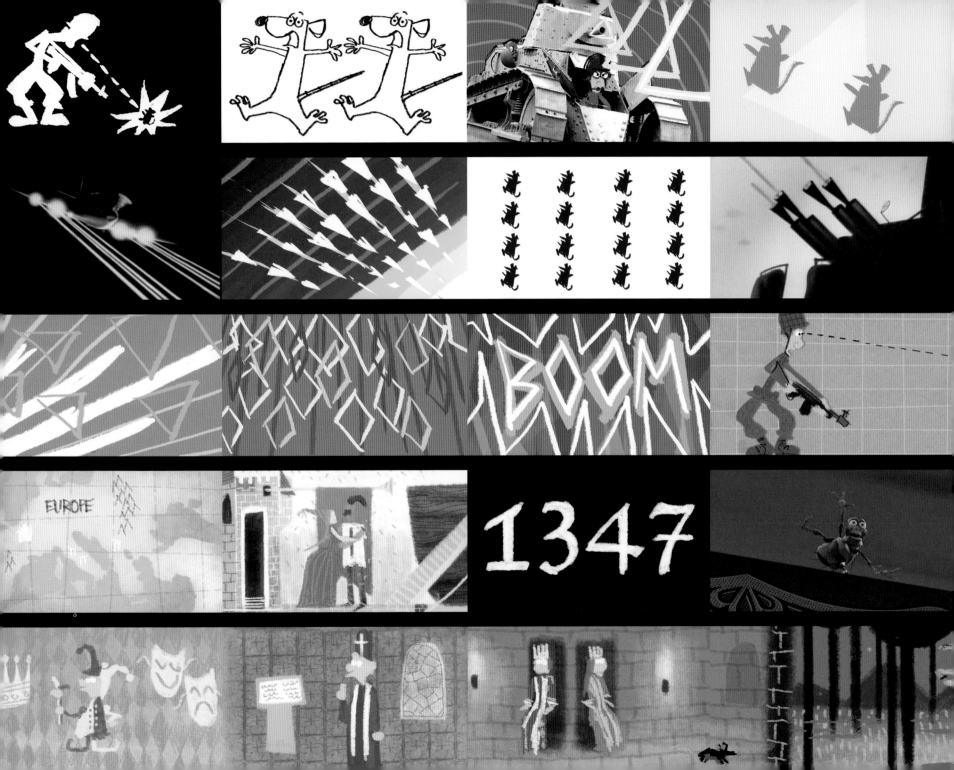

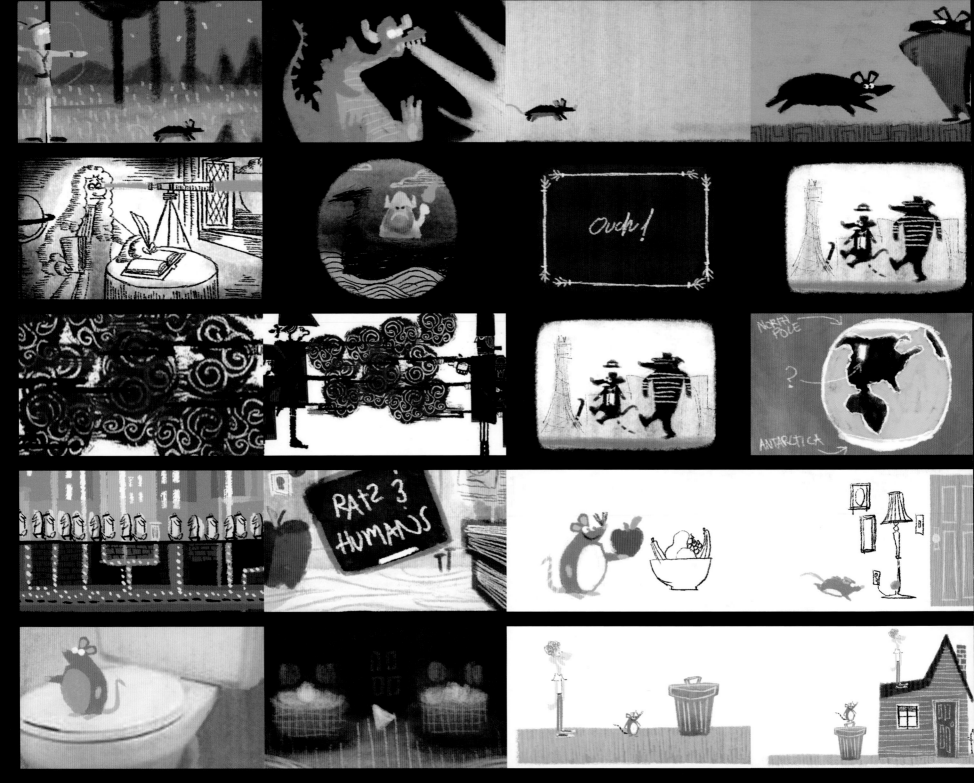

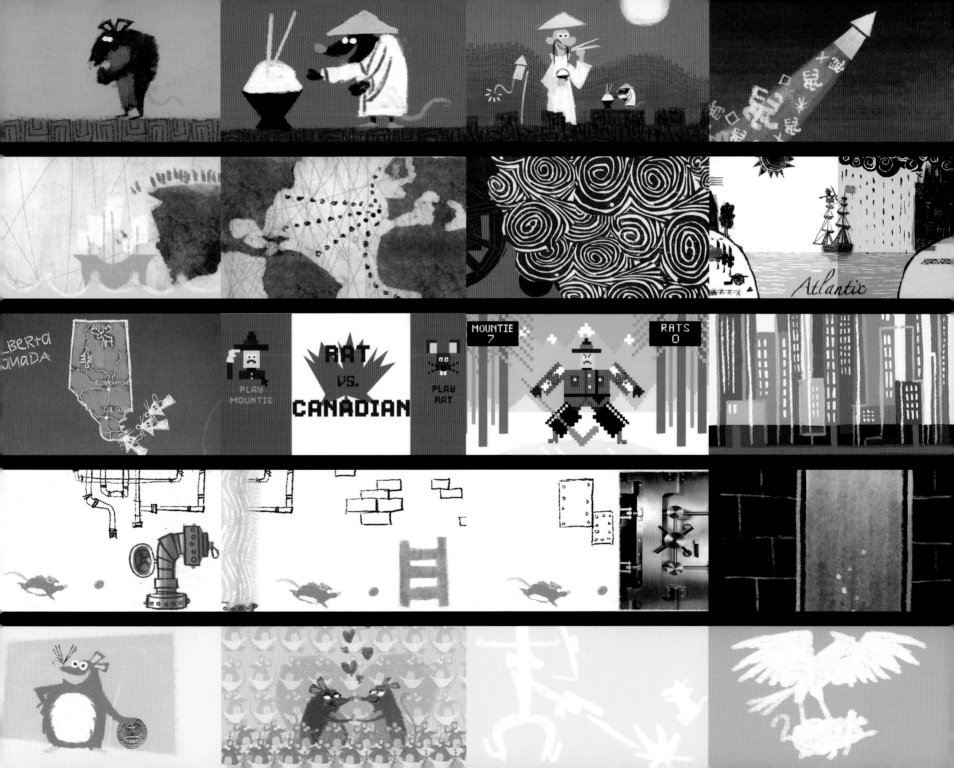

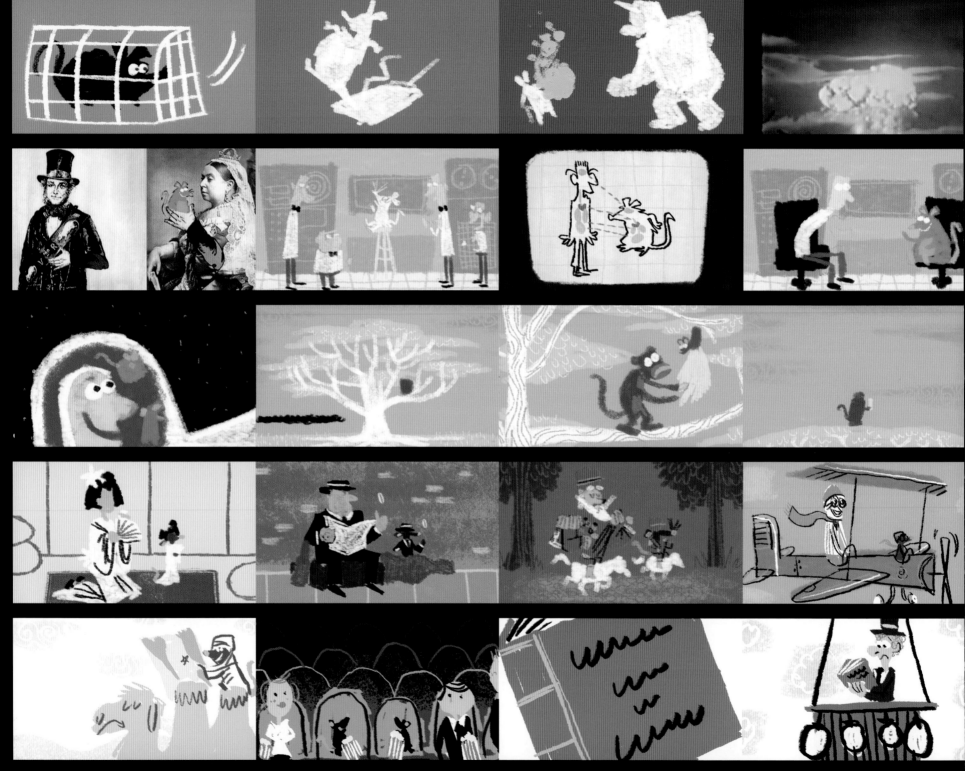

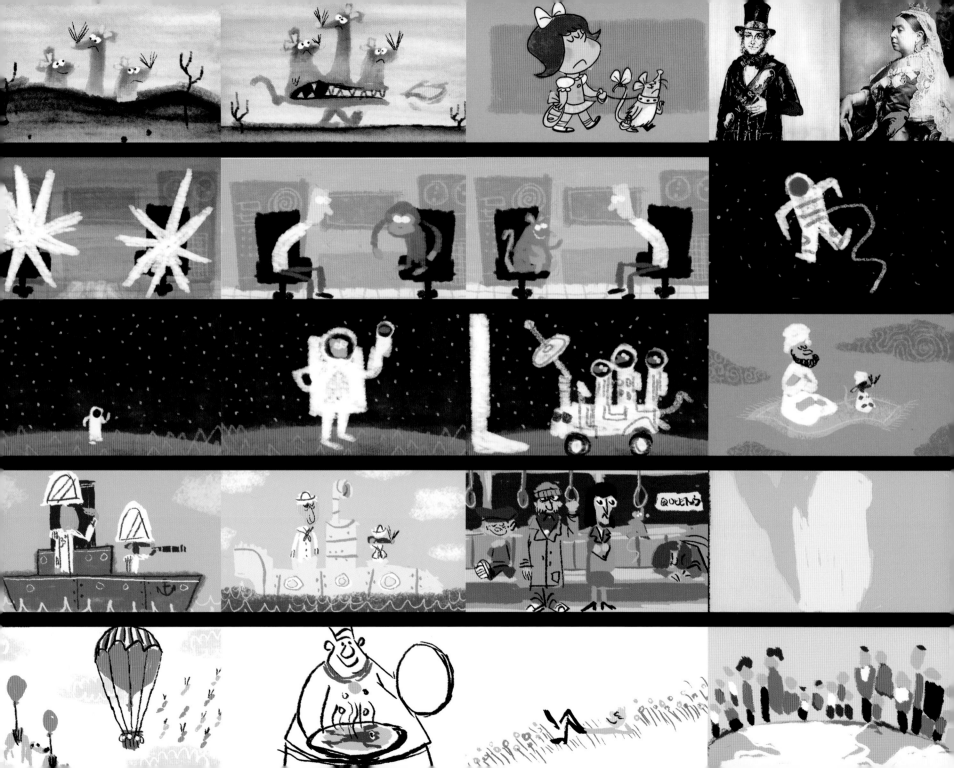

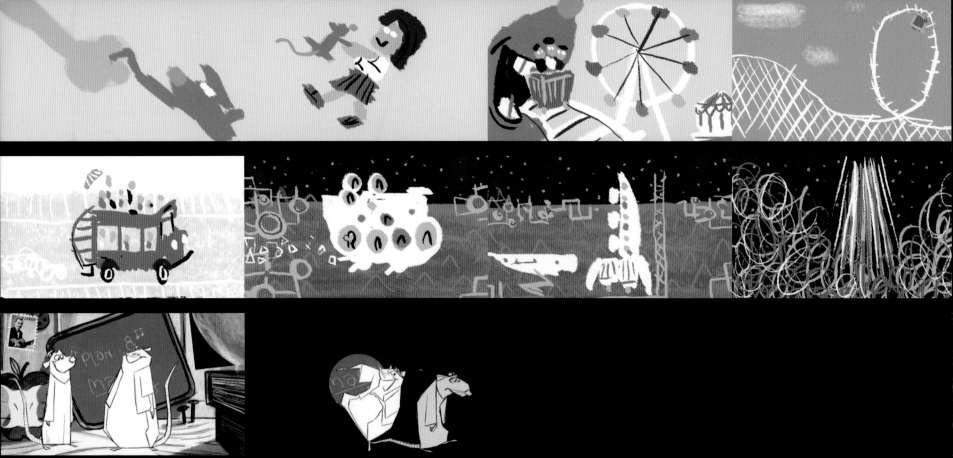

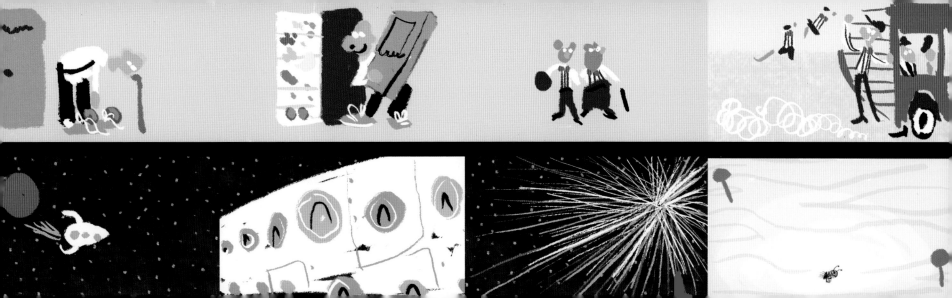

BURN·E

John Lee, Digital, 2008

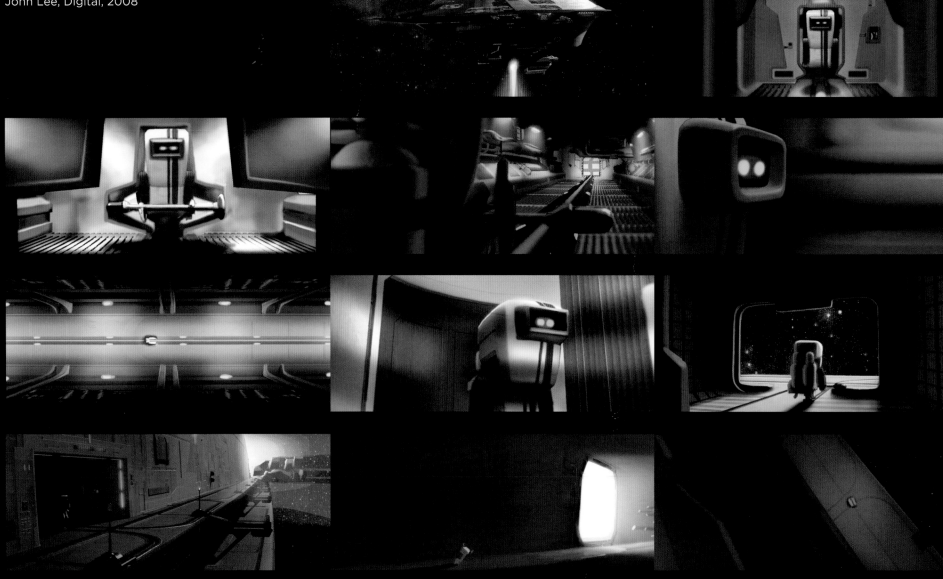

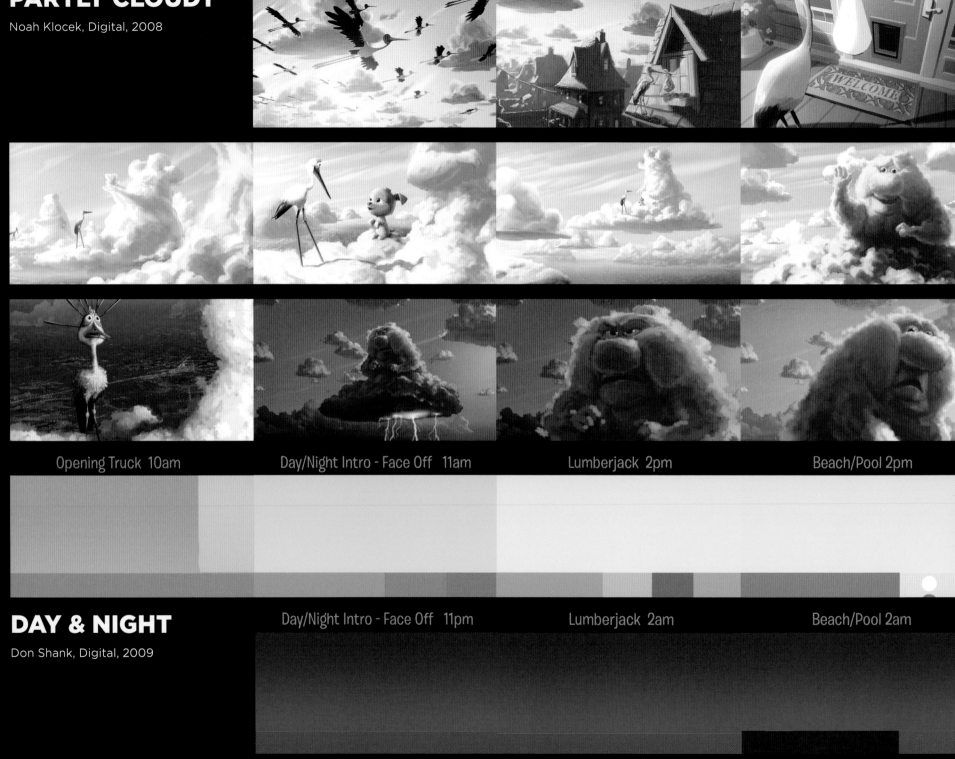

PARTLY CLOUDY
Noah Klocek, Digital, 2008

Opening Truck 10am

Day/Night Intro - Face Off 11am

Lumberjack 2pm

Beach/Pool 2pm

Day/Night Intro - Face Off 11pm

Lumberjack 2am

Beach/Pool 2am

DAY & NIGHT
Don Shank, Digital, 2009

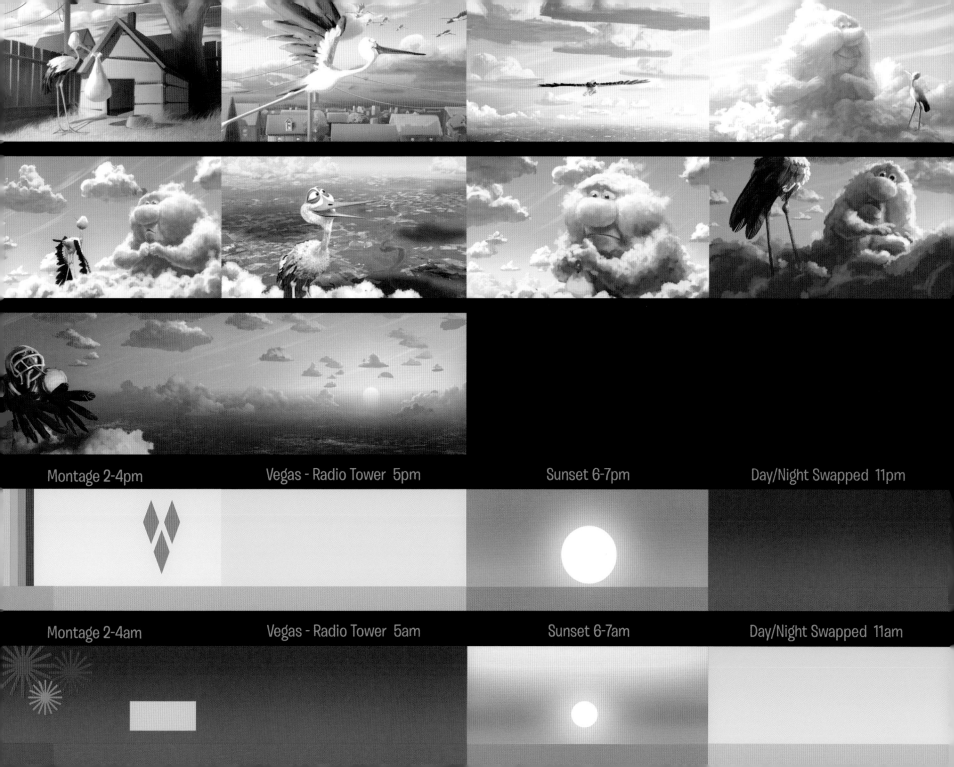

Montage 2-4pm

Vegas - Radio Tower 5pm

Sunset 6-7pm

Day/Night Swapped 11pm

Montage 2-4am

Vegas - Radio Tower 5am

Sunset 6-7am

Day/Night Swapped 11am

RESCUE SQUAD MATER

Sharon Calahan, Digital, 2008

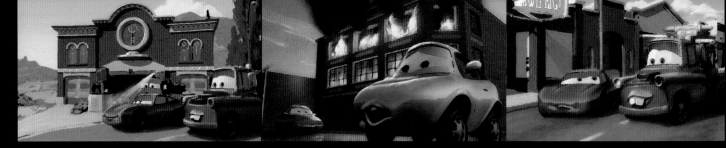

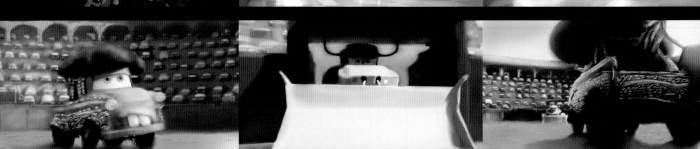

EL MATERDOR

Erik Smitt, Digital, 2008

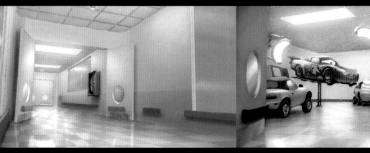

HEAVY METAL MATER

Anthony Christov, Digital, 2009

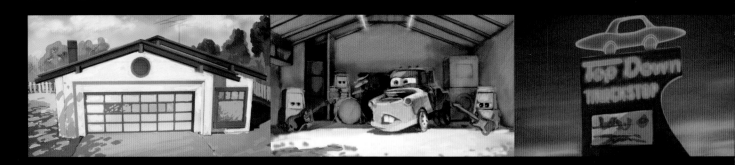

AIR MATER

Bill Cone, Pastel, 2011

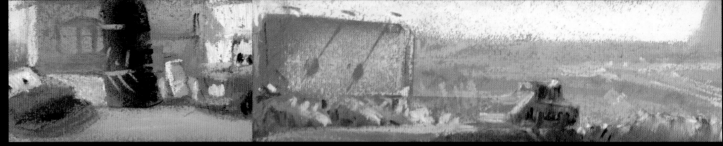

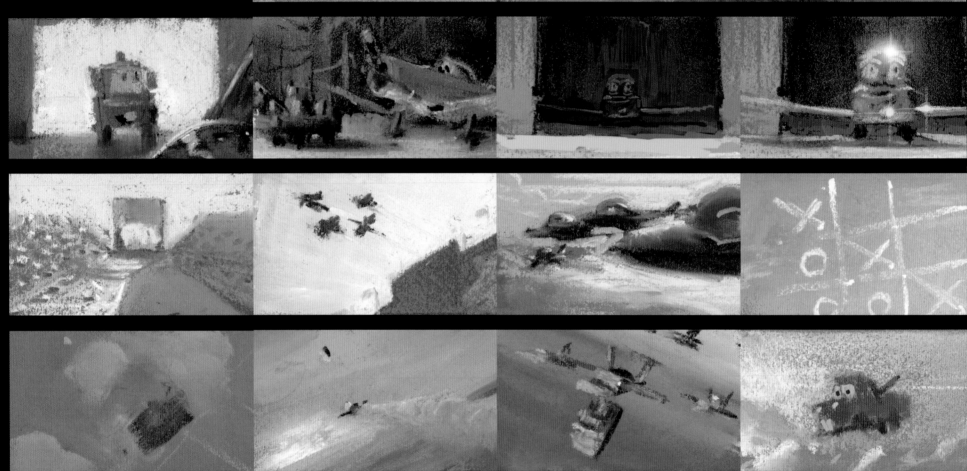

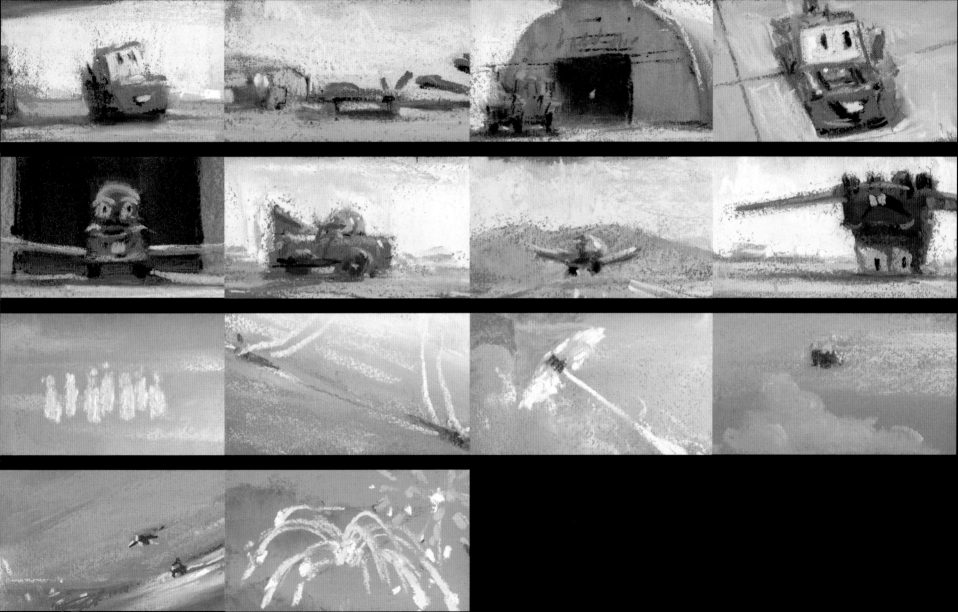

HAWAIIAN VACATION

Ralph Eggleston, Digital, 2010

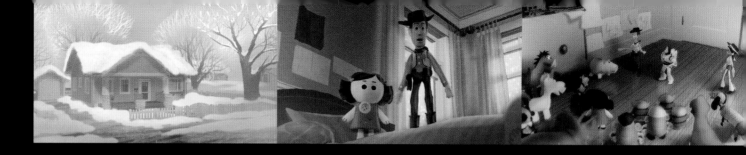
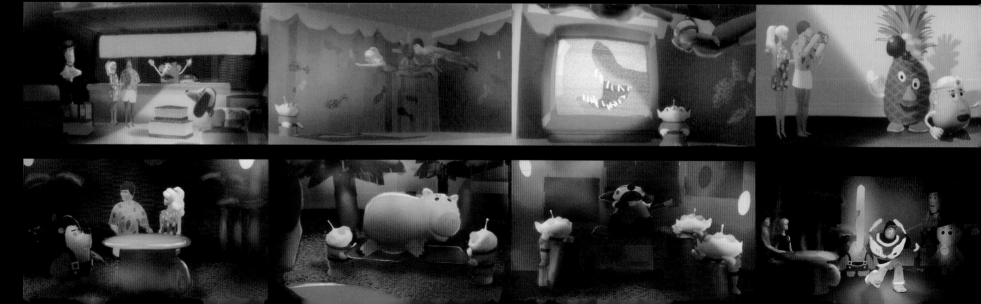

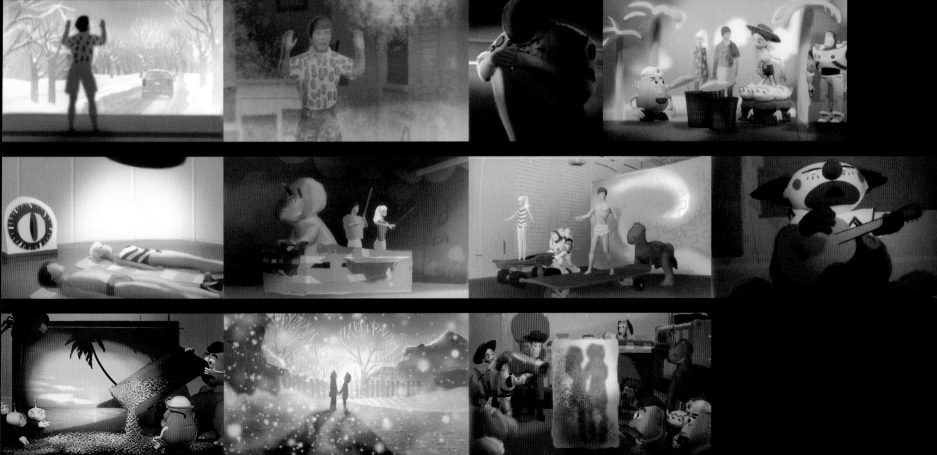

LA LUNA

Bill Cone, Pastel and digital, 2010

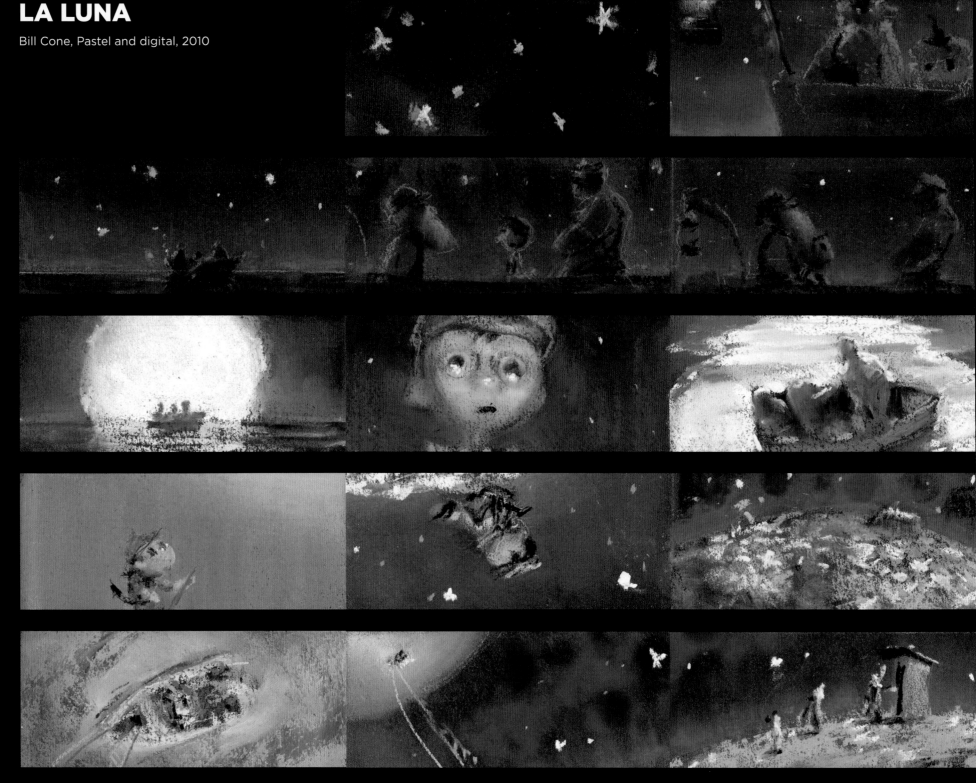

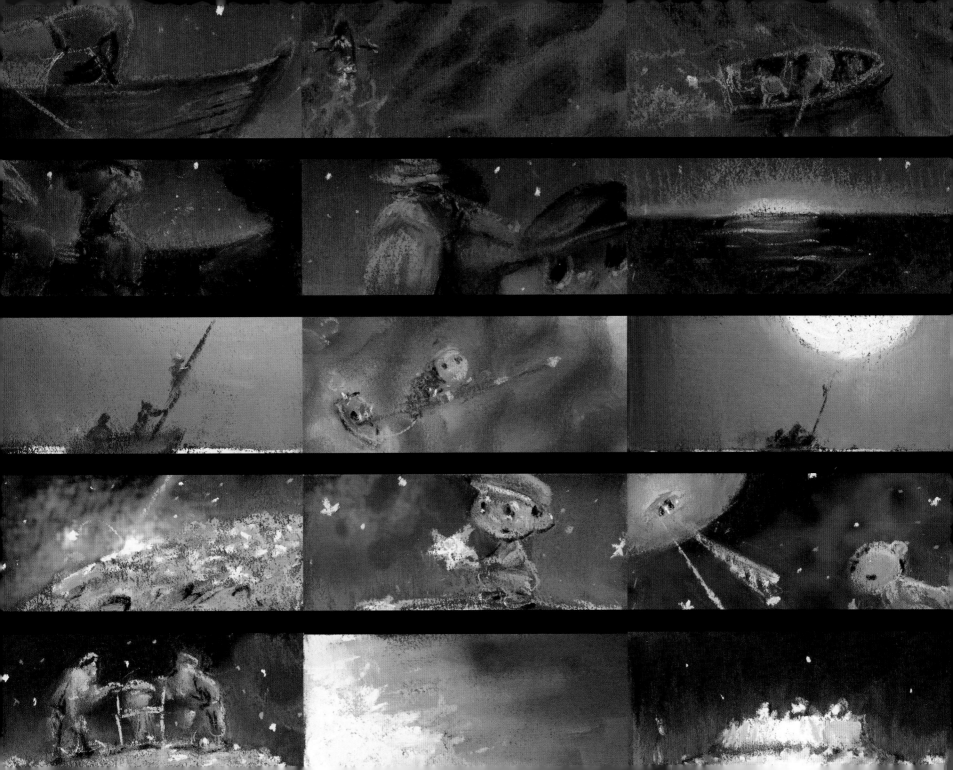

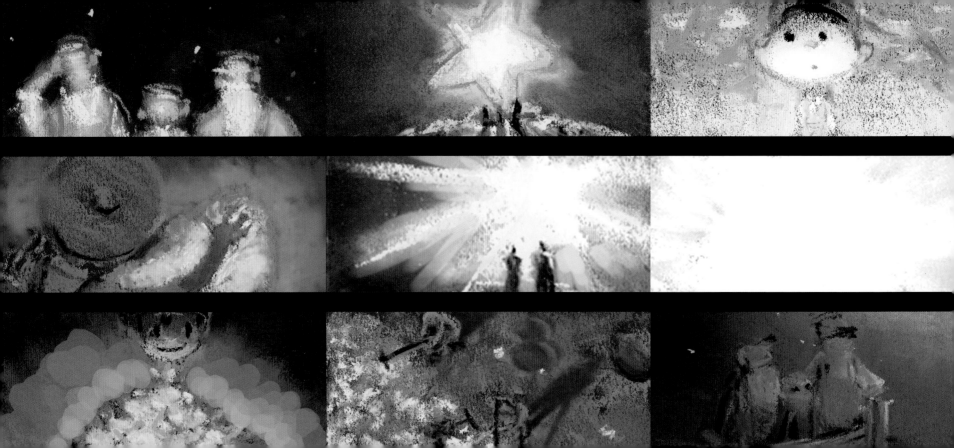

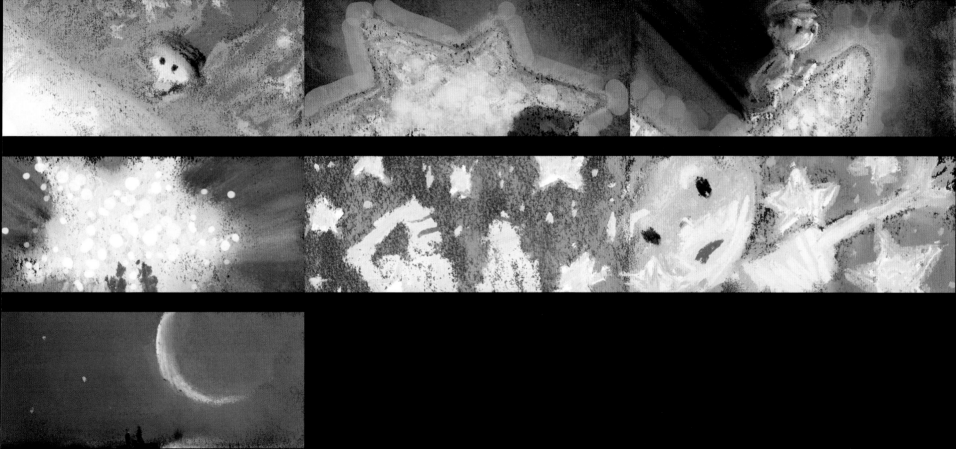

ORLDS

A gallery of visual development art, 1994–2010

With more than a decade's worth of service to the company, Christine Freeman is the longest-employed member of the five-person team of archivists who care for the Pixar Living Archives, Pixar's collection of production artwork, documents, and historical artifacts. The exact number of items held in the archives is not known but is estimated to be over one million pieces and growing.

Most of those million pieces originate from the art and story departments at Pixar, which create tens of thousands of pieces of artwork for every feature film. Just because a film is created with computer graphics doesn't mean that a computer produces the entire film. Artists conceive of every stage of the film long before the first mouse button is ever clicked, and they use every imaginable art material to develop their ideas: pencil, marker, acrylic, pastel, gouache, and even clay.

In the early days of animation, the artwork used to create animated films was considered an unremarkable by-product of the filmmaking process. In those days, long before Pixar, the physical art-making materials were considered to be more valuable than anything that could be drawn onto them. Cel washers cleaned the sheets of celluloid onto which characters were inked and painted so that the cels could be reused in the following film. Unwilling to store them, studios routinely burned animation drawings and backgrounds in dumpsters. Disney, which proved savvier than other studios, sold its production cels at Disneyland in the 1950s alongside more conventional offerings of hot dogs and mouse-ear hats. Disney was also the first studio to create an archive of its work, and today, their Animation Research Library (ARL) holds more than 65 million pieces.

. . .

The Pixar Living Archive began with a suggestion from Jonas Rivera, who proposed the idea while working as the art department coordinator on *A Bug's Life*. One of his earlier tasks had been packing up *Toy Story* artwork and shipping it to Disney's ARL. He felt the studio should keep its artwork in-house as a reference and inspirational resource and, beginning with *A Bug's Life*, Pixar's art has never left the company. (The *Toy Story* artwork returned, too, after Disney purchased Pixar in 2006.)

When John Lasseter worked at Disney in the early 1980s, Disney's animation art archive was called "The Morgue." Pixar's "Living Archive" moniker intentionally sends a different message. "It's a place where artists can go to see the art, touch it, and in certain instances, even borrow the work," said Christine Freeman. Within Pixar's Emeryville campus, a small room serves as an office and processing center for the archives. The majority of the artwork, however, is housed in a four-story office building in a nondescript industrial neighborhood around the Port of Oakland. Buildings and areas within buildings at Pixar are named after New York neighborhoods, and the archives are called "Ellis Island" after the famous island in New York Harbor that housed the records of millions of immigrants entering the United States.

The archivists at Pixar who have been charged with protecting this irreplaceable trove of artwork take their work seriously. They spend hours working on disaster recovery plans and collaborate with third-party experts to prepare for catastrophes, a necessary precaution in the infamously earthquake-prone San Francisco Bay Area. "I like to think we're pretty prepared," Freeman said. For starters, water is routed to the perimeter of the building so that pipes that could leak or cause floods don't hang overhead. The more insidious threat to archives is fire—a warehouse fire started by an electrical fault destroyed much of Aardman Animations' archives in 2005—which is why Pixar chooses to keep its materials in a building that has a waterless fire suppression system. Should a fire erupt, bursts of a colorless, odorless halocarbon called heptafluoropropane will flood the archives, snuffing out the fire while keeping the artwork safe and secure. The facility is climate controlled with humidity maintained at an average of 50 percent (plus or minus 5 percent) and temperature at 70 degrees (plus or minus 2 percent), a stable environment that slows the natural deterioration of art materials.

. . .

To the viewer seeing a film for the first time, Buzz has always been Buzz, and Woody has always been Woody. We cannot imagine these characters looking and behaving any other way. But the archives at Pixar reveal a circuitous development period composed of an infinite number of Buzzes and Woodys.

It is an exhaustive process whittling myriad possibilities into the endearing and distinctive personalities that eventually appear on screen.

The same holds true for a film's setting, which is the focus of this section of the book. The inspirational artwork created by artists allows them to explore ideas for locations unfettered by the restrictions of the computer animation production process. As its title suggests, the art is meant to inspire new ways of thinking about a film. Teddy Newton's collage studies for *The Incredibles* were created not to suggest the film's final look, but to spur thinking about how to incorporate a bold and stylized mid-century design aesthetic. Geefwee Boedoe's concept studies for *A Bug's Life* depict a decorative natural world filled with electric hues of blue and magenta, ants in pure black silhouette, and rhythmic swirls of shapes that neatly tie the frame together. The effect is striking, less concerned with capturing reality than exciting a viewer's senses. As a film is developed, many such avenues are explored before settling on an approach.

For some films, locations are more easily defined than others. *Monsters, Inc.* had a long-gestating development because it involved designing an entire world from scratch. Where do monsters live, work, and play are questions that can be answered only by an artist's imagination. But with the idea of a Southwestern desert landscape firmly implanted for *Cars*, production designer Bill Cone dedicated most of his concept drawings to figuring out how to visually represent the majestic scale and distinctive light of that setting.

In recent times, the archivists' job has shifted from storing physical artwork to preserving artwork that has been created digitally. Artists at Pixar are encouraged to work in the medium they feel best suited to the demands of a film, and nowadays many choose to draw and paint directly on the computer. Working digitally can be especially useful as a film advances deeper into production, since it allows the artists' work to accurately reflect the finished look of the film. Paul Topolos's digital illustration for *WALL•E*, created at an advanced stage of the film's production, would have been difficult to recreate with traditional media.

The artwork created over the last twenty-five years at Pixar is proudly displayed inside of the studio and is made available to the public in books such as this one. In 2005, the exhibition *Pixar: 20 Years of Animation* debuted at the Museum of Modern Art in New York, and the show has since continued on a global tour across London, Tokyo, Melbourne, Helsinki, Seoul, Taipei, Singapore, and Oakland. A newly curated *Pixar: 25 Years of Animation* exhibition began its world tour in Hong Kong in 2011. The principals at Pixar recognize the value of preserving this artwork, which tells the story not only of how the studio's films were created, but of Pixar itself. Each piece acknowledges an unwavering commitment on the part of the studio's artists to discover the strongest way of expressing a story's visual possibilities.

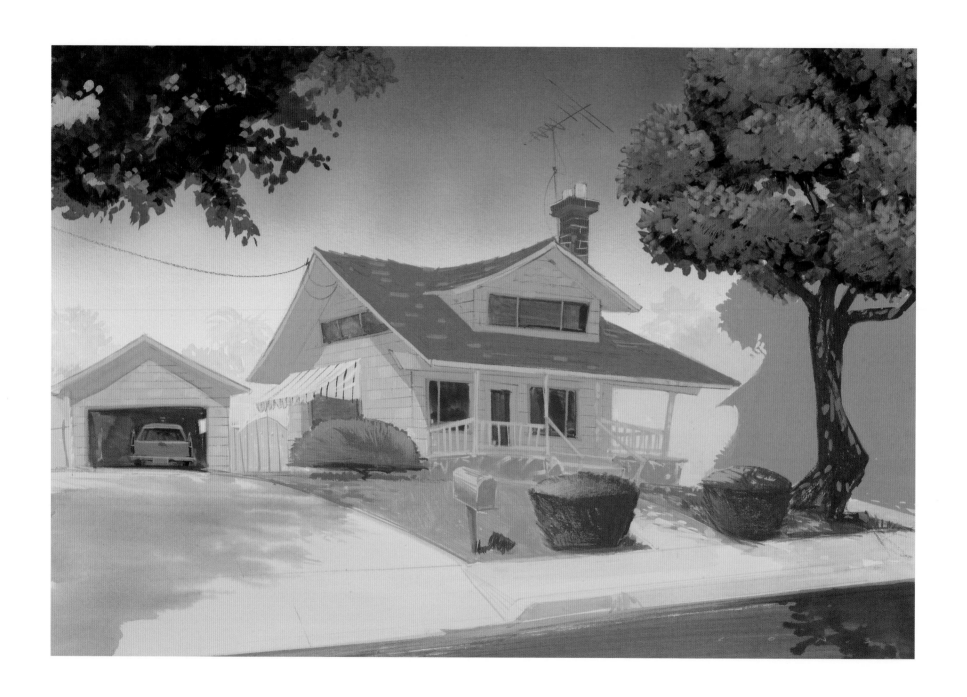

TOY STORY Bill Cone, Gouache and acrylic on illustration board, 1994

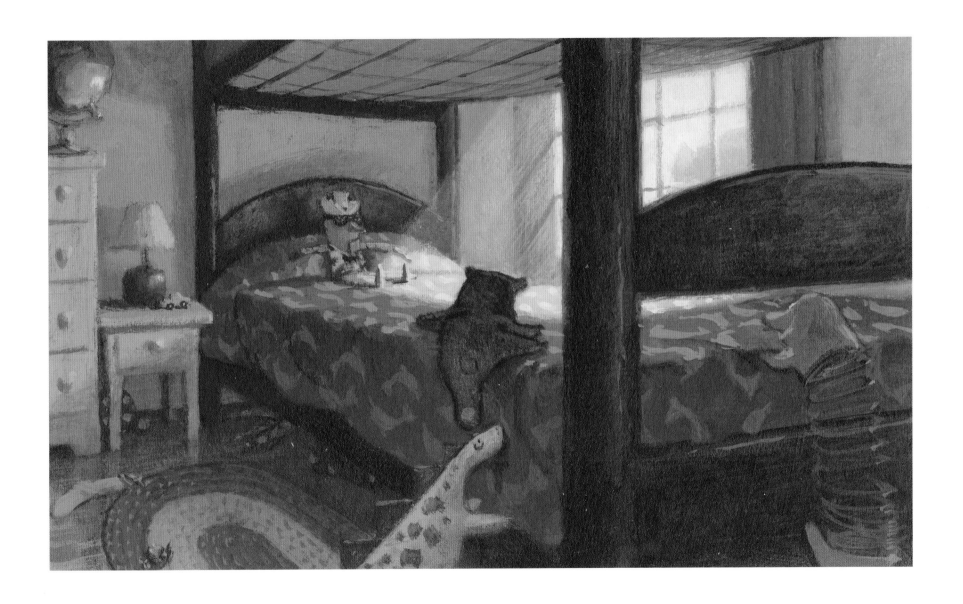

TOY STORY Steve Johnson and Lou Fancher, Acrylic, 1994

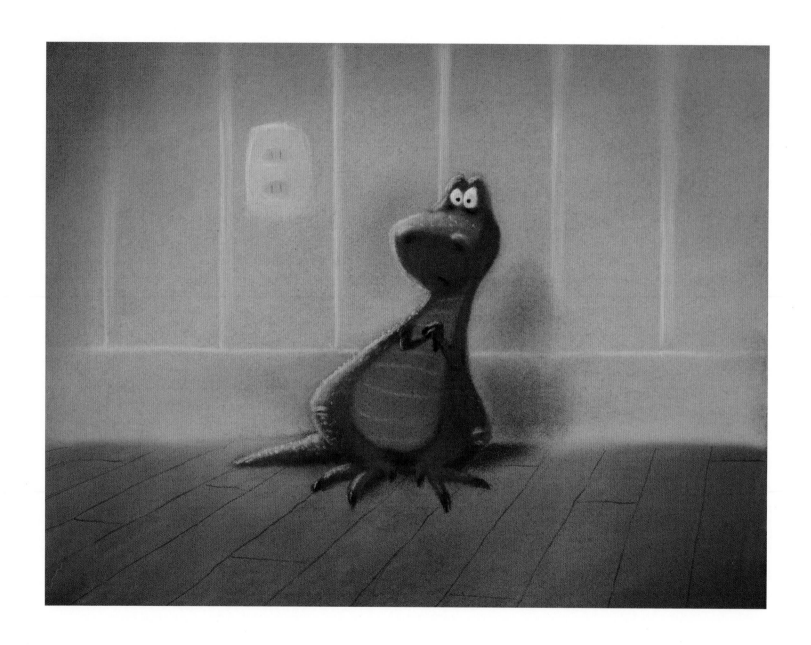

TOY STORY Ralph Eggleston, Pastel, 1994

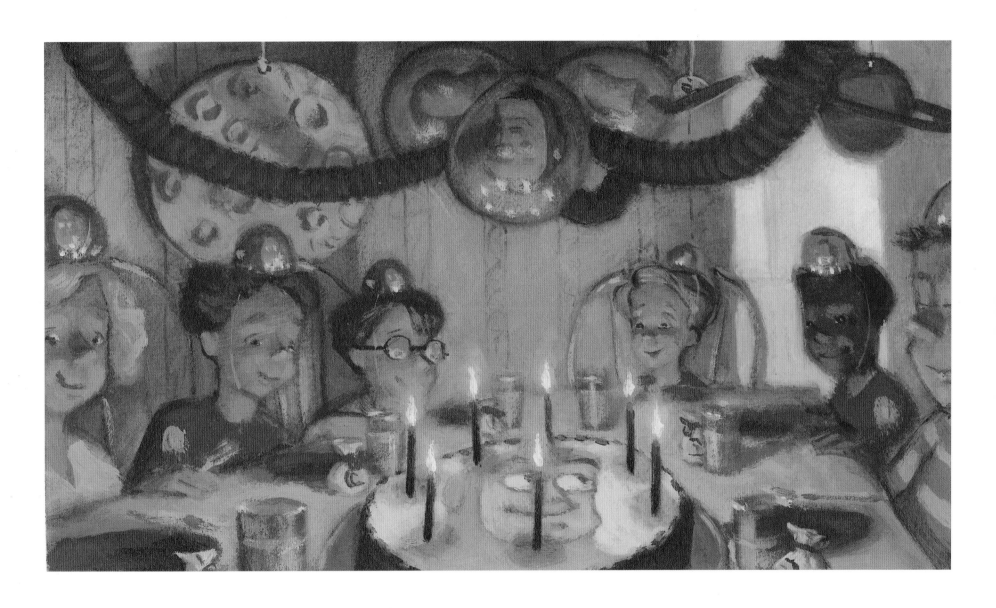

TOY STORY Steve Johnson and Lou Fancher, Acrylic, 1994

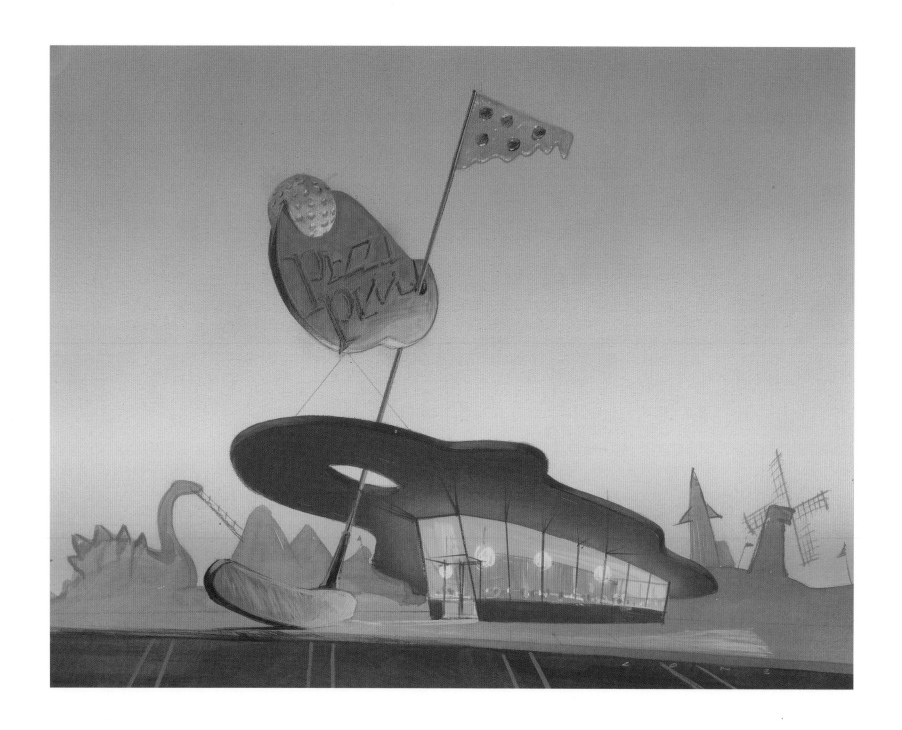

TOY STORY Bill Cone, Gouache and acrylic on illustration board, 1994

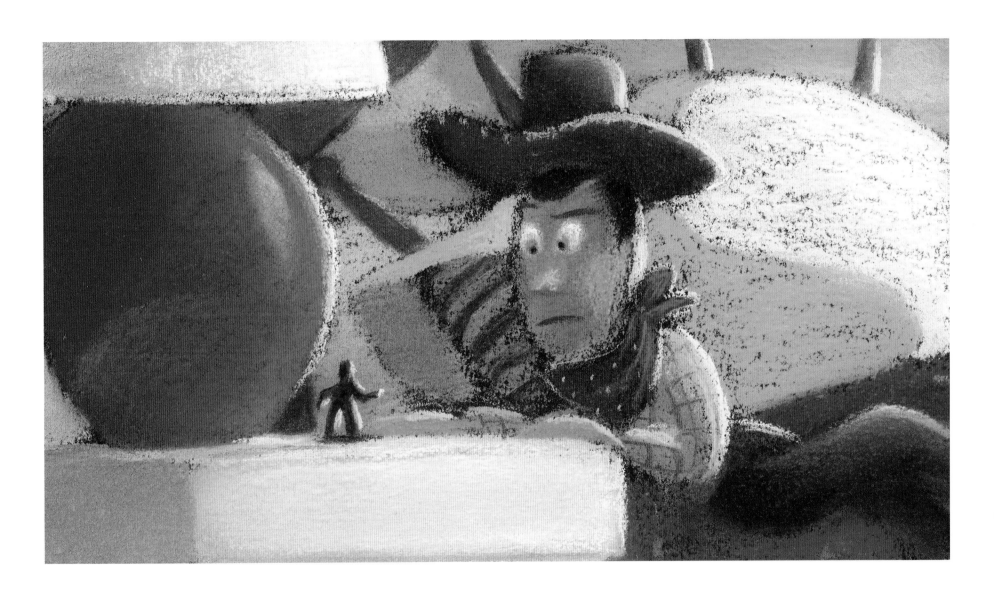

TOY STORY Ralph Eggleston, Pastel, 1994

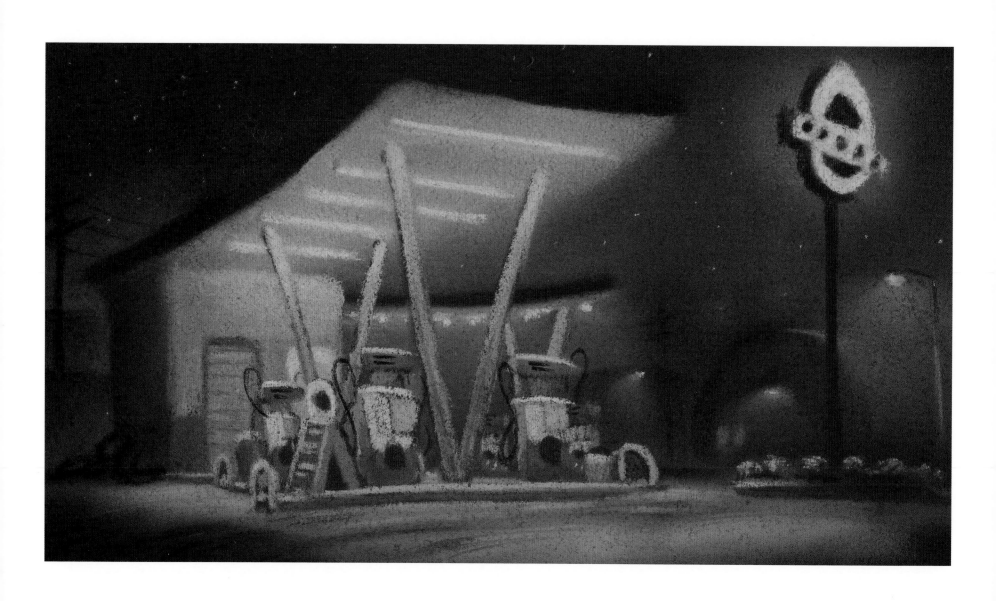

TOY STORY Ralph Eggleston, Pastel, 1994

TOY STORY Tia Kratter, Layout by Ralph Eggleston, Acrylic, 1994.

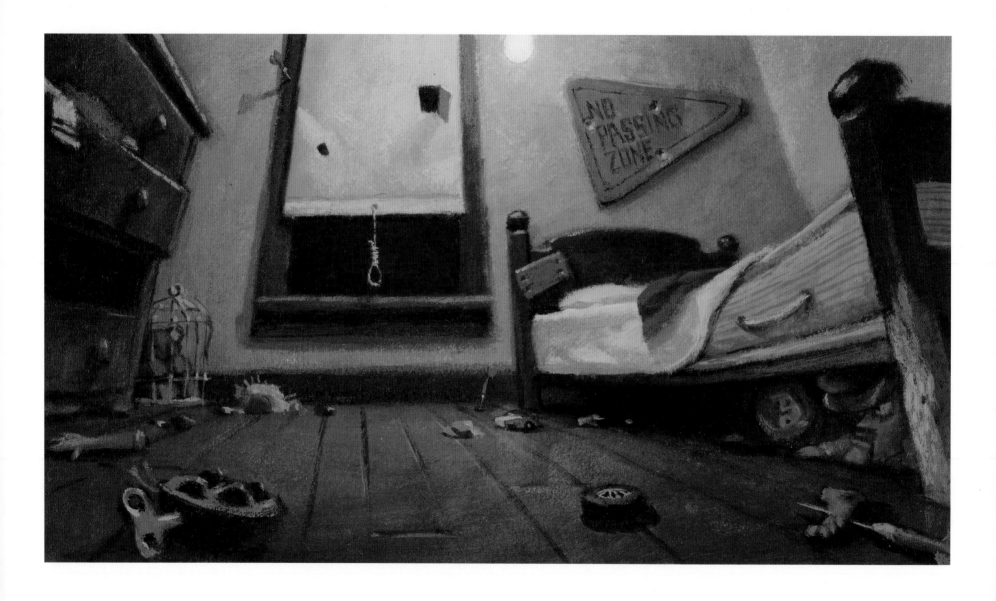

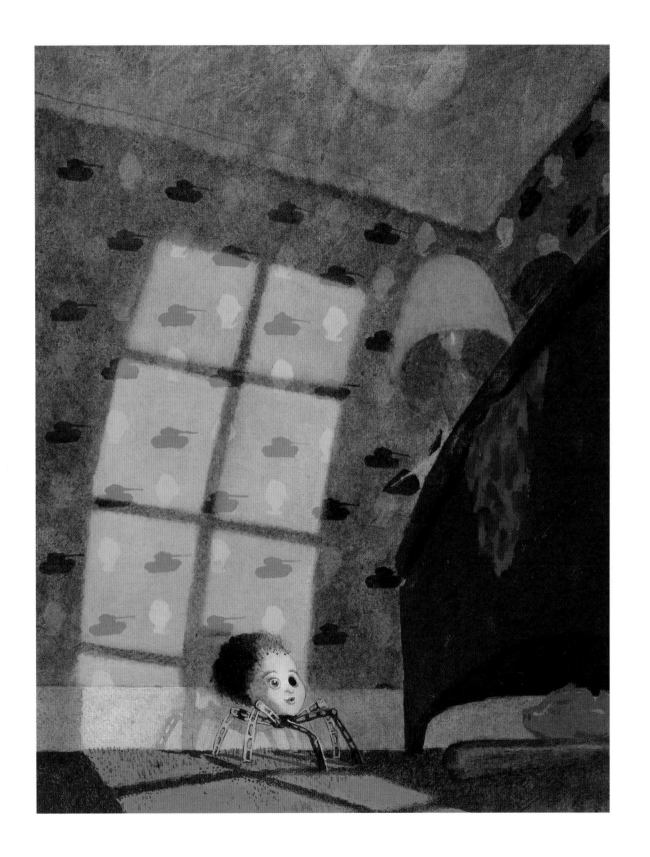

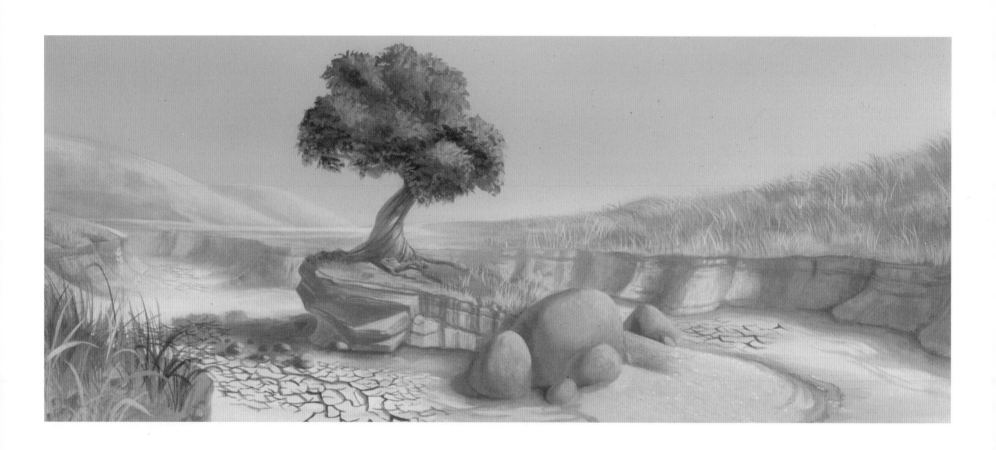

A BUG'S LIFE Tia Kratter, Acrylic, 1997

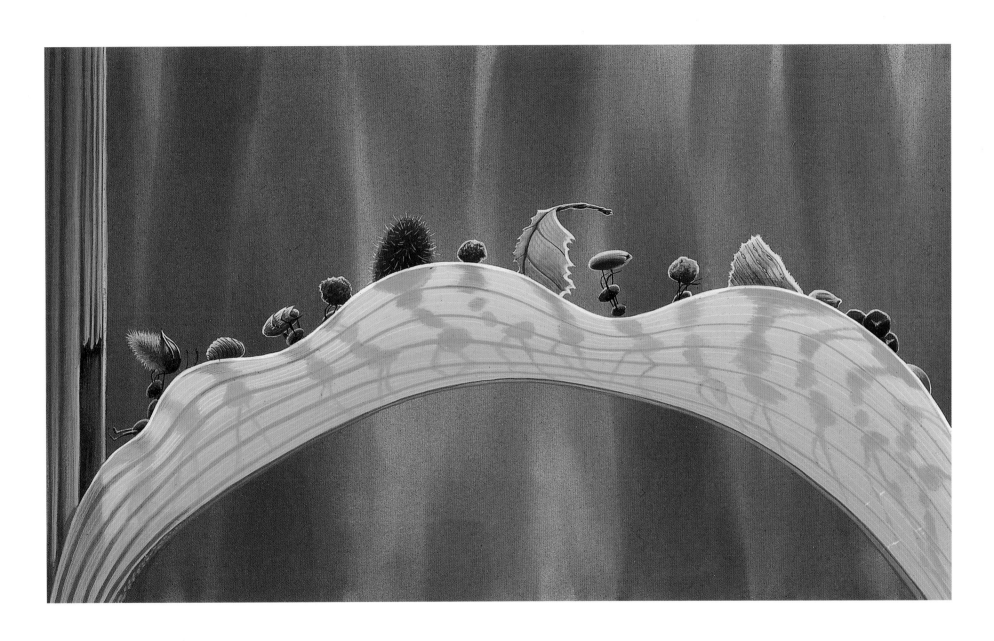

A BUG'S LIFE Tia Kratter, Layout by Bill Cone, Acrylic, 1996

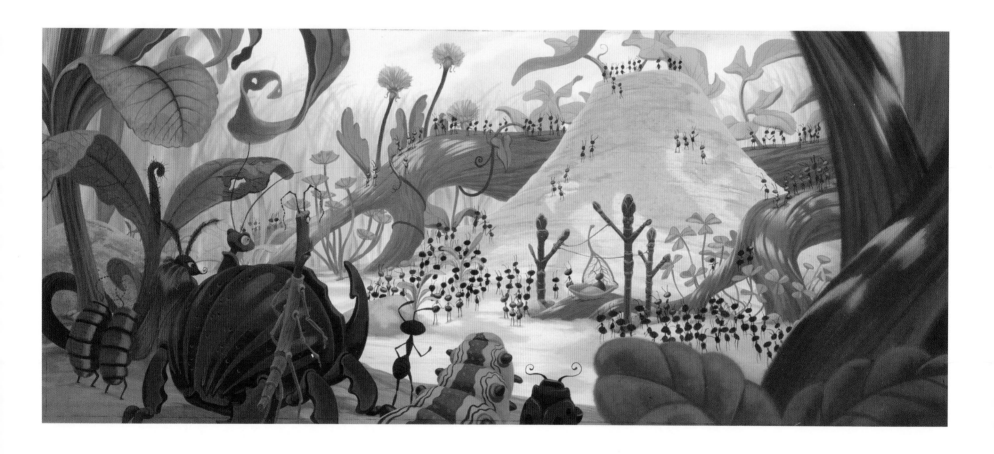

ABOVE

A BUG'S LIFE Tia Kratter, Layout by Geefwee Boedoe, Acrylic, 1996

OPPOSITE

A BUG'S LIFE Tia Kratter, Layout by Geefwee Boedoe, Acrylic, 1996

A BUG'S LIFE Bill Cone, Acrylic and gouache, 1996

A BUG'S LIFE Bill Cone, Acrylic and gouache, 1996

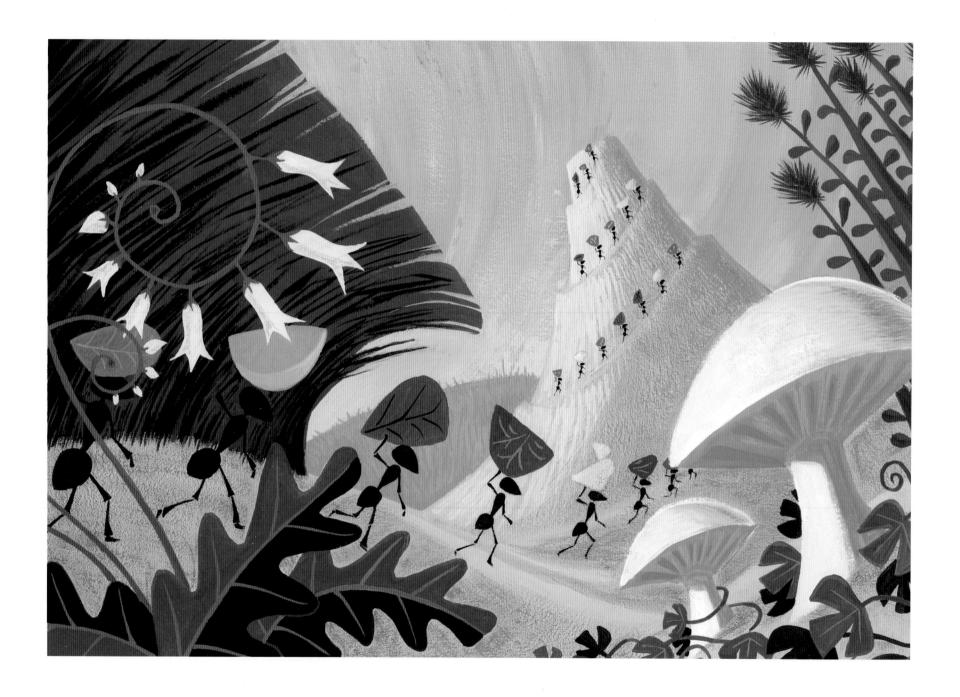

ABOVE

A BUG'S LIFE Geefwee Boedoe, Acrylic, 1995

OPPOSITE

A BUG'S LIFE Geefwee Boedoe, Acrylic, 1995

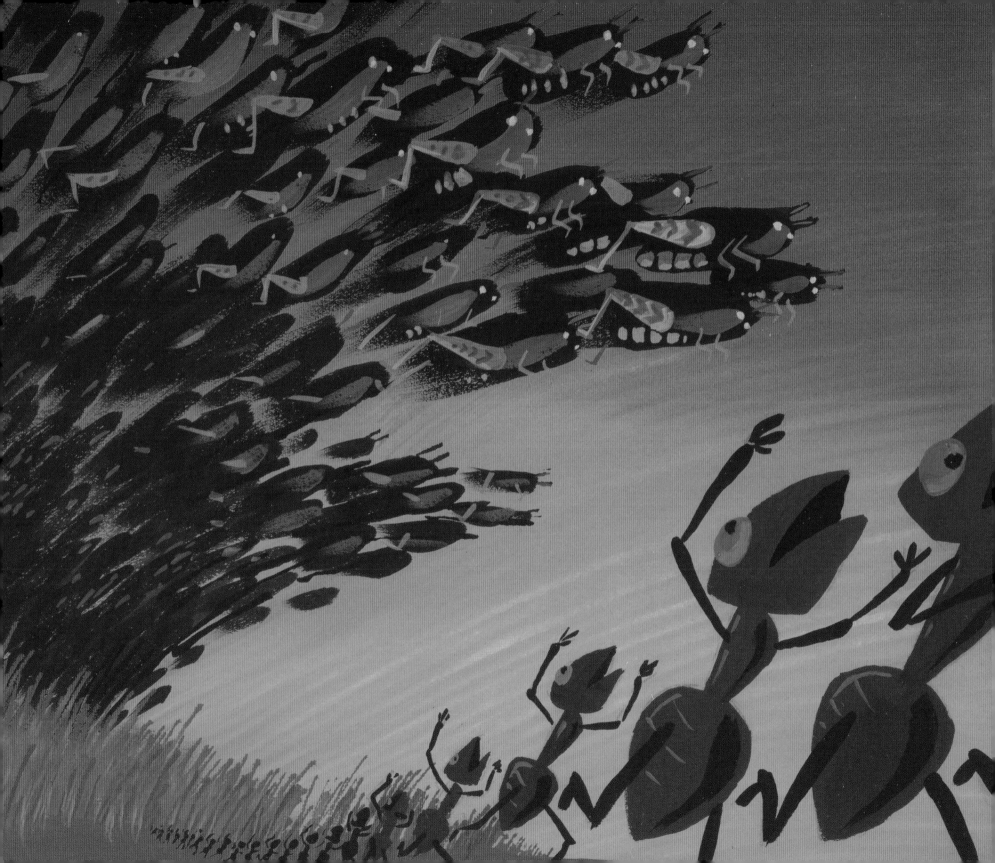

A BUG'S LIFE Bill Cone, Pastel, 1996

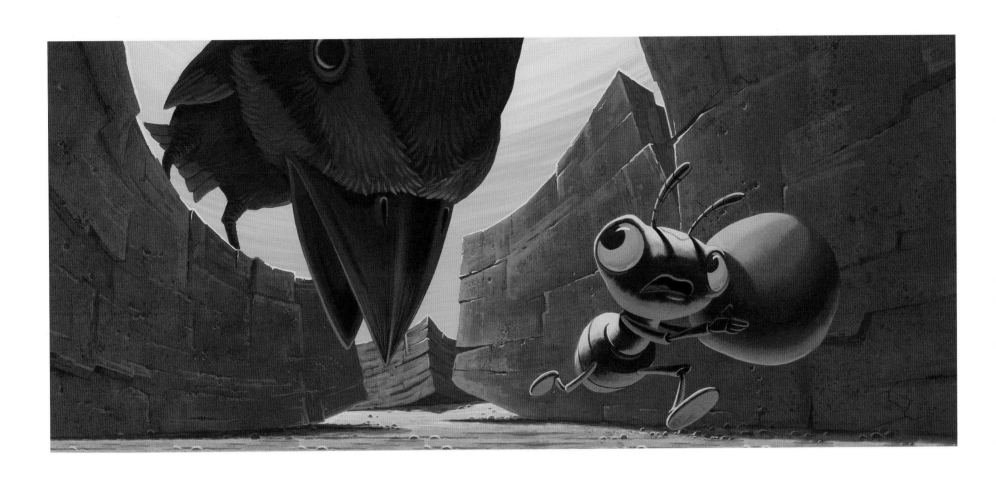

A BUG'S LIFE Tia Kratter, Layout by Bob Pauley, Acrylic, 1996

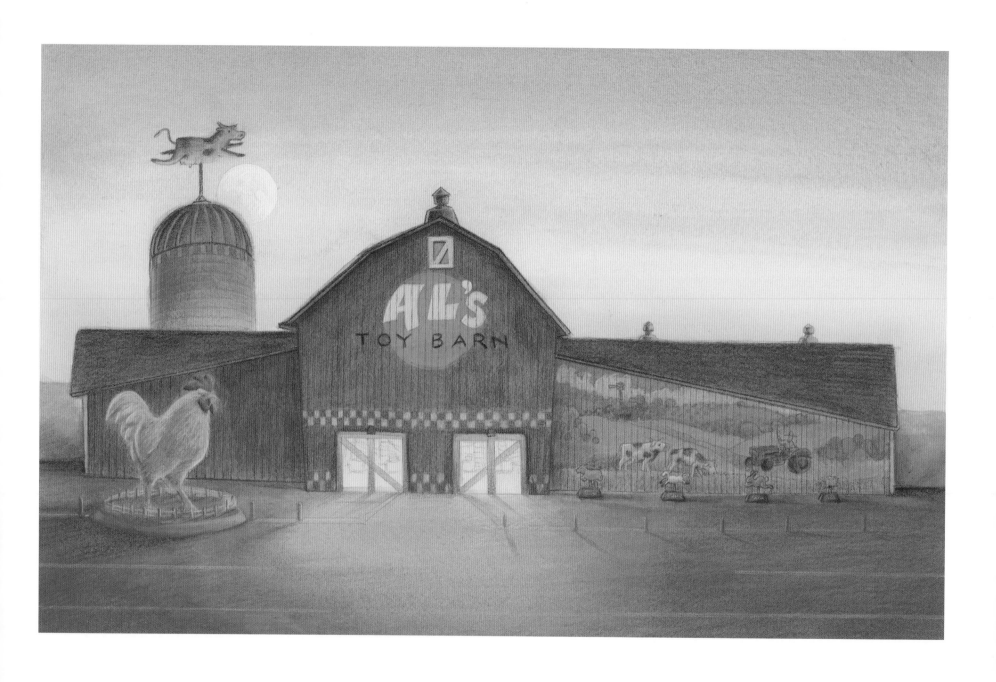

TOY STORY 2 Jim Pearson, Mixed Media, 1998

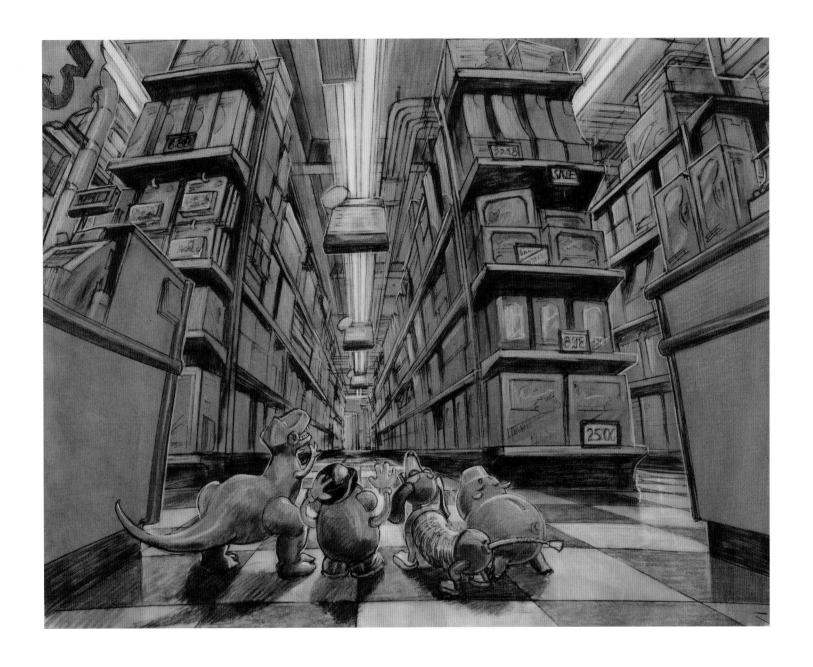

TOY STORY 2 Randy Berrett, Color pencil on vellum, 1997

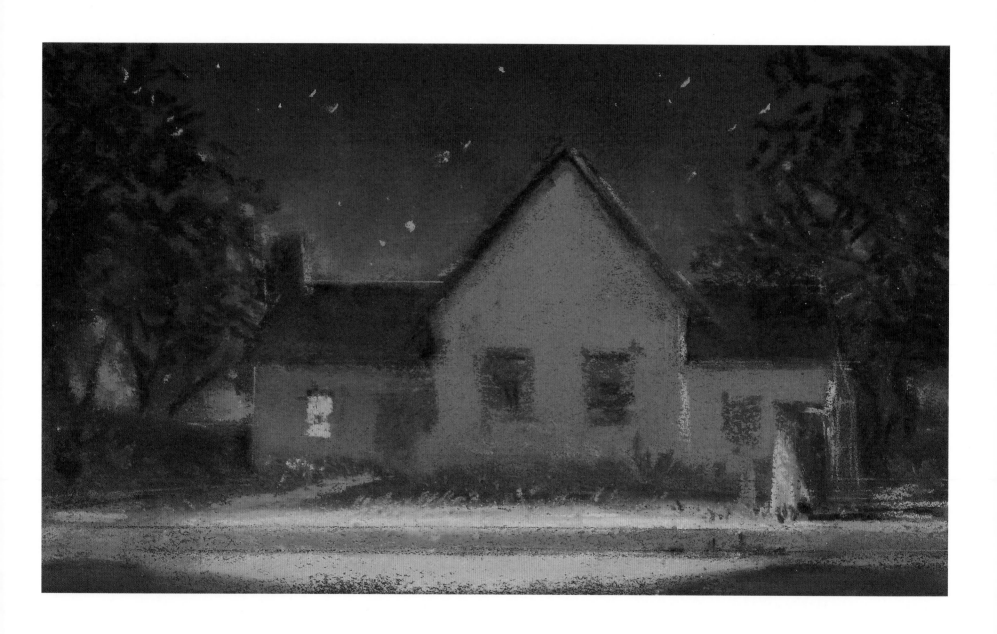

TOY STORY 2 Bill Cone, Pastel, 1998

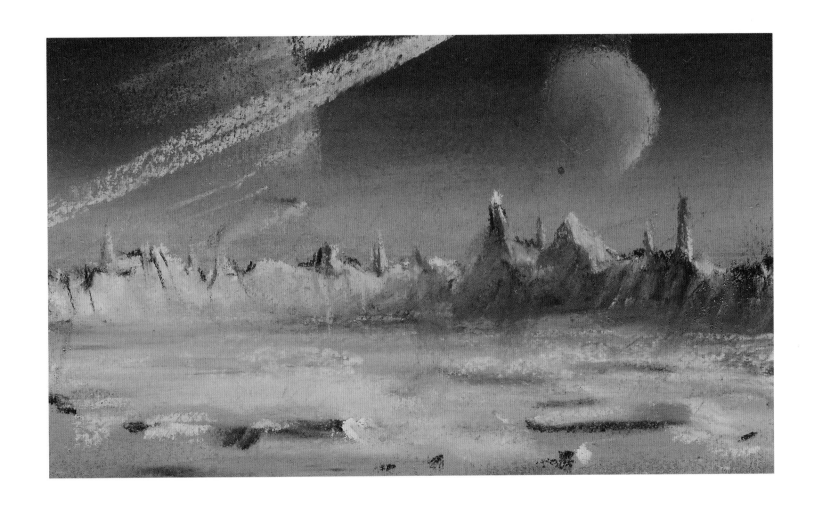

TOY STORY 2 Bill Cone, Pastel, 1998

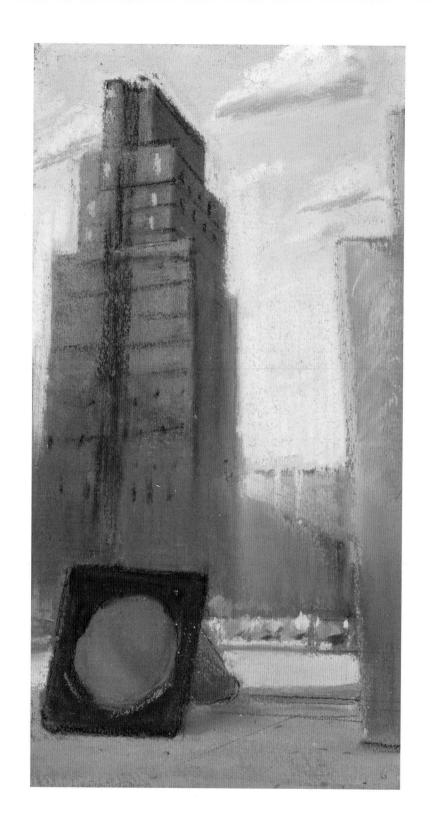

TOY STORY 2 Bill Cone, Pastel, 1998

TOY STORY 2 Randy Berrett, Oil, 1997

TOY STORY 2 Randy Berrett, Oil, 1998

TOY STORY 2 Dave Gordon, Watercolor, 1996

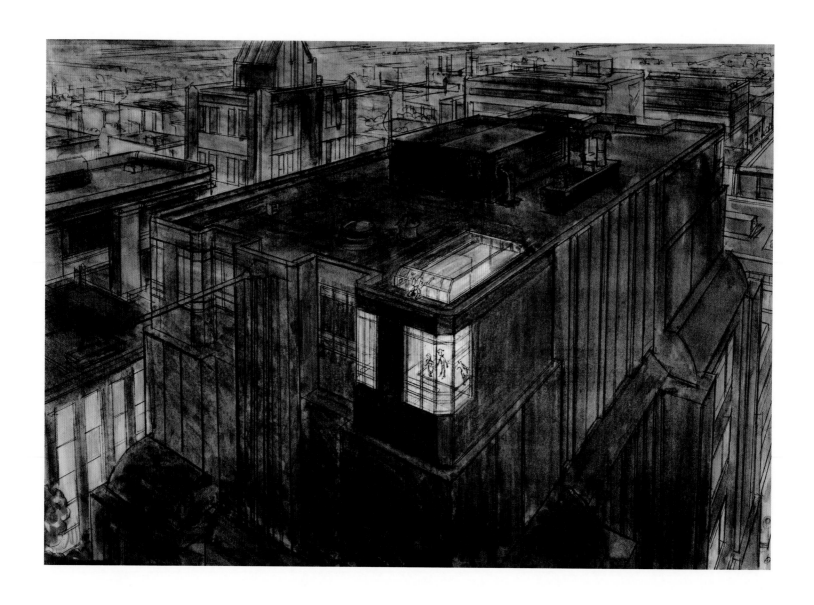

TOY STORY 2 Randy Berrett, Color pencil on vellum, 1997

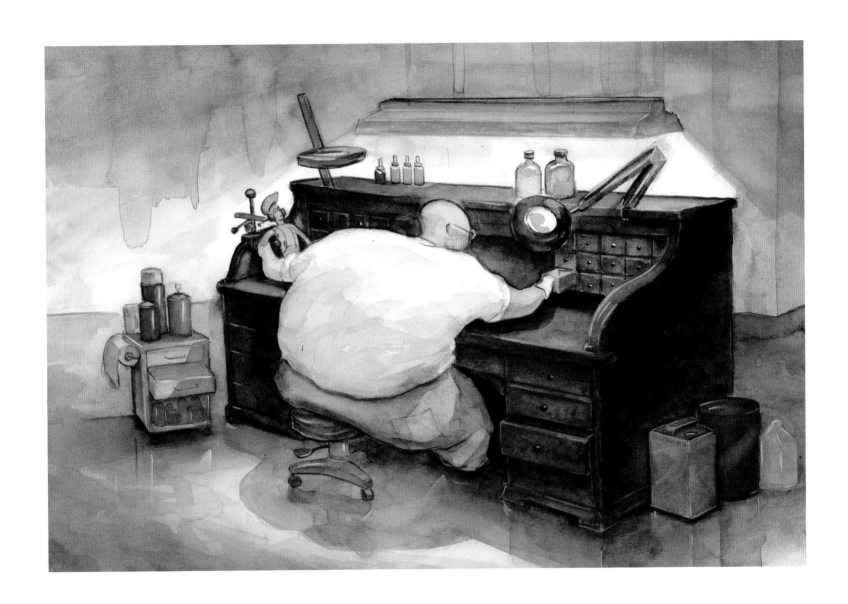

TOY STORY 2 Dave Gordon, Watercolor, 1996

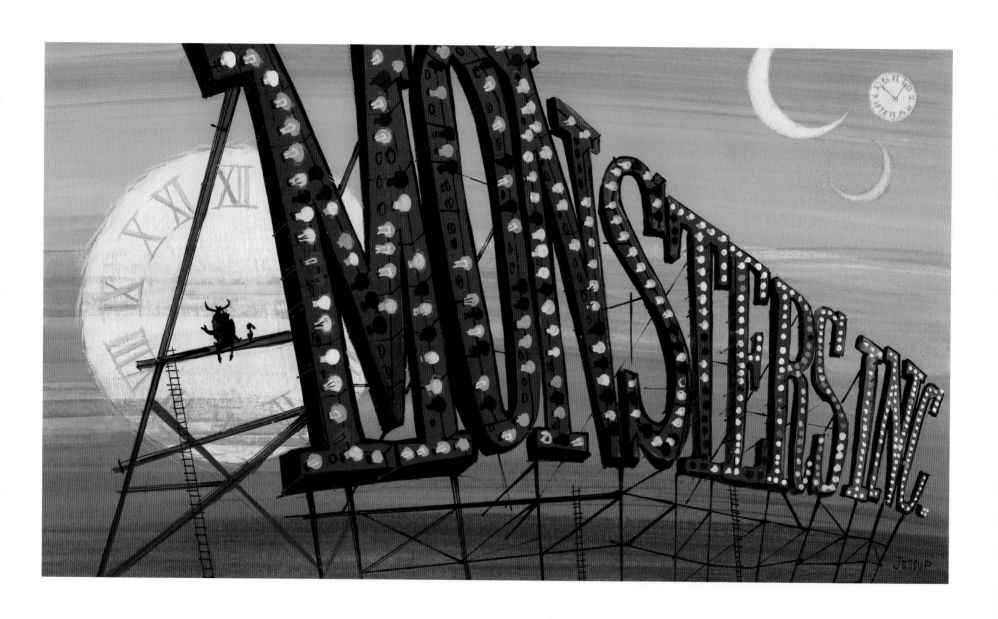

MONSTERS, INC. Harley Jessup, Acrylic, 1998

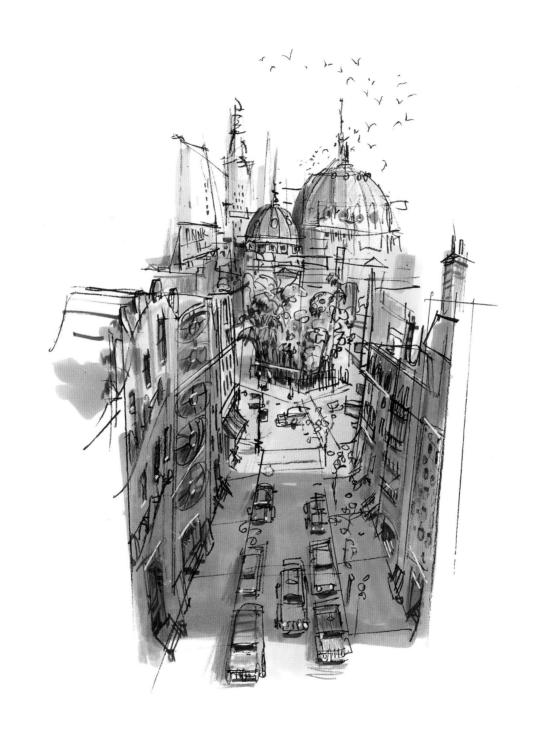

MONSTERS, INC. Harley Jessup, Marker and ink, 1998

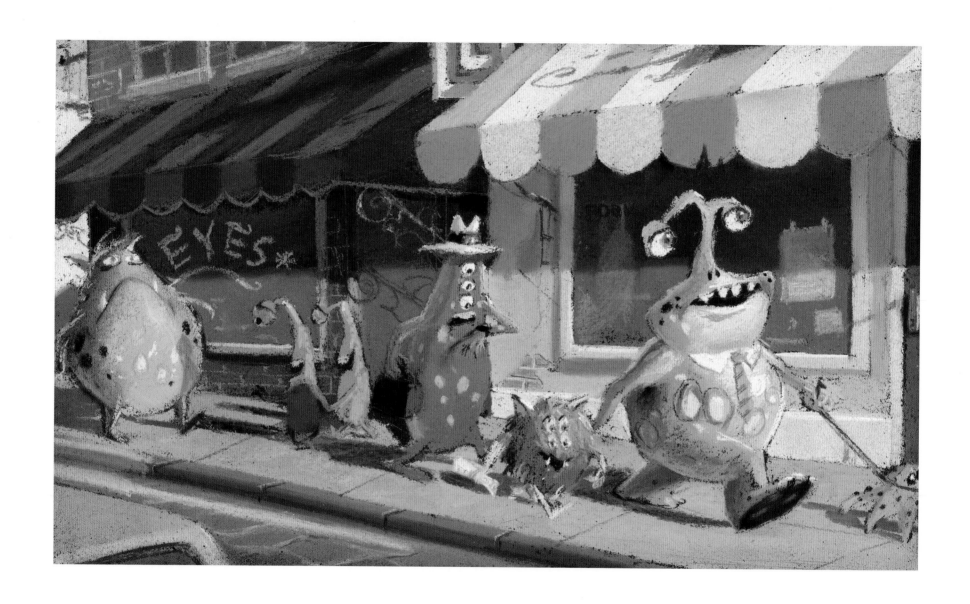

MONSTERS, INC. Dominique R. Louis, Layout by Albert Lozano, Pastel, 2000

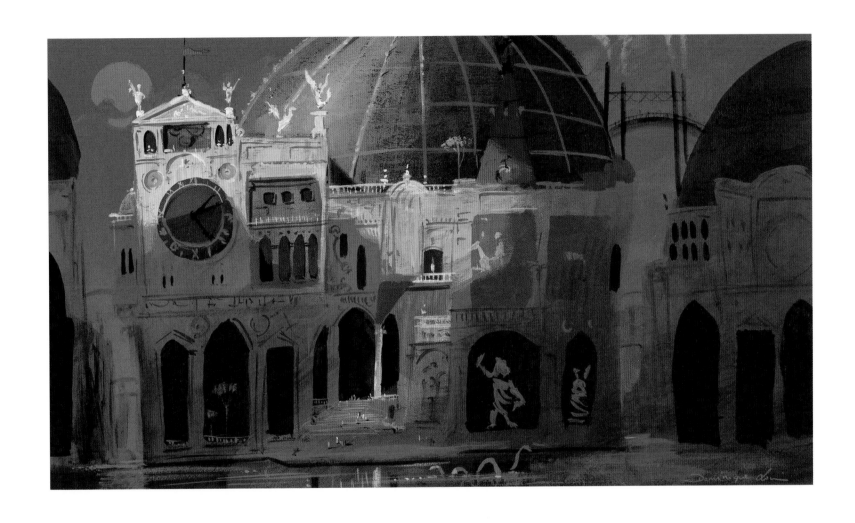

MONSTERS, INC. Dominique R. Louis, Acrylic, 1997

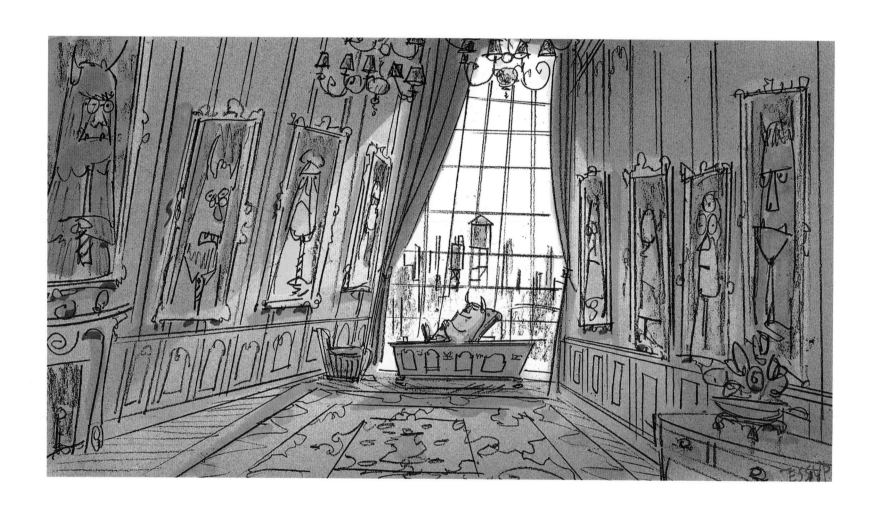

MONSTERS, INC. Harley Jessup, Marker and ink, 1997

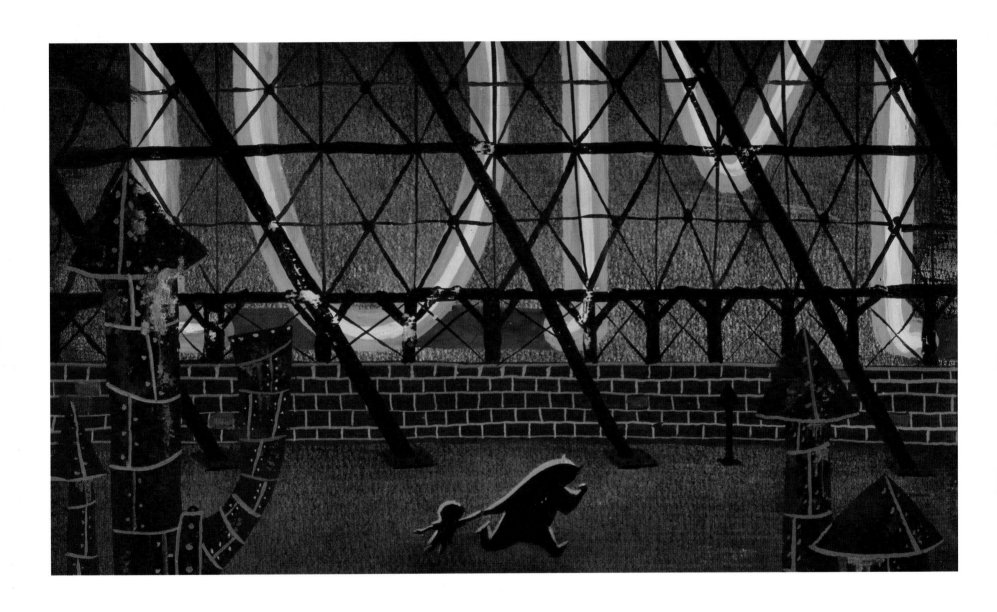

MONSTERS, INC. Ricky Nierva, Gouache, 1997

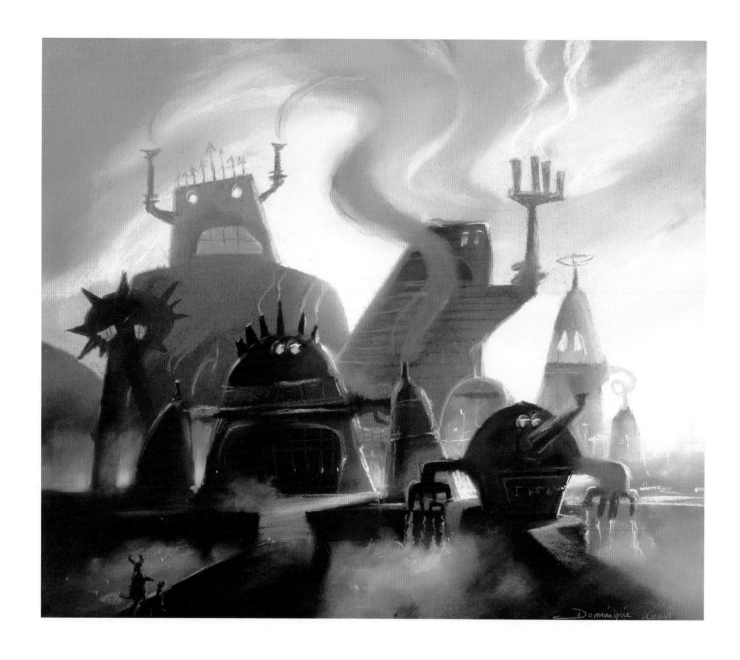

ABOVE

MONSTERS, INC. Dominique R. Louis, Layout by Geefwee Boedoe, Pastel, 1999

OPPOSITE

MONSTERS, INC. Lou Romano, Gouache, 1997

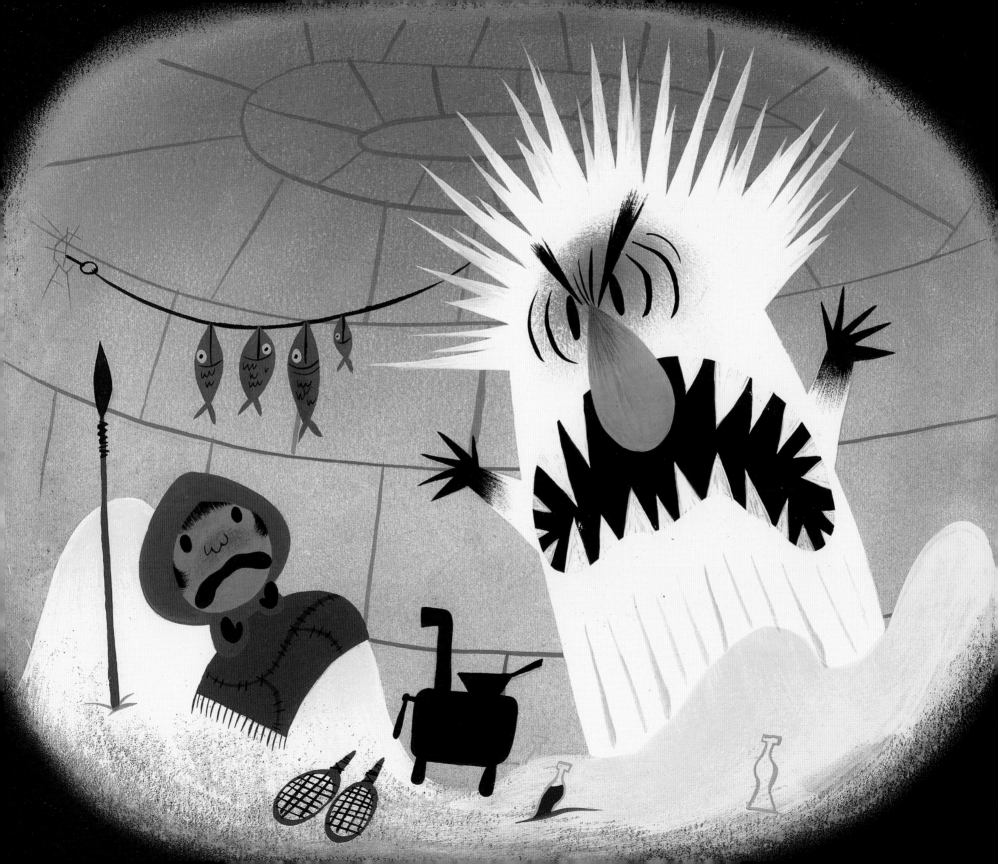

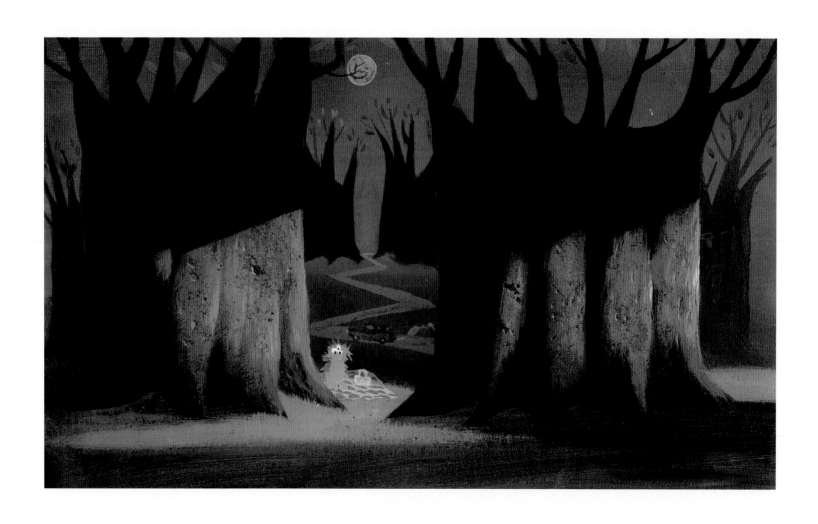

MONSTERS, INC. Dominique R. Louis, Acrylic, 1998

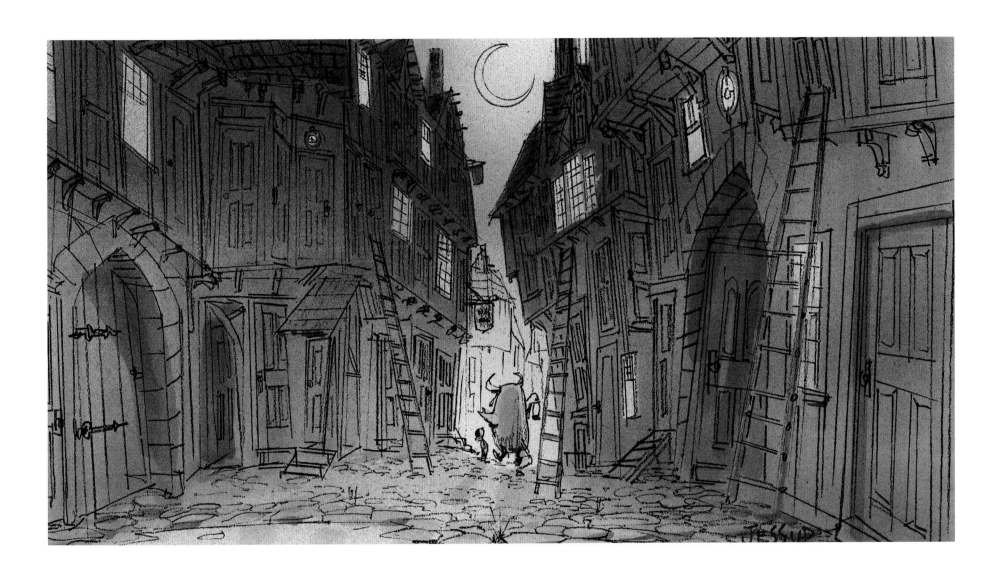

MONSTERS, INC. Harley Jessup, Marker and ink, 1997

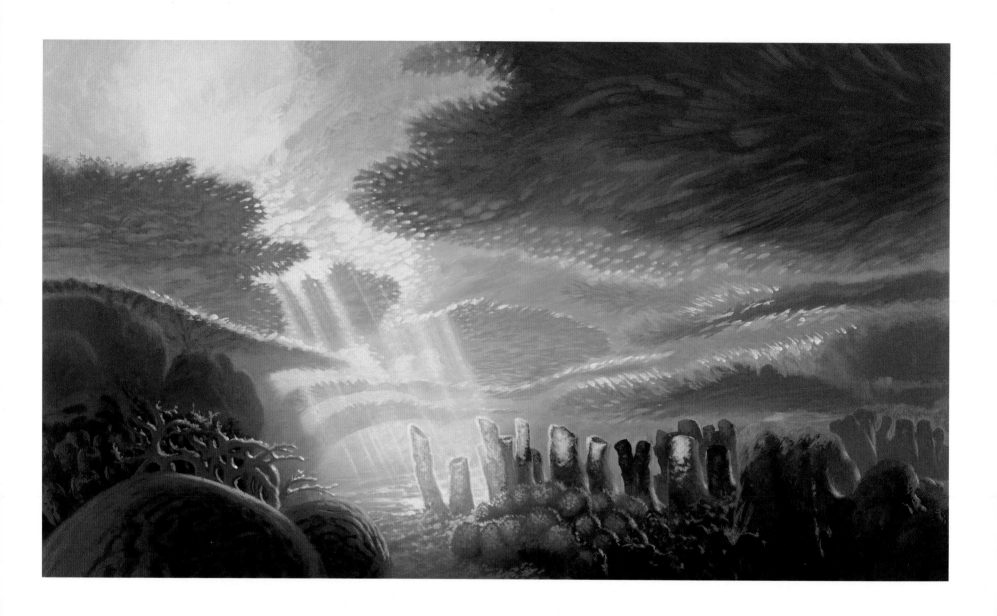

FINDING NEMO Jeff Richards, Layout by Anthony Christov, Acrylic, c. 2002

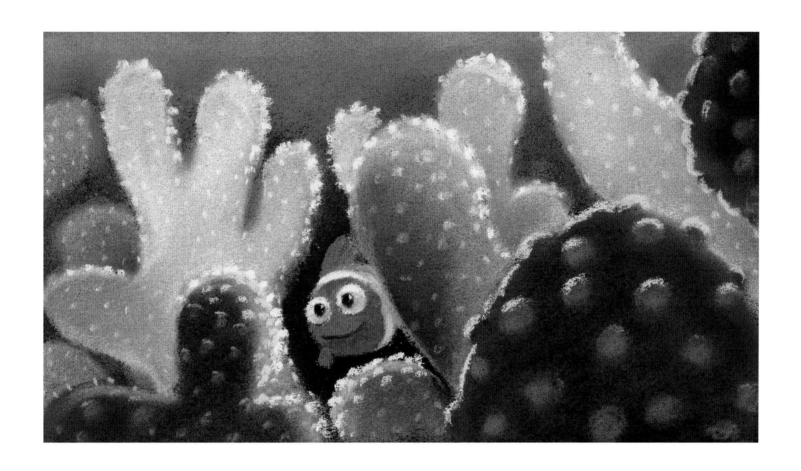

FINDING NEMO Ralph Eggleston, Pastel, c. 2002

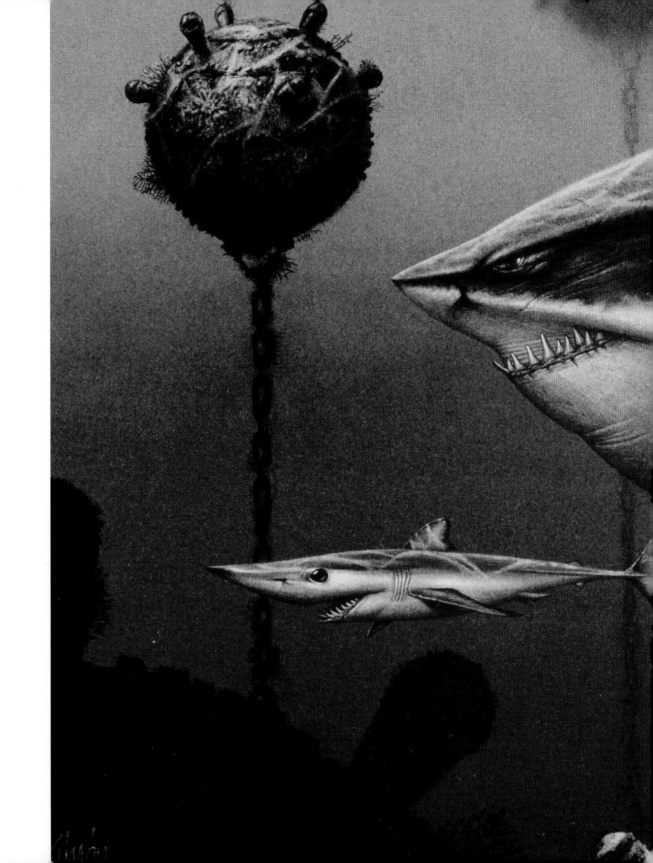

FINDING NEMO Simón Vladimir Varela, Charcoal, c. 2002

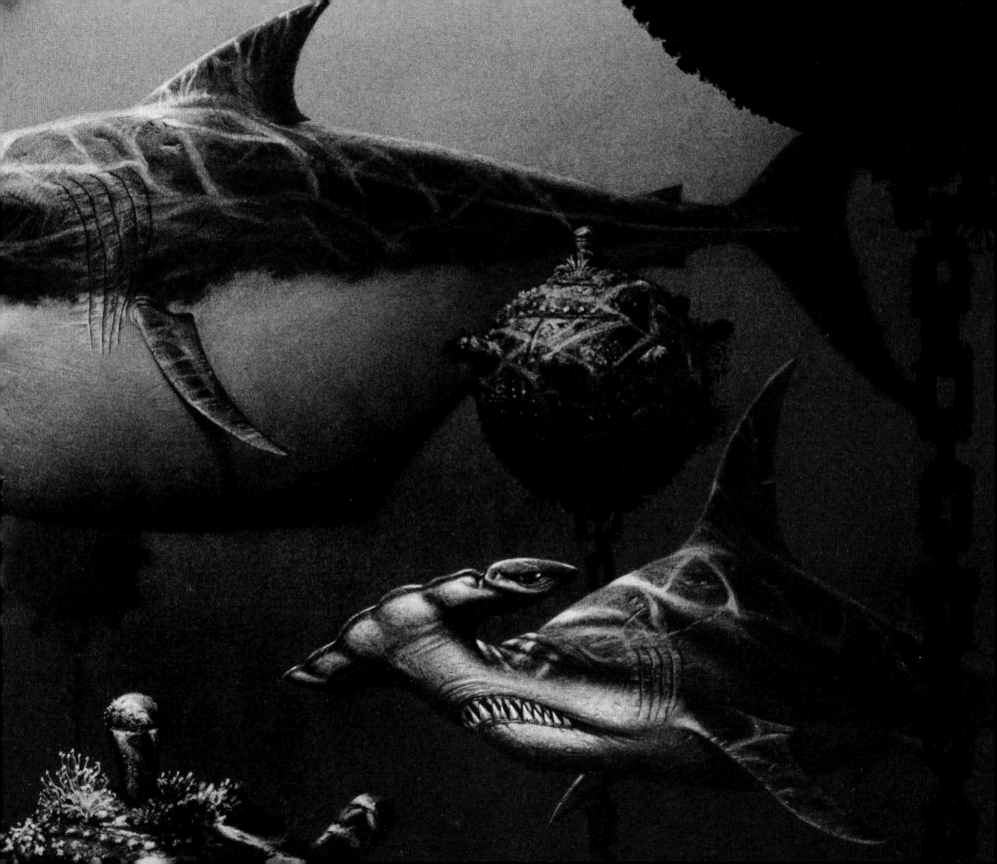

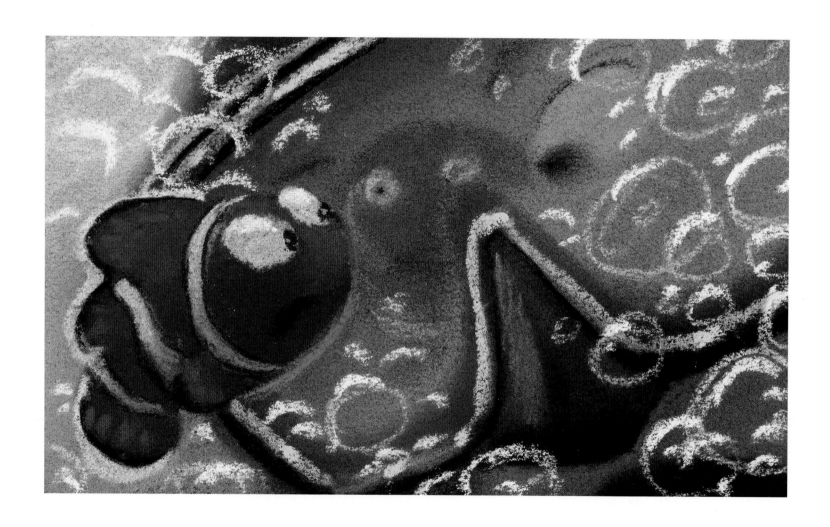

FINDING NEMO Ralph Eggleston, Pastel, c. 2002

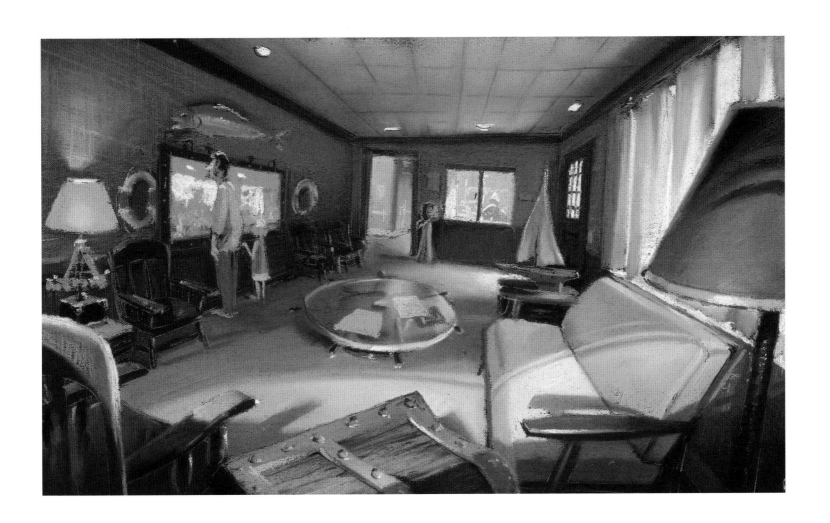

FINDING NEMO Dominique R. Louis, Layout by Nelson Bohol, Pastel, c. 2002

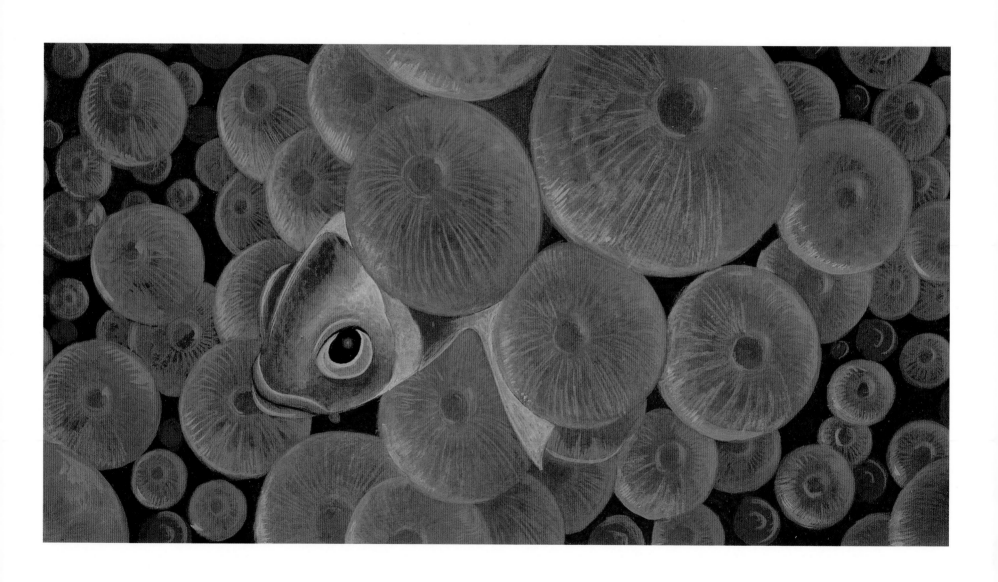

FINDING NEMO August Hall, Acrylic, c. 2002

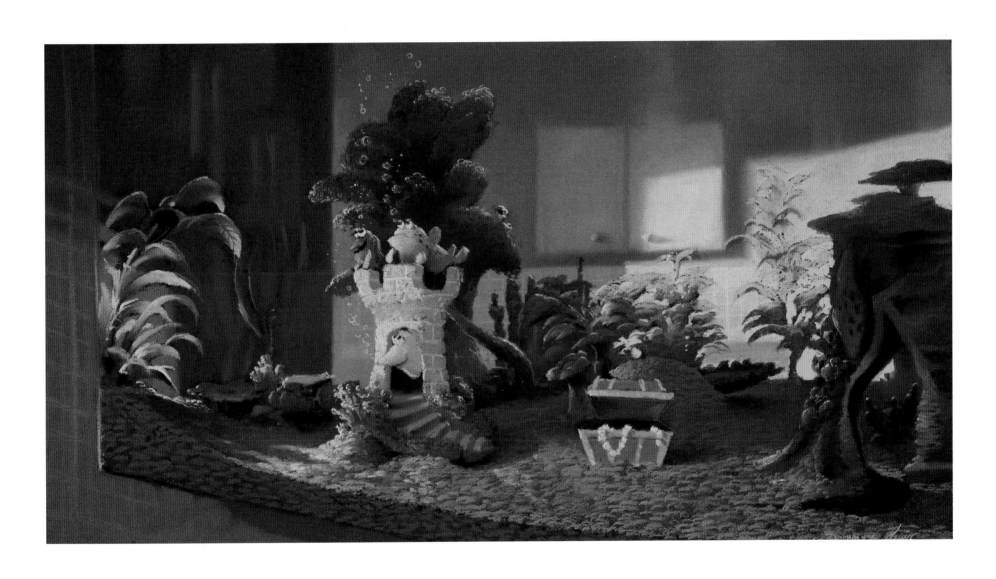

FINDING NEMO Dominique R. Louis, Layout by Nelson Bohol, Pastel, c. 2002

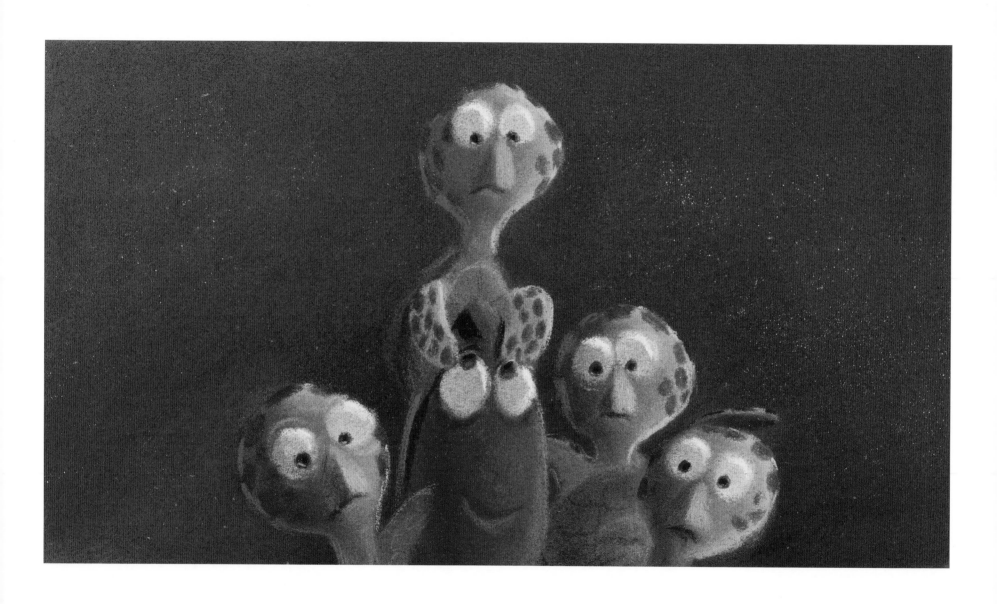

FINDING NEMO Ralph Eggleston, Pastel, c. 2002

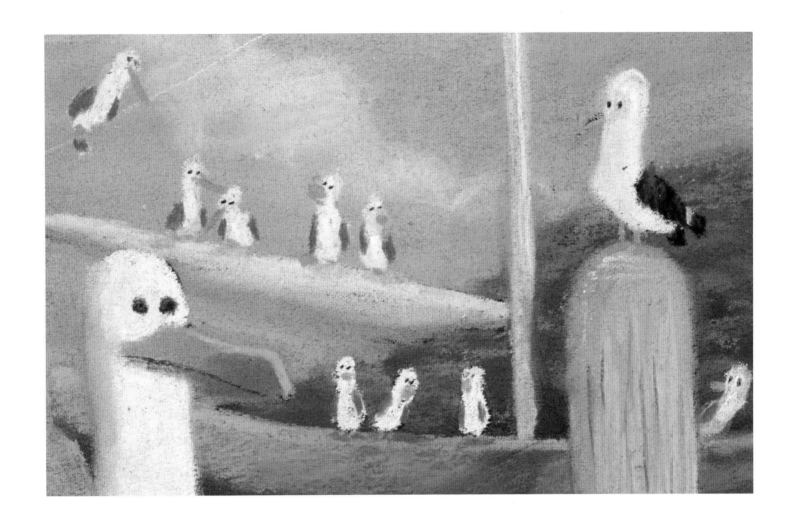

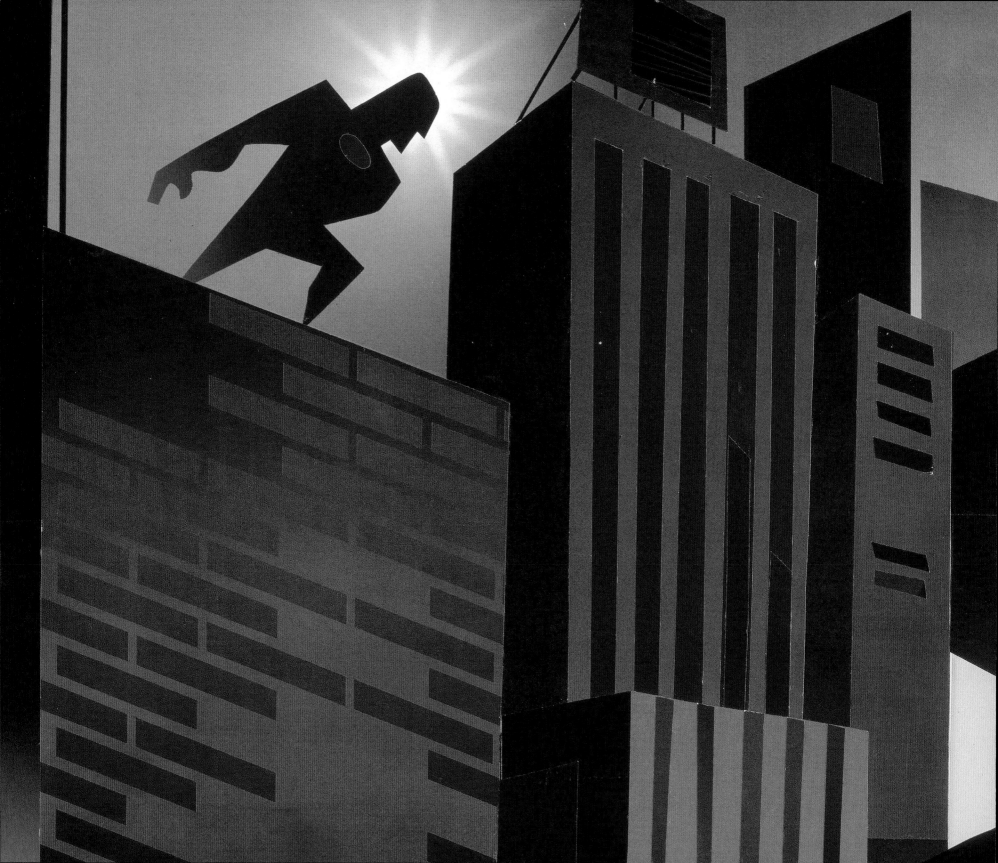

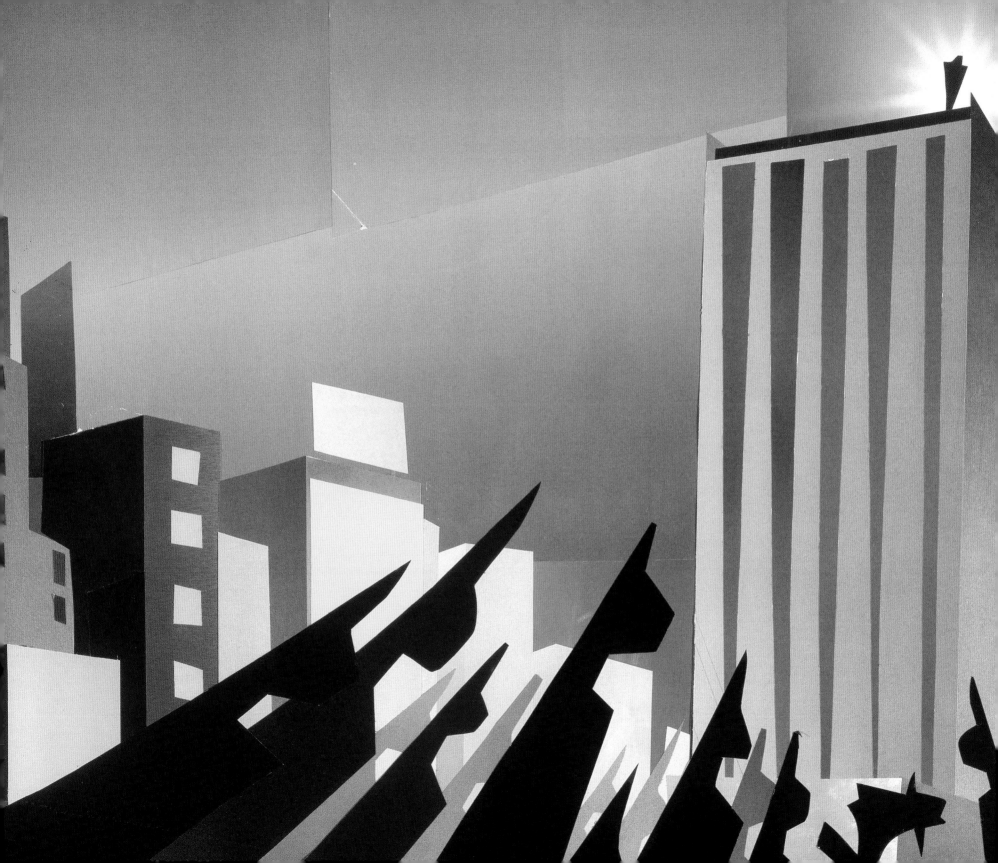

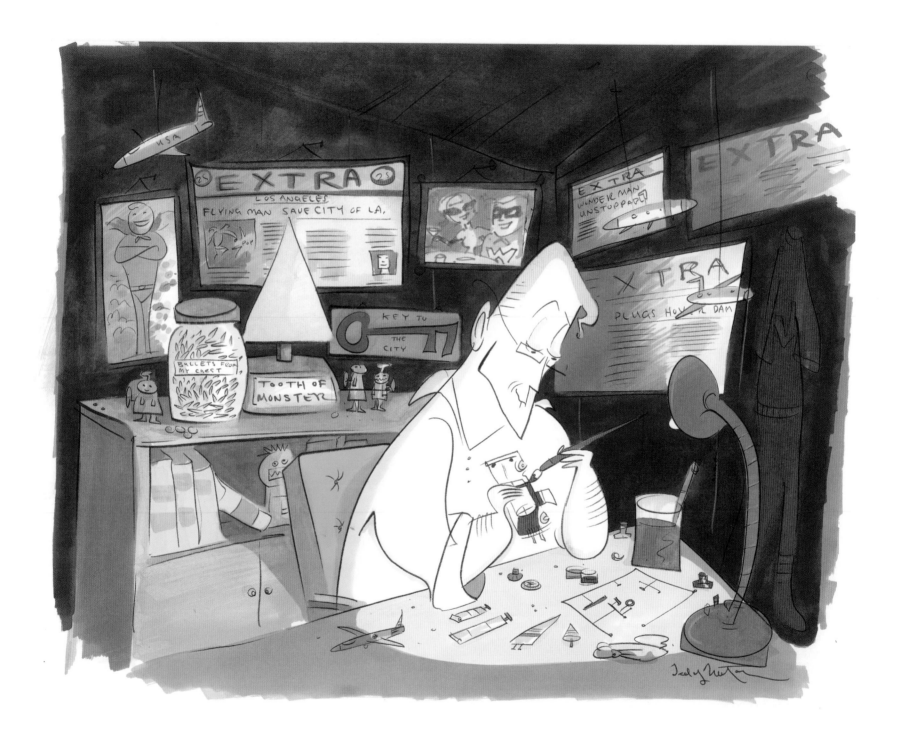

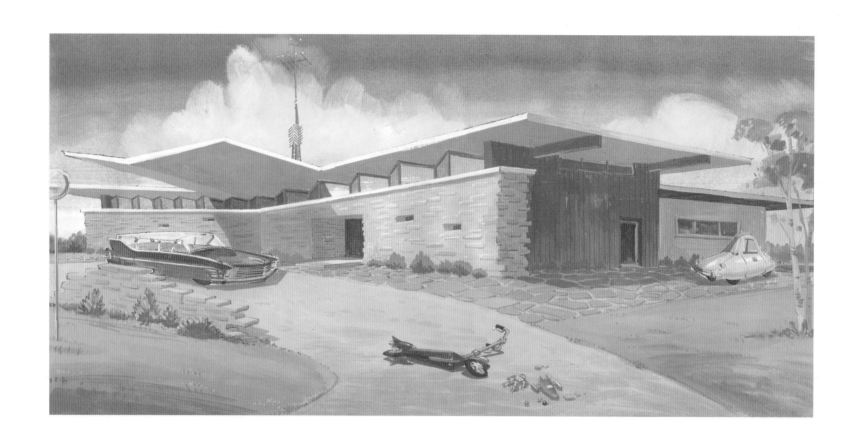

THE INCREDIBLES Scott Caple, Gouache, 2001

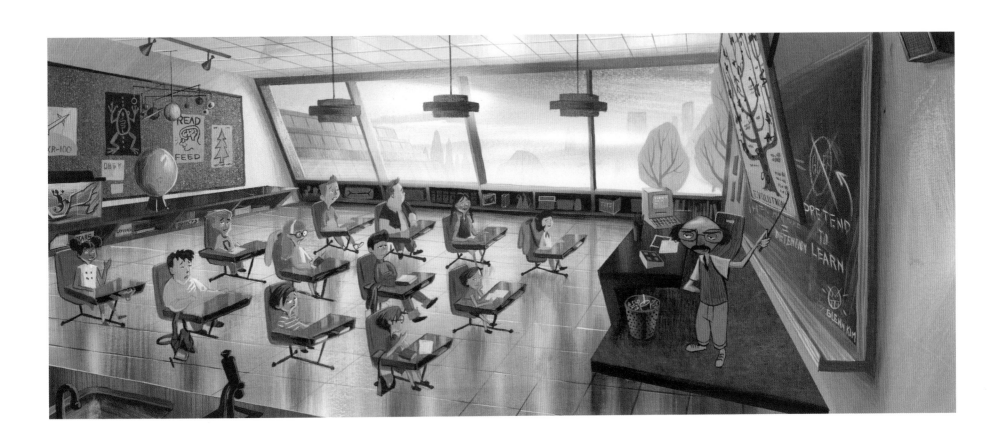

THE INCREDIBLES Glenn Kim, Gouache, 2001

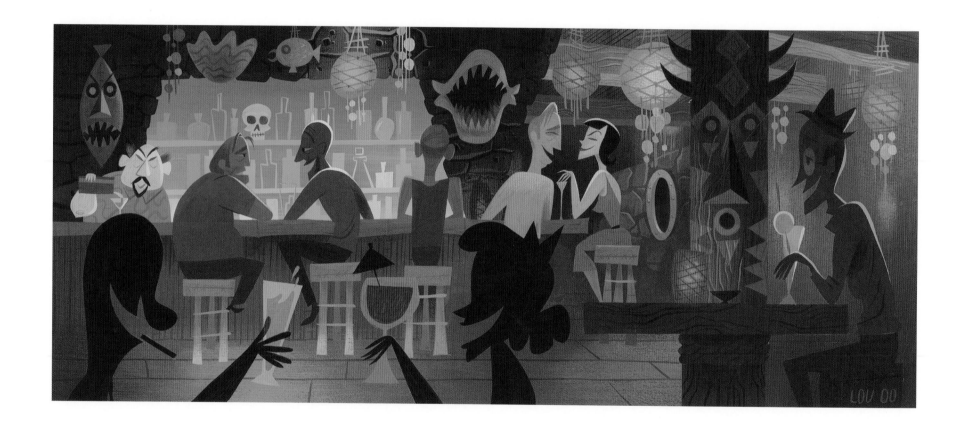

ABOVE

THE INCREDIBLES Lou Romano, Gouache, 2000

OPPOSITE

THE INCREDIBLES Lou Romano, Gouache, 2000

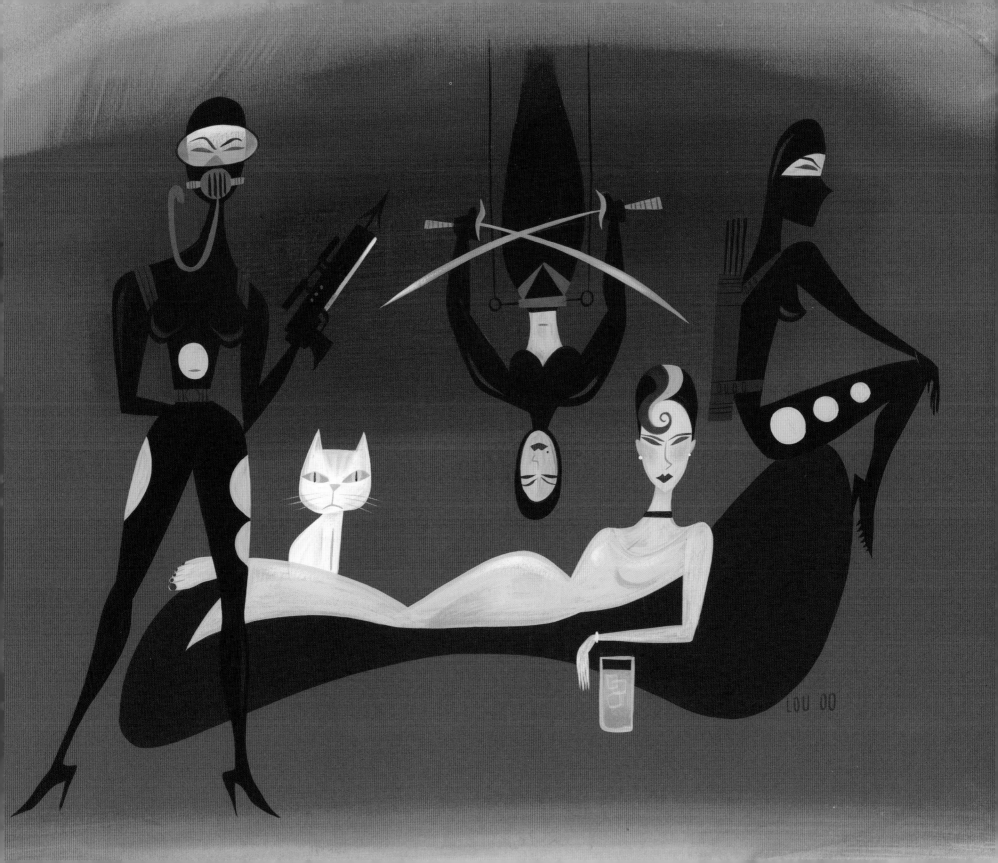

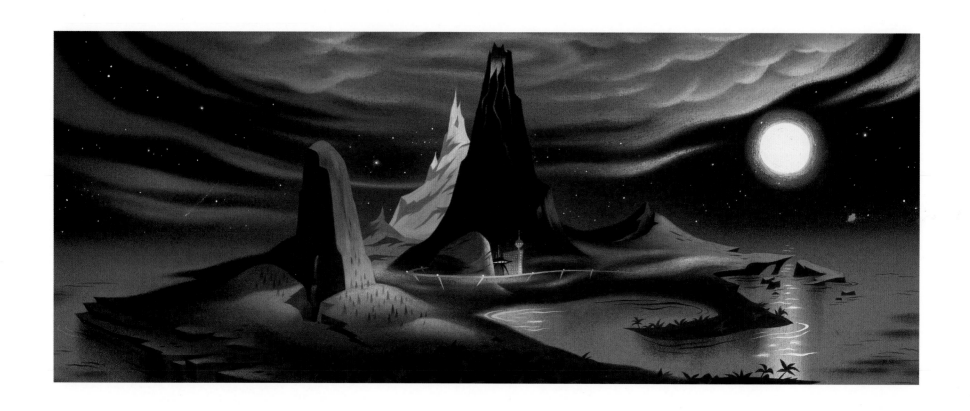

THE INCREDIBLES Lou Romano, Layout by Don Shank, Gouache, 1998

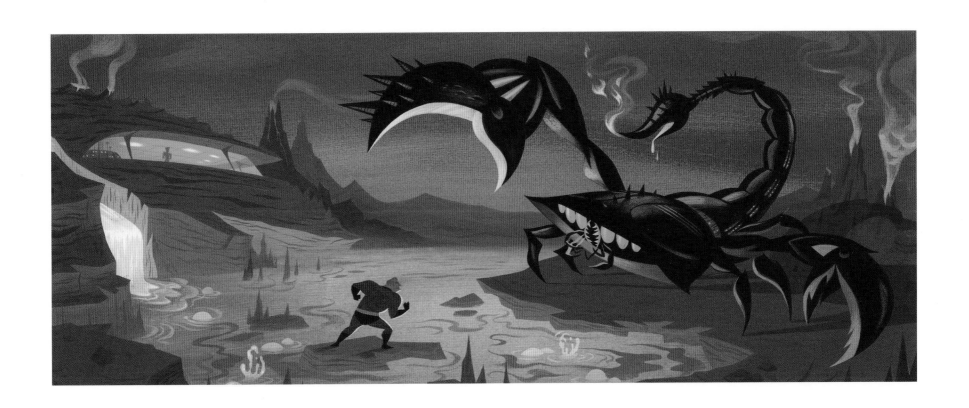

THE INCREDIBLES Lou Romano, Layout by Don Shank, Gouache, 1998

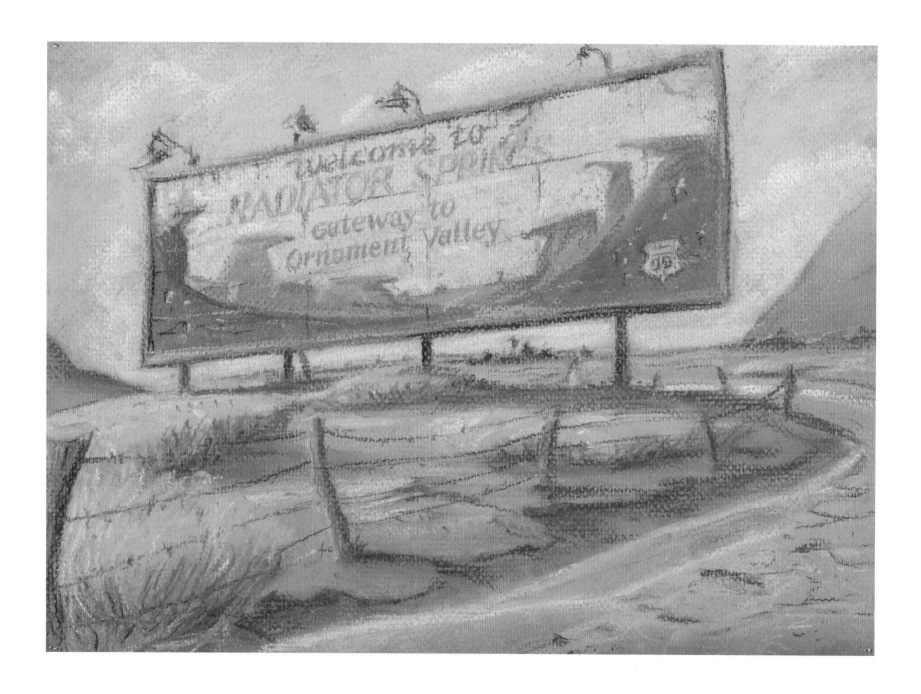

CARS Bud Luckey, Pastel, 2002

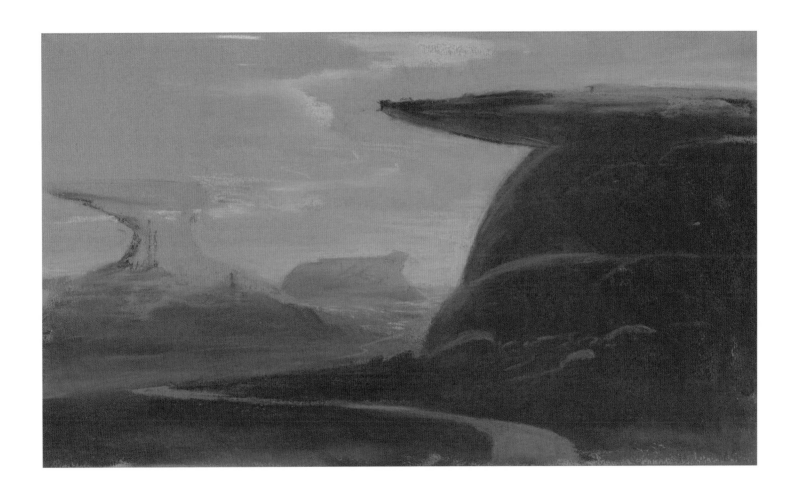

CARS Bill Cone, Pastel, 2001

CARS John Lee, Layout by Nat McLaughlin, Digital, 2005

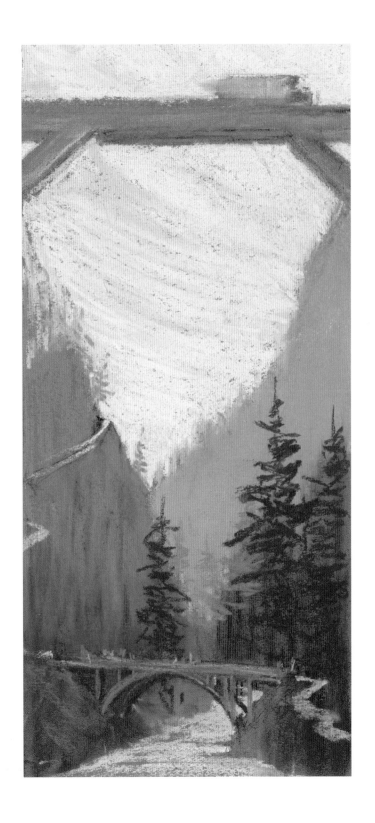

CARS Bill Cone, Pastel, 2004

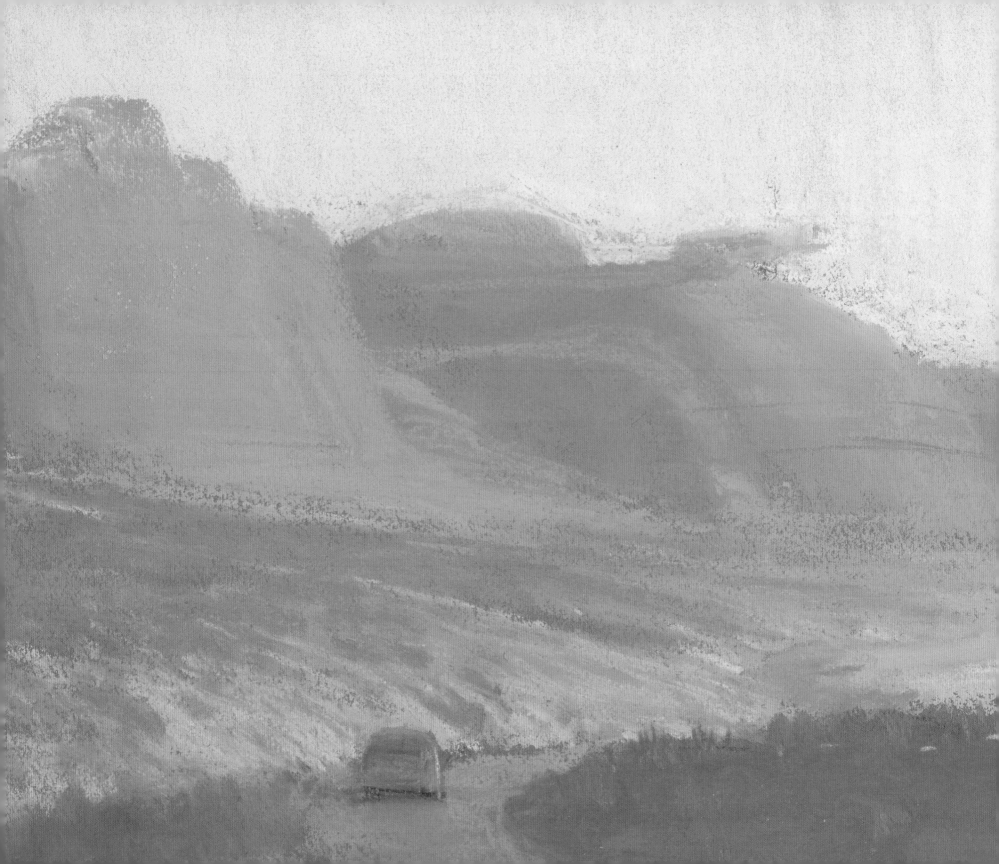

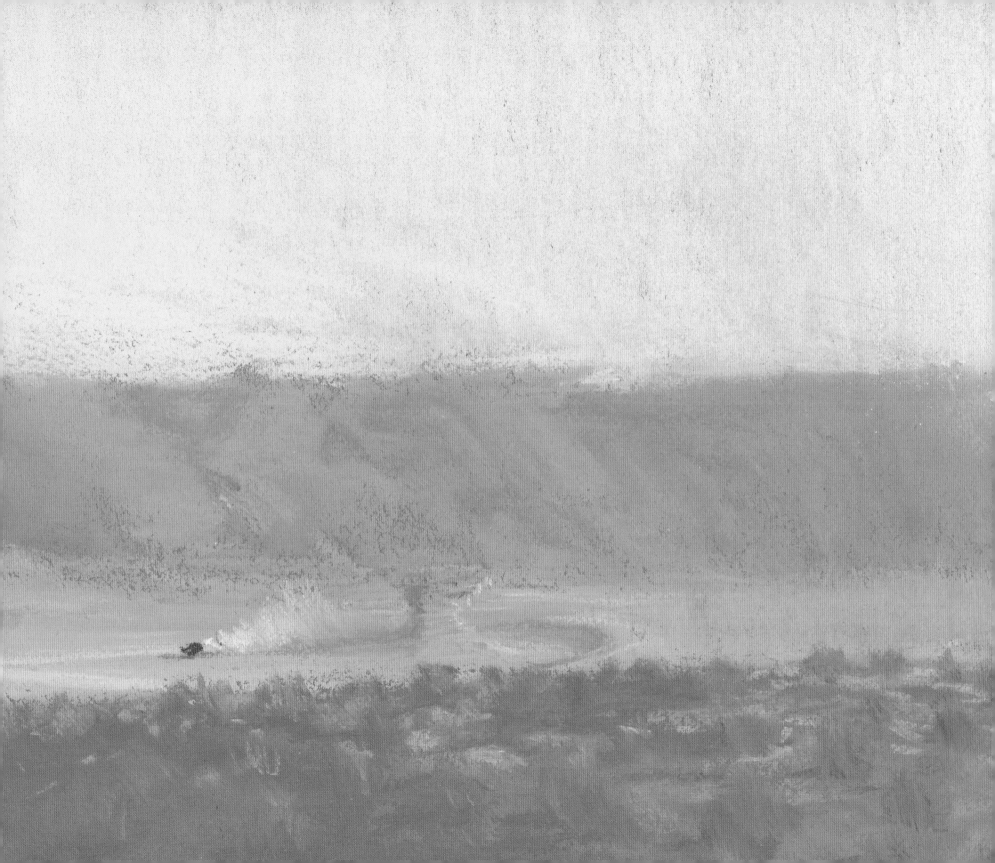

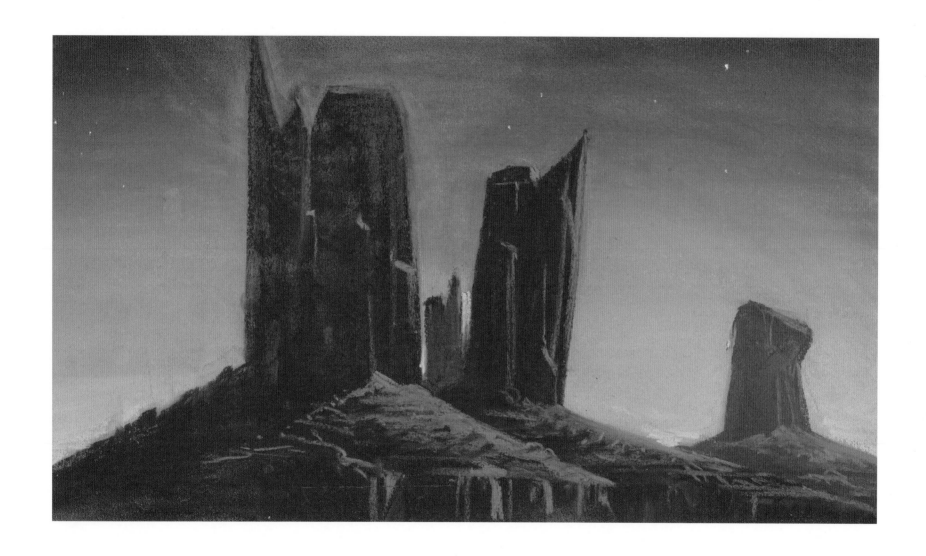

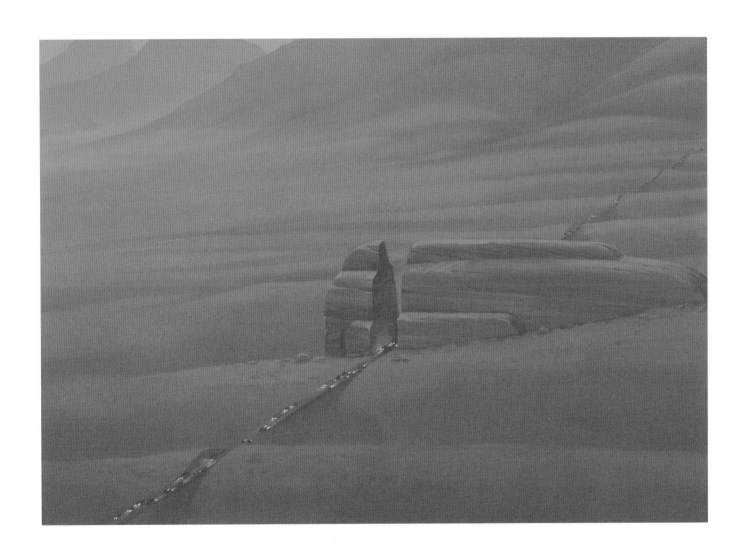

CARS Tia Kratter, Acrylic, 2004

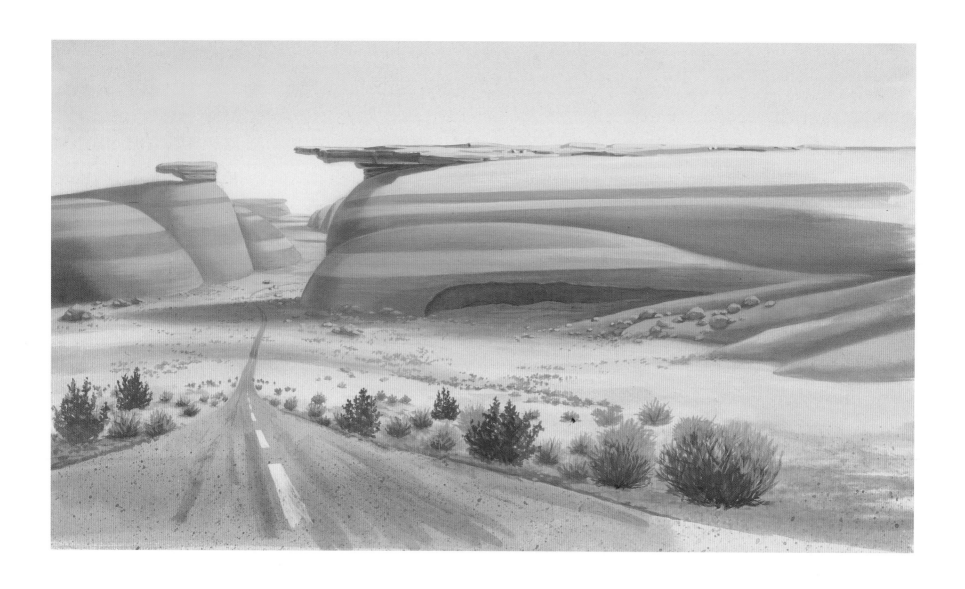

CARS Tia Kratter, Acrylic, 2003

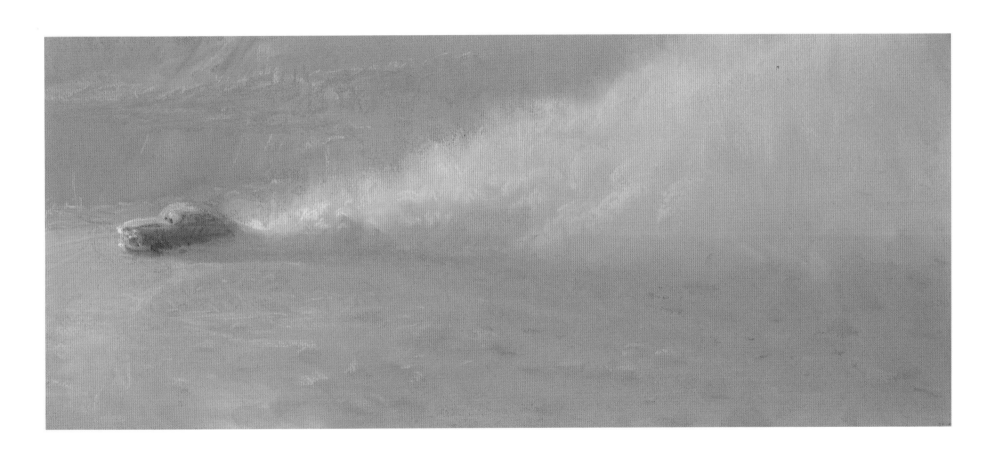

CARS Bill Cone, Pastel, 2004

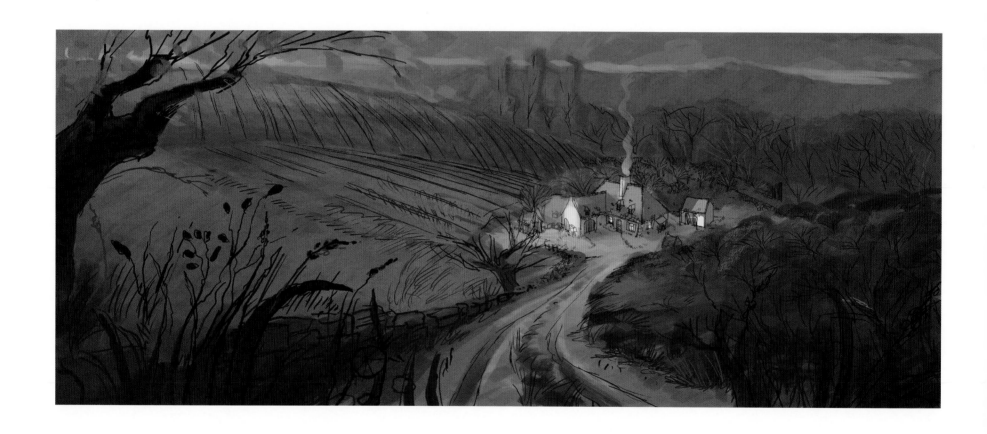

RATATOUILLE Robert Kondo, Digital, 2006

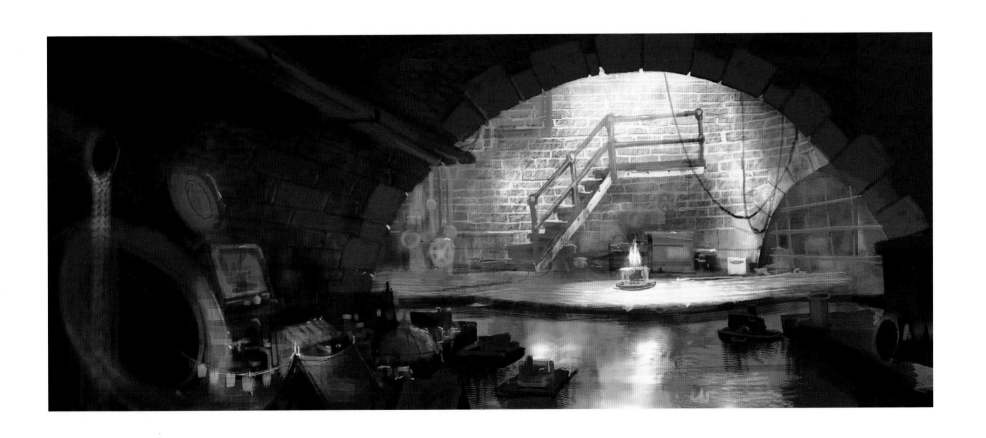

RATATOUILLE Dominique R. Louis, Layout by Harley Jessup, Digital, 2002

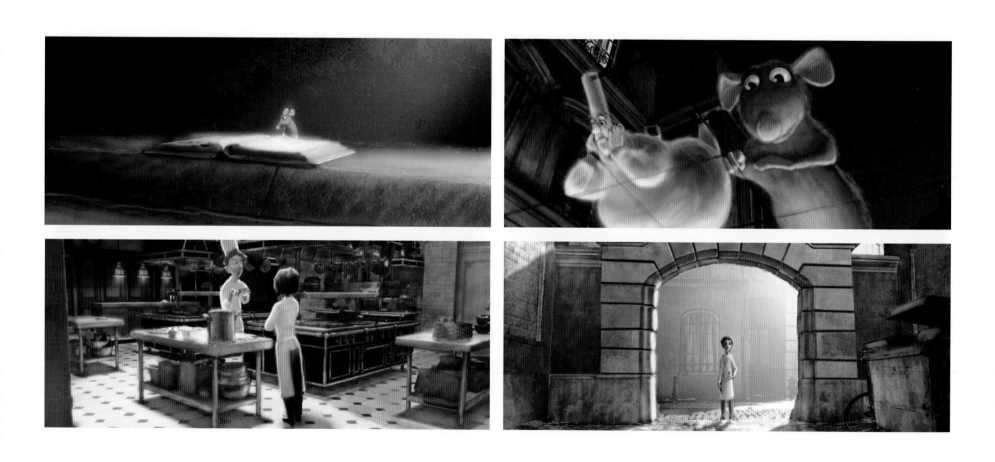

RATATOUILLE Sharon Calahan, Digital paint over set render, 2006

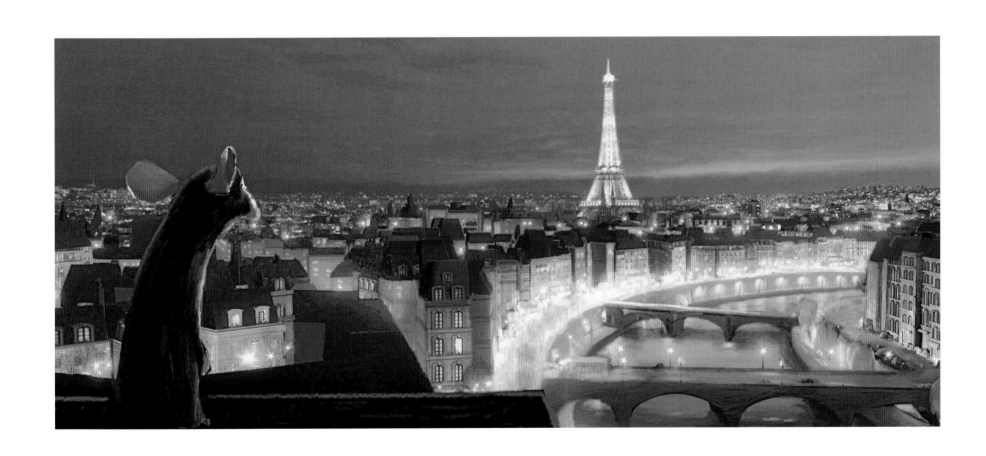

RATATOUILLE Ernesto Nemesio, Digital paint over set render, 2006

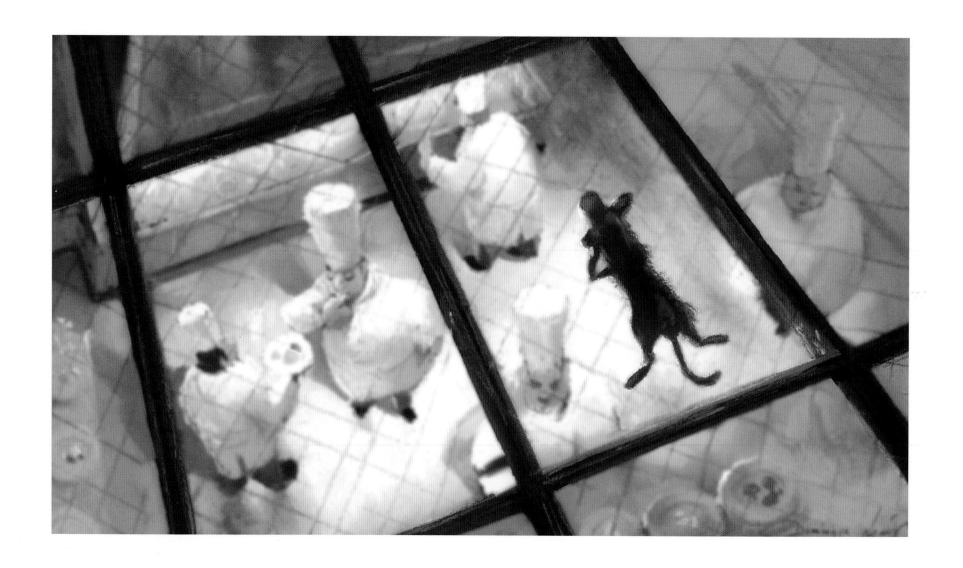

ABOVE

RATATOUILLE Dominique R. Louis, Layout by Harley Jessup, Pastel, 2002

OPPOSITE

RATATOUILLE Harley Jessup, Layout by Enrico Casarosa, Digital, 2004

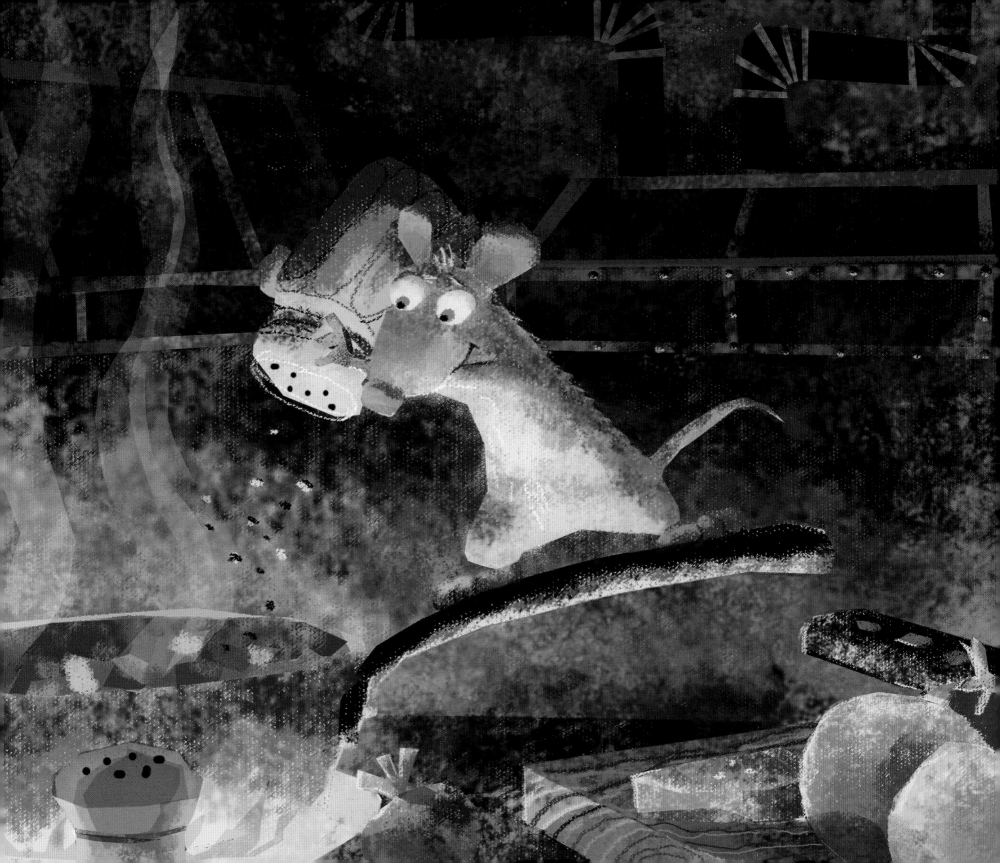

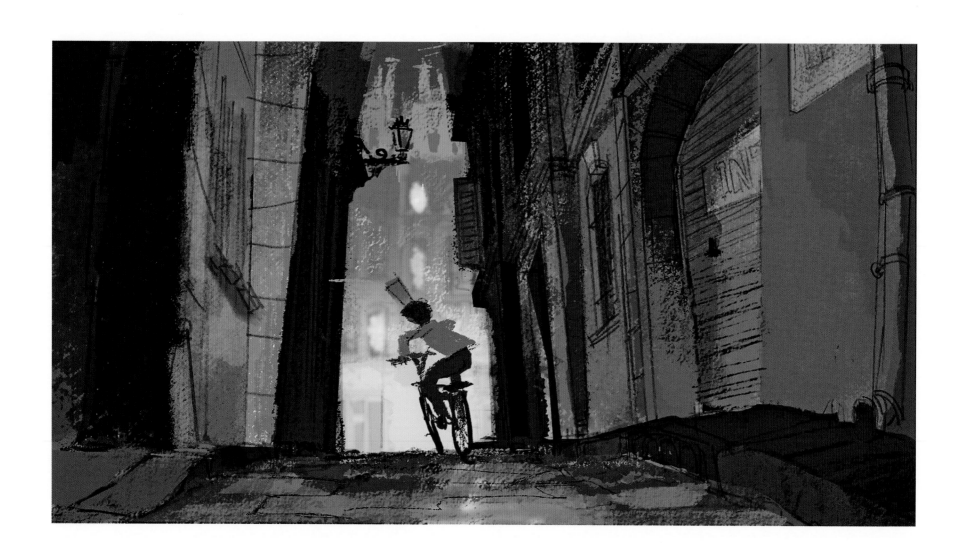

RATATOUILLE Robert Kondo, Digital, 2005

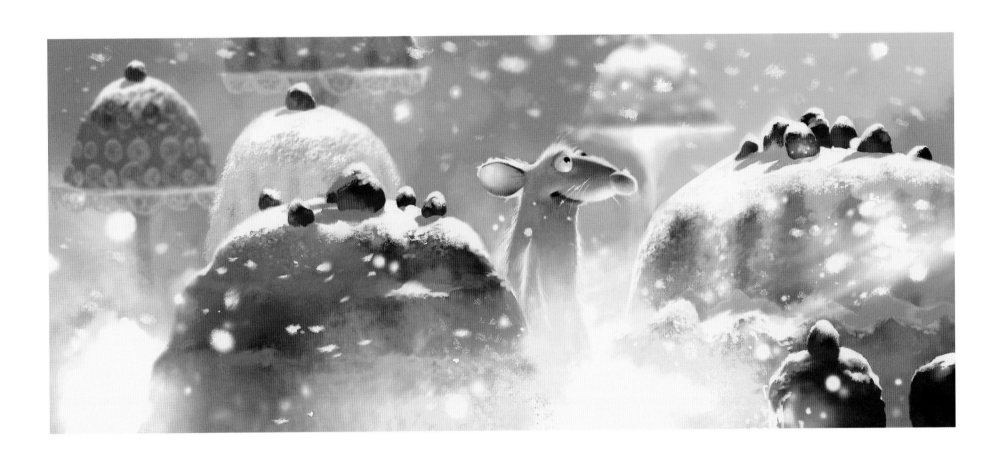

RATATOUILLE Dominique R. Louis, Layout by Harley Jessup, Digital, 2003

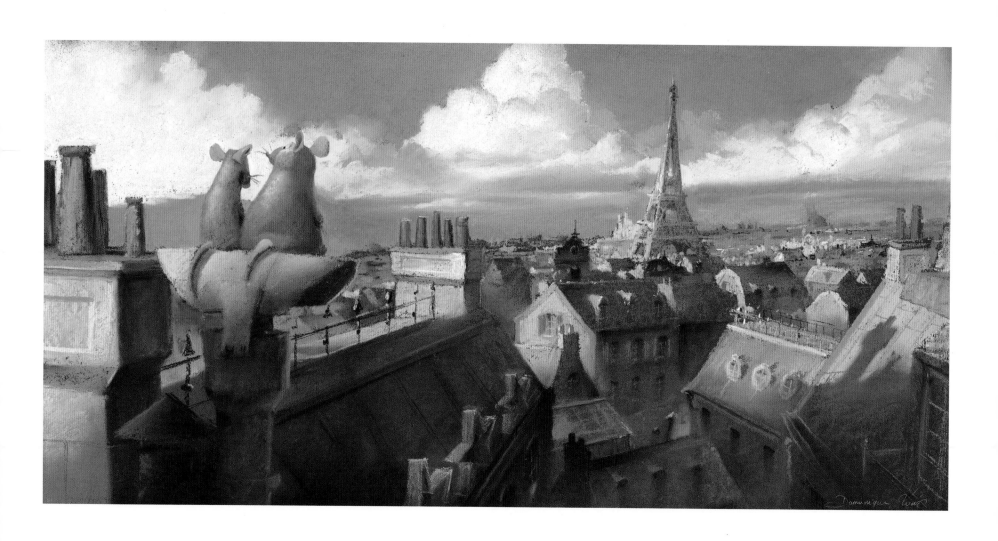

RATATOUILLE Dominique R. Louis, Layout by Harley Jessup, Pastel, 2002

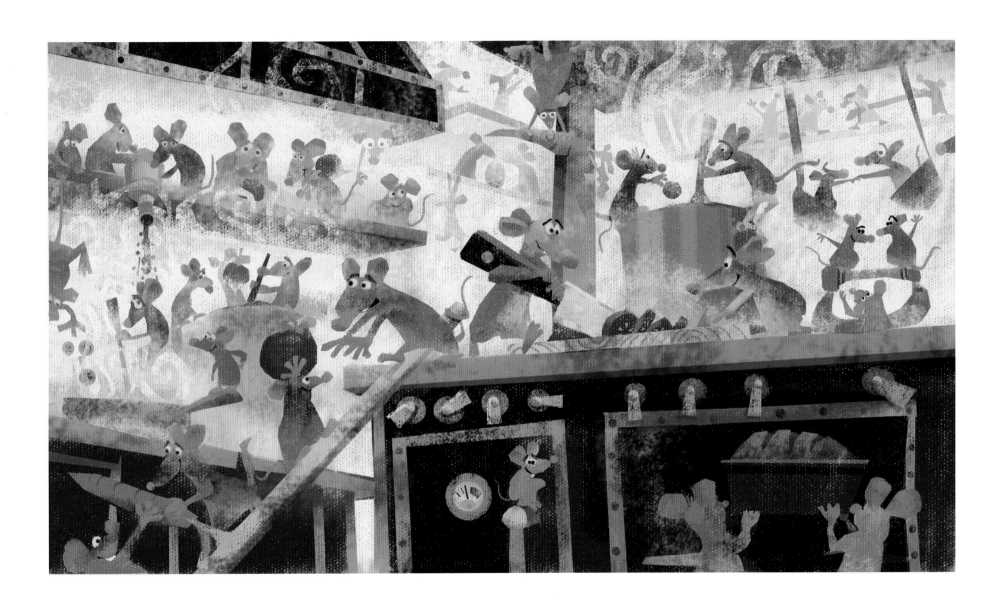

RATATOUILLE Harley Jessup, Layout by Enrico Casarosa, Digital, 2005

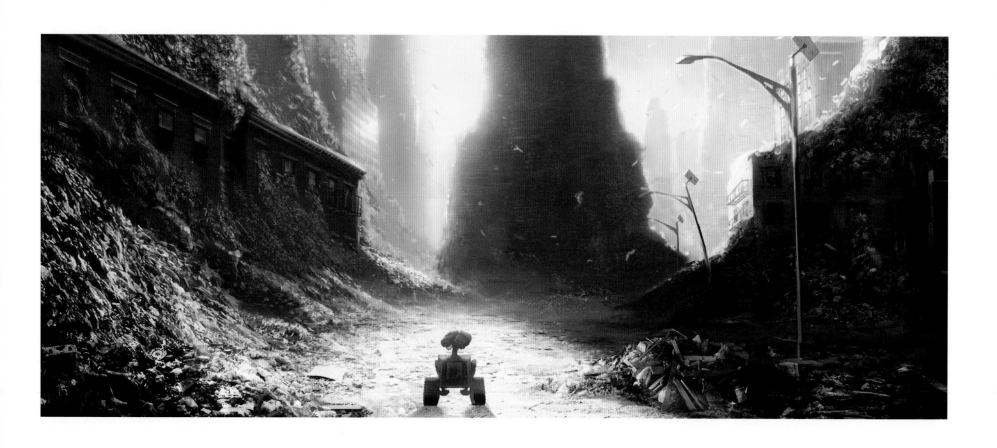

WALL•E Paul Topolos, Digital, 2006

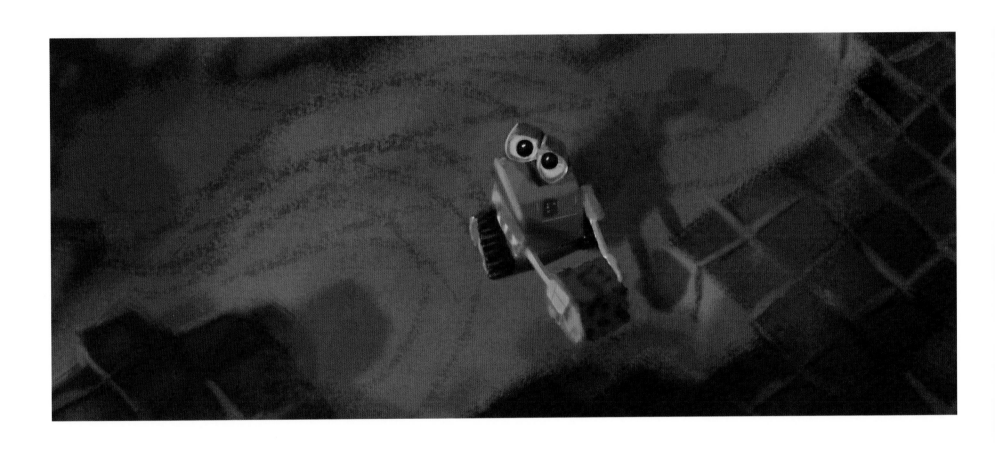

WALL•E Ralph Eggleston, Digital, 2007

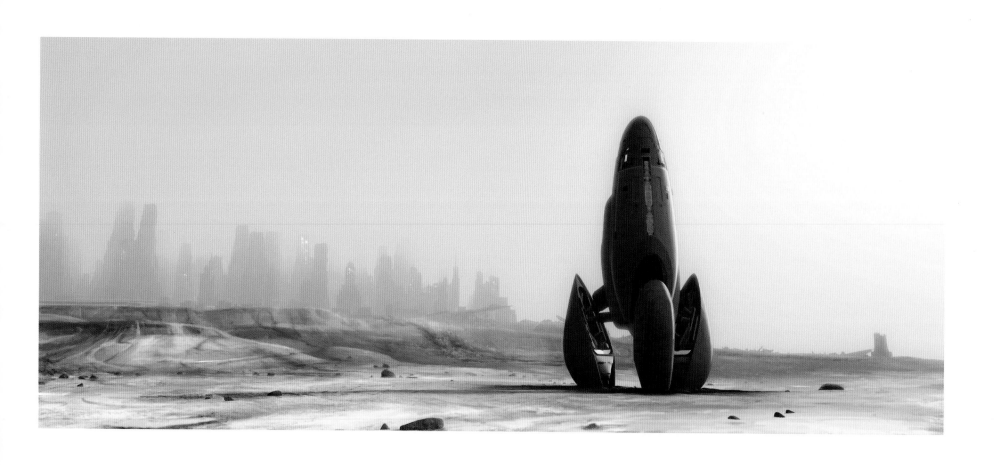

WALL•E Ernesto Nemesio, Digital, 2006

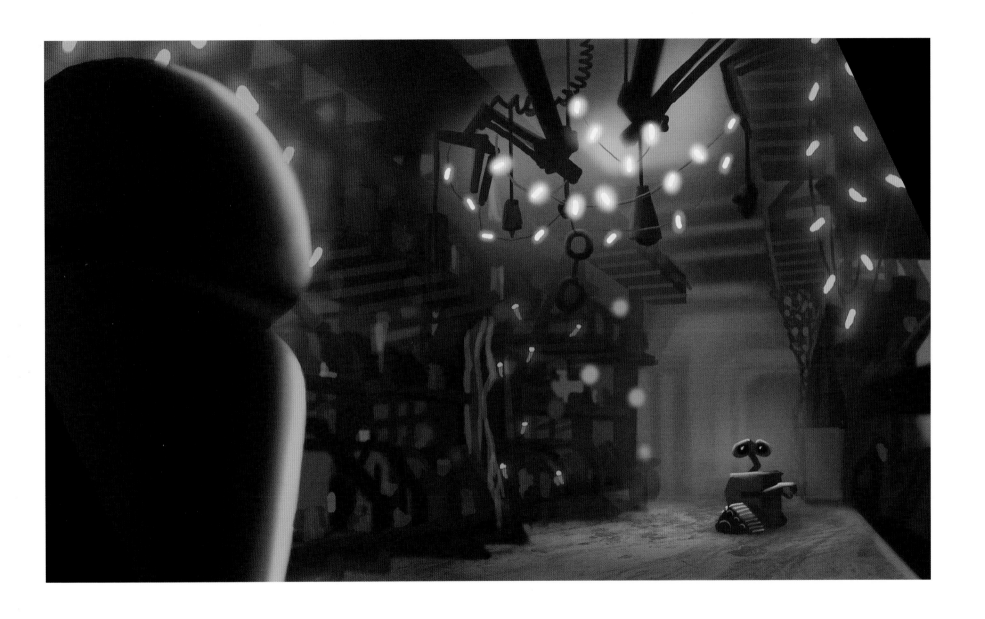

WALL•E John Lee, Digital, 2006

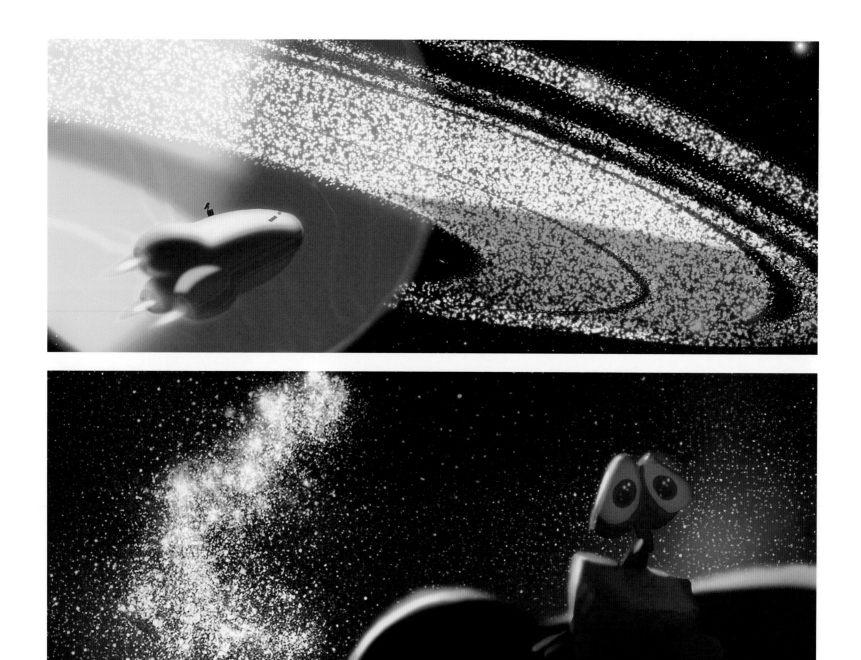

WALL•E Ralph Eggleston, Digital, 2007

282

WALL•E John Lee, Digital, 2006

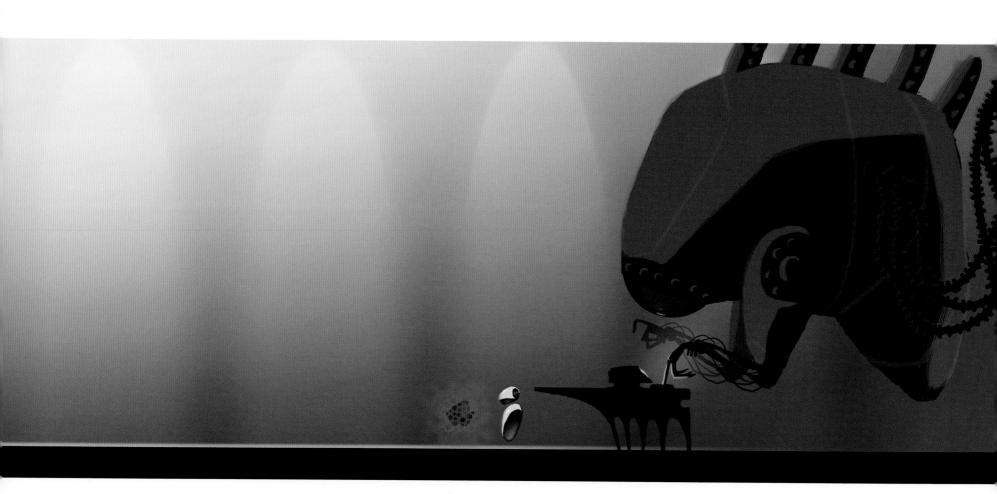

WALL•E Ralph Eggleston, Digital, 2005

WALL•E Ralph Eggleston, Digital, 2007

285

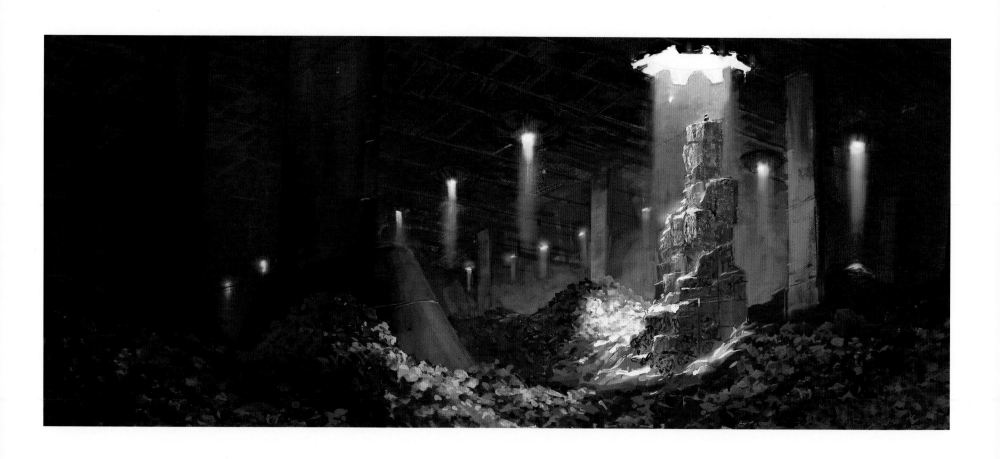

WALL•E John Lee, Layout by Noah Klocek, Digital, 2006

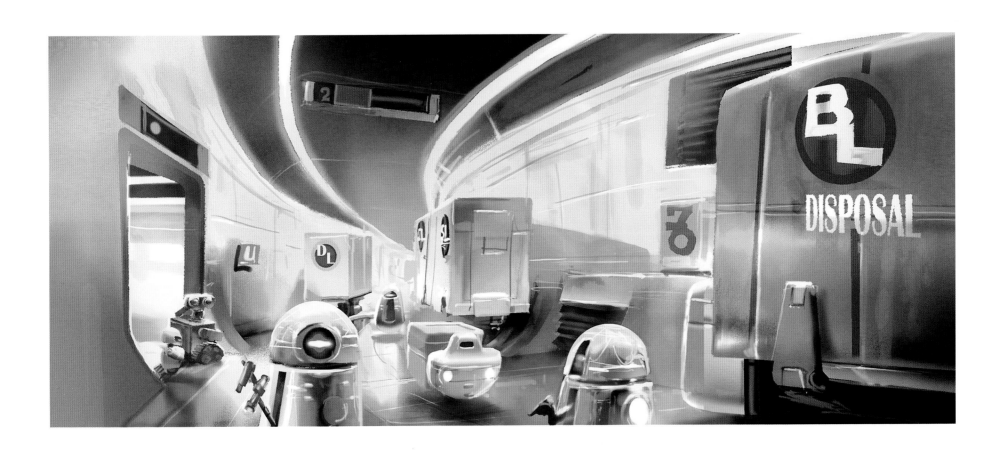

WALL•E John Lee, Layout by Jay Shuster, Digital, 2006

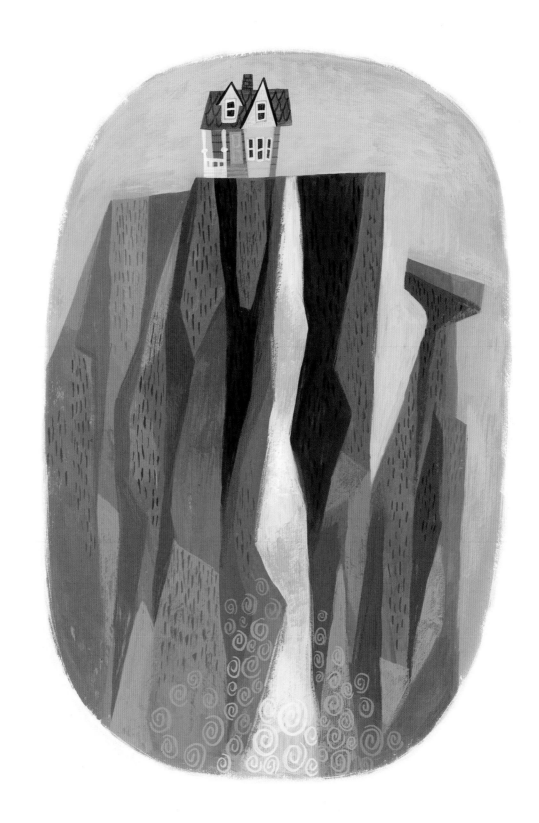

UP Lou Romano, Gouache, 2008

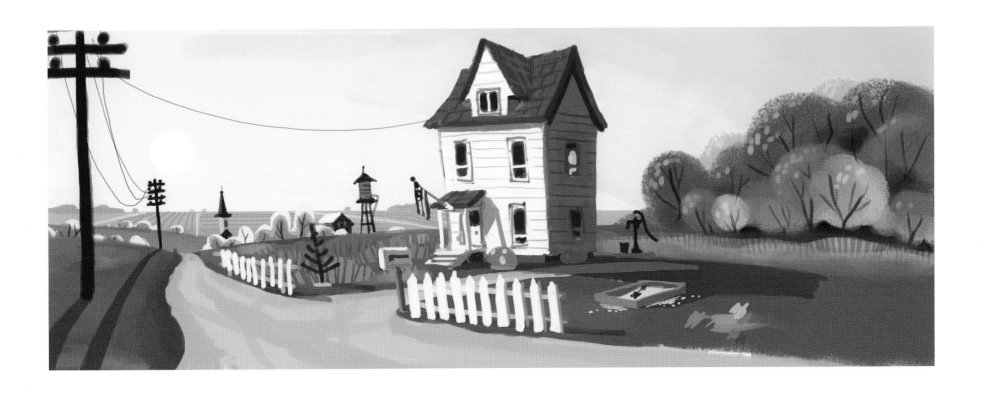

UP Nat McLaughlin, Digital, 2006

UP Don Shank, Digital, 2004

UP Dominique, R. Louis, Pastel, 2005

UP Daniel Arriaga, Pencil, 2007

UP Lou Romano, Gouache, 2006

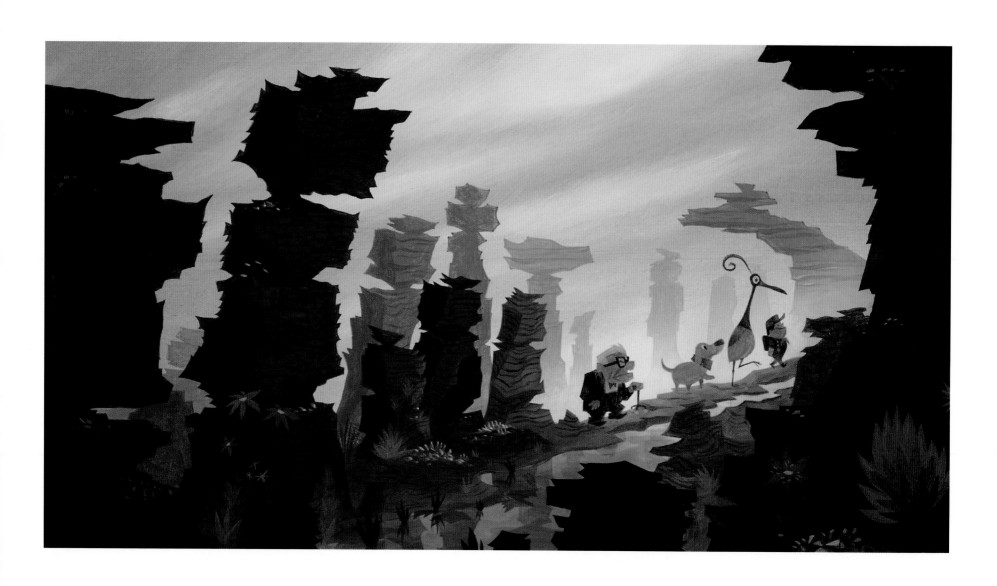

UP Lou Romano, Layout by Don Shank, Gouache, 2006

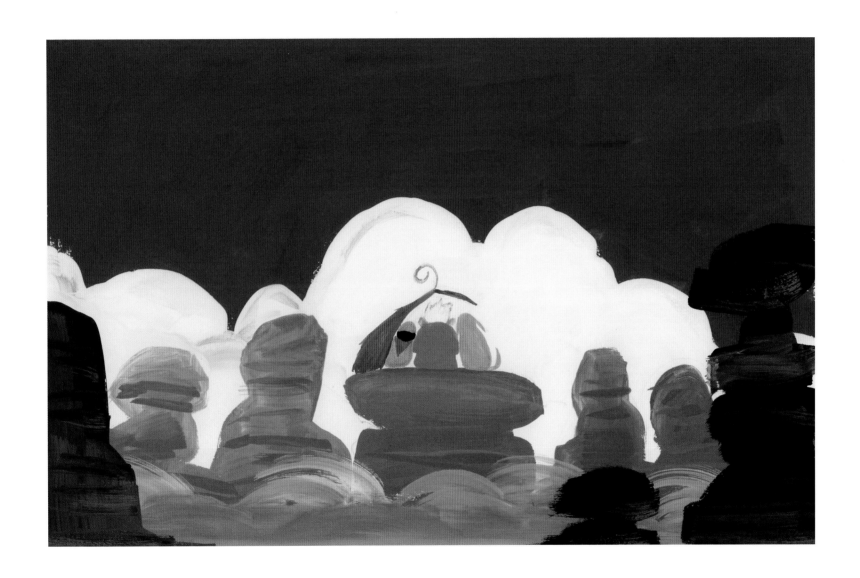

UP Ricky Nierva, Gouache, 2006

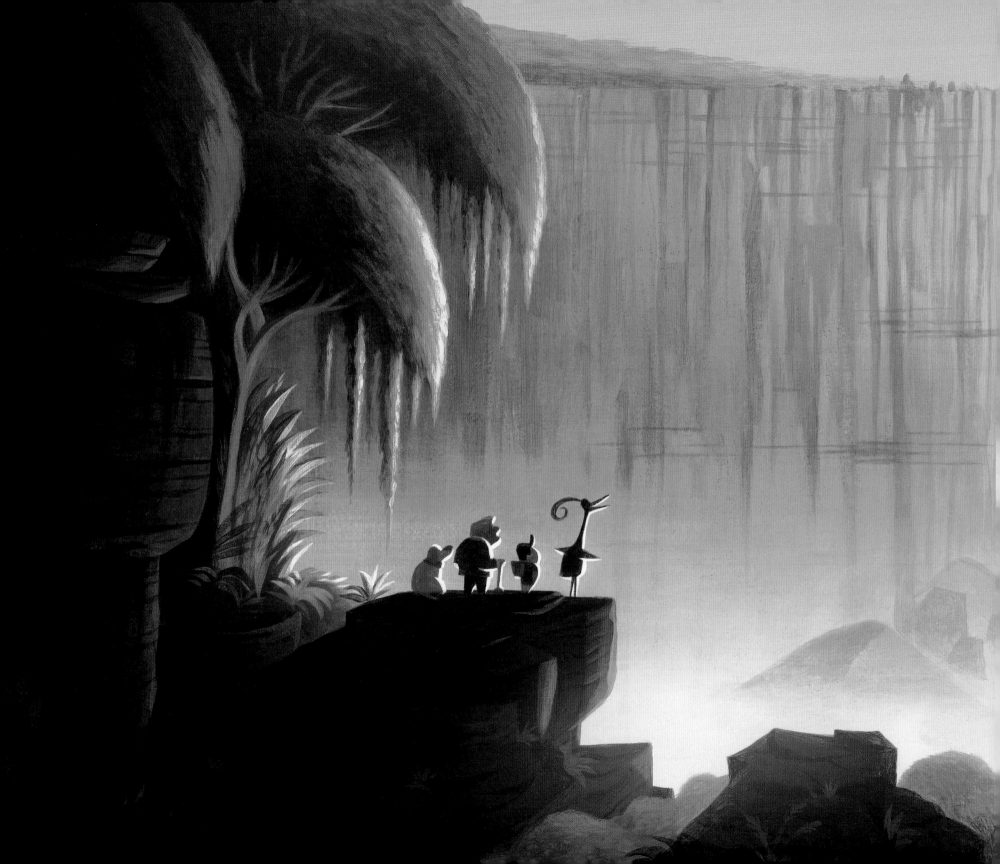

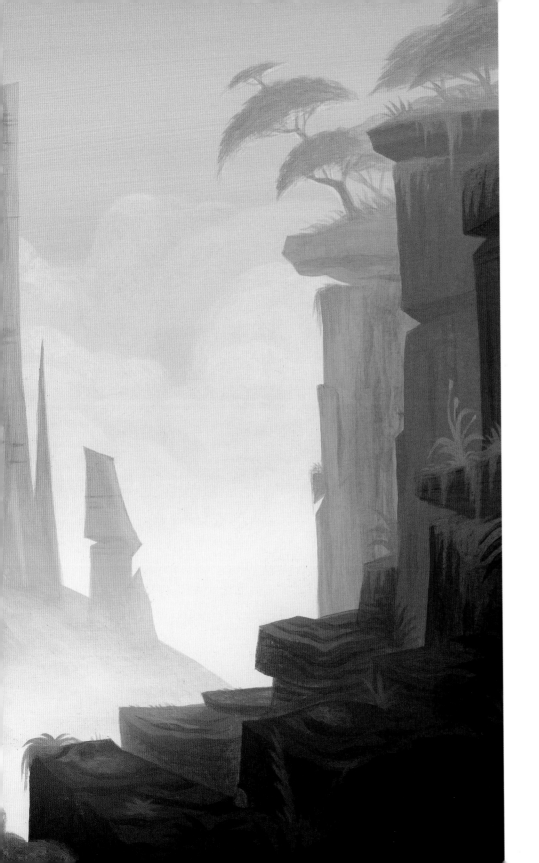

UP Lou Romano, Layout by Don Shank, Gouache, 2005

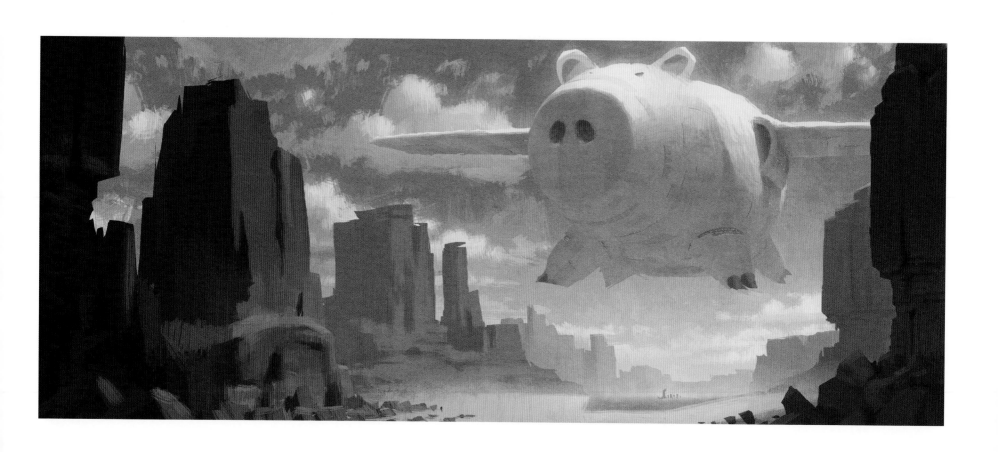

TOY STORY 3 Dice Tsutsumi, Digital, 2007

TOY STORY 3 Dice Tsutsumi, Digital, 2009

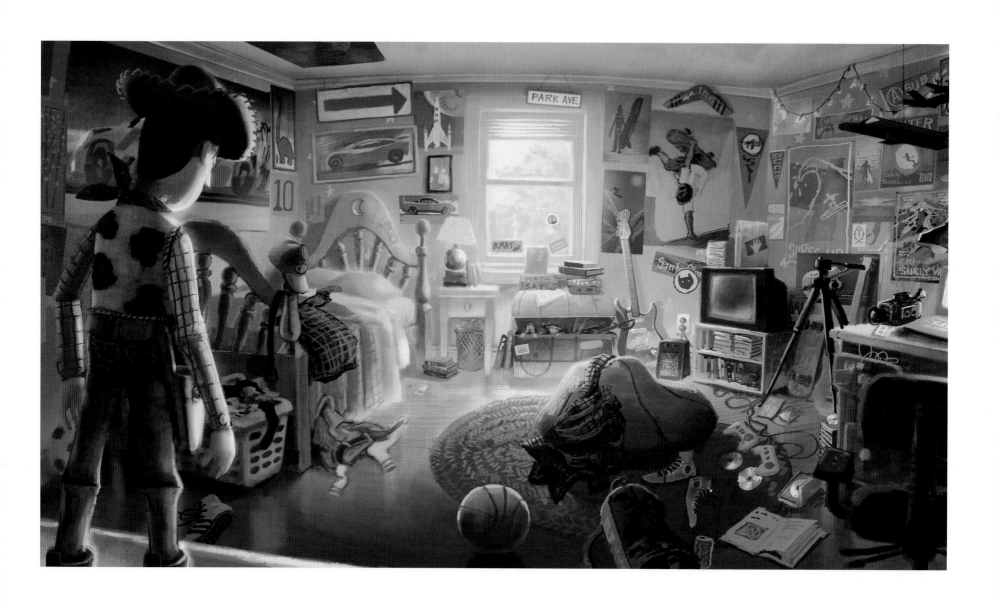

TOY STORY 3 Glenn Kim, Digital, 2007

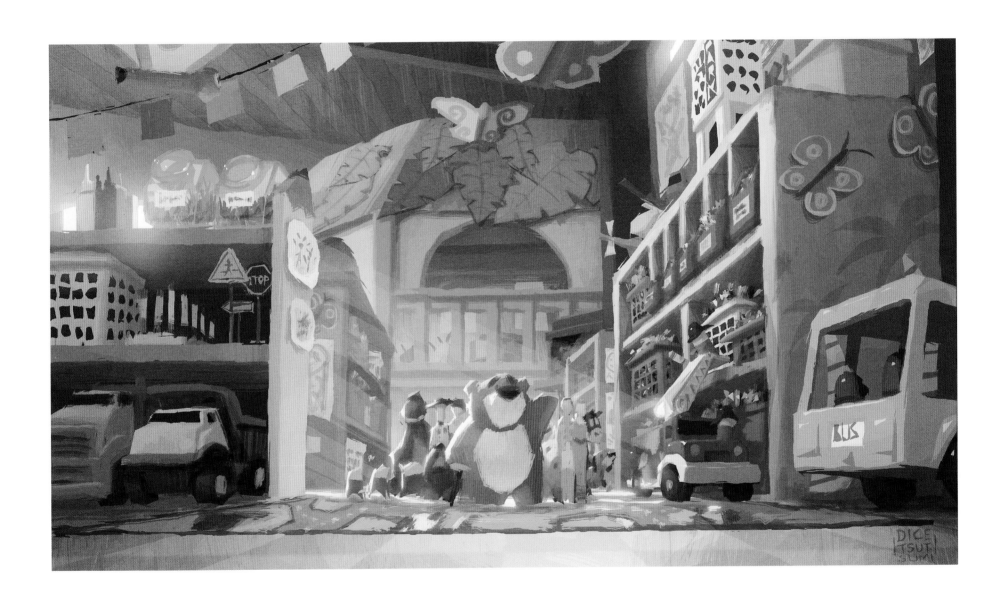

TOY STORY 3 Dice Tsutsumi, Digital, 2008

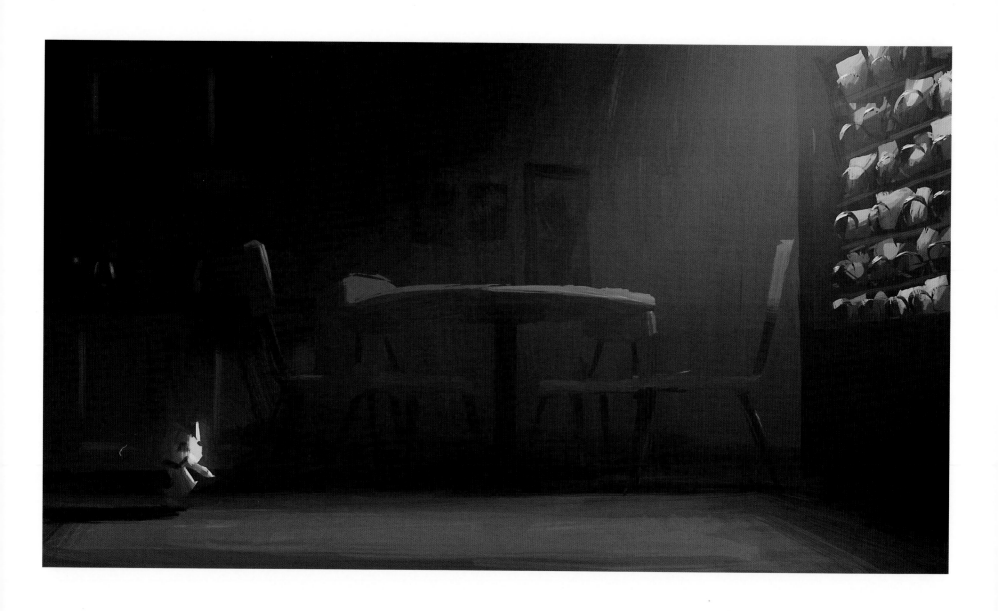

TOY STORY 3 Dice Tsutsumi, Digital, 2008

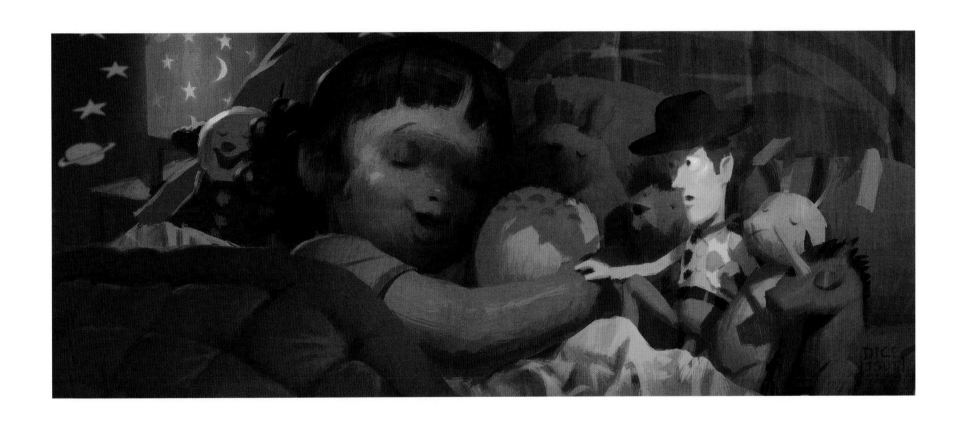

TOY STORY 3 Dice Tsutsumi, Digital, 2007

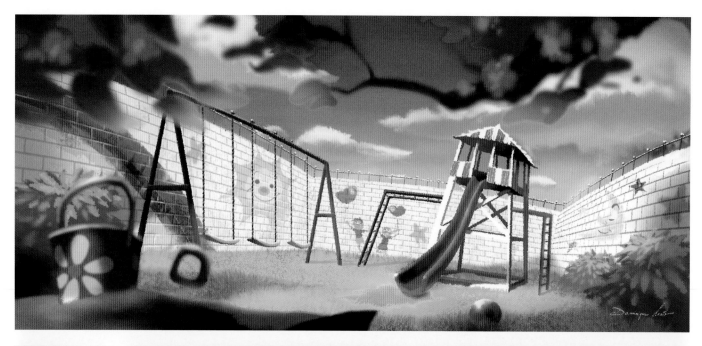

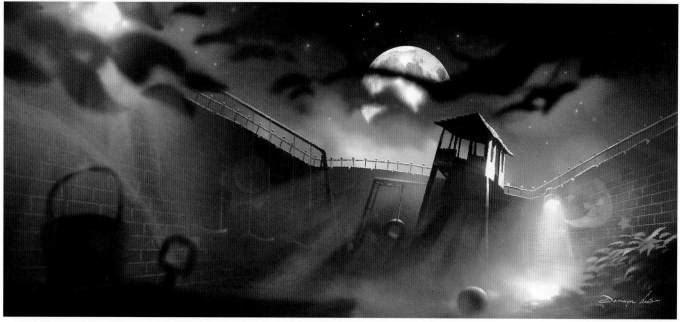

TOY STORY 3 Dominique R. Louis, Digital, 2006

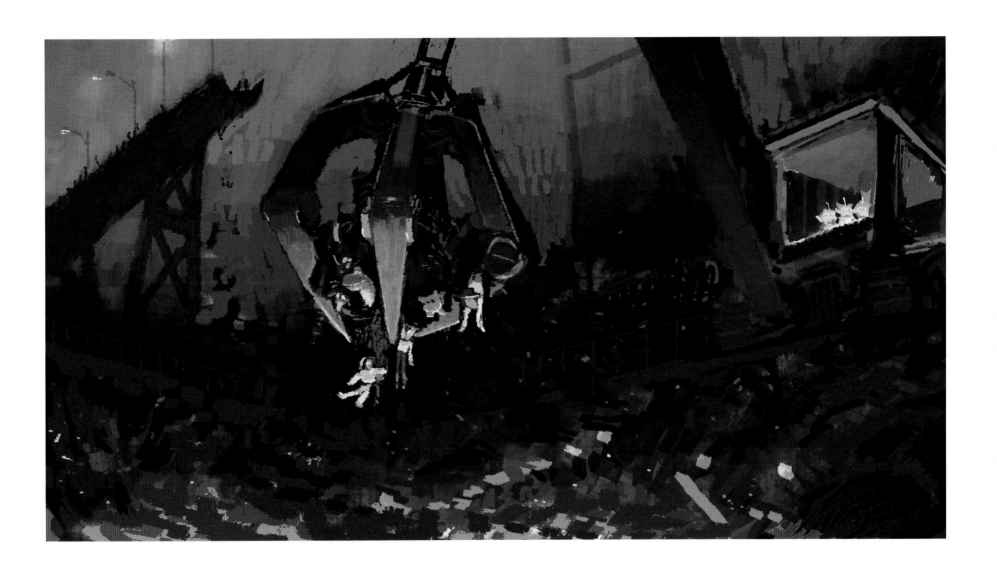

TOY STORY 3 Robert Kondo, Digital, 2007

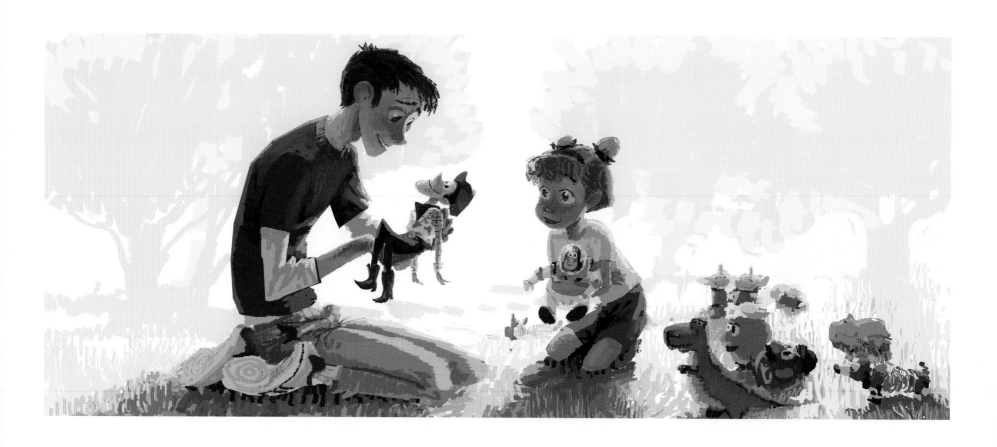

TOY STORY 3 Robert Kondo, Layout by Tom Gately, Digital, 2007

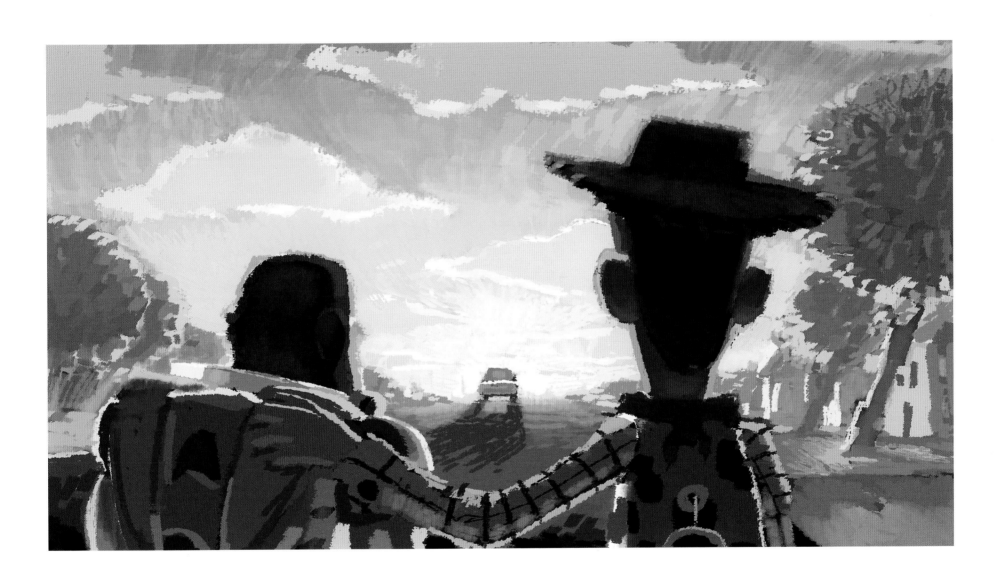

TOY STORY 3 Robert Kondo, Digital, 2007

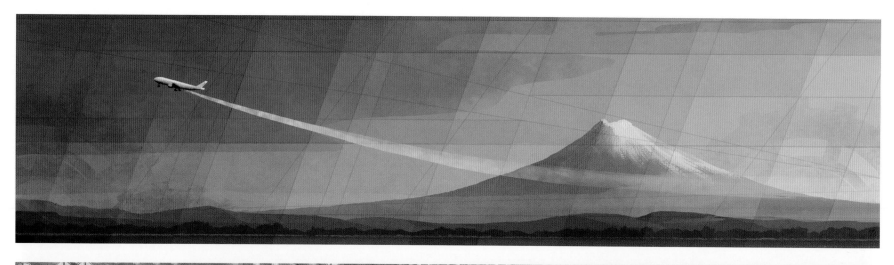

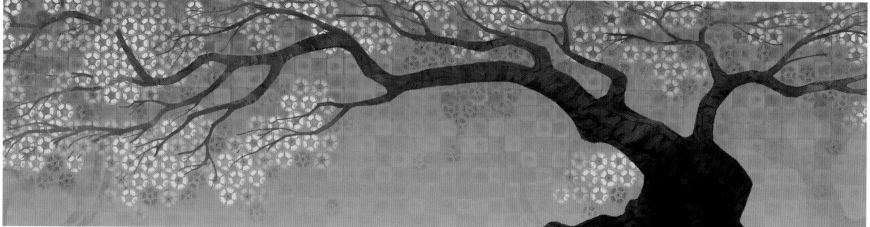

CARS 2 Chia Han Jennifer Chang, Layout by Harley Jessup, Digital, 2010

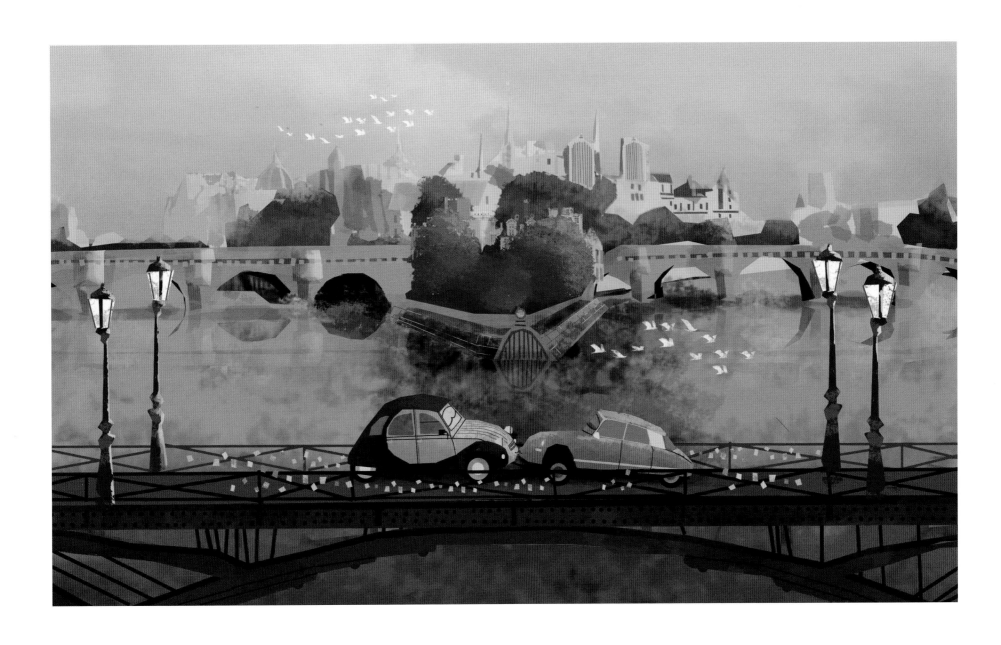

CARS 2 Harley Jessup, Layout by Josh Cooley, Digital, 2010

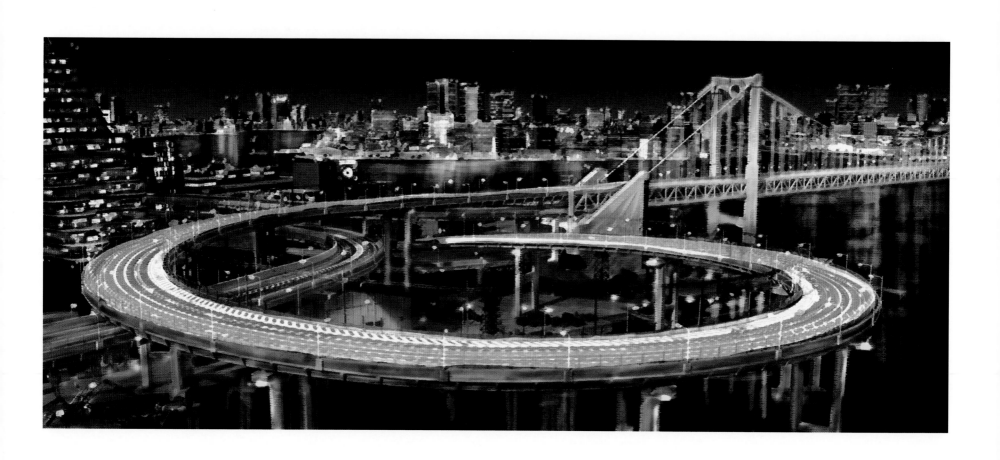

CARS 2 Sharon Calahan, Digital paint over set render, 2010

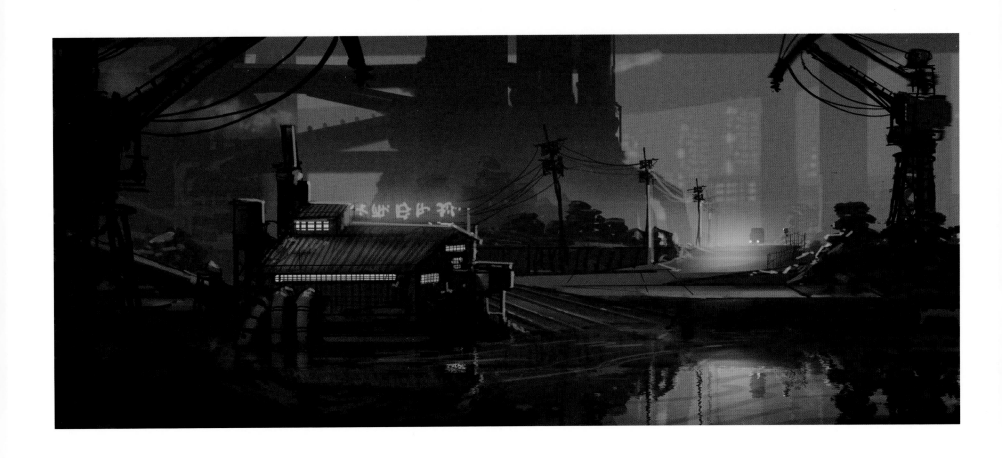

CARS 2 Armand Baltazar, Digital, 2009

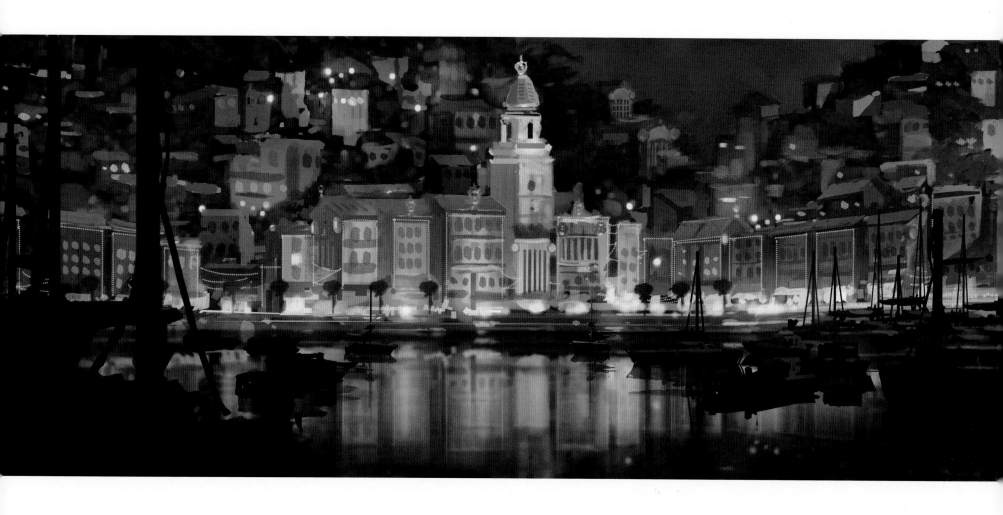

CARS 2 Armand Baltazar, Digital, 2009

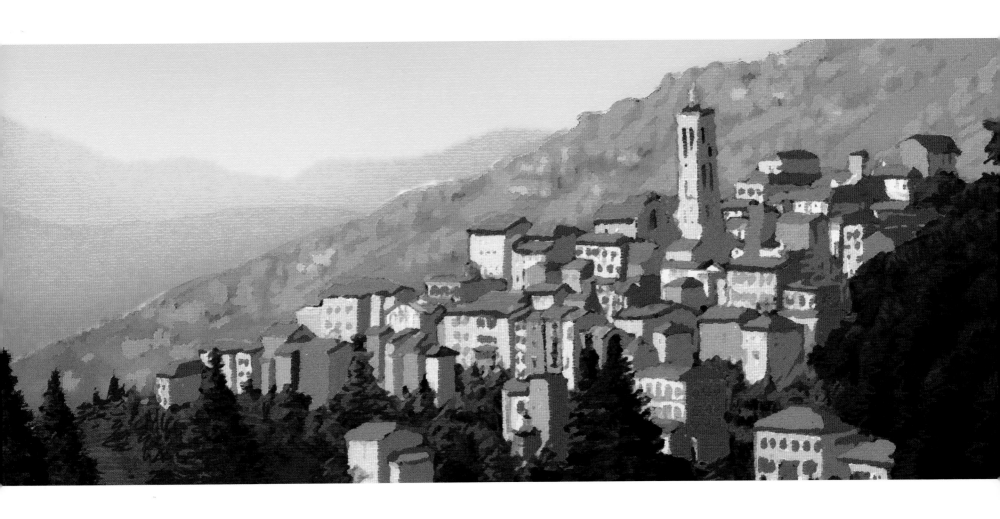

CARS 2 Sharon Calahan, Digital paint over set render, 2010

CARS 2 Armand Baltazar, Digital, 2009

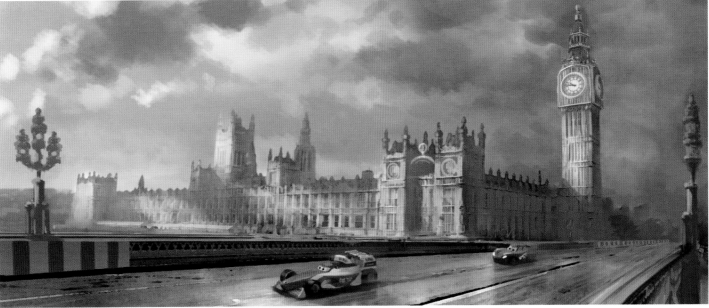

CARS 2 Armand Baltazar, Digital, 2010

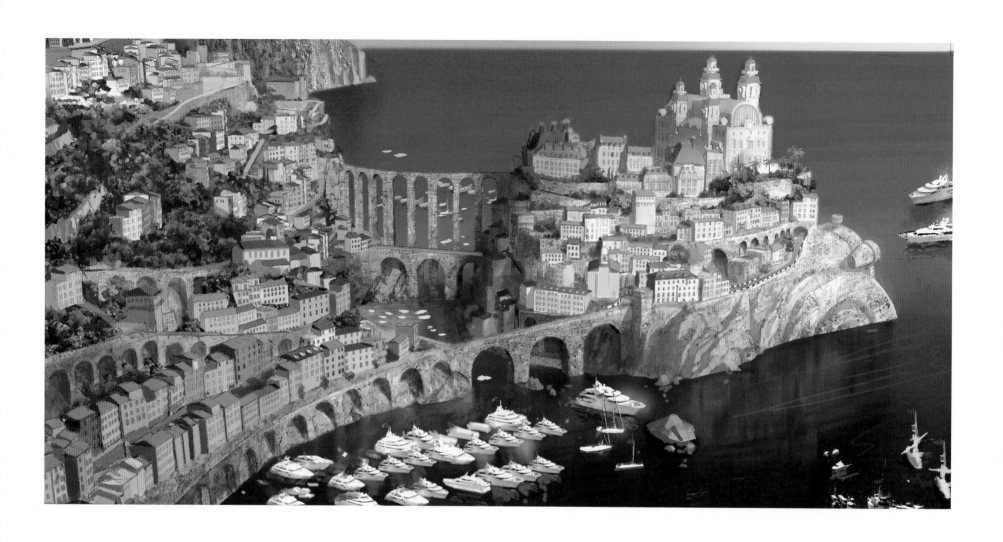

CARS 2 Armand Baltazar, Digital, 2010

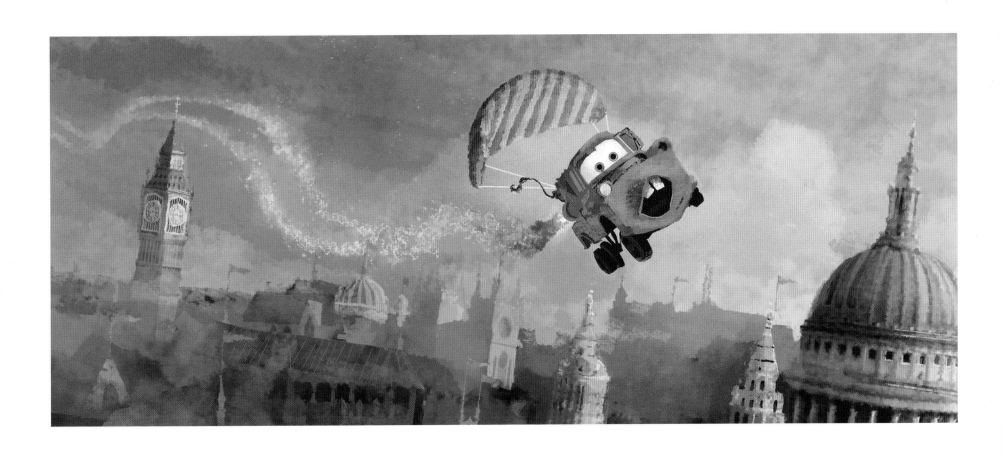

CARS 2 Harley Jessup, Digital, 2010

BIBLIOGRAPHY

Amidi, Amid. *Cartoon Modern: Style and Design in Fifties Animation.* San Francisco: Chronicle Books, 2006.

Andrews, Robert. *The Columbia Dictionary of Quotations.* New York: Columbia University Press, 1993.

Barbagallo, Ron (2008). "The Art of Making Pixar's *Ratatouille*." Retrieved December 10, 2010, from http://animationartconservation.com/?c=art&p=articles_ratatouille.

Canemaker, John. *Before the Animation Begins: The Art and Lives of Disney Inspirational Sketch Artists.* New York: Hyperion, 1996.

Edwards, Cliff. *Mystery of* The Night Café*: Hidden Key to the Spirituality of Vincent van Gogh.* Albany: Excelsior Editions/State University of New York Press, 2009.

Kalmus, Natalie M. "Color Consciousness." *Journal of the Society of Motion Picture Engineers,* Volume XXV, Number 2. August, 1935.

Laverty, Chris (July 19, 2010). "Exclusive Interview with *Toy Story 3* Director Lee Unkrich." Retrieved December 10, 2010, from http://clothesonfilm.com/exclusive-interview-with-toy-story-3-director-lee-unkrich/13829.

Price, Maggie (February 10, 2008). "Bill Cone and Plein Air." Retrieved December 10, 2010, from http://www.artistsnetwork.com/article/cone-plein-air.

Solomon, Charles. *The Art of Toy Story 3.* San Francisco: Chronicle Books, 2010.

ACKNOWLEDGMENTS

LeighAnna MacFadden at Pixar put her trust in me, and Emily Haynes, my editor at Chronicle Books, helped shape the text and guided me through the rough patches.

Some fine folks at Pixar answered my questions: Bill Cone, Ralph Eggleston, Harley Jessup, Ricky Nierva, Elyse Klaidman, and Christine Freeman. Many more fine folks at Chronicle and Pixar contributed to the making of this book: Kelly Bonbright, Andy Dreyfus, Karen Paik, Meg Ocampo, Sarah Boggs, Heather Feng, Jacob Gardner, Emilie Sandoz, Becca Cohen, and Beth Steiner.

I'm also grateful to Richard Vander Wende and Hans Bacher for valuable historical input; Michael Ruocco, who transcribed the interviews and assisted in countless other ways; Jerry Beck, who is always ready to lend a helpful hand; and my parents and Celia for their continued love and support.

—Amid Amidi